LUKE SWANK

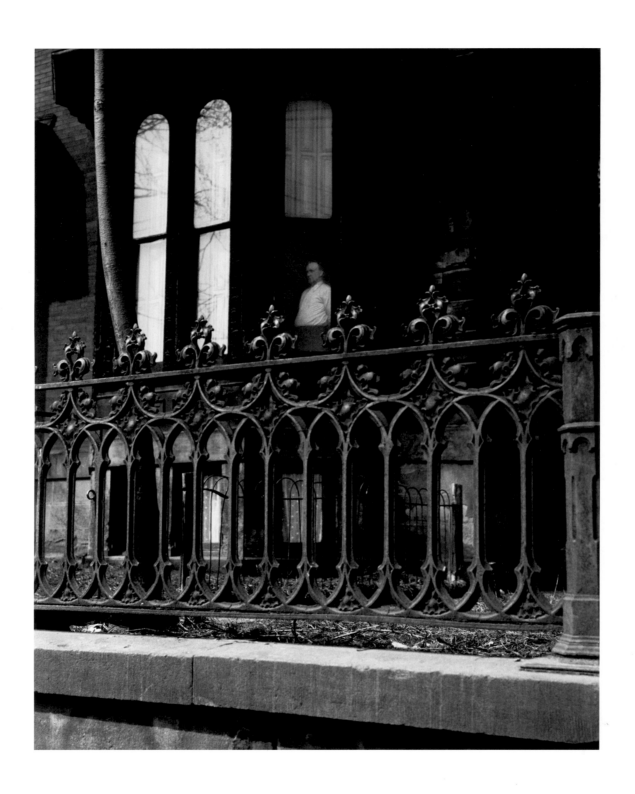

MODERNIST PHOTOGRAPHER

Howard Bossen

UNIVERSITY OF PITTSBURGH PRESS

In memory of Luke and Edith, who have so enriched my life

For Kathy, Colin, and Jorin

Published by the University of Pittsburgh Press, Pittsburgh, Pa., 15260
Copyright © 2005, Michigan State University
All rights reserved
Manufactured in the United States of America
Printed on acid-free paper
10 9 8 7 6 5 4 3 2 1

This book was designed and composed by Ann Walston in Joanna
text type with Magma captions, and Eaglefeather display type.
The type for the title on overleaf is a digital version of Luke
Swank's signature. The book was printed by Meridian Printing in
black and Pantone 405 on 100# Garda Silk Text, and bound
in Ecological Fibers Sierra.

Library of Congress Cataloging-in-Publication Data

Bossen, Howard.
Luke Swank, modernist photographer / Howard Bossen.
 p. cm.
 Includes bibliographical references and index.
 ISBN 0-8229-4253-4 (cloth : alk. paper)
 1. Swank, Luke, 1890-1944. 2. Photographers—Pennsylvania—Biography.
 I. Swank, Luke, 1890-1944 II. Title.
 TR140.S873B67 2005
 770'.92—dc22 2004028396

CONTENTS

FOREWORD *by Richard Armstrong, H. J. Heinz II Director, Carnegie Museum of Art* vi

PREFACE vii

INTRODUCTION 1

CHAPTER 1. Fragments of a Life 3

CHAPTER 2. Steel 28

CHAPTER 3. Circus 37

CHAPTER 4. People 44

CHAPTER 5. Transformations 49

CHAPTER 6. Rural Architecture and Landscape 53

CHAPTER 7. This Is My City 64

PLATES 73

LIST OF PLATES 217

NOTES 223

INDEX 233

FOREWORD

Fortunately for us, the history of modernism is expanding rather than contracting. Within the discipline of photography, Luke Swank's uniquely modernist achievement will now be widely recognized and better understood by Swank's many admirers. For this important contribution to recent and critically important art history, we are deeply indebted to Dr. Howard Bossen. With determination, great industry, and much elegance, Dr. Bossen has authored this book and the exhibition it memorializes. The first comprehensive retrospective of Swank's work as well as the first scholarly publication to examine it are both events of joy and delectation.

Luke Swank's family helped enormously in this effort, and we salute them for their generosity and insight. Likewise, we cite with gratitude our sister institution and neighbor, Carnegie Library of Pittsburgh; first for the safekeeping of these works, and for their subsequent donation to the collection of Carnegie Museum of Art. Michigan State University supported Dr. Bossen's research, and its Kresge Art Museum will present the exhibition.

Cooperative lenders, public and private, lie at the heart of all large exhibitions, and we thank the Art Institute of Chicago; Philadelphia Museum of Art; Southern Alleghenies Museum of Art; Heinz Endowments; Heinz Family Foundation; Western Pennsylvania Conservancy; the Historical Society of Western Pennsylvania; Center for Creative Photography; and the estate of Jean Farley Levy and the Julien Levy Archive for lending work. Similarly we gratefully thank Claudia M. Elliott, Margaret Glock, Dennis Reed, and Mervin S. Stewart, M.D., for crucial loans. The exhibition is supported in Pittsburgh by the Drue Heinz Trust and the Robert S. Waters Charitable Trust; we are grateful to both.

As usual, associate curator of fine arts Linda Batis has been a dedicated and inspired participant in the project's organization; we also acknowledge Cynthia Miller's catalytic role at the University of Pittsburgh Press.

Richard Armstrong
The Henry J. Heinz II Director
Carnegie Museum of Art

PREFACE

I began *Luke Swank: Modernist Photographer* in February 2002, a month after I had come to Pittsburgh as the visiting distinguished professor at Carnegie Mellon University's Center for the Arts in Society. I had never had the opportunity to live in a city where a major museum was just a few minutes' walk from my office. Determined to make the most of this opportunity, I approached the curators at the Carnegie Museum of Art with a proposition: if they would let me have access to their collection I would try to define a project of mutual benefit. At the time, I had never heard of Luke Swank and had no idea how profoundly his work would affect me or how it was to take over my life for the next three years.

Luke Swank and his photographs were almost lost to history. They would have been, if Edith Swank had not bequeathed Swank's photographs and negatives to the Carnegie Institute. Since the 1974 bequest by Edith, the Carnegie Museum of Art has twice featured Swank's photography in one-man exhibitions. The 1980 exhibition Luke Swank surveyed Swank's oeuvre, while the exhibition Reality and Imagination: Photographs by Luke Swank in 2000 concentrated on Swank's abstract work. In addition, Swank's photographs were included in the Carnegie Museum of Art's 1997 exhibit and catalog *Pittsburgh Revealed: Photographs Since 1850.*

While there are several thousand photographs, negatives, and color transparencies by Swank in the Carnegie Museum of Art and the Carnegie Library of Pittsburgh, there is almost no documentation. With the photographs there were copies of typed excerpts of articles, reviews, and letters, almost all from the 1930s, and the catalog for the 1980 Carnegie Museum of Art exhibition Luke Swank that contained a brief biographical sketch and a reprint of Beaumont

Newhall's 1938 article "Luke Swank's Pennsylvania." In short, while there was a treasure trove of photographs, there was little to put the images into any context and to bring Luke Swank back to life.

The immediate problem, if a major exhibition and book were to be created, was to find out more about Luke. With my colleague Linda Batis, I began a search, first for Luke's son, Harry, and then for any additional information that could be located about Luke, his life, and his work.

From the start, this project has been graced with good fortune. We sent letters to the Swanks in the Johnstown area and to a twenty-six-year-old address for Edith Swank's brother. Fortunately, the address was good. The property was still in the family, and Edith and Luke's niece, Claudia M. Elliott, contacted us. Claudia and her husband John Jeffery invited me to see the letters, photographs, and other items they had. For more than a year, John and Claudia kept finding new pieces of information that were important in understanding Luke's life. In their collection were photographs by Luke, several of which are in the book and exhibition; letters by Edward Weston, Willard Van Dyke, and Frank Lloyd Wright to Luke; and Edith's letters about Luke to her brother and sister. Edith was a professional writer, and through her letters and the letters written to Luke he was beginning to get a voice.

Shortly after my first visit to Claudia and John, John Walters walked into the Carnegie Museum of Art wishing to donate a few photographs that were made by Luke Swank. These special photographs were of John and his childhood friend, Luke's son, Harry. Through John I was able to work out more biographical details and was led to the sister of Harry's first wife.

Next we found Harry's daughter, Grace Swank Davis. Grace, named for her grandmother, Luke's first wife, was born after her grandfather had died. Her father had not told her much about Luke and she didn't have letters or photographs, but she did have family history and that helped to flesh out my understanding of Luke's life. Grace suggested I contact Fred Dahlinger Jr., then the director of historic resources and facilities at the Circus World Museum in Baraboo, Wisconsin, and ask him to look at Luke's circus photographs. Perhaps he could help me with identifications. Fred not only identified many of the clowns and all the circuses that Luke photographed, he also was the first to suggest that Luke's circus photography had to have begun between 1919 and 1924 because of the words on the marquee in Swank's photograph "To the Big Show." Another circus historian, Robert MacDougall, confirmed Fred's suggested dates.

Just after I thought I had finished my research and was beginning to write, Claudia M. Elliott contacted me about some cousins she had spoken to at a family reunion who said they too had some material. Nancy Hessel had a treasure trove of family letters that extended as far back as the 1890s and reached forward into the 1980s. Many of these letters were from Edith Swank to her mother and sister. They described how she met Luke, her life with him, and the effect his death had upon her.

Luke Swank: Modernist Photographer could not have been done without the opportunity given to me by the Center for the Arts in Society at Carnegie Mellon University and its director Judith Schachter [Modell], and the generous support I received from the Intramural Research Grant Program at Michigan State University.

Cynthia Kernick helped open the door to the Carnegie Museum of Art for me. Louise Lippincott, the museum's curator of fine arts, and Linda Batis, the associate curator of fine arts, welcomed me into their collection. Linda Batis, curator of the museum's 2000 Swank exhibition, was my guide through the photography collection and from the start has been my sounding board and collaborator. Without her assistance, advice, and wisdom this project would never have happened. Louise Lippincott arranged my introduction to the University of Pittsburgh Press director Cynthia Miller and helped pave the way for this book. And Richard Armstrong, H. J. Heinz II Director of the Carnegie Museum of Art, supported the idea of this project from the beginning.

Amber Morgan, Erica DiBenedetto, and Ruth Edelstein provided much-appreciated support services at the Carnegie Museum of Art. Richard Stoner did most of the copy photography for the images in the book. Charlotte Wright digitally retouched the scanned images. Their expertise in these technical tasks has greatly contributed to the quality of the reproductions.

Clyde "Red" Hare, one of Pittsburgh's longtime photographers, the organizer of the 1980 Luke Swank exhibition, and author of Luke Swank, the catalog for that exhibition, generously shared his knowledge and insights about Swank and Swank's place in the history of photography.

Margaret Glock, who still lives in Johnstown and is the widow of Luke's second cousin Earl Glock Jr., provided letters that Earl Sr. had written home about his and Luke's college years as well as several old newspaper clippings and documents related to the Swank Hardware Company. Margaret gave me a guided tour of Johnstown that enabled me to better understand Luke's life there.

My research would have been much more difficult without the assistance of three students: Jocelyn Malik, a graduate student at Carnegie Mellon University, worked with me to make study images and catalog Swank's photographs in the Carnegie Library of Pittsburgh, helped track down old reviews, and checked facts; Emily Kujawa, my professorial assistant at Michigan State University in 2002–2003, helped design and implement the database that kept track of the more than 1,700 images collected for this project; and Frank Kaminski Jr., my graduate research assistant at Michigan State University in 2003–2004, performed a multitude of tasks in preparing the manuscript.

Drafts of the manuscript were read by Linda Batis; Tom Beck; Charlee Brodsky; Kerry and Joe Chartkoff; Eric Freedman; Darcy Greene; Constance Schulz; Brian Silver; and my sons, Colin and Jorin, and wife, Kathy. Subject experts Thomas E. Leary and Richard Burkert read "Steel," and Fred Dahlinger Jr. read "Circus." Each of the readers has helped to make this a better book.

Gil Pietrzak and Greg Priore at the Carnegie Library of Pittsburgh, and Kerin Shellenbarger, a research librarian in the Historical Society of Western Pennsylvania at the Senator John Heinz Pittsburgh Regional History Center, all provided appreciated assistance.

Walter Kidney, architectural historian at Pittsburgh History and Landmarks Foundation, helped identify several of the locations of Swank's Pittsburgh work. Thomas E. Leary at Youngstown State University explained the steelmaking process to me and helped identify many of the steel photographs. Richard Burkert, executive director of the Johnstown Area Historical Association and director of the Johnstown Flood Museum, helped to identify Swank's Johnstown photographs and also tirelessly worked to track down some elusive dates.

Curators Graziella Marchicelli of the Southern Alleghenies Museum of Art, Kate Ware of the Philadelphia Museum of Art; and Sarah Meister of the Museum of Modern Art; Leslie Kott Wakeford, collection manager at the Art Institute of Chicago; and Clinton Piper, museum programs assistant at Fallingwater, all provided valuable assistance with their collections. Leslie Calmes, archivist for the Center for Creative Photography at the University of Arizona, and Nancy Barr, assistant curator of graphic arts at the Detroit Institute of Arts, uncovered important letters. Ed Lehew, archivist at the H. J. Heinz Company, showed me the Pittsburgh Landmarks series of public service ads from the early 1950s and shared his memories of Edith Swank. Dr. Mervin S. Stewart and Dennis Reed generously loaned items for the exhibition.

Marie A. Difilippantonio, assistant to the late Mrs. Jean Levy, opened the papers of Julien Levy to me. And Jonathan Levy Bayer, Julien and Joella Levy's son, graciously spoke with me about his father and mother.

Susan Bandes, director of the Kresge Art Museum at Michigan State University, and April Kingsley, curator, both embraced the idea of this project from the beginning. Susan, James Hopfensperger, Steve Lacy, and Pat McConeghy all read early drafts of my research proposal. Loraine Hudson and Stacy Smith of Michigan State University arranged copyright permissions. Kim Piper-Aiken transferred the digital audio recordings of the interviews to a Macintosh friendly environment. Jeffrey Marler first commented on the stagelike compositions of Swank's urban photographs.

At the University of Pittsburgh Press, editor Sara Lickey provided greatly appreciated counsel and tightened my writing, and Ann Walston designed a beautiful book.

I am especially grateful to Claudia M. Elliott, who kindly granted permission to reproduce Swank's photographs as well as excerpts from his letters and those of Edith Swank.

To all these people, as well as to others too numerous to mention here, I give my thanks. The book and the exhibition would not have been possible without you.

Of the total body of Swank's work known to survive, the Carnegie Museum of Art has 366 photographs and the Carnegie Library of Pittsburgh has about 4,000 negatives and 2,400 prints, as well as most of his color transparencies and all of his stereograph glass plates. The Luke Swank collection in the Carnegie Library has been only partially catalogued. The negatives are listed in a database with comments transcribed from Swank's original negative envelopes. The database lists 3,257 negatives that are clearly his and 742 negatives

of aerial views that the library has marked as belonging to his collection, for a total of 3,999 negatives. (While the library has placed the aerial views with the Swank collection, there are no aerial view prints clearly made by Swank, nor was there a mention of aerial photography in any letter by him or his wife or any mention of this form of photography in any article about him during his life.) While library records indicate there are 689 prints there are more than forty boxes of prints with an average of 59 prints per box. This means a more accurate estimate is over 2,400 prints with about 20 to 30 percent duplicates. There is a large overlap between the print and negative collections, but there are also a large number of negatives for which there is no print and a large number of prints for which there is no negative.

The Carnegie Library of Pittsburgh is also the repository for the materials of the Western Pennsylvania Architectural Survey (WPAS). Several hundred of the more than two thousand photographs in this collection are by Swank although only a handful are directly linked to him by name.

The Western Pennsylvania Conservancy owns 875 photographs and color transparencies. They are housed at Fallingwater, though few of them of them are of Fallingwater. The Avery Library at Columbia University has several of Swank's Fallingwater images in the Edgar Kaufmann Jr. Archive. The Museum of Modern Art's collection includes 34 pieces. The Philadelphia Museum of Art has 37 pieces; 18 pieces are in the Southern Alleghenies Museum of Art. Additional works can be found in the Art Institute of Chicago; the Kresge Art Museum of Michigan State University; the Smith College Art Museum; Library & Archives Division, Historical Society of Western Pennsylvania, Pittsburgh, and a few other institutions.

Almost all of the reproductions of Swank's photographs used in the book were made from vintage prints, which show the passage of time and the fragility of the photographic image. In an effort to present the photographs as they would have appeared in Swank's lifetime, some image scans have been retouched electronically to eliminate dust marks, scratches from reproduction, and other obvious signs of degradation, to the extent possible.

Luke Swank rarely dated his photographs. Although the Carnegie Library of Pittsburgh holds an index card file that lists client names, project dates, and negative numbers for much of his commercial work, the records for his artistic work are far less complete. Consequently, dating Swank's negatives and photographs was a challenging exercise. Dates are given to the photographs based on an assessment of one or more clues: previous catalog dates in the Carnegie Library of Pittsburgh database file for the Swank negative collection and

dates written on some prints in that collection; references in letters by Swank or his wife Edith to specific images, types of images, or locations; his commercial index card file for a few images where his art and commercial work intersected; files in the Western Pennsylvania Architectural Survey for work done for that project; references to specific images or types of images in articles published about Swank during his lifetime; the type of photographic paper or mount Swank used for individual images; negative size and whether an image was made as a color transparency; and consultation with experts on the history of the American circus, the steel industry, and Pittsburgh history.

Just as Swank rarely dated his photographs, he also titled few of his photographs. I have added descriptive titles for all of Swank's untitled photographs, in order to eliminate confusion for the reader. These added titles are indicated in captions and in the list of plates by square brackets. Adding descriptive titles admittedly may influence the viewer in a way Swank would not have intended. For this I take responsibility and offer my apologies.

LUKE SWANK

Introduction

Luke Swank was one of the pioneers of modernism in photography and one of the first to teach photography at an American university. Like most photographers of his generation he was self-taught. Cultured and widely read, he studied the work of the photographers he thought were important to learn composition, lighting, and approach to subject. Once he digested these lessons, he integrated them into his unique study of American culture that began around the mid-1920s and lasted until his premature death in 1944.

Modernism in American photography, as it is currently understood, was defined in the late 1920s and early 1930s by the clean, razor-sharp vision of image makers who included Luke Swank, Paul Strand, Charles Sheeler, Walker Evans, Berenice Abbott, Ansel Adams, Edward Weston, Imogen Cunningham, and Margaret Bourke-White. But the historical record is filled with shadowy spaces and dark recesses where some people recognized in their own time have became lost to future generations. Although Swank was well known in the 1930s, and contemporary critics compared him to such luminaries as Alfred Stieglitz and Edward Steichen, he was largely forgotten after his death. He became the missing modernist. In the essays that follow I explore his life, discuss his photographs, and examine reasons why he fell into the obscurity of historical near-oblivion.

The 1930s was a dynamic period in American art and photography. Julien Levy opened his seminal gallery in New York in November 1931 and gave Swank a one-man show, Photographs of the American Scene, in early 1933. Not even Walker Evans had a one-man show before Swank.[1] In 1932 the Museum of Modern Art first exhibited photographs as part of the Murals by American Painters and Photographers exhibition. Swank's image "Steel Plant" was

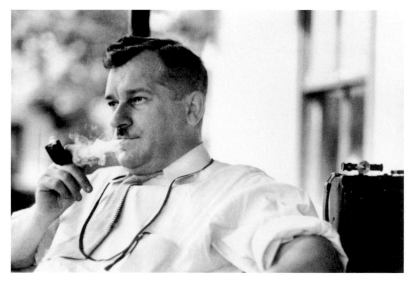

FIGURE 1. Photographer unknown. Luke Swank. Collection of Claudia M. Elliott.

featured, along with photo-murals by Berenice Abbott, Edward Steichen, and Charles Sheeler. And in 1940, Swank, along with Stieglitz, Weston, Cunningham, Evans, Henri Cartier-Bresson, Strand, and others, was invited by Ansel Adams and the art historian Beaumont Newhall to participate in the inaugural show of the Museum of Modern Art's newly formed department of photography.

Swank not only exhibited in New York and Pittsburgh but also was known on the West Coast. He had more photographs than anyone else accepted into the First Salon of Pure Photography. Group f.64, whose members included Edward Weston and Imogen Cunningham, organized this 1934 California exhibition. Swank's photographic philosophy fit within this group's modernist aesthetic,

which helped define one of the principal directions of art photography for the rest of the twentieth century.

Swank's subject matter was diverse. He explored the behind-the-scenes life of the circus, examined historical rural architecture, transformed mundane household items and industrial parts into interesting abstract forms, made portraits, found beauty in the grittiness of the steel industry, and in his most mature work, described urban life as only a visual poet could.

While his images are stylistically similar to those of many of his modernist contemporaries, his vision was unique. All but his earliest work is precise and sharp, mostly with extended depth of field, and his subjects depict a documentary reality that often embraced elements of dreamlike states. He incorporated details that pushed his realism into the realm of the surreal. What makes Swank's vision individual is his combination of traditional machine age and social documentary content with a dramatic and poetic use of light, form, and the picture frame. Swank's photographs, while most often produced in a documentary style, were only rarely linked to words; when they were the words provided minimal information.[2] Swank's decision not to attach words that provide context and direct meaning demonstrates that while his images are crisp and clean, they are less about specific place and more about transcendence of place to universality of experience.

He reveals the industrial might of western Pennsylvania defined by its steel mills in graceful, yet hard-edged images of the places and the workers who helped propel the industrial growth of the country. He explores lyricism, light, and shadow through his creation of abstract still life photographs.

His photographs of the circus move from documentary record of circus life to explorations of abstract form; from the real to abstractions of the real, to the surreal.

His architectural explorations of rural western Pennsylvania and of buildings in Pittsburgh pay homage to form, detail, and the interplay of light that subtly transform the record of old structures into multilevel explorations of place and time.

And his photographs of people, going about their daily lives, present life's little moments precisely seen, extracted from the flow of time and forever frozen for our contemplation.

The images speak for themselves. They are an extraordinary look at the America of the mid to late 1920s, the Depression, and the first half of World War II.

1 — Fragments of a Life

On May 31, 1889, after much heavier than normal rains, the dam burst on Lake Conemaugh, a man-made lake about fifteen miles above Johnstown. The water roared down South Fork Creek to the Little Conemaugh River, picking up speed and carrying along everything in its path. Broken trees, smashed houses, animals, and people caught in the path of the devastating torrent of water all roared through Mineral Point and East Conemaugh, crossing the line into Johnstown at 4:07 p.m. The whistle above Harry Swank's machine shop blew an audible but ineffective warning. "Everyone heard shouting and screaming, the earsplitting crash of buildings going down, glass shattering, and the sides of houses splitting apart." The "drowning and devastation of the city" in the infamous Johnstown flood "took just about ten minutes."[1] More than 2,209 lives were lost, including those of Jacob and Catherine Swank; their son Fred; their daughter Jennie; and their daughter-in-law Ella and her child. The building housing the Swank family hardware store, J. Swank Son & Co., was destroyed by the flood, but as soon as the water receded employees of the store built a temporary structure with timber gathered from the streets.[2] Six days after the city was devastated, on June 5, 1889, Jacob and Catherine's son Harry married Sarah Hartzell in a much smaller and more somber ceremony than originally planned. Their son, Luke Hartzell Swank, was born in Johnstown on February 21, 1890.

Luke Swank came from Pennsylvania Dutch stock. His family were longtime residents of Pennsylvania's Laurel Highlands, having settled in Somerset County in 1774 or 1775. Swank's grandfather Jacob Swank, originally a potter, moved to Johnstown in neighboring Cambria County in 1854 and opened a hardware store there in 1862.[3] After the flood, the family business was reorganized as Swank Hardware Company. Luke's father, Harry, eventually became president and continued to develop the business with his brothers Morell and George W. and his cousin Charles Glock. In 1900, Swank Hardware had thirty-eight employees. In 1906, it burned. It was replaced in 1907 with a six-story fireproof terra cotta structure. According to at least one account, by this time, Swank Hardware had become the "largest mercantile concern between Pittsburgh and Philadelphia."[4] Whether this claim was completely accurate or not matters little because it serves to illustrate that Swank Hardware was an important part of the Johnstown business community. The prospectus for a public stock offering in 1920 described the company as "one of the largest jobbers and retailers in Pennsylvania of hardware, tools, mill and mine supplies, automobile accessories, sporting goods, paints, glass, house-furnishings and furniture." It employed 175 people with sales over $2,240,000 and had five buildings with over 250,000 square feet of space.[5] In a letter written in 1920 to his friends and customers, Harry Swank claimed that the business was "the second oldest mercantile house in Johnstown," and its future was "inseparable from the future of the steel and coal industries."[6]

By the time Luke Swank was a teenager, his father had begun to diversify his business interests. Harry Swank became vice president of the First National Bank around 1903, vice president of Swank Motor Sales by 1925, and by 1929 he added the title of secretary-treasurer of the Johnstown Tire and Rubber Co. to his résumé. The Swanks had it all: money, prestige, position. Luke grew up in an affluent, influential family, and as he became an adult, their affluence and influence only increased. But by the mid-1930s, the banking problems of the Depression caught up to Harry Swank. He lost a

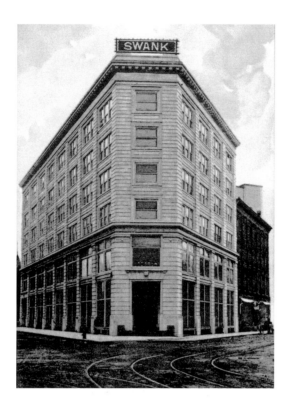

FIGURE 1-1. Color postcard of Swank Building, Johnstown, Pa., c. 1907. Collection of Margaret Glock.

great deal of money and control of his hardware company. By this time Luke was in his mid-forties, the affluence was gone, and Johnstown would be part of his past.

Swank attended Pennsylvania Agricultural College (now Pennsylvania State University) with his cousin Earl Glock from 1907 to 1911 and graduated with a degree in horticulture. Cousin Earl commented on life at State College in a letter to his father at the beginning of the 1907 school year. "There are over one thousand boys in the school and twenty-four girls. . . . [T]he 400 freshmen make it the largest freshman class. Things are so overcrowded. . . . [M]y class is divided into three sections and possibly will be divided again." While the college was experiencing tremendous growth, it was still a time when few women attended. Earl's letters describe his cousin Luke as a good source for a quick loan of five dollars and as a tutor in chemistry.[7]

In February of 1917 Luke married Grace Ryan, daughter of a leading wholesale grocer. Their published wedding announcement described them as a "popular young couple" and him "as a most energetic and enterprising young man."[8] Grace was well educated. She graduated from St. Joseph's Academy, Seton Hill, in nearby Greensburg, a residential Catholic high school, and attended Georgetown Visitation, founded in 1799 as colonial America's first school for young Catholic women. She was not one of the twenty-four pioneering female students in Swank's class at Pennsylvania Agricultural College.[9]

During the years between his college graduation and his marriage, as many young adults do, Swank explored his options. He was an employee in his father's hardware store,[10] put his education in horticulture to work as a vegetable farmer, and trained German shepherds on the family farm in Upper Yoder Township, not far outside of Johnstown in Cambria County. Luke's wedding announcement in the Johnstown newspaper described his dog-training enterprise: "He has built up a pack of imported trained dogs along the German lines to do police work, and some of these canines have been sold to Armour's and other large firms at excellent prices."[11]

In 1917 Luke entered the Army, believing he would be able to train dogs for the war effort. Evidently, it wasn't his expertise in dogs the Army valued, but the facility for chemistry he had displayed in college. He spent two years as a lieutenant making "war gasses" in Washington, D.C., where he had an accident with a poison gas canister. He was hospitalized for months and his health was adversely affected for the rest of his life.

After the war, Luke and Grace returned to Johnstown with their son, Harry, born in 1918 in Maryland while Swank was still in the service. Nearing thirty, and with a wife and son, Swank did not return to training dogs or to farming. He returned instead to the family business. The 1920 census lists Swank as a salesman for Swank Hardware, and newspaper articles from 1921 name him as one of the members of the board of directors. The 1925 city directory lists Luke as a department manager for Swank Hardware. By the early 1930s he was describing himself as a manager for the Swank Motor Company.

Although Luke was on the board of directors of Swank Hardware and took a managerial role in his father's business ventures, it is by no means clear just how active he was. His granddaughter, Grace Swank Davis, claims that according to tales from her father, Luke and Grace lived mostly off a trust fund, allowing Swank to spend his time exploring his muse—a muse that led him to woodworking and gardening before he devoted his energies to learning photography.[12] The quality of his gardening can be seen in photographs he made prior to 1935 of the formal garden behind his home, a garden that befits a man with a degree in horticulture and demonstrates his interest in English-style gardens.[13]

Folklore has it that Luke Swank first picked up a camera when he was nearly forty and within two years was exhibiting his work in New York's Museum of Modern Art. The truth, of course, is much more complicated. Apparently, Swank was fascinated by photography

even as a little boy. When he was six or seven, according to one obituary, "In a darkened section of the cellar he was mixing chemicals and developing his first pictures."[14]

John Walters, born in 1919 and a childhood friend of Luke's son, remembers when he was between six and eight years old seeing photographs in the Swank home that Luke had made of Grace and of steel mills. This dates some of Luke's work to the mid-1920s or perhaps even a few years earlier. Remembering Grace's pictures, Walters commented: "I'm quite sure a lot of them were nudes. I came home once and told my mother that I saw a picture of Harry's mother and I don't think she was wearing any clothes. My mother was quite shocked." The nude photos were on the wall in a bedroom or guest room and, of course as he remembers it, Harry wasn't supposed to show them to him.[15] While no prints of a nude Grace survive, there are stereograph glass plates Swank made of her posing nude in the garden of their home on Milton Street in Johnstown.

Walters also remembers seeing pictures of steel mills and streets in mill neighborhoods—probably around Woodvale, a section of Johnstown where one of the Bethlehem Steel plants was located. Walters saw these photographs in the late 1920s and commented that they were "very stark."[16] These easily could have been any of the Johnstown steel mill photographs reproduced in this book, especially his photograph "Spruce Street, Franklin Borough I," which shows homes of steelworkers near one of the Johnstown mills (plate 6).

While memories fade with time, these dates make sense when viewed in light of several other factors. There is no doubt that Swank was seriously exploring photography by the mid-1920s. By the late 1920s he was an enlightened amateur aware of the trends, practices, and controversies within art photography. He may even have begun to take on commercial assignments sometime in the mid to late 1920s. By 1930 he was operating a studio from the Democrat Building and had letterhead indicating he was a photographer. There is a 1931 letter indicating that the steel mill series began sometime in the mid to late 1920s.[17] In an April 1932 letter to the art dealer Julien Levy, Swank commented that starting "about a year ago . . . I have devoted all my time to photography."[18]

This dates the beginning of his full-time dedication to photography to the spring of 1931. Yet, why Swank chose, for the most part, to present himself as a naïve newcomer to the medium in the late 1920s is not known. Perhaps he thought that springing seemingly from nowhere would help build his mystique as an artist. Reassembling the bits and pieces of his life make it clear that Swank spent a decade learning his craft, thinking about the medium, and

FIGURE 1-2. Luke Swank. [Interior of Swank's Home], c. 1932. Collection of Claudia M. Elliott.

experimenting with subject matter, photographic styles, and techniques. As a photographer he was self-educated. Like most photographers of the period, his training was, according to his own testimony, "not very systematic"; it was one of "trial and error, along with careful analysis of other workers' successes and my mistakes."[19]

Not much is known about the family life of Luke, Grace, and young Harry. What little there is has been filtered through time and generations, or is what can be gleaned from examining a few surviving photographs Swank made of his home. The photograph of the interior of the library in the Swank home reveals people of means with refined taste and a great love of books. It is a sophisticated space where one of Swank's more abstract steel mill studies casually adorns a table that also has a glass bowl filled with loose cigarettes. On the hardwood floor is a tasteful oriental rug; elsewhere in this photograph is a small, framed print of old large sailing ships, figurines, and a lovely bowl.[20] While enlarging this image doesn't make all the titles readable, the literary tastes of Luke and Grace can be discerned. Their preferences included H. G. Wells's *Outline of History*; the cartoonist Peter Arno's *Hullabaloo*; *The Racial History of Man* by Roland Dixon; and several volumes of the works of Eugene O'Neil. Other titles include *The Spider Book*; *Plays of the Moscow Art Theater Musical Students*; and *Byzantine Portraits* and other books on the history of art. Rounding out the library are books on gardening, natural history, music, firearms, fish, games, and China. This eclectic library fits well with the description of Luke by his second wife Edith, who noted him as a man of towering intellect and the most widely read man she ever met. Along the same lines, Luke's grand-

daughter commented that her father liked to tell her that Luke once translated the New Testament from Greek into English for his own amusement.[21]

But Luke and Grace also had a lighter, less serious side. They liked to entertain and could even be silly, if the stories Harry passed on to his daughter, Grace Swank Davis, are to be believed. "I had the idea that they were young and of their time, of the twenties," she said. "My dad used to complain to me that he hated that song the 'Sheik of Arabie'—it was from a movie by Rudolph Valentino. He would be upstairs trying to sleep and they'd be having parties downstairs and they'd be playing that on the phonograph and it would wake him up."[22] In later years they were frequent guests of Edgar and Liliane Kaufmann at Bear Run in Pennsylvania, a weekend retreat well known for the Kaufmanns' parties long before the wealthy couple built Fallingwater on the site.[23]

In addition to parties, the Swanks frequently visited Pittsburgh for music and theater, visits during which they may have socialized with the Kaufmanns. They also frequently traveled to New York where Harry explored the city on double-decker buses while Luke and Grace attended to other matters, which by the early 1930s must have included Luke's exhibitions. The entire family went to museums and stayed in fancy hotels, according to family lore. All the lore is believable given the money, education, and social position of Luke and Grace, but none of it is now verifiable.

What is verifiable is that by the end of the 1920s, Swank was taking his photography seriously. He wanted recognition and validation as a photographer and looked first to the pictorialists' photographic salons as a place to exhibit his work.

Luke Swank created a brilliant body of work between the late 1920s and his untimely death in 1944. In 1931, while still selling cars in his hometown of Johnstown, he entered his work into both the Pittsburgh and Los Angeles competitive photographic salons and had his work selected for exhibition and publication. And by 1932, his five-part photo-mural "Steel Plant" was featured in the exhibition Murals by American Painters and Photographers, the inaugural exhibit of the permanent home of the Museum of Modern Art on 53rd Street in Manhattan.[24]

Dry plate photography was introduced in the late 1870s and George Eastman's first roll film camera in the 1880s. As photography became much more accessible to the general public, camera clubs began to form, and photographic salons first appeared in the 1890s in Europe. Pictorialism began in the late 1800s as a movement working for recognition of photography as an art on a par with painting, sculpture, and printmaking. Its goal was to change the public perception of photography as a simple mechanical process that did not require any skill. To establish photography as an art, photographers embraced a variety of tactics to emulate painting and printmaking, including the use of textured drawing papers, the addition of hand color, and the softening of focus to create impressionistic and romanticized effects.

In 1902, Alfred Stieglitz invited a group of pictorialist photographers to form the Photo-Secession. This group, which also included Alvin Langdon Coburn, set the direction of art photography for the next several decades. The work of the Photo-Secessionists stands in stark contrast to the pioneering social documentary work of photographers such as Jacob Riis and Lewis Hine, both of whom concentrated on using photography to examine social problems with the Progressive Era notion that photographs could be useful in the fight for social reform. In 1916, Paul Strand, active in the Photo-Secession and a former pupil of Lewis Hine, showed Alfred Stieglitz a photograph of a New York street scene that was shot from above looking down, exploiting sharply defined shadows caused by an afternoon sun, a composition where every inch was in sharp focus and where the print was made to retain, not mask, all these purely photographic properties. This image departed from the painterly qualities of the Photo-Secessionists' images. When Strand showed this image to Stieglitz, it radically shifted Stieglitz's thinking about photographic art. To many, this represents the beginning of photographic modernism.

Salons had become particularly popular by the end of World War I; many of the better ones attracted a wide variety of competitors. Often named for the cities where they were located, the photographic salons Swank entered were national and international in their scope. The Pittsburgh Salon founded in 1914 was for many years one of the best known and most widely respected in the country. According to Christian Peterson, author of *After the Photo-Secession: American Pictorial Photography, 1910–1955*, "Juries for the Pittsburgh salon maintained high standards and did not accept prints that had been previously exhibited in the United States or that were more than a year old. The salon also gained prestige from its venue, the Carnegie Institute, which often hung the photographs in the same galleries where its nationally renowned annual survey of paintings and sculpture was installed."[25] In 1918 members of the Camera Pictorialists of Los Angeles organized their own salon. Within a few years, it was as respected as the one in Pittsburgh.[26]

Swank, as he was learning about photography after the end of World War I, experimented with the romantic, stylized, and soft-

focus approaches popular with the pictorialists. In 1931 Swank was accepted into the Pittsburgh Salon and exhibited with photographers from Europe including the Czechoslovakian photographer František Drtikol, as well as local photographers such as F. Ross Altwater, an important Pittsburgh photographer who by 1931 had been making photographs of steel mills and steelmaking for many years.[27] That same year, Swank also was accepted into the Los Angeles Salon.

Much of Swank's early work is pictorialist—moody, romantic, and tending to soft focus. Three subjects are represented: people, still lifes, and steel mills. The photographs of people are largely romanticized images of models, mostly female, where Swank explores dramatic artificial lighting and poses, often using costumes to create theatrical portraits. Pictorialist publications frequently showed examples of dramatically illuminated Western women dressed in Oriental costume. Swank also experimented with this type of stylized fantasy (figure 1-3). While the image is contrived, stiff, and even a little silly, it does reveal a sense of drama in the way it is lit. Some of Swank's most interesting still life pieces also show this penchant for dramatic lighting (plate 72), as do many of his naturally illuminated urban scenes (plate 108).

Not surprisingly Swank's first wife, Grace Ryan Swank, is the subject of several portraits (plate 66). His son, Harry, was also a frequent subject; however, there is only one surviving formal portrait of him in the Carnegie collections (figure 1-4). This portrait presents the viewer with a three-quarter view of Harry at the age of nine or ten. Since Harry Swank was born in 1918, this dates the portrait to 1927 or 1928 and is consistent with the notion that Swank was working seriously in photography by the mid-1920s.

An example of still life, the second subject Swank treated in the pictorialist manner, is the photograph of a woven basket lit dramatically from the side that he entered into the Pittsburgh Salon competition for 1931. This still life is identified in the catalog for the Eighteenth Annual Pittsburgh Salon of Photographic Art as a bromide print with the title "Old Basket in the Cellar"[28] (plate 69).

Swank also used a pictorialist style in his early studies of the Bethlehem Steel Works in Johnstown. These range from his photograph of the "Lower Cambria Works" (plate 4), which is one of the softer of his soft-focus images, to several other steel mill images including "Blast Furnaces, Lower Cambria Works" (plate 5), "Spruce Street, Franklin Borough I" (plate 6), "Steel Worker with Foundry Crane" (plate 24), and "Steel Worker in Foundry" (plate 28). A photograph from Swank's steelmaking series titled "Ingot Molds" was accepted in the All-American Photographic Salon competition in Los Angeles in 1931.[29] The image is identified in the catalog as a

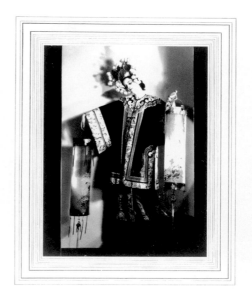

FIGURE 1-3. Luke Swank. [Woman in Oriental Costume], c. 1925–1930. Gelatin silver print, 9½" x 7½"; mount 18" x 14". Carnegie Museum of Art, Pittsburgh; Gift of Edith Swank Long by transfer from the Pennsylvania Department, Carnegie Library of Pittsburgh, 83.76.134.

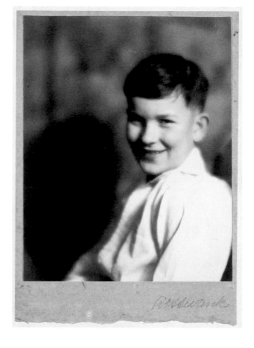

FIGURE 1-4. Luke Swank. [Harry Swank], c. 1928. 9" x 7"; mount 13" x 9¹⁄₁₆". Carnegie Library of Pittsburgh Gift of Edith Swank Long.

bromoil print—a print style that often used a textured paper similar to drawing paper to soften an image. It was one of the techniques of the period favored to help move the detailed descriptive quality of a sharply rendered image toward the softer dreamlike quality pictorialists thought to be more artistic.[30]

Swank also entered the 1932 competition sponsored by the Camera Pictorialists of Los Angeles, the Fifteenth Annual International Salon of Pictorial Photography. Swank's photograph "Painters"[31] was identified as a chloro-bromide print in the publication for this salon. It showed two men painting the metal stairs that climb the side of blast stoves and the head and shoulders of two others at the bottom of the frame, one with a cigarette dangling from his mouth. The identification by print type illustrates just how important process was to the pictorialists.

James Nichols Doolittle commented in the *Pictorialist 1932*, the publication of the competition, on the movement of the emerging modernist photographers away from staged, overtly romantic, soft-focus images toward greater clarity of vision. Doolittle wrote: "But what shall we call these folks? Radicals? Modernists? Iconoclasts? We can't call them artists unless we admit their stuff as art and art is born of tradition . . . has a background with rules and regulations. So we'll call them modernists, if anybody cares."[32]

Swank, like others who were moving from pictorialism to modernism, adopted an approach to his subjects that was decidedly modernist before he abandoned the soft, textural papers and the mounting techniques of the pictorialists.

Pictorialists favored stylized methods of mounting their photographs. Grace Swank's portrait (plate 66) and "Steel Worker with Foundry Crane" (plate 24), the only large Bethlehem Steel photograph whose original mount has survived, represent a mounting style typical of pictorialists, with fine, inscribed lines surrounding the image. Each of the three small photographs of the Bethlehem Steel Mill (plates 1, 2, and 3) and Swank's portrait of Harry are examples of another typical pictorialist presentation style in which the photograph was mounted on an attractive paper, most often textured, which in turn was mounted on a larger mat, creating a layered image. When Swank abandoned pictorialism in favor of modernism, he used dry-mount tissue that extended beyond the edges of his photographs to form a border for his images, visually lifting them off the background mount. The use of dry-mount tissue instead of art paper to border the image represented a unique and modern interpretation of the way Alvin Langdon Coburn and other Photo-Secessionists mounted their prints.

The manner in which Swank presents his work demonstrates his

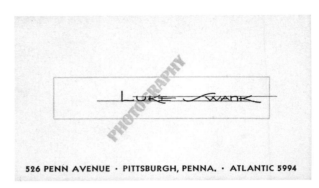

FIGURE 1-5. Luke Swank's business card, c. 1937–1944. Carnegie Library of Pittsburgh; Gift of Edith Swank Long.

awareness of various trends and movements within the contemporary world of American photography. In addition, the evolution of Swank's signature on his work suggests that he was striving to achieve a particular effect. His earliest work is signed with the signature that he used on letters. The portrait of young Harry bears this signature. The Swank collection in the Carnegie Library of Pittsburgh has a few prints that show he was experimenting with calligraphy. By the early 1930s, his stylized signature, which is slightly reminiscent of Frank Lloyd Wright's, was fully developed. By the late 1930s, he was using this signature not just for his photographs, but also to create a branded identity that extended to his letterhead and business cards (figure 1-5).

Swank's approach to pictorialism most likely began in the mid-1920s when its practitioners started to move away from the use of soft-focus lenses and toward the creation of their images through manipulation of the printing process. Christian Peterson in *After the Photo-Secession* described how pictorialism began to change:

Fewer and fewer traditional pictorialists used soft-focus lenses after the 1920s. This was largely a result of the onset of modern times and the untimely death in 1925 of Clarence White, a great promoter of the lens. Soft-focus effects, however, did not entirely disappear from pictorial imagery. By the 1930s numerous pictorialists began hand-manipulating their photographs, creating diffused images from sharply focused negatives. Traditional pictorialists desired total control over their imagery, which led some to hand manipulation. They believed that the negative was merely a means to an end and that only the photographer's imagination limited what could be done. Pictures without handwork were thought to reflect only factual recordings of the mechanical camera.[33]

The negative for Swank's soft-focus "Lower Cambria Works" survives in the Swank negative collection in the Carnegie Library of

Pittsburgh. A modern print made from this negative demonstrates that the film was sharp and finely detailed (figure 1-6). The relative softness of the vintage print was created through the textured, matte surface printing paper Swank used and not through a soft-focus lens on his camera.

By the end of 1931, Swank was thinking about exhibition opportunities outside of salons, just as he was moving rapidly toward modernism. Modernism emerged, in part, as a reaction to pictorialism. With its hard-edged realism it was better suited than pictorialism to express the post–World War I fascination with industrial themes of the dawning machine age. Peterson commented: "In the mid-1910s Alfred Stieglitz, Paul Strand and others insisted that creative photographers pursue the unique aspects of their medium. Shunning the manipulative techniques and escapist attitudes of pictorialists, they established a modern aesthetic for photography. In essence, modern photographers made creative pictures of everyday subjects, rendered in sharp focus and a full range of photographic tones. Their images were sometimes abstracted, relating directly to cubism and other avant-garde movements, and always void of common sentiment. Modernist photographs, above all, were unmistakably camera-generated images that showed no darkroom sleight of hand."[34]

Moving toward modernism, Swank now sought to get his pictures handled by the innovative art dealer Julien Levy, who opened the Julien Levy Gallery in New York City in November 1931 with the landmark American Photography Retrospective Exhibition featuring the photographers Mathew Brady, Gertrude Käsebier, Charles Sheeler, Edward Steichen, Alfred Stieglitz, Paul Strand, and Clarence White.[35] Julien Levy played a major role in Swank's artistic life. It was largely through Levy that Swank began to be noticed. Levy introduced many important artists and photographers to American audiences.

While many of Levy's artists traveled in the same circles as his first mother-in-law, the poet and painter Mina Loy, Swank found Levy himself.[36] Swank's approach was direct and his timing was perfect. He wrote to Levy on December 31, 1931, telling him that he had seen Levy's gallery listed in the *New Yorker*, introducing himself, and offering to submit photographs for Levy's approval.[37] Swank's letter sheds light on his early career, including the fact that he began to photograph as a hobby. While he had set up a studio in Johnstown, it is not clear that he was making his living yet from photography. Swank writes: "For several years I have been making photographs by permission and with the cooperation of the Bethlehem Steel Company in their local plant. This work has been

FIGURE 1-6. Luke Swank. [Lower Cambria Works], c. 1930. Modern gelatin silver print. Carnegie Library of Pittsburgh; Gift of Edith Swank Long, SW7142.

simply a hobby of mine and the pictures are not of an ordinary commercial character, but are purely pictorial. A number of them have been shown in photographic salons. One of them appears in the present issue of the *Los Angeles Pictorialist*."[38]

While there is no surviving record regarding the first time Levy saw Swank's photographs, he must have thought highly of the work. Levy included Swank's photographs with the group of images that he helped place in the large survey show International Photographers, organized principally by Josiah Marvel, a staff photographer at the Brooklyn Museum. This exhibition in March 1932 featured many photographers who became the most notable of the twentieth century. Swank's four steel foundry photographs were shown in the company of work by Berenice Abbott, Margaret Bourke-White, Imogen Cunningham, Walker Evans, George Platt Lynes, Man Ray, Lee Miller, Paul Outerbridge Jr., Charles Sheeler, Edward Steichen, Edward Weston, André Kertész, Herbert Bayer, László Moholy-Nagy, and Tina Modotti, as well as several others. Sheeler showed photographs from both his rural Pennsylvania architecture series and his industrial photographs made for the Ford Motor Company. The images from both of these series, as shall be seen later, have significant similarities to what Swank had been doing and would continue working on for many years. If Swank had previously been unaware of the work of these photographers, his inclusion in this show certainly brought them to his attention.

The International Photographers exhibition shared billing with the 42nd Annual Exhibition of Pictorial Photography of the Brooklyn

Institute of Arts and Sciences. One review contrasted these two exhibitions saying, "The international exhibit showed a modern trend featuring hard, clear-lined and unusual subjects treated in modernistic ways . . . ," while the 42nd Annual Exhibition was described in stark contrast as "play[ing] up the artistic . . . with a view toward lighting and atmospheric effects."[39] These comments illustrate the schism between the photographers stuck in the pictorialism of the past and those, like Swank, who having abandoned pictorialism led the way into modernism.

Another article describes the international exhibition as one of "magnitude and importance," providing "an opportunity to compare European methods with American methods," as well as providing "cerebral adventures among its multiple exposures, photomontages, photograms, [and] rayograms."[40]

Immediately after Swank's inclusion in the Brooklyn show, Levy, along with Lincoln Kirstein, invited him to create mural studies for the 1932 Museum of Modern Art (MoMA) exhibition *Murals by American Painters and Photographers*. Kirstein, at that time, was the director of the exhibition and editor of the magazine *Hound & Horn*. Levy commented in his memoir that "What was of real interest to me was that all projects would be exhibited by the Museum of Modern Art. This meant that photography would be given museum recognition on a large scale, and I enthusiastically recruited a group of photographers whose work I found interesting."[41] Swank's "Steel Plant" (plate 8) was included with photographic murals by Abbott, George Platt Lynes, Sheeler, and Steichen and painted murals by Stuart Davis, Reginald Marsh, Georgia O'Keeffe, and Ben Shahn.

This exhibition, the first at the Museum of Modern Art to include photography, was created partly in response to the achievement of Mexican mural painters such as Diego Rivera and José Clemente Orozco, and partly "to encourage American artists" to explore the opportunities for the decoration of American buildings.[42] Each contributor was given the loose charge of creating a mural that reflected "some aspect of the post-war world."[43]

Levy commented in his essay introducing the photo-mural portion of the exhibition that the invited photographers were given only three weeks to prepare their sketches, making all the more remarkable the quality of the photographic murals produced.[44] Part of the reason to include photographers in a show originally conceived just for painters lay in recent developments in photographic technology. Levy commented that "[t]he use of photographs for wall decoration was made possible by the perfecting of a sensitized paper in large sheets, which would reproduce, when exposed to a projected image from a negative, the original tones with the original

scale of values in enlarged size."[45] The museum worked with a commercial photographic printing company to translate the photographers' sketches into the large mural panels.

Swank's "Skip Bridge and Dust Catcher I" (plate 9), the triptych depicting the mechanism for delivering raw materials to the top of a blast furnace, was one of five designs he created for Levy's approval.[46] The left and right sides reveal that Swank flipped the negative of the same image to achieve a "mirror" image. "Steel Plant," the study that was selected for the show, is a five-part montage with each part showing some aspect of the blast furnace of Bethlehem Steel's Franklin Works in Johnstown. Swank built his mural studies from images he printed as individual photographs. This can be seen in "Skip Bridge" (plate 10) and "Skip Bridge and Dust Catcher II" (plate 11), the two striking, strong, and elegant images that were used to create the skip bridge mural montage; and in the photograph of the library in Swank's Johnstown home. In this photograph the image of the top of the blast furnace with smoke, clouds, and electrical wires used in the top corners of the five-part "Steel Plant" mural is prominently displayed on the library table.

While Swank created his murals by placing rectangular images in a pattern, others in the exhibition used different techniques to create their murals. For example, Charles Sheeler, in the center panel of his photo-mural "Industry" (figure 1-7) cut out pieces of smokestacks, added them to the image, and rephotographed them.[47] And Thurman Rotan's "Skyscrapers" was a cubist montage of overlapping cutouts of the same building photographed from different perspectives.

The exhibition received mixed reviews. Many of the comments regarding the mural painter portion of the exhibition were absolutely scathing in their condemnation. Many of the painters were criticized for presenting "nimbly argued communism,"[48] besides simply making bad paintings.

Lincoln Kirstein, defending the exhibition in *Hound & Horn*, made the wry observation that "[t]he attitude of the critics can be conservatively represented in the genteel statement from the *New York American*: 'Surely the Museum of Modern Art could not do better than to close at once the American Mural exhibition.'"[49]

While most of the press was unflattering about the painters, the photographers fared much better. In a review in *Art News*, Mary Morsell was effusive with her praise for the photographic murals, after blasting the painters. She commented:

It is the photo-murals which carry off the major honors of the show and yield elements of boldness and imaginative power found but rarely among the muralists. With commendable taste the hanging committee

have placed Steichen's magnificent "George Washington Bridge" with its breathless crescendo of line, directly in the entrance foyer. From it one passes to a series of brilliant syntheses of modern industrialism and city vistas, produced for the most part by the "montage" technique of combining and mounting sections of different photographs to form one composition. The masters in this medium, with the aid of their cameras, have produced panels that are instinct [sic] with the true drama of modern industrialism, instead of its weak literary substitute. The girders of Ber[e]nice Abbott's "New York," the almost Rembrandtesque chiaroscuro of Rittase's "Steel" and the cubistic geometry of Rotan's repeated pattern of skyscrapers, speak for themselves as freshly patterned evocations of this day and age. The vibrant beauty of the machine and the shining surfaces of metal sing out in pure symphonies of black and white in such photo-murals as Dureyea and Locher's "Metal, Glass and Cork," Gerlach's "Energy," Sheeler's "Industry" and Swank's "Steel Plant," while Stella Simon in her "Landscape and Cityscape," achieves a bloom and richness of tone that somehow escapes those with the whole gamut of pigmentation at their command.[50]

For Swank, the five mural studies represent a great coup as well as an interesting experiment. Imagine what it must have meant to Swank to be included in MoMA's inaugural show, when he had been entirely unknown to the New York art world just five months before.

Levy was aware of the problems of scale for the photographers. He commented that the "enlarged mural is a new and independent production, and the photographer who does not visualize in advance the final scale of his picture will usually be surprised and dismayed by the results."[51] A large portion of the criticism of both the painters and photographers revolved directly around this problem. Some critics felt that the various mural studies weren't conceived as murals: They were merely large easel paintings or photographs. The scale of the work can best be appreciated by looking at one of the photographs of the installation (figure 1-8). In this photograph, Steichen's image of the recently completed George Washington Bridge, at 9 feet 10 inches high by 8 feet, towers over the statues in the room. And through the archway, Berenice Abbott's "New York," with its "photographs of steel girders and plates mounted in relief" is next to Thurman Rotan's "montage of different photographs of the same building."[52] Most of the photographs, as well as the paintings, were displayed with a full-sized panel centered over an enlarged but not full-sized mural. These were based upon the actual smaller maquettes the photographers created. Steichen's image was the only one produced on a monumental scale.

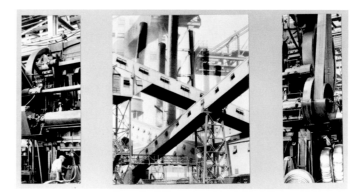

FIGURE 1-7. Charles Sheeler. Industry, 1932.
Gelatin silver prints (triptych), 7⅞" x 2¾"; 7¹¹⁄₁₂" x 6⅜"; 7⅞" x 2¾". The Art Institute of Chicago; Julien Levy Collection; Gift of Jean and Julien Levy, 1975.1146a-c. Reproduction, The Art Institute of Chicago.

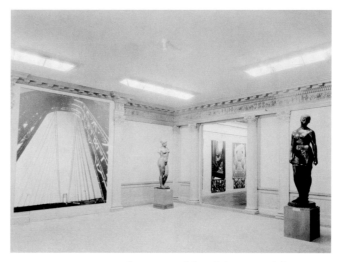

FIGURE 1-8. Anonymous. Installation view of the exhibition Murals by American Painters and Photographers, The Museum of Modern Art, New York, May 3 through May 31, 1932. Digital image © 2003 The Museum of Modern Art, New York.

Swank, along with many of the others who exhibited, evidently decided that working in this large scale was not something he wanted to continue, for the only examples of this style in his work are the five studies he created in preparation for the invitational show. Many generations later, photographers such as Thomas Struth and Andreas Gursky would develop an aesthetic around monumentality. Margaret Bourke-White, while not a participant in this exhibition, did explore the photo-mural format as architectural decoration a few years later when she created huge, wraparound photo-murals for the NBC Studios in 1934.[53]

Several photographers in the MoMA exhibition showed their work at the Julien Levy Gallery. The gallery had opened in 1931 with

the intent of showing photography, modern art, and experimental film and immediately garnered praise for its first exhibition and for Levy's artistic vision. One article announcing the opening of the gallery "devoted to photography as art," commented that "Mr. Julien Levy has not only shown himself a sensitive observer of the Zeitgeist, but has given concrete evidence of the courage of his convictions. Others have concurred that photography very well might be the art of the 20th century, but to back this idea with a gallery and to put the idea to the test is another matter."[54]

Swank's exhibition in early 1933, Photographs of the American Scene, took place within the first eighteen months after the opening of Levy's highly influential gallery. His exhibition was preceded by a few thematic group exhibitions such as American Photography Retrospective Exhibition, the inaugural exhibition for the gallery; Surréalisme; and individual photography exhibitions for Lee Miller and Berenice Abbott. Exhibits for Walker Evans, George Platt Lynes, Brett Weston, and other important photographers followed. In 1932 and 1933, Levy also exhibited the surrealist work of Salvador Dalí and Max Ernst; gave Man Ray his first solo show of photography; and, in 1935, mounted the exhibit Documentary and Anti-Graphic Photographs by Henri Cartier-Bresson, Walker Evans, and Manuel Alvarez Bravo.

Swank's work fits with modernist photographers such as Evans, Abbott, Bourke-White, Edward Weston, and Sheeler. In addition, his pictures of the streets of Pittsburgh in the 1930s share an aesthetic sensibility with the visionary French photographer Eugène Atget, who photographed the streets of Paris in the early twentieth century. While the reputations of these artists have grown over the years to place them among the greats of the twentieth century, Swank largely vanished from the American scene, not unlike the vanishing parts of Americana he photographed during his life.

The surviving correspondence between Swank and the Julien Levy Gallery is decidedly one-sided; most of the letters are from Swank to Julien or his wife, Joella Levy. In these letters, written mostly between 1931 and 1933, Swank reveals a good deal about his thoughts on his work and the state of photography, what the Levys' interest in his work means to him, and how he views what they were trying to do for photography.

In a letter from April 1932 addressed to Joella Levy, Swank says that he is sending them photographs he had made in New York the previous week. This letter reveals his insecurities about the quality of his printing and how difficult it is to make a really good photograph: "The prints I am sending you are much too flat, so if you decide to use any of them please return them all to me, marking the

ones you like, and I shall immediately send better ones." He continues: "Mr. Levy told me about the old wall at the corner of 7th Avenue and 19th Street. . . . It was a difficult thing to photograph so as to secure any composition, but I felt that the few diagonals in the one helped a little."[55]

In an undated letter to Joella Levy that is the follow-up to the April letter, he tells her he is sending "photographs for your New York exhibition. I think you will like these prints much better. There is an extra one of the old wall at 19th Street for Mr. Levy. . . ."[56] The New York exhibition Swank referred to occurred in May and June of 1932, coinciding with MoMA's mural exhibition. In the end, Swank did not participate. Levy decided to use New York photographers and titled the exhibition Photographs of New York by New York Photographers.

While Levy stuck close to home on his New York exhibition, correspondence indicates that he remained impressed with Swank's work. Almost all of Levy's encouraging words to Swank are lost, but a sense of the conversation between them can be gleaned from Swank's letter to Julien Levy dated December 9, 1932.

I am glad you liked the pictures I sent you. I feel I am learning to print a little better and getting more out of my negatives. I printed them over a number of times to get just what I needed.

Regarding the one man show, I hope you decide to put it on for me. I know how conditions are and what you are up against, so would be willing to do something to help out on the expense, either by bearing some of the advertising expense, or making some sales arrangement which would permit you to make out. I am naturally anxious to have my pictures shown and feel it means more to me than the matter of sales from one show. So I shall be very glad to hear from you on some arrangement that will insure your showing my work.[57]

One of the few surviving letters from Julien Levy to Swank tells Swank that he hopes "you're pleased that we have the best dates of the season for you and that the show will meet with great success and criticism though it is difficult to sell pictures these days."[58] Levy, like everyone was feeling the sting of the Depression. Eventually Levy concluded that it was easier to sell paintings and drawings than photographs, but in 1933 he was still optimistic about his dedication to exhibiting photography.[59]

The first Julien Levy Gallery at 602 Madison Avenue had two gallery spaces. Swank's work occupied the red gallery in back while Mina Loy's was in the front. Both exhibitions had their own announcements. Swank's had an image of a carnival, shot from the inside of a carnival ride. Dramatic lighting created silhouetted dark

spaces with brightly illuminated patches revealing the Ferris wheel and other details (figure 1-9). In contrast, Loy's announcement featured one of her delicate, whimsical line drawings. A column titled "Around the Galleries" that appeared in the *Art News* on February 4, 1933, commented on both exhibitions at the Levy Gallery. Mina Loy, the painter, poet and mother-in-law of Julien Levy received top billing. The commentary on Swank is notable both for the praise the work received as well as the observation of the columnist who says that there are

photographs on view . . . by an American camera artist who rejoices in the almost unbelievable name of Luke Swank. He sounds as if Sherwood Anderson had invented him, but the very interesting and correctly managed views of various portions of the American scene cultivated by this artist serve to substantiate his claims to photographic entity and acclaim. While Mr. Swank relies wholly on intuition to get his various effects, disclaiming any academic sense of composition, line or accent, he certainly knows his stuff, as the saying goes, and there are many prints, particularly the circus set, that are well worthy of highly expert camera artists.[60]

Concurrent with Swank's exhibition at the gallery, Levy organized an exhibit of contemporary photography for the Smith College Museum of Art in Northampton, Massachusetts. Four photographers were represented: Walker Evans, George Platt Lynes, László Moholy-Nagy, and Luke Swank.[61] In March Levy placed Swank's work in a much larger traveling exhibition and again in a traveling show that went to Wesleyan University in Connecticut in April. Checklists for these venues in the Julien Levy papers list the prices of the work for almost all the photographers. It is interesting to see the relative value in 1933 of these artists. Swank's work at $7.50 per print was near the bottom, which is understandable, given his newness to the scene. Atget's and Francis Bruguiere's work went for $10 a print; Berenice Abbott, Alfred Stieglitz, André Kertész, Moholy-Nagy, and Walker Evans commanded $15; Anton Bruehl and Clarence White $25; with Man Ray's valued at up to $45. A Mathew Brady photograph could be had for the miserly sum of $1.[62]

While Swank was continuing to work on his photography in 1933, he was also feeling the effects of the Depression as evidenced by his comments to Allen Porter, Julien Levy's assistant. "I have neglected to write, hoping daily that our banks would open and I would enclose a checque [sic] for my announcement. But they are opened here only on a very limited basis, and I don't know just when matters will straighten out. So if Smith College sends a checque [sic] please credit it to my account and tell me the difference

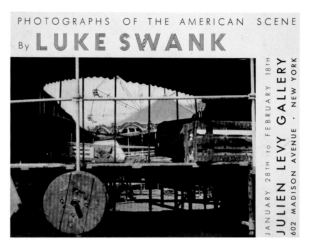

FIGURE 1-9. Photographs of the American Scene by Luke Swank. Julien Levy Gallery exhibition announcement, 1933.
Courtesy of the estate of Jean Farley Levy and the Julien Levy Archive.

and I will send either a checque [sic] or a money order."[63] Swank continues the letter with the announcement that he is now working on the architectural survey that would culminate in the 1936 book *The Early Architecture of Western Pennsylvania*, written by Charles Stotz and largely illustrated by Swank.[64] "At present I am spending my spare time making photographs of buildings built before 1860, for a survey made by the Pittsburgh chapter of the American Institute of Architects. They have received a nice fund for the purpose and I am greatly enjoying the work. The lack of knowledge of architecture of the early builders in this section enabled them to build very fine buildings. I know that some of the pictures will interest you."[65]

Swank at some point later in the spring of 1933 was able to get his bank check. In the letter enclosed with the check apologizing to Mrs. Levy for the delay, Swank offers his appraisal of the contributions to photography that the Levys were making with their gallery. He also offered his observations on the reaction of critics to the Murals by American Painters and Photographers exhibition: "I feel that American photographers certainly owe a great debt to you and Mr. Levy. Through you[r] efforts they have been given the first opportunity to show their work in large exhibitions as a fine art, and the way is probably made easier for future recognition. I don't think that any individual photographer or even any group of photographer[s] could have done what you have, and I hope they all appreciate it as much as I do. While there was a variety of opinion, most of the critics seemed to feel that the photographers acquitted themselves about as well as the painters. And they apparently all had to take notice of the photographs at least, which is certainly much better than being ignored." He goes on later in the letter to talk

about his current projects, demonstrating that he worked on multiple themes at the same time. His comments are also invaluable in helping to date his work, especially part of his circus photography, the still life and abstract images, and even some of his Pittsburgh scenes: "I have been making lots of pictures. I was with a circus for three days last week and had the time of my life. My son was with me and now he is the biggest person in the city. He feels much superior to all his friends now. I have been making pictures of snow fences, concrete construction forms, an old barn, flowers, kitchen utensils, a great concrete bridge in Pittsburgh, a carnival and some other subjects. I have had only Sundays to do these things, so Sunday has not been a day of rest for me."[66]

In another undated letter to Julien Levy written sometime in early 1933, Swank talks about his difficulty in evaluating his own photographic work and humbly asks Levy to judge the quality of his work. "I suppose you have received my pictures by this time and I hope you were not disappointed in them. They are all subjects that Mrs. Swank and I admire very much, so our judgment on them is not very good. I can usually depend upon Mrs. Swank's appraisal, but with these pictures, like me, she sees the subject instead of the picture. So we will have to let you judge." He then sums up the guiding idea behind his work: "I feel that I want my work to be illustrating the things that are passing in our American scene. The Circus (Sells-Floto will not be on the road this year) the river steamboat, the log cabin, the mountain farm, the carnival—all are passing. All are very American."[67]

Swank had clearly defined his subject matter. With the exception of commercial work and photographs of Fallingwater made for his friend and patron Edgar Kaufmann, Swank concentrated throughout his career primarily on this theme of what is passing in American culture.

This burst of correspondence and the exhibitions arranged by Levy seem to have stopped as abruptly as they started. While Swank exhibited in many places after 1933, those exhibitions do not have Levy's mark on them. In fact, the last surviving letter from Swank in the Julien Levy Archive dates to 1935. The letterhead now carries the stylized Luke Swank signature placed over the word "photographer." He tells Levy about his move to Pittsburgh. "We are now living in Pittsburgh. We are near a little town called Etna which is a very unusual and picturesque place. It was settled in 1790 and was an important town on the river and canal years ago. There are buildings of all types and conditions. It is an almost unbelievable place. I know I can make several hundred interesting pictures in it. If you are interested I shall be glad to do so at once. I think I could show

you the pictures in probably two weeks, or even less if the weather permits. It would probably make a little different show from what you usually run, as the pictures would all be related." He ends the letter with the comment "Hoping that you will show my pictures. . . ."[68] The tone of Swank's remark is plaintive. He addresses Levy almost like a supplicant. Perhaps Swank understood that Levy was beginning to shift directions with his gallery.

By 1935 Levy had begun to move away from aggressively showing photography. He did continue some photographic exhibitions, including one for Brett Weston and the important show Documentary and Anti-Graphic Photographs by Henri Cartier-Bresson, Walker Evans, and Manuel Alvarez Bravo. This shift came about because he had reluctantly concluded that the market wasn't developed enough for an aggressive program in photography to be profitable.[69] There is no record of additional shows for Swank. There is mention, however, in a November 1939 letter written by Edith Elliott, who became Swank's second wife in February 1940, that he was exhibiting at Levy's gallery.[70]

Whether this was a full exhibit or Swank simply supplied some new work that Levy made available at the gallery is hard to determine. Either way it suggests that Swank and Levy's relationship continued. The gallery addresses are stamped on the back of some of Swank's prints in both the Carnegie Library of Pittsburgh and in the Julien Levy Collection in the Philadelphia Museum of Art. While some prints carry the 602 Madison Avenue address, others give the address as 15 East 57th Street, where the gallery moved in 1937 and remained through 1941.[71] Levy continued to act as a dealer for Swank even if he was no longer showing his work.

For Swank, the Levy connection was certainly important, but he also sought other venues for his photography. In 1934 he exhibited in New York at Delphic Studios, a gallery that previously had a one-man show of Moholy-Nagy's work. Frank Crowninshield, a well-respected collector of art and the longtime editor of *Vanity Fair*, introduced Swank's exhibition. He wrote:

These photographs of circus life are the work of Luke Swank, a distinguished, if heretofore obscure Pennsylvania photographer. . . . [T]here can be no question but that his reputation will soon flourish nationally. Many of his still life arrangements, seen privately in New York, have been compared to Stieglitz's—the same sensitiveness to surfaces, the same sobriety of lighting, even—surely we may thus speak of photography—the same quality of being American.

Not only is Luke Swank interested in interpreting American life, but in revealing what is peculiar to American light and air. Therein, we believe, lies his artistry.[72]

Crowninshield, in these few words, offers an important assessment regarding Swank's place in photography. Given Stieglitz's stature in the world of photography and art, this comparison suggests that Swank, who was only a few years into his career as a photographer, belonged with the most renowned photographic artists.

The Delphic Studios show featured mostly Swank's circus photographs, a series he had been working on for several years. The circus, a prominent, fascinating, and mythic feature of American culture, hits its peak in 1903, when ninety-eight separate circuses toured the country.[73] By the time Swank began to photograph the circus, its long decline had started. Swank's circus photographs beautifully illustrate his interest in photographing what was passing in American culture.

Swank had success exhibiting on the East Coast. In 1934 he turned his attention to a new type of salon, one sponsored by Group f.64 founded in 1932 by a loosely knit set of West Coast "photographic purists" that included Ansel Adams, Imogen Cunningham, John Paul Edwards, Edward Weston, and Willard Van Dyke. Edwards, in an article in a 1935 edition of *Camera Craft*, articulated the Group f.64 credo: "The purpose of Group f.64 is not militant. It has no controversy with the photographic pictorialist. It does feel however, that the greatest aesthetic beauty, the fullest power of expression, the real worth of the medium lies in its pure form rather than its superficial modifications."[74]

Group f.64 advocated the use of panchromatic films capable of recording long tonal ranges and having a fine grain structure to maximize detail within the resulting negative. Its members believed in the use of glossy printing papers because this type of paper "more correctly present[s] the value of the negative, and give[s] a depth and richness of tone utterly lost on matt surface papers." They even advocated dry-mounting prints onto bright white mats,[75] a big departure from the decorative mats favored by many pictorialists.

Swank, who had exhibited with both Weston and Cunningham in 1932, had already reached a similar conclusion by the time he first contacted Julien Levy in 1931; his prints were crisp, clean, and modern. Given his philosophical belief in the power of "pure photography," it is not surprising that, in 1934, he entered the First Salon of Pure Photography, organized by Willard Van Dyke and Mary Jeanette Edwards at their 683 Brockhurst Gallery in Oakland, California. Van Dyke, Edward Weston, and Ansel Adams were the judges. In a September 1934 article in *Camera Craft*, John Paul Edwards discusses the genesis of the idea for the salon, offers a definition of the term "pure photography," and comments on Swank's contribution to this exhibition.

The idea for the salon emerged from the criticism that "Edward Weston, Anton Bruehl, Imogen Cunningham, and other leading workers in the modern photographic movements did not send their work to the nationally known salons." Van Dyke argued that the "national salons did not seem interested in pure photography as a definite movement. . . ." This salon sought to feature photographers who were modernists. It was conceived as an antidote to the old salons that championed pictorialism, the movement abandoned by Weston and Swank.[76]

Six hundred photographs were submitted. Fifty-seven images by thirty-four photographers were selected.[77] Swank had five photographs from his Pittsburgh series included—more than anyone else competing.[78] Edwards commented that Swank's photographs "measure up as the best individual group of the exhibition."[79] An urban still life of woven baskets, boxes, hanging rope, and other items titled "Pittsburgh #12" (plate 114) was one of his images in this exhibition and was reproduced in the *Camera Craft* article.[80]

In his acceptance letter into the Salon, Van Dyke offers Swank a one-man show at the 683 Brockhurst Gallery in October and asks him to send some of his circus photographs for this exhibition. He continues, "Ansel Adams and Edward Weston join me in congratulating you on the fine work you are doing."[81]

A few weeks later, Swank wrote to Van Dyke registering his delight at being thought of highly by Weston and Adams and providing his only clear statement of influence:

Your letter was one of the great thrills of my life. To think of yourself and Ansel Adams and (I know you won't mind when I say this) above all—Edward Weston, admiring my pictures—well, I can't think of anything to say. You at some time in your life had the same feeling, and will understand.

Men who are leaders seldom realize how far their influence extends. My work may show it only in a diluted way, but Mr. Weston has had a great deal to do with my photographic education. What I know about the portrayal of textures I probably owe more to his influence than to anyone else. So I hope he will honor me by considering me his pupil.[82]

Swank concludes by saying he will send photographs for this one-man show and will include a number of his circus pictures.

Van Dyke shared Swank's letter with Weston, who wrote: "[Van Dyke] evidently told you of the enthusiasm with which we greeted your significant contributions to the salon. So I am writing to tell you this: that your letter meant much to me. It is always a deep satisfaction to know that in some way one has been a stimulus in another's work—especially when the work is so fine. You, honor me."[83]

During this period Swank was exhibiting regularly and continued to receive critically positive reviews for his photography. Between 1934 and 1936 Swank was the subject of much comment in the press, especially in Pittsburgh, but also in other papers including the *New York Times*. This coverage chronicles his move from amateur to professional and from Johnstown to Pittsburgh.

Harvey Gaul wrote a charming, folksy introduction to his *Pittsburgh Post-Gazette* review of Swank's one-man show at the Carnegie Institute of Technology in January 1934. "Luke Swank, of Johnstown, makes his bread-and-butter selling spares, taking dents out of fenders, squirting anti-freeze into radiators. In a word, he's in the automobile business."[84]

Swank Motor Sales Company, Inc., the business Gaul referred to, was the Johnstown Buick dealership owned by Swank's father and uncle. The description of him as handyman and mechanic, while providing a folksy image, is disingenuous, for Swank was a well-educated, cultured man who was, at various times, a manager for the hardware firm and the automobile dealership owned by the family. This image of an "aw shucks kind of guy" from the rural highlands of Pennsylvania seems to be one that Swank liked to foster. Gaul was not the only one to describe Swank in this folksy sort of way; evidently Swank liked to project this kind of image, or he would have corrected the record. In his biographical note to Julien Levy written in late 1932 or early 1933, however, he clearly indicates that he is a manager of an automobile dealership and not a mechanic.[85]

In describing some of Swank's projects, Gaul provides invaluable assistance in dating some of his work. Because Swank rarely titled and even less frequently dated his work, Gaul's descriptions offer evidence that his pictures of houses on hills with wooden staircases for reaching them (plate 137) predate January 1934, as do many, if not all, of Swank's abstract compositions. We learn from Gaul that "when he finishes with his circus studies he goes batting around Soho, kodaking as he goes, and comes down with crazy houses in crazy lines. . . . Pots-and-pans make a project; a dilapidated, shredded basket makes an arrangement; a spare tire and a wire can make a stunning still life, so he goes around the town snapping the bizarre, baroque, and burlesque."[86]

A more serious article about this exhibition appeared in the *Pittsburgh Sun-Telegraph* and quotes Swank on his philosophical beliefs about photography. This quotation not only describes Swank's ideas clearly, it is also one of his few surviving direct comments on the medium of photography.

The photographs should never, except in a few specialized cases, be modified by any kind of handwork. Modern equipment and materials have rendered this unnecessary. In common with the works of graphic artists, the photograph must have interest and composition. Almost any subject may be interesting. Composition in the subject is of great importance to the photographer as he cannot accentuate, modify or eliminate as can the artist, but can record only what is before his lens. For the most part, simple subjects, comparatively 'close-ups,' are most suitable. Distant objects tend to become flat and uninteresting.

The camera can do one thing supremely well, i.e., portray textures. The nature of the materials of the objects photographed, whether wood, stone, iron or what not, should always be perfectly obvious and interesting.[87]

In short, Swank echoed the ideas articulated by Group f.64 and firmly placed himself in the camp of the modernists. However, while he professes a categorical purism, it becomes clear, as I will show in later chapters, that he practices a modified form of modernism in which cropping an image is acceptable.

By 1935, the *Bulletin Index* was referring to Swank as Pittsburgh's best-known photographer. This assessment came in an article describing a three-part show at Kaufmann's Department Store in downtown Pittsburgh. Kaufmann's, like other department stores of this period, hosted art exhibitions. Part one featured a traveling exhibition of the U. S. Camera Salon and included "such A-1 photographers as Steichen, Margaret Bourke-White and Max Thorek." Part two was Swank's one-man show. Part three presented the work of local news photographers.[88] Swank presented "serene studies of sunlight and shadow which have all the depth and detail of reality"—classic descriptive terms used for image makers with a commitment to modernism. That he was given his own space within this larger exhibition might have been due to his reputation about town or to the patronage of his friend Edgar Kaufmann.

The *Pittsburgh Press* in October of 1936 commented on his diverse one-man show at the Gulf Gallery in Pittsburgh. This exhibition, based upon the account in the article, covered a wide range of Swank's work. "The appeal of the exhibit . . . lies largely in Mr. Swank's evident preference for taking pictures of things and figures exactly as they are to be seen in everyday life—he never tries to re-arrange objects into cute designs, or pull figures into artificially pretty forms."[89]

"Luke Swank's Pennsylvania" appeared in the fall of 1938. Written by Beaumont Newhall, then the librarian of the Museum of Modern Art, this article—the only in-depth piece written about Swank's work during his lifetime—appeared in the first issue of *U.S. Camera Magazine*. *U.S. Camera Magazine* was an offshoot of *U.S. Camera Annual*, a publication that had featured Swank's work for several years.

Newhall speaks of Swank as a photographer who "believes in a straightforward technique—no retouching, straight prints on glossy paper."[90] This is as clear an endorsement of the perspective put forth by Group f.64 and other modernists as can be found. Newhall begins to make the case in this article for Swank's inclusion as one of the important modernist photographers.[91]

Eleven years after the Museum of Modern Art opened and nine years after the Murals by American Painters and Photographers exhibition took place, MoMA's Department of Photography was created in 1940. While the museum included photography in exhibitions in its first decade, photography as a full-fledged department followed architecture by seven years and industrial art and the film library by five years.

The curators of the first exhibition organized under the auspices of the newly created department were Beaumont Newhall and Ansel Adams. Newhall, who had organized the history of photography survey exhibition for the museum in 1937, had been elevated from his position of librarian to become the first curator of the photography department. Adams, who made idealized, technically astounding photographic landscapes of the American West, was then, as now, one of the most recognizable figures in photography. Together, Newhall and Adams created an inaugural exhibition titled Sixty Photographs: A Survey of Camera Aesthetics, which included images by over thirty photographers.

Swank was represented in this show, along with nineteenth-century masters and contemporary image makers. Featured were the Scottish calotype pioneers David Octavius Hill and Robert Adamson and the French photographers Henri Le Secq and Eugène Atget. Mathew Brady was represented with his "Ruins of Richmond." Timothy O'Sullivan's "Ancient Ruins in the Canyon de Chelle" and "Inscription Rock" graced the walls. Berenice Abbott; Henri Cartier-Bresson; Ansel Adams; Dr. Harold Edgerton, the pioneer of strobe photography; Walker Evans; Dorothea Lange; László Moholy-Nagy; Man Ray; Charles Sheeler; Edward Steichen; Paul Strand; Clarence White; and Edward Weston and his son Brett helped to round out this exhibition showcasing a virtual who's who in the history of photography.

Alfred Stieglitz was accorded the honor of having eight photographs included that surveyed his work, from "The Terminal," made in 1892, to "The Dead Poplars, Lake George," from 1934. David McAlpin, chairman of the museum's Committee on Photography, acknowledged Stieglitz's importance in his introduction to the exhibition: "Photography is deeply indebted to Alfred Stieglitz for his courageous pioneering and experimentation, for his untiring struggle to have it recognized as a medium of artistic expression, for his impact on more than a generation of workers and his uncompromising demands on them to achieve the finest quality of craftsmanship and perception, and for his influence on the taste and discernment of the public."[92]

Newhall and Adams were not trying "to define but to suggest the possibilities of photographic vision." They purposely excluded a lot of photographic endeavor including color photography and commercial, advertising, and scientific images. Curiously, they did include Edgerton's "Golfer," a work that bridges scientific investigation of the effect of stroboscopic light on objects in motion and compositional and aesthetic concerns.

In a letter that Newhall wrote to Adams on New Year's Day 1941, he discusses the show at great length. He tells Adams, who was unable to attend the opening, about the decisions regarding how the pictures were hung, the way the gallery was painted and lit, and even where plants were placed to break up space. He also gives Adams a rundown on who showed up at the opening and comments on what they did and said. What is remarkable in this letter is Newhall's detailed account of Stieglitz's visit. He wrote, in part: "Stieglitz came to see the show yesterday morning with Dave [McAlpin], and spent about half an hour in the gallery, looking at every print. What he had to say was most interesting. He liked the Emerson very much—the best Emerson print he had seen. Next he singled out the Swank footprint as especially fine."[93]

Swank's contribution to Sixty Photographs: A Survey of Camera Aesthetics was listed in the catalog as "The Doormat" (figure 1-10). While it was not one of the few images used to illustrate the exhibit catalog, it was identified from an installation photograph in MoMA's collection. "The Doormat" is a study of texture and contrasts. Two dark vertical gashes cut through the snow in the upper left, a footprint lies to the right, and the geometrically patterned metal doormat cuts diagonally across the bottom. The image is finely detailed, revealing multiple textures and nicely handled light in a high key situation. The snow is wet and heavy, just on the edge of melting.

Why this particular image of Swank's was chosen over all of his other images is impossible to say. What is clear, however, is that in creating this grand sweep through the history of photography Newhall and Adams chose to include Swank's work and Stieglitz thought it "especially fine"—important recognition, indeed, from three of the most revered and influential figures in the history of the medium.

After relating Stieglitz's comment on Swank, Newhall continued his report on Stieglitz's reactions:

FIGURE 1-10. Luke Swank. [The Doormat], c. 1930–1941.
Gelatin silver print, 5¹⁵⁄₁₆" x 8⅛". The Museum of Modern Art, New York, 278.1941; Gift of the photographer. Digital image © The Museum of Modern Art, New York/Licensed by SCALA/Art Resource, New York.

Even more surprising was the good he had to say about the Westons—Lettuce Ranch, Tide Pool, and Melting Ice he thought were all Edward at his best. He said he had a personal prejudice against Moholy, and would refrain from commenting. . . . We had put the O'Keeffe hands beside Porter's Baby, a juxtaposition which he liked. The Model he didn't seem to like: the Evans Legionnaire he thought revealed Evans' weakness, a completely meaningless handling of the background. But the Evans interior he thought fine. . . . The Sheeler White Barn [figure 6-4] was one of the finest things in the show; the Ford Plant [figure 2-10] not so surely seen. . . . And finally the hanging panel with his Poplars. "Perfectly presented; just the kind of lighting it needs. Only I would have put the print higher, for it sweeps upward."[94]

Stieglitz, while generous with his praise and circumspect with his criticisms, provides an interesting commentary on his own artistic values and prejudices. He ended, as Newhall reported, with the gentle admonishment of how, although the lighting and presentation of his "Poplars" was perfectly presented, he would have hung it differently and by implication more effectively.

During Swank's lifetime he had only one more opportunity to exhibit a body of work. In October 1942, he had a joint exhibition with Philip Elliott (not related to Swank's second wife Edith Elliott) at the Albright Art Gallery in Buffalo, New York. Swank was most likely invited because Elliott had strong Pittsburgh ties and the two men must have known each other. Elliott came to Buffalo in 1941 from the University of Pittsburgh, where he had been an art professor, to direct the Albright Art Gallery's School of Fine Arts. He was known both as a painter and a documentary photographer. Elliott showed photographs of barns, markets, and antiques, while Swank exhibited, according to an article in the *Buffalo Fine Arts Gallery Notes*, "forthright records of his native Western Pennsylvania, its industries and countryside. Shots of Pittsburgh steel mills, which called up a note of another world in smoke-produced haze, contrasted forcibly with crystal-clear shots of boats, barns, houses and children."[95]

By the 1940s Swank was less concerned with public venues for his art and more concerned with commercial opportunities; the best provided him the time and opportunity to make art after satisfying the commercial requirements of his clients.

Until 1934 Swank was able to devote most of his photographic energies to making art. He could engage in his photography as an enlightened amateur, much like Alfred Stieglitz whom he so thoroughly admired. But by the end of 1934, the realities of the Depression came crashing down on him and he was confronted with having to find a way to support himself and his wife and son for the first time outside of the comforts of the formerly successful family businesses. From being an enlightened amateur photographer who photographed whatever he wanted, he became a professional who photographed what his clients needed.

Swank began a full-time photographic career in Pittsburgh in 1935, when John Bowman, chancellor of the University of Pittsburgh, hired him as the university's official photographer. In a letter to Julien Levy, Swank announced: "I am now the photographer for the University of Pittsburgh. They have given me very fine quarters, a good salary, and work to keep me busy only about half the time, and with the option of doing any outside work I may wish to do. To me the combination is almost heavenly. I only hope that it won't all be so nice my work suffers in quality."[96] The fear he expressed to Levy was valid. He had reached a turning point: from 1935 until his death in 1944, he had to divide his photographic endeavors between what paid his bills and what satisfied his soul. The trick he faced was not to let the commercial demands completely crowd out his art.

At the University of Pittsburgh, Swank had responsibilities to photograph people and places on campus. Within the first few months, he proposed broadening his duties to include the creation and implementation of a photography course that would emphasize photojournalism. This course was hailed as an innovative development in education. It was reported on in both the Pittsburgh press and the *New York Times*. The *Times* commented: "With the flare of flash bulbs and the click of camera shutters, a new course has made its appearance on the campus of the University of Pittsburgh. What is

thought to be the first formal instruction in news photography began with the present semester there."[97]

Swank said he designed the course "to give the maximum of practice and the minimum of theory," as well as "to teach something about every kind of photography."[98] It is not important whether it was the first photojournalism course at an American university or just one of the earliest. More important was its breadth; in what was ostensibly a news photography course, Swank introduced his students to a much wider perspective on the medium. Swank was an innovator in the history of photographic education. His appointment predates the opening of Moholy-Nagy's New Bauhaus in Chicago by two years and was a decade or more earlier than most universities began to offer serious courses in photography. The formal move of photographic education to the academy is a post–World War II phenomenon.

Swank taught at Pitt for two years until 1937, the year Edgar (E. J.) Kaufmann provided the financial backing for him to open his own studio at 526 Penn Avenue. One 1938 article said the reason he left Pitt was that his liberal beliefs were at odds with the administration, a situation so endemic at the university at that time that the university was "black-balled by the college-teacher's association."[99] If politics played a significant part in his leaving, then the situation at Pitt that he had described to Julien Levy in 1935 as almost ideal must have turned sour. His departure, however, may also be explained simply by the desire to more fully develop his own photography business, something much easier to do from his own studio than from the institutional confines of his photographic working space in the recently completed Cathedral of Learning, the University of Pittsburgh's landmark skyscraper.

Swank, however, did not abandon teaching. He resumed by teaching night classes downtown at Duquesne University. He continued to teach until 1941, when, according to a letter from Edith, "so many of the boys who used to go to night school [were] in the army that the colleges discontinued a lot of their work."[100]

It is not known how, when, or where Swank and Kaufmann met, but they became close friends. Perhaps it was in 1908 when Kaufmann purchased a general store in Connellsville, Pennsylvania, a small town southwest of Johnstown,[101] that he became acquainted with the Swank Hardware store. In 1907, Harry Swank had opened a new six-story, pie-shaped building on the corner of Bedford and Main in Johnstown. At that moment, when Kaufmann was the proprietor of the store in Connellsville and Luke was still attending Pennsylvania State Agricultural College, the Swank mercantile enterprise was much grander than Kaufmann's general store.

Swank and Kaufmann may have become friends sometime around 1925, "when E. J. undertook commercial house-building . . . with a prototype home that still stands east of Pittsburgh, in Johnstown."[102]

In a way, their lives were destined to be linked. Each came from dominant merchant families. Both loved horses. Luke and Liliane Kaufmann, Edgar's wife, shared dogs as an interest; she bred and showed dachshunds, while he had trained German shepherds for security tasks.[103] And both men knew Julien Levy, although it is not known who met Levy first, Swank as an exhibiting artist, or Kaufmann as a collector of the artists Levy showed in his gallery. It is possible that Swank introduced Levy to Kaufmann, given that Kaufmann began to collect modern art after Swank began his involvement with Levy.

Both men appreciated the art of Diego Rivera. Kaufmann owned Rivera's conté crayon drawing *Profile of a Man Wearing a Hat* and his watercolor *Torrid Siesta (El Sueño)*.[104] At one time, a Diego Rivera black-and-white line drawing hung in Swank's studio, in the room that was "adapted to a woman's living" for his second wife, Edith.[105] Levy once brought Frida Kahlo to Fallingwater for a weekend visit after Kaufmann purchased one of her paintings.[106]

Maybe most importantly, Swank and Kaufmann both had keen intellects and both embraced modernism in the 1930s before most Americans were ready for it. Swank showed this by rejecting pictorialism and adopting a crisp, razor-sharp, modernist approach in his photography. Kaufmann showed his appreciation of modernism by commissioning Frank Lloyd Wright to build his extraordinary home Fallingwater, and through artwork he acquired from Levy, especially that of Frida Kahlo and Diego Rivera.

While Levy was the center point for Swank's early artistic life, Kaufmann held that role in Swank's commercial life. In September 1937, six months after Grace's death, Swank went into business with Kaufmann. Previously, Kaufmann, a "master of publicity," had most likely acted just as patron to his friend.[107] He now became his employer, with a vested interest in his financial success.

Kaufmann Studios, a separate operating unit of Kaufmann's Department Store, was reorganized as Luke Swank, Inc. According to the corporate papers, Kaufmann Studios had been formed "for the purpose of carrying on the business of useful and artistic decorative work, consisting of completely or partially constructing and decorating buildings, halls or rooms; and the buying and selling of all manner and kinds of useful and artistic objects for use or ornamentation."[108] The company's purpose was broadened to include "carrying on a general photographic and art business."[109]

Edgar Kaufmann resigned as president and director of Kaufmann Studios with the proposition that "the corporation secure the services of Mr. Luke Swank as President and General Manager of the corporation."[110] This business unit that Edgar was reorganizing had three shareholders and 500 shares; Edgar owned 498 of them. From Kaufmann Studios came $5,000 into the renamed and restructured corporation. Swank contributed all equipment he currently owned and any future equipment he would acquire.

With this agreement, Swank became president of the newly formed Luke Swank, Inc., effective October 1, 1937. He was to receive a monthly salary of $400 for twelve months. Although he retained 498 of the 500 voting shares, Kaufmann stepped back from corporate governance. Irwin D. Wolf, his brother-in-law and the manager of Kaufmann's Department Store, remained on the board and his son, Edgar Kaufmann Jr., was added to the board and given the title of vice president. Although Swank was president, he held no stock, and all check transactions required a second signature by one of the other officers.

This arrangement lasted barely more than a year. In November 1938, a reorganization plan was filed providing for the merger of Luke Swank, Inc., Investment Land Company, Kaufmann Department Stores Securities Corporation and Sampeck Clothes, Inc. into Kaufmann Department Stores.[111] When the reorganization was completed, the just over one-year-old business had been completely reabsorbed into Kaufmann's primary business structure. The surviving papers do not indicate what, if anything, Swank got out of the merger, nor do the papers indicate if he remained on Kaufmann's payroll. Whatever happened, Swank was left with his studio on Penn Avenue. Based upon comments in Edith's letters, by the time she married Luke in 1940 he had become an independent businessman with several employees and a diverse client base. The H. J. Heinz Company was his largest single client. Luke and Edgar remained friends, with Edgar possibly retaining the role of patron, on an informal if not a formal basis. While no paperwork has been found that clearly demonstrates how Kaufmann ended up with a collection of almost nine hundred of Swank's photographs, it is fair to assume that Swank either gave this work to Kaufmann out of gratitude or as payment for his help.

Swank, a frequent guest of the Kaufmanns' at Bear Run, the Fallingwater site, photographed much of the construction of the famous home by Frank Lloyd Wright beginning in 1936. He even made motion pictures of it, "where great heaps of stone" quarried on the property for the stone walls "can be glimpsed."[112]

Clyde Hare, a longtime Pittsburgh photographer and author of the 1980 Carnegie Museum of Art catalog on Swank, commented in an interview that he "found it very interesting that at about the same time Kaufmann was thinking about architecture and structure and building Fallingwater, he was collecting Swank photographs of rural architecture and rural stonework. That may have helped Kaufmann in his input to Frank Lloyd Wright on the house. There are a lot of little threads that go back and forth that we have lost to time and history. Just little clues that happen every once in a while where you see Swank photographing rural stonework and rural construction and you find later photographs of Swank taken of Fallingwater as Kaufmann is constructing it."[113]

Swank continued to photograph Fallingwater at least through 1942 and to use Fallingwater as a setting for some of his most personal, intimate images. While he made a large number of images of both the interior and exterior, these images are primarily descriptive record photographs. Few, if any, have the compositional edge of his best work. Seven of these images, however, were featured in the 1938 MoMA exhibition that showcased Fallingwater (figure 1-11). The exhibition featured Wright's drawings as the centerpiece of the show, with Swank's and two other photographers' work as the supporting cast.[114]

By 1937 Edgar Kaufmann Jr. was working at MoMA. He became heavily involved in public relations work to promote Fallingwater and the 1938 MoMA exhibition on the new house. He kept busy distributing Swank's Fallingwater photographs to the media and even helped place Swank's photographs in William Randolph Hearst's *Town & Country* magazine, a publication not noted for featuring modern architecture. As a result of the public relations campaign to promote the stunning new home sitting over a waterfall at Bear Run, Swank's Fallingwater photographs became his most widely distributed images. They were not the best images he made during this period, nor did they reflect the style or themes that make Swank an important photographer. In fact, when the photographs were referred to in the *New York Times*, Swank wasn't even mentioned, although the photographs were described as excellent.[115] The emphasis was, as it should have been, all on Wright's amazing architectural triumph and not on Swank's record of it.

It is undoubtedly from this body of work that Swank came to the attention of Wright, at whose request Swank later traveled the eastern part of the country to photograph some of his other projects. A letter Wright wrote in 1941 offers Swank flattery and a commission—and little else:

If I've never written to you before thanking you for your fine work in photographing the Kaufmann Guest House: here's to you—quite the finest job I ever saw. . . . I like pure photographic technique such as yours. Which moves me to ask if you will accept an appointment as official photographer of all buildings—Pittsburgh and East?

Honorarium? God help us all at the moment. But the honorarium will improve with time.[116]

This letter goes on to provide the details of what Wright wants photographed and, while he offers to pay only Swank's direct expenses, Wright does tell him he needs the work done immediately in Virginia, Massachusetts, and on Long Island.

While the letter is a testament to Wright's nerve as well as a comment on his own financial situation at the time, Swank either accepted Wright's less-than-generous offer or worked out a more favorable relationship. A letter Edith Swank wrote to her mother commented that "Frank Lloyd Wright called for some pictures immediately and so our plans were definitely shot."[117] In the winter of 1941, Swank and Edith traveled to several locations to make photographs for Wright. Wright, however, was not pleased with the pace of Swank's work on his project. The last piece of surviving correspondence between the two is a testy telegram from Wright on March 24, 1941. "Dear Swank: Can we have a look at some photographs? Life is short. Time fleeting."[118] It is not clear whether this assignment ever was finished, nor is it clear if Swank ever was compensated for this work. Hardly any of Swank's images of Wright's projects, with the exception of Fallingwater, have survived in any of the archives of either man's work.

The period 1935 to 1937 must have been particularly difficult for Swank. His wealth had disappeared. His family had to adjust from the life of privilege they led in Johnstown to a significantly more modest one in Pittsburgh. With the financial security once provided by the family businesses now gone, Swank had to find a way to make a living outside of the various family enterprises. The Swanks' son, Harry, was rebelling and decided circus life had more appeal than college. And Grace, Luke's "dearly loved and extraordinarily beautiful" wife, died of cancer in March of 1937.[119]

Swank began his relationship with the H. J. Heinz Company in 1936 and it lasted the rest of his life. It is not clear how Swank gained an entrée into the Heinz Company, but it is certainly possible that his friend Edgar Kaufmann linked him up with H. J. Heinz II, who was the only high-society friend Kaufmann had in Pittsburgh.[120] It was through his work for the Heinz Company that Swank met Edith Elliott, who became his second wife.

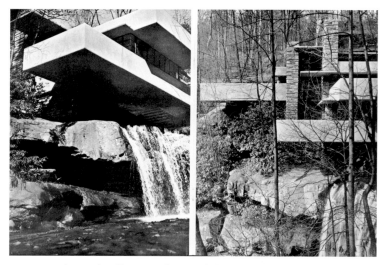

FIGURE 1-11. Luke Swank. Fallingwater photographs by Luke Swank, in *A New House by Frank Lloyd Wright on Bear Run, Pennsylvania*. The Museum of Modern Art, New York, 1938. Collection of Claudia M. Elliott. Digital image © The Museum of Modern Art, New York/Licensed by SCALA/Art Resource, New York.

21

"I'll be brief and to the point and give you the news. . . . I am now an employee of the H. J. Heinz Company," wrote Edith to her mother in May of 1934.[121] Edith, a graduate of the University of Chicago in art history, architectural history, and home economics, was just starting her career as a writer, home economist, publicist, and organizer of props for photography sessions. Beginning in 1935, if not earlier, she was given a variety of responsibilities related to the creation of advertising and public relations photography for the company.[122]

Edith's letters from 1934 through the early 1950s provide insight into Swank's photographic projects, their evolving relationship, their marriage and family life, and her intense desire to protect and enhance Swank's reputation after his death in 1944. From Edith's letters emerges a portrait of Swank as a kind, fiercely intelligent, driven man who loved his work but knew how to have a good time. He enjoyed music and conversation, food and friends. He was a man who was demanding as well as doting, a man who pushed her to grow beyond anything she dreamed possible.

Edith was a professional writer. She wrote pamphlets and columns for Heinz that were distributed nationally to newspapers, as well as cookbooks and a book, *The Story of Food Preservation*, illustrated by Swank.[123] Three index card files containing hundreds of cards in the Swank collection in the Carnegie Library of Pittsburgh also help flesh out Edith's comments in her letters about life with Swank. She most likely created at least two of these card files: the first, the D-series, describes much of Swank's rural photography while the

second describes his circus photographs. The third set, on his commercial work, lists client, date, negative number, and a short description of most of his assignments. Whether this file provides a complete record of his commercial work, or just a significant portion of it, is impossible to determine. Either way, it provides important information on his clients, what he did for them, and when he did it.

The card file for his commercial work covers May 1936 through the spring of 1943, several months before his health failed him and about a year before his death. Based on this file, it is reasonable to date the beginning of his work for H. J. Heinz to the end of May 1936. For at least part of this period he was under contract to Heinz, where he worked enough to be issued his own official Heinz picture identification badge.

His first project, dated May 26, 1936, was one of at least three where he traveled to locations in several states to make documentary-style photographs of crops, farm workers, and modern agricultural and food processing techniques. He completed similar assignments in 1938 and 1940. Of the few photographs that survive from these trips, most are a bit stilted and lack the kind of frozen real-life moment so evident in the best of his rural and urban photographs. They appear to have been shot from a script that required the active participation of the people being photographed. Even though he was working in a restricted and contrived manner, he was able to create a few powerful images, including a portrait of a young female farmworker and an image of men loading baskets onto a flatbed truck (plates 56, 85). According to comments in Edith's letters, Swank also used these travel opportunities to make his own images.

Some descriptions written on these index cards seem to confirm the scripted nature of this pseudodocumentary work. One card describing a photograph taken at the Bowling Green, Ohio, plant in May 1936 reads, "24—Men planting tomatoes–horses"; another reads, "32—Men watering tomato plants in cold frames"; and from another card from the same day, "10—Men loading cold frames on wagons." The number assigned to the negative precedes the description. The last entry for his work for the H. J. Heinz Company, dated March 10, 1943, lists the final negative as number 28828. While the card file doesn't list every number, the sheer quantity of cards, more than 550 for H. J. Heinz alone, all recording from one to fifteen entries, confirms the vast number of photographs Swank made for the company.

Several of the camera magazines in which Swank published his personal work list three cameras that he used: Graflex, Model D 3¼ x 4¼ inch, Speed Graphic 4 x 5 inch, and Contax.[124] In commer-

cial photography, however, he worked mostly in the 4 x 5 inch film format with some 5 x 7 and 8 x 10 inch work, as well as some that were described in the card file as "miniature rolls," most likely 35 mm. He shot in both black and white and color. After Kodachrome sheet film was introduced in 1938 some of the work moved from black and white to color transparencies.

His photographs were used for advertising, cookbooks, and magazine articles as well as for a variety of public relations purposes. A still life composition of vegetables, created for a 1939 cookbook as a two-page spread, is reproduced here in black and white (figure 1-12). The surviving photograph is a lush dye-transfer color print and resides in the Carnegie Library of Pittsburgh collection.[125] Some of his work for Heinz also ended up being used in publications such as *National Geographic*, which ran a story on food production in 1942.[126] Curiously, Swank's photograph of two Heinz kitchen workers in white dresses and hats receiving mandatory manicures was put in a feature titled "Flashback" on the *National Geographic* Web site for Brazil in 2002. All the commentary was, of course, in Portuguese.[127]

Unfortunately most of Swank's commercial work, for Heinz as well as other clients, has been lost. The Heinz Company archivist was unable to locate more than a handful of items that could be directly attributed to Swank. The Carnegie Library of Pittsburgh has a small number of color and black-and-white food photographs, as well as a few commercial images done for other clients. It is from examining the card file that the extent of his client base can be seen. Among his clients were Aluminum Company of America, Calgon Company, Campbell Ewald, Chevrolet, Copperweld Steel, Ford Motor Company, General Electric, Kaufmann's Department Stores, and Edgar Kaufmann. Ultimately, however, the cards are mute and it is through Edith's voice that the most is learned about this period of Swank's life.

Edith's letters to her family are often chatty and filled with details about her work and social life. In November 1939, Edith wrote a lengthy letter to her sister Nancy describing trips for the H. J. Heinz Company to work the New York World's Fair and a California fair. She said "I handled a lot of tough situations. . . . Out in California I came face to face with my first labor agitator. It was a minor triumph that I turned him away with Heinz honor (if you want to call it that) my own veracity and his good humor."[128] Her comments demonstrate self-confidence in her professional abilities, in sharp contrast to the insecurities she described in letters concerning her ability to live up to the expectations she perceived Swank had of her.

She goes on to tell Nancy how her job evolved to include responsibilities for photographic sessions. "We do a great deal of food photography in our department now—both in black and white and color—and my chief end of the job is in working on the layouts and selecting dishes and accessories," she wrote as part of the long lead-in to her most important news:

I have one other friend and he's pretty choice. In fact in my whole collection of unusual men I consider him the choicest. As a superior mind and well developed personality he has no peer among my collection. However, he is almost 50, a widower with a nineteen-year-old son, and anyway I must seem a callow child to him.

His home is the only really civilized place I know of in Pittsburgh, his is a genuine erudition. No one though hereabouts who knows me knows that Luke and I are seeing anything of each other—except for Betty and one of the other youngsters in our department. He's an amazing Dutchman—Pennsylvania Dutch and Swiss to be exact. He's done a great many things in his day—among them being a research chemist with the army and a college professor, besides inheriting a largish department store in the east [that] he ran through his youth.

His prime passion though was always for photography and he has within the past five years given up everything else for that. He is a photographer of Steichen, and Margaret Bourke-White stature. Considered already a truly great artist.

He and I always had good conversations together—but last spring I had my first real brush with him. I had to have publicity pictures taken—and he practically won't do portrait work. Nonetheless that was the job and I bullied him into taking a really good one of me. He hates taking portraits so much that he asks a hundred and fifty dollars a dozen as a certain way out of ever having to take them. But we have a contract with him to do our department work so we come in a different category. Not the hundred and fifty category. Well, we talked

all morning, and then suddenly he casually got to work and before I knew it we had a collection of good pictures, which is unusual because I photograph poorly.

He sent me books during the summer (he considers me a promising illiterate) and wrote an occasional note—then when I came back this fall we just sort of easy like began seeing each other. In his home (which is a combination of studio and laboratories and dark rooms and apartment in a downtown business building) there are good books, good conversation, good music, good food, good wine, interesting friends.

He is a very simple, homely, rugged sort of person. And I'm wondering just exactly how interested I am beginning to be in him.[129]

Edith certainly became genuinely interested, and Swank must not have considered her too callow a child even though she was much his junior. In fact, she was nineteen years younger than he, and only nine years older than Swank's son, Harry. Their relationship blossomed over the next several weeks, and in mid-January 1940 Edith writes to her sister Nancy and her brother John and his wife Jo announcing that she and Swank will marry in early February. To John and Jo she offers this description of her intended husband: "He is wise and simple and kind—a sort of Carl Sandburg American."[130] But to Nancy she reveals insecurities about becoming a partner to a man of fame and distinction: "Luke is quite a distinguished man and there will be an awful lot I'll have to live up to—but he is such a solid, simple, comfortable man—and he is wise and kind and I can do my growing gently."[131] And in her one surviving letter to Swank, written while visiting her parents to give them news of her impending wedding and seek their blessing, she wrote:

It's nice I didn't fail you at Fallingwater. I left there feeling I had miserably since I was so much less scintillating there than I usually am when someone tries to make me exhibit A. In fact I felt shy and silent so much of the time that I thought you must have really been very much ashamed of me. Liliane Kaufmann positively froze the marrow of my bones and made me feel unalterably gauche. Not that I disliked her. It was that she was such a perfection of her type. Another time or two and I'd get over it because I liked her tremendously. It's just that she has that elegant maturity that fills me with despair and makes me think I never will grow up after all. Maybe Dutch is right and you have a female Peter Pan on your hands.[132]

These insecurities plagued her throughout her marriage and beyond. But both Edgar and Liliane Kaufmann became her close friends as well.[133] In the 1940 letter to her brother and his wife, Edith confides

that for their honeymoon; "we're going up to Fallingwater—a Frank Lloyd Wright house in the mountains that belongs to a friend of Luke's. The Kaufmanns use it chiefly for weekends and not a great deal in the winter at all—so they've turned it over completely to us. I don't know whether we'll stay in the big house or one of the guesthouses. I'm hoping for the latter." Edith is probably referring to the guesthouse, completed in 1939, that sits above the main house. It is also possible that she is referring to Kaufmann's original cottage at Bear Run, neatly named the Hangover for its position on the land and as a comment on the partying there.[134]

Their wedding was small. Attending were Swank's friend Franklin Bell, who had been Edith's direct boss at Heinz, Edith's mother, her friend Betty, and Swank's son Harry. They were married on February 5, 1940, by the Reverend Bernard Clausen, the charismatic, unorthodox minister of Pittsburgh's First Baptist Church. Reverend Clausen was a strong advocate of social justice, preached on the radio, and broadcast over KDKA a sunrise service on Easter Sunday 1941, with "the church quartet and organist, with a pump organ," from ten thousand feet above Pittsburgh in a DC3 airplane.[135] He is also the Reverend Dr. C. that Swank refers to in his undated one-act, one paragraph play he wrote in homage to Margaret Bourke-White:

The curtain rising discloses a stage black with darkness. From a small barred window high on the wall comes light faint and cold as winter moonlight on the slabs in a country graveyard. The darkness consumes the light before it can touch anything. All is as quiet as dim deep dungeons in a ruined castle. The light fades from the window. Then a glow yellow and sulfurous as hellfire in a midnight fog flickers and fades. Again all is dark. But into the darkness writhe and crawl creatures visible only by the light they give off—a light soft and phosphorescent as from corpses rotting in tropical jungles. At times one flies upward, bat-like, and disappears. Others come in. Suddenly all stop moving. And then with rat-like squeaks they leave. All is black—silent. Suddenly through the dark there bursts a sound—loud, harsh, colorless, mirthless, grating—the laughter of the Rev. Dr. C.[136]

The play was written after Bourke-White's visit to Swank's Pittsburgh studio sometime after November 1937. Written perhaps as part of a thank you for Bourke-White's gift of one of her photographs and her book with Erskine Caldwell, *You Have Seen Their Faces*, the play can be seen as a metaphor for the quality of light and the working conditions found in the interior of a steel mill—a place intimately familiar to both Swank and Bourke-White.

After their marriage, Luke and Edith lived in his studio at 526 Penn Avenue. The studio became not just the center of Swank's business, but also the center of their lives together. Business and family intertwined in this space. To her brother and sister-in-law, Edith related her concerns about dealing with Swank's staff: "He has a staff which I must inherit with a great deal of tact and discretion—a couple of laboratory assistants, a secretary, receptionist and a housekeeper. Sometimes I wonder what my role will be—but it seems Luke has plenty cut out for me." He wanted her to be his business partner as well as life companion, but he didn't want her to continue her full-time career at Heinz. She goes on to say, "For one thing I may continue writing a few columns. Mr. Bell and Mr. Heinz have both turned down my resignation—and they talk of transferring me to our agency payroll—and let me freelance on my own time."[137]

Subsequent letters demonstrate she took on a significant role in helping manage the business and freelanced extensively for Heinz, often as a writing partner for projects she and Swank jointly developed. This fit neatly into the overall plan they were developing to evolve his business from photography alone to one that would allow him to make pictures and her to write. They wanted to develop projects that allowed them to travel and work together, but first, they needed to take care of the past.

Swank hadn't "bothered to clear up that 1929–'33 mess," Edith wrote, "but now that he had taken a fresh grip on life, he wanted to be free of all those harassing old problems. It was an honorable bankruptcy since the bulk of the indebtedness was simply from signing accommodation notes for his Father at the bank. He had made good his own losses, but his Father not only lost the store, but all his business at the bank too."[138] While his financial problems stemmed from the bank crashes of 1929–1933, Luke didn't file for bankruptcy until July 1940, shortly after his marriage to Edith. The case was discharged in December, enabling him to disencumber his estate from any claims, something he wanted to do to protect his new wife.

Edith's letters indicate that Swank was constantly working long hours and juggling multiple projects. She talks of how they wanted to do several projects that involve her background in art and architectural history and his photography. She enumerates these in a variety of letters. One was to be a book on the people and architecture of the Pennsylvania Dutch region of Pennsylvania. It would have included the Ephrata Cloister in Lancaster County, Pennsylvania, and the Amish whom Swank photographed on trips they took in 1940 and 1941. In correspondence from this period, Edith describes their travels, sometimes done in support of work on the book they did together for Heinz, *The Story of Food Preservation* (figure 1-13), some-

FIGURE 1-13. Old Springhouse, in *The Story of Food Preservation* by Edith Swank, illustrated by Luke Swank (H. J. Heinz, 1943).
Reproduced with permission of the H. J. Heinz Company, L.P.

times for clients such as Frank Lloyd Wright, sometimes for projects for museums such as the Philadelphia Museum of Art, and sometimes for publications such as *Life* magazine. Some of their travels were for her projects; most were for his. In one October 1941 letter Edith wrote, "We have taken a number of quick long trips lately. I do not get very much notice and it keeps me humping to manage. Several weeks ago we made a hurry-up trip to White Sulpher Springs to take some color pictures for *Life*."[139]

The trips that fit most into their hopes for the future were made for projects where he had been commissioned to photograph and she to write. "We have been cleaning up the last of the pictures for my book of which the apple butter picture was the finish. It seems impossible that the book could still be hanging fire, doesn't it? I have had my work done for so many months it makes me feel very detached about it. There were several pictures Luke had yet to get— but either the season was wrong to get them or he did not have time until just recently. Last weekend we went east, into the Dutch country again, where we managed to find the rest that we needed."[140]

By the fall of 1941, Edith was no longer the outsider. She was heavily involved in managing the studio and provides an interesting insight into the problems she encountered. The problems she describes just before the onset of World War II are not that different from those faced by small entrepreneurs today.

We have been having the most changes in our staff here. Jane, whom we thought would be the perfect office girl, decided to marry and leave us. . . . Then two or three weeks ago, Dutch, who has been with Luke ever since he was with the University decided also to leave. He has been offered a job doing color photography with a portrait photog-

rapher in town—with about seventy-five dollars more a month pay than Luke's business can give him. When it came to leaving Luke he nearly broke down and decided to stay—but he has an ambitious young wife who insisted.[141]

Swank didn't want to train a new assistant but wanted to bring his son into the business. Harry had helped out before, but although he was a good enough photographer to be published alongside his father in the 1937 *U.S. Camera Annual*, Harry had wanted to make a life for himself in the circus. He had worked in the circus in the late 1930s, but in 1941 he was living with his young wife in Johnstown. Edith describes the hopes and fears surrounding bringing the independently minded son into the business:

In [Dutch's] place we are taking Harry into the business. . . . It is with some misgivings that Luke is hiring Harry, since he does not know how well the Father-Son relationship will work in business, but he feels he owes Harry a chance at the job, and an opportunity to develop the business. . . . Luke is too busy to break in a stranger. He has a job to offer and Harry needs the job and has the skill so it seemed only the part of fairness and reasonableness to give him a chance at it.[142]

This arrangement didn't last. There are no letters that discuss whether the arrangement ended because Swank and Harry couldn't work together or because war broke out a few months later, changing everything. Harry spent the war in the military. According to one of Swank's obituaries, Harry was a military photographer. His daughter, however, vividly remembers her father complaining that while he was a photographer, the army made him a cook. Regardless of which version is accurate, the fact remains that when the war ended his father was dead, the studio gone. Harry returned to the circus. He remained in touch with Edith, and even introduced her as his mother when she visited with him in 1947. But Harry didn't often speak of his father, according to his daughter, Grace Swank Davis.[143]

The toll the war was taking on the country can be understood from a letter Edith wrote in 1943. It discusses the problems companies like Heinz were having due to the scarcity or lack of critical manufacturing materials and the fears she and Swank had that these shortages would result in a greatly reduced need for their professional services. Her letter also provides insight regarding the success of companies that paid attention to the needs of the war effort, compared to those that didn't. She is hopeful, however, that the newly emerging business combination of writer and photographer pursuing book projects will save them.

Like every other business of this sort Luke's business is in a precarious position. If there ever was a time when I could put my hand to the plow it's now. But I couldn't see that by myself—and Luke would never mention it. Like all luxury businesses we may go by the boards. In our writing and picture taking combination—like this book of ours—we have the thing that will save us. Working together, we can switch our type of work and keep ourselves, and our dependents going.

A number of Luke's clients—like the Ford Motor Truck Company, have, of course, completely closed down. Then—this month—Heinz have been struck below the belt. We have no tin, and cannot manufacture anything packed in tin after March first. Furthermore, everything the government considers a luxury food is also banned. That means about everything Heinz made. No soups, beans, macaroni, spaghetti, or anything like that. We are confined to a few pickles, strained foods, ketchup for as long as our own sugar and spices holdout, apple butter, horseradish, peanut butter and a few things like that.

No one in the company is talking about it yet, and we have not had our last specifications from the government. But for the time being all the advertising has been scrapped. Since Luke was an integral part of the advertising, he, too, may be scrapped.

We have three clients lined up—pending the publishing of our Heinz book—so Luke and I are hopeful. If worst comes to worst, like everyone else, we can trek to Washington. But we would rather not.[144]

Sadly, Edith's hope was misplaced. Swank's health, which had been precarious for years, got worse. He suffered from high blood pressure and from residual problems caused by the poison gas accident in the research facility he worked in during World War I. By Thanksgiving 1943, nine months after Edith's letter, Swank had become an invalid. Less than four months later, in mid-March 1944, he suffered a heart attack, slipped into a coma a few days later, and died at 4:30 a.m. on March 14.[145]

Edith was devastated. She wanted to protect Swank's reputation but didn't know how. So, for a time, she did nothing. By 1946 it was clear to her that she needed to think about the best way to preserve Swank's legacy. She had been contacted by museums interested in all or part of his work. She wanted to preserve his personal work, his photographs of steel mills, the circus, the streets of Pittsburgh, the rural parts of Pennsylvania and the eastern part of the country, as well as his architectural work on Fallingwater and other buildings by Frank Lloyd Wright and H. H. Richardson. She wasn't all that concerned with the purely commercial work. Evidently, she was aware that those pictures, while they had paid the bills, weren't part of his enduring contributions to photography. After being ap-

proached by MoMA regarding the possible donation of Swank's Wright and Richardson prints and negatives, Edith turned to Swank's friend and patron Edgar Kaufmann seeking his wisdom. To Kaufmann she wrote:

I would not wish to overplay the ward role; but in the matter of Luke's photographic affairs I do not feel wholly competent, and so would appreciate some counsel.

For some time it had been my plan ultimately to give the Museum many of Luke's negatives and prints, but they have always seemed rather indifferent; so I concluded perhaps Luke's work was too much a folk art for them, and my intentions cooled with time. It was an ardent, if silent, hope of mine that the Museum might sometime be interested in a show of Luke's work.

My sole interest, you understand, is to act to Luke's best advantage. The Philadelphia Museum, the Carnegie Museum, and the Congressional Library all have also evinced an interest in the ultimate disposition of Luke's negatives. It was with no intention to play hard-to-get that I parried each of their thrusts as they came. It seemed too soon to be unloading, both because my wits weren't collected, and because I had no way of knowing whether Luke's reputation would mature—or otherwise. Perhaps this is one way of helping it happen.[146]

If Kaufmann provided wisdom, it has been lost. Unfortunately, all that has survived is Edith's letter to Kaufmann and her December 1946 reply to Ada Louise Huxtable, assistant to the curator at MoMA whose request a month earlier had prompted Edith to seek Kaufmann's advice.

I have been to considerable pains to keep the non-business negative collection intact, the more so because there are no prints of so many of them. Luke seldom made more than one or two prints of any negative. In many instances, where a collection of shots was involved, as in a building, he would photograph a variety of angles just for the record, yet he might have printed no more than one or two negatives. Of the prints he did make, Luke frequently gave away his only copy to museums or friends who cherished his work. The only negatives that I know of his parting with, however, are some of those used in the Buhl Foundation's "Survey of Architecture in Western Pennsylvania." Many of these he gave to the Carnegie Museum, though not the entire collection.

I do want you to know my attitude is neither recalcitrant nor commercial; my sole concern is to act the very best possible advantage to secure Luke's reputation as an artist. Timing is, I know in cases of this kind, of the utmost importance, as is also the wisest disposition of

such material. I will let you know, therefore, in short order, about the Wright and Richardson collections.[147]

These two letters provide the only clues about her assessment and understanding of Swank's legacy and her intent to protect it. In the end, MoMA didn't receive a major gift from Edith. MoMA's collection is comprised instead of photographs Swank gave to the museum before his death, most likely in connection with the creation of MoMA's Department of Photography in 1940, as well as the photographs of Fallingwater from the 1938 show and a few images of Richardson's Allegheny County Courthouse. Nor did Edith give work to the Library of Congress or the Philadelphia Museum of Art. For reasons of her own, most of Swank's work remained packed in boxes until after her death.

Edith returned to the employ of H. J. Heinz after Swank died. She remained there until 1952, when she remarried and moved from Pittsburgh. One of the last projects she worked on for Heinz was a series of institutional advertisements produced to promote Pittsburgh. These ads appeared in the programs of the Pittsburgh Summer Opera and the Pittsburgh Symphony in 1951 and 1952. They each feature a different photograph of Luke Swank's Pittsburgh and a statement tying each photograph to Pittsburgh's history. In a way this series was Edith's salute and farewell to the man who had meant so much to her.

The reasons why Luke Swank's body of work vanished from view are simple yet complicated. The obvious reason is that Edith held back the work for decades after his death. But there are other more complex reasons. Swank died relatively young in 1944. The photographers who were his contemporaries—Walker Evans, Margaret Bourke-White, Ansel Adams, Henri Cartier-Bresson, Edward Weston—all lived much longer, and their longevity meant they were alive when the market for photography as art slowly began to mature in the late 1950s. Also, to take advantage of an emerging market there has to be a supply of images. Since Edith kept almost all of the known prints off the market, no demand could be created for his work.

Almost all of Swank's known work is held in institutional collections, and only a handful of galleries have any of his work for sale. The small number of his photographs in the marketplace contributes to his diminished visibility over the last sixty years.

While Swank spent the first half of the 1930s working to get his photographs exhibited, most of the final eight or nine years of his life were split between making art and creating industrial, food, and

FIGURE 1-14. Luke Swank. [Street Scene with Steam Train], c. 1935. Heinz/Pittsburgh Landmarks Ad, 1951–1952. Carnegie Library of Pittsburgh. Reproduced with permission of the H. J. Heinz Company, L.P.

other commercial images. During this period he had to make a living and had little time to promote himself as an artist. This may also partly explain why he began to drift out of view after he died.

While Swank produced a large and varied body of work and exhibited in the most important gallery and museum of his time, his visibility was more ephemeral than that of his contemporaries, who managed to keep themselves and their images in front of the public. Swank did not write about his philosophy of photography as Weston and Adams did, nor did he publish books of his photographs as Evans and Bourke-White did. Many of his contemporaries found more consistently visible public venues for their photographs through regular jobs with magazines, and one, Henri Cartier-Bresson was a cofounder of the Magnum Picture Agency. The ephemeral nature of Swank's visibility while alive helps to account for his vanishing visibility after his death.

Ultimately, it is less important to ponder why he, like so many of the subjects he photographed, disappeared from the American scene, and more important to appreciate that although Edith kept his photographs hidden in boxes for decades, she ultimately bequeathed them to the Carnegie Institute.[148] This bequest preserved the legacy of a remarkable photographer and now enables Swank to reclaim his place as one of photography's important early modernists. As his photographs emerge from the storage boxes they were consigned to, he rejoins his distinguished peers including Abbott, Bourke-White, Cartier-Bresson, Cunningham, Evans, Sheeler, and Weston.

2 — STEEL

The view on approaching the mill was of another world—the looming plant sheds, the convoluted tubing of blast furnaces, the trusswork of ore bridges over mounds of reddish ore, the winding roads through hundreds of acres of buildings large and small, metal platforms and stairs, ductwork and railroad tracks, trucks and locomotives, torpedo and thimble and other types of railroad cars. It was a scene of dazzling complexity as arcs and angles, solids and openwork, perpendiculars and bold horizontals intersected and played off one another. Shapes danced along the horizon. Monumental building walls formed solid, imposing planes. Plumes of water vapor rose from rooftops as steam issued into the cold winter air.[1]

Although written in the late 1990s, Laurie Graham's description of a steel mill's otherworldliness must resemble the industrial landscape Swank observed spread out before him in Johnstown seventy years earlier. It describes the industrial pieces, geometry, and abstractions that he visualized so beautifully in his steel mill photographs. This was the machine age, the time between the two world wars when America's growing industrial might was celebrated in art and photography. Swank's personal homage to the machine age is embodied in his abstract sculptural photographs of steel mills. Two other subject categories within Swank's steel mill photographs are men working and the industrial landscape. The industrial landscapes and worker photographs, however, belong less to his fascination with the machine age than to the broader exploration of Americana that his circus, rural, and urban studies represent. They are often brooding images, sometimes dark and menacing, that present a hard reality.

Swank began to photograph Bethlehem Steel in Johnstown around 1927, the year Charles Sheeler photographed Ford's River Rouge Plant and a year before Margaret Bourke-White began her study of Otis Steel in Cleveland. Swank mentioned in a letter to Julien Levy that the mills were his first in-depth study. His study of steel mills began, Swank said, with personal aesthetic "pictorial" exploration rather than commercial intent and continued, off and on and in a variety of locations, until the 1940s.[2] These images encompass pictorialism and modernism, and black-and-white and color as well as glass plate stereography.

Carnegie Library's Swank negative collection includes several images without extant prints that most likely represent Swank's earliest attempts to make industrial landscapes. These images are distant views of the outside of a steel mill.[3] While showing the big picture of steel, they lack the intimacy and comfortable knowledge of the steelmaking process that his later work demonstrates. These views also lack the compositional precision evident in later work. They are made on 3 x 5 inch film rather than the 4 x 5 inch and larger formats used for most of his later work. Another bleak industrial landscape viewed from a distance is shown in figure 2-1; this is Swank's one surviving glass plate stereograph of steel mills: a positive stereograph created for viewing, just as the paper print made from a negative is the form intended to be seen.

As an educated man of means who read widely and made cultural trips to New York, Swank was aware of the work of several well-known photographers of the early part of the twentieth century. When his images, on occasion, bring to mind the work of his contemporaries such as Alfred Stieglitz and Edward Weston, it is because he carefully studied their work. Overtones of other photographers, such as Charles Sheeler, can also be seen, and it is likely that

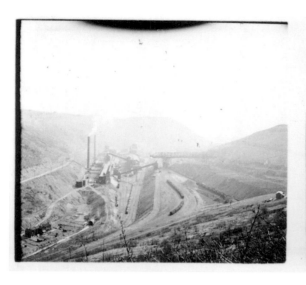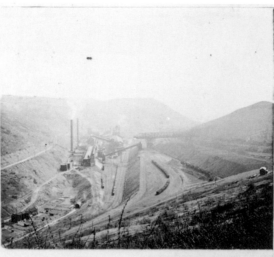

FIGURE 2-1. Luke Swank. [Steel Mill Landscape], c. 1927–1934.
Positive glass plate stereograph, 2⅜" x 5⅛".
Carnegie Library of Pittsburgh; Gift of Edith Swank Long.

he was aware of their work before he began to exhibit with some of them in the 1930s. He commented to Levy that although his photographic education was informal, it involved the "careful analysis of other workers' successes."[4] His informal and mimetic approach to learning photography was like that of many of his peers.

Swank's library tells an even more detailed story. His collection included several issues of Alfred Stieglitz's *Camera Work* beginning in 1904, in addition to many of the publications his own work appeared in. Various pictorialist publications beginning in 1920 are represented, including a *Japan Photographic Annual* and the issue of the *Los Angeles Pictorialist* Swank mentioned in a 1931 letter to Levy. There are also several publications on photographic technique that discuss exposure control, lighting, and color photography. (From the late 1930s, there are books on the history of photography as well as books by Walker Evans and Margaret Bourke-White.) The publications from the 1920s and earlier make it clear that Swank was studying both the images of his time as well as the techniques for mastering his medium. Also in his library is a book from 1920 titled *The Commercial Photographer* that speaks to the business side of photography, an important issue to him by the mid-1930s.[5]

Swank was a great admirer of Stieglitz, whose influence can be seen in some of Swank's images. For example, the Carnegie Library's Swank negative collection contains an image whose composition is strikingly similar to Stieglitz's seminal photograph "The Hand of Man," made in 1902 (figure 2-2). Tucked in the collection of letters, memorabilia, and photographs owned by one of Swank's nieces was a cutout reproduction of Stieglitz's famous image. A comparison of a modern print made from Swank's negative to Stieglitz's "The Hand of Man" makes Swank's comment about learning his craft by

studying the work of others manifestly clear.[6] Both images use the frame in a similar manner and present a sweeping view of railroad tracks within an industrial environment. They clearly differ in that Stieglitz's shows the locomotive centered and a dominant element in the frame, while Swank's shows a locomotive on the left, distant and small. Once these two images are laid side by side, it is hard to imagine that Swank was not consciously emulating Stieglitz's famous photograph when he made his own composition. While "The Hand of Man" has the turn-of-the-century Photo-Secessionist pictorial softness, because Swank's image only exists as a negative it is not known if he interpreted this image in a pictorialist or modern style, or simply regarded it as a learning exercise and never printed it. This comparison demonstrates that he was learning by imitating. He was aware of what he was doing and was developing his artistic persona.

Swank was involved with photographic salons by 1931, suggesting that in addition to learning about the works of photographers from publications he may have had direct knowledge of Pittsburgh photographers Charles K. Archer, Hew Charles Torrance, and F. Ross Altwater, who were working with similar subject matter. As a member of an elite business family, he may have come across Bourke-White's work in early *Fortune* magazines, although this would have been two to three years after he began his own photographic study of steel mills and several years before he met her. In short, it is likely, given Swank's comment about studying the work of others and the contents of his personal library, that he was not only aware of what was being done in pictorial photography but had closely studied the work of photographers whose subject matter had an affinity to his own.

Most of the steel mill photographs in this book date from

FIGURE 2-2. Alfred Stieglitz. The Hand of Man, 1902/print c. 1924–1934.
Gelatin silver print, 3⅝" x 4⁹⁄₁₆". Courtesy of George Eastman House, 74:0052:0084.
© 2004 The Georgia O'Keeffe Foundation/Artists Rights Society (ARS), New York.

30

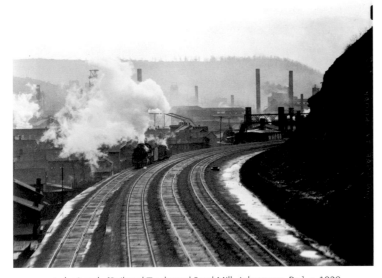

FIGURE 2-3. Luke Swank. [Railroad Tracks and Steel Mill, Johnstown, Pa.], c. 1929.
Modern gelatin silver print. Carnegie Library of Pittsburgh; Gift of Edith Swank Long,
SW1888b.

Swank's early body of work and are a part of his study of Bethlehem
Steel's Franklin Mills in Johnstown.[7] Swank's steel mill photographs
can be divided into two stylistic groups. The first have the visual
characteristics of documentary photographs, that is, they are de-
scriptive of both place and process but lack the connection to words
that provide a context and framework necessary to truly fit into that

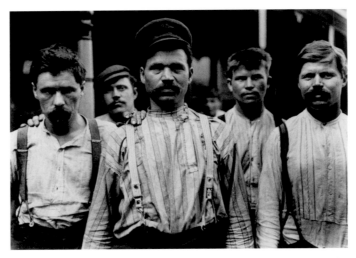

FIGURE 2-4. Lewis Hine. Steelworkers at the Russian Boarding House, Homestead, Pa., 1908.
Gelatin silver print, 4⅝" x 6⁹⁄₁₆". Courtesy of George Eastman House, 77:0187:0069.

genre. The second group is more abstract. These photographs show
Swank's interest in abstracting form from function by creating poetic
interpretations of isolated elements of steelmaking. With these
images, for the most part, only those who know the steelmaking
process understand which piece of that process Swank presents to
the viewer.

Karen Lucic wrote, in *Charles Sheeler and the Cult of the Machine*, that
"[d]uring the years between the world wars, the products of
rationalized industrial production—grandiose factory complexes,
proliferating mass-produced goods, and towering, steel-framed
skyscrapers—seemed to represent modernity in its very essence. The
intense concentration on the manifestations and character of the
machine age approached the dimensions of a cult."[8] Swank came of
age as a photographer in this period; his entire body of work was
framed by the ends of the two wars.

Several years before the First World War, in 1907, Lewis Hine
came to Pittsburgh to work on the Pittsburgh Survey. This project
examined "conditions of life and labor of the wage-earners of the
American steel district" and was published in Paul Kellogg's *Charities
and The Commons* magazine.[9] At that time, Hine was hired to show the
effects of industrialization on people's lives. It would not be until the
1920s that, abandoning his earlier social criticism, he too embraced
the cult of the machine in his "Men at Work" series. In 1907 his
images concentrated on steel mill workers, their families, and their
living conditions, rather than on buildings and industrial processes.
His Pittsburgh photographs represent early examples of photography
used in the aid of social science and social reform. He had shown
how photographers could develop their own point of view: "By

World War I," F. Jack Hurley wrote in *Industry and the Photographic Image*, "Hine had demonstrated that he could use his camera to support a political position. He had learned to select his subjects, to use pose, light and surroundings to emphasize his feelings. What Hine had done, others could learn to do. Photography was no longer confined to the simple recorder role. It could express a point of view. The visual vocabulary that would soon be known as industrial photography had been enriched."[10]

Swank, while sharing humanist values with Hine, produced a body of work much less infused with the political and social agendas that defined Hine's early work. Meaning in Swank's steel mill photographs is not linked to a political dialog like Hine's, but to the descriptive content and formal properties of the images themselves. They were working toward different ends. Swank was making aesthetic statements while Hine was producing documents for the purpose of influencing social policy.

Hew Charles Torrance and Charles K. Archer photographed Pittsburgh and its steel mills in the pictorialist style. Both were active in Pittsburgh as well as other pictorialist salons. Torrance, who was born in Scotland, also often exhibited in the European salons. Their work is soft, romanticized, and dreamlike. Swank's soft pictorial industrial landscapes "Lower Cambria Works" (plate 4), "Blast Furnaces, Lower Cambria Works" (plate 5), and "Spruce Street, Franklin Borough I" (plate 6) share an aesthetic approach with Torrance's and Archer's romanticized industrial reality. In these images, Swank meets his subject head-on from an eye-level perspective that has an almost architecturally correct alignment and directness. Like those of Torrance and Archer, these photographs deal with a contemporary theme in a manner that is reminiscent of an impressionist view of the world—through a filter that allowed for emotion and interpretation rather than precision.

Torrance's 1924 photograph "River View with Barges" (figure 2-5) presents a steel mill on the left with barges filling up the river in the foreground. Soft and romanticized, it has remarkable compositional similarities to Swank's modernist interpretation of a similar scene made sometime in the mid-1930s. Swank's photograph, "River Barges and Steel Mill" (plate 134), in contrast, is clear, hard, and precise. But that is due to Swank's move away from the pictorialism that characterized several of his photographs of Bethlehem Steel's Franklin Mills in Johnstown.

Archer's "Prosperity—A Vision" (figure 2-6) from 1929 portrays three adolescent girls viewed from behind looking out toward a steel mill engulfed in its own haze. The image is a celebration of the prosperity the machine age promised, but in the hindsight of

FIGURE 2-5. Hew Charles Torrance. River View with Barges, 1924. Gelatin silver print, 9⅞" x 13⅜". Carnegie Museum of Art; Gift of the Carnegie Library of Pittsburgh, 83.6.13.

FIGURE 2-6. Charles K. Archer. Prosperity—A Vision, 1929. Bromoil print, 11⅞" x 10⅜". The Photographic Section, Academy of Science and Art of Pittsburgh.

history it stands as an ironic comment on the soon-to-start Depression. Formally staged rather than spontaneous, this pictorialist image emulates painting instead of the pure properties of photography.

Archer's image contrasts with Swank's eerie, melancholy view of building parts, railroad tracks, and broken-up street spaces. Unlike Archer's painterly romantic vision, Swank's "Franklin Borough"

(plate 12) is gritty and portrays the steelmaking environment in an unromanticized way. With its fractured frame presenting bits of geometric forms in silhouette, it stands compositionally between Swank's descriptive industrial landscapes and the tightly composed photographs of abstracted sections of steel mills where Swank unequivocally embraced the cult of the machine. Swank's modernism valued precision and detail: it was direct and sculptural.

F. Ross Altwater was an industrial and commercial photographer credited with the "development of a special 'gold-tone' printing process, the production of large-scale photomurals and the invention of an asbestos-wrapped camera that allowed him to photograph aspects of steel production under climate conditions previously too extreme to be documented in photographs."[11] Altwater began his career almost twenty years before Swank. He photographed the Jones and Laughlin steel mill on the Monongahela River in Pittsburgh at roughly the same time Swank was making his photographs of Bethlehem Steel in Johnstown. Altwater's work achieves a poetic quality akin to Swank's but is largely descriptive rather than interpretive. Even Altwater's "Steel Mill on the Monongahela" (figure 2-7), a night view of the Jones and Laughlin mill with its Eliza Furnaces silhouetted in the foreground, is more purely descriptive than much of Swank's best work. Swank created abstract images that emphasize form, not function.

Swank also made many images that, like Altwater's, present a full view of the industrial environment. Three small photographs of Bethlehem Steel's Franklin Mills in Johnstown (plates 1, 2, and 3) are most likely among his earliest steel mill studies. This conclusion is based upon two factors: the matte, textured paper they are printed on and the style in which they are mounted. Soft, textured paper was a staple of the pictorialists. Even a hard-edged, crisply focused image would take on some of the painterly qualities of handmade art when printed on this type of paper. The quality of handwork was also reinforced by the practice in the pictorial salon movement of mounting photographs on successive layers of art paper. When Swank moved to a more modernist approach, he abandoned this style of photographic presentation in favor of a simpler one. Although small and jewel-like, these three images present a much less romanticized and more highly detailed view of the industrial landscape than do his other pictorialist steel mill photographs.

When Swank was making his soft pictorialist interpretations of the mills, he started with sharp negatives, with great depth and detail. Like many pictorialists, he created the soft-focus effect in the darkroom rather than by using a special soft-focus lens when he exposed his film. His "Lower Cambria Works" (plate 4) presents an

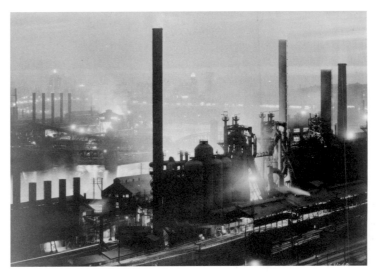

FIGURE 2-7. F. Ross Altwater. Steel Mill on the Monongahela, c. 1931. Gelatin silver print, 7⅞" x 9⅝". Carnegie Museum of Art; Gift of the Carnegie Library of Pittsburgh, 84.41.5.

industrialized environment where the ugliness of that scarred landscape is muted when compared to the sharpness of the negative.

Swank eventually applied a modernist interpretation to some of these early steel mill images, as can be seen by comparing his two versions of "Spruce Street, Franklin Borough" (plates 6 and 7). While these photographs were not made from the same negative, they were created at the same time. Both negatives were sharp; the soft focus seen in "Spruce Street, Franklin Borough I" was the result of the way Swank printed it. In this version, he presents a romanticized view of a street leading down to a hazy steel mill flanked by the homes of steel mill workers. The frames in both versions are almost identical; the vehicles are in the same place. The principal difference in the images is the location of people who were walking around oblivious to the photographer recording their neighborhood. The modernist interpretation, "Spruce Street, Franklin Borough II," lets the viewer see the true gritty, grimy living conditions of the steelworkers.

It is not known exactly what year he reinterpreted this scene, but two factors suggest that it was around 1938. First, a reinterpreted "Spruce Street, Franklin Borough I" was featured as the lead photograph in Beaumont Newhall's article "Luke Swank's Pennsylvania," which appeared in August 1938.[12] A careful examination of the image in U. S. Camera reveals that it is based upon the negative also used to make the soft-focus image. While the cropping of the two images differs a little, the number of people in the street and their positions are identical to "Spruce Street, Franklin Borough I."

FIGURE 2-8. Beaumont Newhall, "Luke Swank's Pennsylvania," *U.S. Camera Magazine* 1.1 (Autumn 1938).
© 1938 Beaumont Newhall; © 2004 The Estate of Beaumont Newhall and Nancy Newhall. Permission to reproduce courtesy of Scheinbaum and Russek Ltd., Santa Fe, N.M.

Second, the modern interpretation, "Spruce Street, Franklin Borough II," is printed on a cool-tone black-and-white gelatin silver paper mounted without the edges of the dry mount tissue framing the photograph. This approach to printing and method for print presentation is modernist and appears more often in prints Swank made after the mid-1930s.

While Swank's body of steel mill images covers the entire manufacturing process, his photographs are an aesthetic encounter between image and viewer, not a sequential descriptive presentation of manufacturing method. According to Thomas Leary, an industrial historian, several of the tightly composed modern images—the ones that present abstracted sections of the mill—required Swank to climb up into various sections of the plant to aim his camera at the places he photographed.[13] Leary's analysis makes clear that Swank's images were not casually made. With the exception of long shots made from outside the confines of the mills, the places he explored and the camera angles he used required special access and the cooperation of people within the company. Images such as "Top of Blast Furnace" (plate 16) and "Hot Blast Stoves and Waste Heat Stack" (plate 18) are examples of perspectives and angles that would have required permission and quite possibly assistance to reach.

Embracing the stark beauty found in industrial components, Swank stripped location out of these abstract images. They celebrate the ingenuity and creativity of American industry. What is within the frame is important. What is outside, Swank has deemed irrelevant. With most, scale has been taken away as well, leaving the viewer to ponder just how large are the sections of these huge industrial machines. Not until confronted with Swank's "Man on Top of Hot

Blast Main" (figure 2-9), in which a tiny human figure is seen from behind, does the staggering magnitude of these industrial objects become clear.

Swank's tightly cropped images with fractured isolated forms are comparable to the photographs of Charles Sheeler and Margaret Bourke-White. Swank and Sheeler exhibited together on several occasions in the early 1930s. By the late 1930s Swank knew Bourke-White on both a personal and professional level, and his work had appeared alongside hers in *Fortune* magazine.

The industrial photographs of Sheeler and Bourke-White share similarities with Swank's sculptural steel mill images. Both may be classified as acolytes of the machine age, but "Sheeler's approach was coolly taxonomic while Bourke-White's was warm and emotional."[14]

Sheeler photographed the Ford Motor Company's River Rouge Plant in 1927 for the N. W. Ayer and Son advertising agency. The goal was to enhance Ford's corporate image.[15] River Rouge was one of American industry's most innovative manufacturing facilities. Here the steel for Ford's vehicles was made, as well as the automobiles that rolled off the assembly lines. From this series of photographs Sheeler created his photo-mural for the 1932 MoMA exhibition Murals by American Painters and Photographers. Sheeler's "Ford Plant, River Rouge, Blast Furnace and Dust Catcher" (figure 2-10), like Swank's photographs that celebrate the machine age, is direct and "taxonomic" but employs a less dramatic use of light than was typical for Swank. Shadows are cast, but they remain relatively soft, unlike in many of Swank's photographs where the shadows are deep, forcing the viewer to intimately examine the nooks and crannies of the shadowed spaces. (See plates 10 through 19.)

In an essay titled "Charles Sheeler: A Radical Modernism," Gilles Mora commented on the River Rouge series: "Because Sheeler had already established his particular style—objective, distant, and rigorously formal—he would be able to apply it to the most varied of subjects: vernacular, architectural, or industrial. But, and this is most important, Sheeler was the first to photograph all these subjects as if they were works of art—positioned between the documentary and the aesthetic, between absolute objectivity and legibility of layout."[16]

History sometimes forces a reevaluation of firsts. In his sculptural steel mill series, Swank was working along similar lines as Sheeler at about the same time Sheeler made his River Rouge images, and he may have been working out problems in content and composition parallel to Sheeler, or perhaps even a little earlier than him. It is also possible that Swank began his series after seeing some

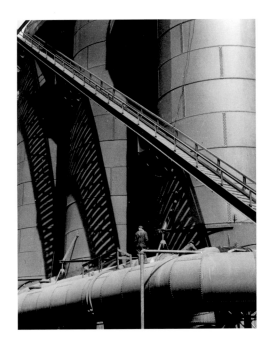

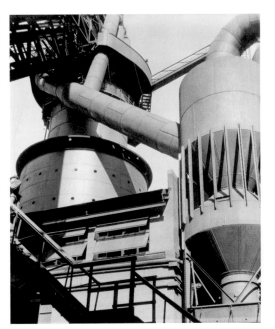

FIGURE 2-9. Luke Swank. [Man on Top of Hot Blast Main], c. 1930. Gelatin silver print, 7½" x 5¾". Carnegie Library of Pittsburgh; Gift of Edith Swank Long,

FIGURE 2-10. Charles Sheeler. Ford Plant, River Rouge, Blast Furnace and Dust Catcher, 1927. Gelatin silver print, 9½" x 7⅜". The Art Institute of Chicago; Julien Levy Collection, Special Photography Acquisition Fund, 1979.113. Reproduction, The Art Institute of Chicago.

of Sheeler's River Rouge work. Given the absence of dates on Swank's photographs, we will never know for certain whether they were made before, in parallel, or in reaction to Sheeler's work.

Bourke-White photographed Ford's River Rouge Plant in 1929 after photographing at Cleveland's Otis Steel in 1928. Like Swank in his earliest work, Bourke-White also made romanticized pictorialist photographs. Just after she began to work with industrial subjects she, like Swank, abandoned the romanticized soft-focus approach for a hard-edged modernism.[17] Bourke-White's "Ford Motor: Blast Furnace" (figure 2-11) used the same blast furnace, or an identical one, that Sheeler had photographed two years earlier at River Rouge. Her framing of the subject is more radical than Sheeler's. The off-kilter frame gives the image both energy and a sense of emotion that is not evident in Sheeler's more straightforward approach but is manifest in images by Swank that use light and shadow to create mystery.

The lighting in Swank's interior steel mill subjects is dramatic. It relies on sunlight filtering in from windows high up in the wall of the mill, or on light from the molten metal itself. With both types of light sources, figures are partially or fully silhouetted and dimensionality is created by sidelight. The most purely descriptive is Swank's "Steel Worker with Foundry Crane" (plate 24);[18] there are enough details that what the worker is doing is clear even to a viewer unfamiliar with the steelmaking process.

At the other end of the spectrum are such photographs as

"Filling Molds with Molten Iron, I and II" (plates 26, 27).[19] The workers in both images are in shadow, making the task performed more mysterious. The dramatic, almost stagelike lighting Swank used in these photographs, as well as in "Interior of Cast House, Molten Pig Iron and Runners" (plate 22) and "Steelworkers with Cupola Furnace in Iron Foundry" (plate 25, the steel mill interior image reproduced in Newhall's article), endows them with a theatrical quality that he further developed in his urban studies. While many of Swank's pictures convey the power and majesty of the worker, his "Steel Worker in Foundry" (plate 28) and "Eating Lunch" (figure 2-12) present a weariness that reflects the hard realities of the steelworker's life. In these studies of workers, Swank presents beautifully illuminated, carefully composed stage sets. He shows his viewers the drama, as well as the fatigue, found in the normal rhythms of work.

Swank's dramatic interiors conjure up images where "a glow yellow and sulfurous as hellfire in a midnight fog"[20] reveals the surreal environment of steel mills. The phrase comes from the one-act play Swank wrote in homage to Margaret Bourke-White sometime in late 1937 or early 1938. It is a perfect metaphor for the eerie light in photographs of steel mill interiors familiar to industrial photographers like Swank and Bourke-White.

The photographs of workers point to a deep understanding of their lives. They reveal the vision of a man who understands the work being performed and the people engaged in the process. He

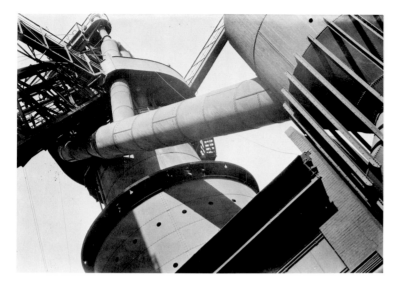

FIGURE 2-11. Margaret Bourke-White. Ford Motor: Blast Furnace, 1929.
Gelatin silver print, 9⅜" x 13⅞". Margaret Bourke-White Collection, Syracuse University
Library, Department of Special Collections. © Estate of Margaret Bourke-White, BW FRD
6646.

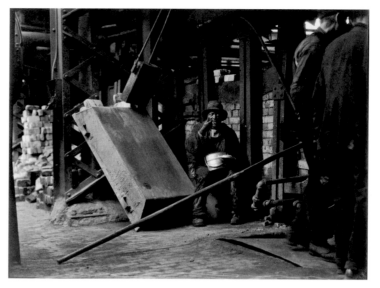

FIGURE 2-12. Luke Swank. [Eating Lunch], c. 1927–1935.
Modern gelatin silver print. Carnegie Library of Pittsburgh; Gift of Edith Swank Long,
SW1881a.

presents them as they are, sometimes bored, sometimes weary, sometimes laboring hard. He neither demeans them nor turns them into heroic figures. As Beaumont Newhall observed in 1938:

[Swank's photographs] are the work of a man who has lived among the mills, and who has learned to separate the characteristic from the spectacular. When he takes his camera inside a foundry, he sees with the eyes of a workman, rather than with those of an outsider. In the picture he produces of the mills, workmen stand about in bored attitudes waiting for the fountain of white-hot metal to subside, so that they can go on with the job, or they are engrossed in their work, oblivious of the cameraman. You are looking at a factory, not a fireworks display. Swank does not see the story of steel merely in terms of production; he has photographed the homes of employees, their shops, and the dreary wastes of mud and slag [that] surround them.[21]

Mystery gives way to description and documentation as Swank moves his camera back to focus on the industrial landscape. In several instances his landscapes fall somewhere between his sculptural close-ups and his broad vistas. In his industrial landscape "Railroad Tracks next to Coke Oven Battery" (plate 21), where the light bounces off the rails, the arch cuts the image in two, and the waste heat stack in the background is heavily shadowed, he also demonstrates that dramatic spaces are not reserved for interior scenes.

As Swank pulls the camera further back, he turns from admiring the stark beauty of industrial engineering to recording social reality. The photographs that incorporate steel mills into urban landscapes are not concerned with the beauty of the steelmaking process. While a number of these photographs were made in Johnstown in the late 1920s and early 1930s, many were made in Pittsburgh and other locations from the mid-1930s on. In these images Swank explored how the life and culture of steel fit within the physical and social environment, an environment that is outside the mill but visually and psychologically attached to it. In "Living by the Mill" (figure 2-13), Swank presents a rare glimpse of men, women, and children, both black and white, outside in the chill of winter in a dreary, run-down, working-class neighborhood in front of a mill. His photograph "Two Boys Overlooking Steel Mill" (figure 2-14) presents a distant view of the mill from the perspective of children who presumably in a few years will take their place alongside their fathers, uncles, and older brothers.

"River Barges and Steel Mill" (plate 134) and "Automobiles, Cobblestone Street, and Steel Mill" (plate 135) each illustrate in their own way that steel totally dominates the landscape. These images also lack the direct frontal perspective that the majority of Swank's steel images have. This shift in perspective makes the views Swank presented in these urban landscapes less intimate.

Swank, like Bourke-White, photographed the steel industry for *Fortune* magazine. In 1936, their photographs shared a two-page spread in the last part of a multi-issue examination of the U. S. Steel

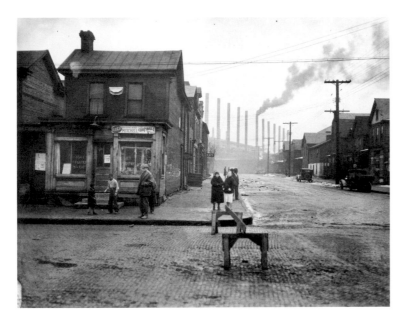

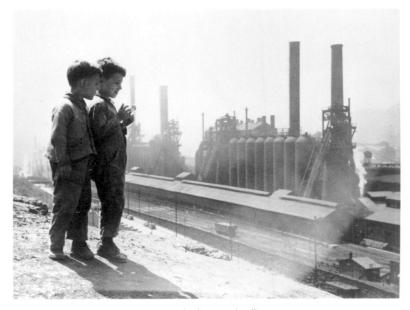

FIGURE 2-13. Luke Swank. [Living by the Mill], c. 1927–1935.
Modern gelatin silver print. Carnegie Library of Pittsburgh; Gift of Edith Swank Long,
SW2029.

FIGURE 2-14. Luke Swank. [Two Boys Overlooking Steel Mill], c. 1927–1935.
Gelatin silver print, 5¹⁵⁄₁₆" x 7⅞". Carnegie Library of Pittsburgh; Gift of Edith Swank Long,
SW40.

Corporation. Bourke-White's photograph featured a trainload of ore leaving the Great Hull-Rust open-pit mine. Swank's was an urban industrial landscape captioned "Along the Monongahela, outside Pittsburgh, march the corporation's towns."[22] Swank presents a view of workers' houses, seen from high on a hill overlooking Homestead next to Pittsburgh. The omnipresent mill is in the background. While this photograph was included in an article on steel, the image is also an urban study. Swank's urban scenes, as I will discuss in a later chapter, shift from the monumental to recording little moments. They move from the specificity of an identifiable place to the universality of recognizable and shared experience. Swank's humanistic touch ties many of the steel images to his views of urban life.

Swank's few color transparencies, made in the early 1940s, circle back to his early descriptive views of the industrial landscape. They describe place, scope, and scale, but unlike his earlier, more tightly and dramatically composed images, they don't reveal the mystery, magic, or sculptural beauty of the engineering marvel that was the steel mill of machine age America.[23] His color, while

technically competent, lacks the heightened drama and finely honed aesthetic sensibility apparent in his black-and-white photographs. The color images are important because they are examples of early modern color industrial photography; all were made within the first few years after the introduction of Kodachrome sheet film in 1938.[24]

Swank saw steel mills in a multidimensional way. His studies of steelworkers stand in contrast to the photographs treating parts of steel mills as sculpture. His sculptural photographs reflect the prevalent cultural fascination with modernity that also was exemplified in the industrial photographs of Sheeler and Bourke-White. However, much of the rest of his work is antithetical to a cult of the machine; it is concerned not with new attitudes toward the machine and new ways of depicting it but with what is passing in America. These subjects include the circus; historic rural architecture; and old, decaying urban environments, as well as steelworkers. Swank's abstract steel mill photographs, along with a small group of other abstract images,[25] stand as a magnificent anomaly within his larger body of work.

3 — Circus

The circus was more than just a subject for Swank; it was a family fascination that turned into an obsession for his son, Harry. Swank's father instilled his love for the circus in Swank as well as in his grandson. John Walters, a childhood friend of the young Harry, remembers that grandfather and grandson would go at sunrise to see the circus trains being unloaded.[1] While Walters doesn't remember whether Swank accompanied them, it is easy to imagine that the grandfather took charge of the grandson, enabling Swank to pursue his photographic explorations of the circus unencumbered by an excited, inquisitive child. In the mid-1930s, Harry also photographed the circus while he accompanied his father; his pictures were good enough to be included alongside Swank's in the 1937 *U.S. Camera Annual* (figure 3-1).[2]

Newspaper accounts from 1935 indicate that Swank allowed his sixteen-year-old son to join the circus.[3] Although Harry returned home after one season, the circus was much more than an adolescent flirtation; the circus became his home on and off for most of the rest of his life. When he returned to the circus in 1938, he worked as a sideshow doorman for the Barnett Brothers Circus, and in 1939 he became their front door superintendent and press agent.[4] By 1947, Harry was a part owner of his own circus, according to a letter written by Edith Swank.[5]

Swank's circus photographs are varied in style as well as subject matter and range from abstract to documentary. Swank presents the circus from behind the scenes: the animals coming off the train cars; roustabouts ably assisted by elephants helping raise the circus tents; abstract details of the tents; performers standing and sitting around outside, some chatting while waiting for their acts to begin or relaxing after finishing (plate 35); and quiet moments that allow a roustabout to nap on top of bales of hay while a dog rests obediently on the ground (plate 36). His photographs of clowns include several, such as Emmett Kelly and Otto Griebling, whose names are still known more than seventy years later (plates 41, 42, 43, 44, and 46), as well as images of others whose faces he immortalized although their identities have been lost to time (plates 48, 49, and 50).

Just as the identity of many of his subjects has been forgotten, so has the circus life Swank explored through his photography. Rooted in the European circuses of the late eighteenth century, the earliest American circuses were initially presented in one ring in a permanent building.[6] As the American circus developed, it became itinerant and moved from city to city, town to town, and village to village carrying its own tent—the Big Top—first by steamboats and wagons and later by railroad.

As more and more of the country was explored, the circus continually expanded into virgin territory. Shortly after the first settlers claimed new ground, the circus followed to provide entertainment. Circus expansion increased after the country was linked with a transcontinental rail line on May 10, 1869. In fact, less than three weeks later on May 27th, the Dan Castello Circus was the first to use the rails to reach the rich mining areas of the West.[7] The golden age of the American circus began around 1871, the year the sixty-one-year-old P. T. Barnum, originally known for his museums and hoaxes, was persuaded to go into the circus business. It lasted until at least 1905 according to some circus scholars, and to as late as 1918 according to others. Its decline began, in part, because of the vanishing of the American frontier.[8]

In the 1920s, during the second decade of the long decline of

FIGURE 3-1. Luke Swank and Harry R. Swank. Two-page spread from *U.S. Camera Annual 1937*, edited by T. J. Maloney (New York: William Morrow & Company), 84–85.

the American circus, Swank began to photograph circuses that came to Johnstown and other parts of western Pennsylvania. He photographed at least four circuses, three of which traveled by rail.[9] The colossal Ringling Brothers and Barnum and Bailey Circus used ninety railroad cars, while the smaller Sells-Floto Circus and Hagenbeck-Wallace Circus each used around thirty. The much smaller Downie Brothers Circus traveled by truck.[10]

Before radio and film, entertainment was direct, not mediated like it is today. The circus coming to town for its yearly visit, especially in small towns like Johnstown, was a big event.[11] Families came to see the animals, including elephants, lions, and camels, unloaded from the train. In the nineteenth century and the first several years of the twentieth century, people lined the streets to see the circus parade. By the 1920s fewer and fewer circuses continued this tradition.

As the 1920s moved into the 1930s and radio and film increased their penetration into American culture, the circus remained popular. It faced, however, a variety of pressures including economic and competitive ones brought on by the Depression, changing demographics and transportation systems, and competition from the new entertainment forms. Between 1929 and 1933 railroad circuses shrank from thirteen to three, and trains gave way to trucks.[12] Some circuses simply disappeared, while others were gobbled up by their competitors. For the survivors, the Big Top slowly moved back to the indoor arena, especially in big cities, bringing the circus full circle. In 1929 both Sells-Floto and Hagenbeck-Wallace were bought from the American Circus Corporation by Ringling Brothers and Barnum

and Bailey, which continued to tour them for a time, but eventually closed them down.[13] The circus, therefore, was part of the vanishing America that Swank found endlessly fascinating and was the subject of one of his earliest studies on this theme.[14]

Swank's circus series began in the period 1919 to 1924.[15] This predates his steel mill studies by several years and demonstrates that he was seriously working in photography five to ten years earlier than previously thought. At least one surviving photograph Swank made of the Ringling Brothers and Barnum and Bailey Circus could not have been made after 1924, according to circus historians who studied Swank's "To the Big Show" (plate 29). Both Fred Dahlinger Jr., former director of historic resources and facilities at the Circus World Museum in Baraboo, Wisconsin, and Robert MacDougall, a self-described circus historian and for twenty-five years the general manager of the Ringling Brothers and Barnum and Bailey Circus, concluded that the circus used the marquee in this photograph only between 1919 and 1924.[16] In addition, if the hill seen in the top left is in Johnstown, then the photograph was made between 1919, the first year the combined name of the Ringling Brothers and Barnum and Bailey Circus was used, and 1921, when the circus last visited there. It is also possible that the photograph was made in Pittsburgh in 1923 or 1924 or in some other town the circus visited in western Pennsylvania during this five-year period.[17] Johnstown, however, remains the most likely location because most of Swank's early work was made close to home, during his days off or when he could steal an hour or two from his workday.

Swank's "To the Big Show" reveals the canvas for the Big Top spread on the ground with other tents, including the cookhouse to the right, already erected. A group of workers on the right side of the image is pounding stakes into the ground for the Big Top.[18] Behind these workers are several people, some blurred as they move through the space, others standing and chatting or seated near one of the circus wagons. The light level was relatively low and Swank's film relatively slow, yet he retained sharpness and depth even though movement blurred some elements. Because the image is printed on a smooth, glossy, gelatin silver paper rather than on the flat, matte-surface papers used in his pictorialist photographs, "To the Big Show" demonstrates that as Swank was exploring pictorialism in his 1920s figurative and steel mill images, he already was flirting with modernist ideas in his circus studies.

At once exotic and mysterious, the circus was extensively depicted during the 1920s, 1930s, and 1940s by both painters and photographers. The reputations of some photographers, for example, Edward Weston, have grown over the decades to mythic proportions.

Others, like Edward J. Kelty and Kenneth Heilbron, are largely forgotten, experiencing an artistic fate similar to Swank's.

While most of Swank's and Weston's work is dissimilar, the circus is one place they intersect. Swank's abstract circus work reflects the influence of Weston, and he commented in a 1934 letter to the photographer Willard Van Dyke that he owed his understanding of the portrayal of texture to Weston.[19] Weston, in 1924, pointed his camera upward to create his formal abstract "Circus Tent" (figure 3-2). Weston obliterated the function of the tent through the use of a relatively narrow field of view. He let the light filter through the tent canvas, revealing its texture and skeletal structure. This same sensibility can be seen in Swank's "Circus Tent II" (plate 53), one of a small group of his circus images where formally composed abstraction was his primary concern. To create "Circus Tent II" Swank, like Weston, pointed the camera up. The light filtered through the canvas to reveal differing textures and densities. Unlike Weston's image, Swank's has more depth; the space has not been flattened, and the inclusion of two poles reveals structural supports.

Some photographers, like Swank, waited for the circus to come to them. Others followed it, not thinking of the circus as material for artistic or documentary subject matter but using it for more utilitarian commercial gain. Edward J. Kelty, a banquet photographer who photographed countless retirement parties, made a reputation and a business for himself by following the circus. He photographed many of the same circuses as Swank, but his pictures are different. Kelty is best described as an official group portrait photographer. Some of Kelty's photographs were made with an enormous view camera that enabled him to include hundreds of circus performers and other personnel in a single frame.[20] In many of Kelty's photographs, including his 1931 Hagenbeck-Wallace photograph shown here (figure 3-3), the individuals are arranged in neat rows; they sit or stand properly and look directly at the photographer. While Swank made only a few group shots and none that included hundreds of people, both his "Nineteen Clowns" (plate 47) and "Group of Clowns with Umbrella" (plate 45) are less formal and more spontaneous than Kelty's groups. The clowns, although posed together, are allowed to express themselves as individuals; the expressiveness Swank captured in their faces and body language resulted in dynamic, charming, and compelling group portraits of the 1930 Sells-Floto clown alley.[21]

Kenneth Heilbron, a commercial and fashion photographer from Chicago, had much in common with Swank.[22] Both men studied the behind-the-scenes aspects of circus life and Heilbron, like Swank, was a pioneering photographic educator. In 1938 he

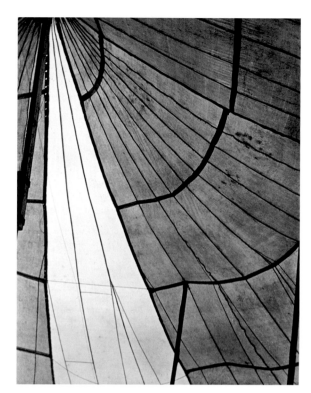

FIGURE 3-2. Edward Weston. Circus Tent, 1924. Gelatin silver print, 9¼" x 7". Center for Creative Photography, University of Arizona, Tucson, 81:120:004. ©1981 Center for Creative Photography, Arizona Board of Regents.

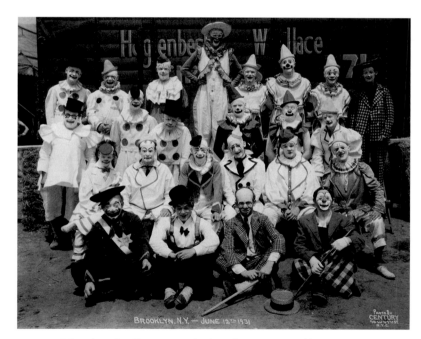

FIGURE 3-3. Edward J. Kelty. Clowns, Hagenbeck-Wallace Circus, Brooklyn, N.Y., June 12, 1931.
Gelatin silver print, 10" x 13". Courtesy of E. J. Kelty's sons and the Alan Siegel Collection, New York. Permission from Ringling Bros. and Barnum & Bailey, The Greatest Show on Earth.

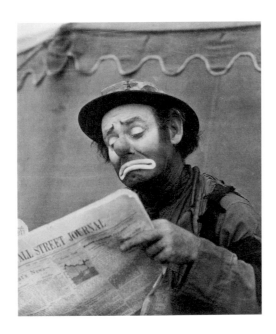

FIGURE 3-4. Kenneth Heilbron. Untitled [Emmett Kelly], c. 1930–1949. Gelatin silver print, 16" x 13½". The Art Institute of Chicago; Estate of Kenneth and Edna Heilbron, 2000.216. Reproduction, The Art Institute of Chicago.

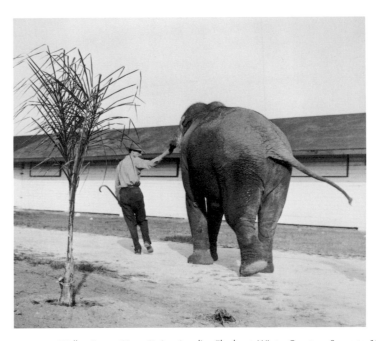

FIGURE 3-5. Walker Evans. Circus Trainer Leading Elephant, Winter Quarters, Sarasota, 1941. Gelatin silver print, 6⁹⁄₁₆" x 7½". The J. Paul Getty Museum, Los Angeles 84.XM.956.941. © The J. Paul Getty Museum.

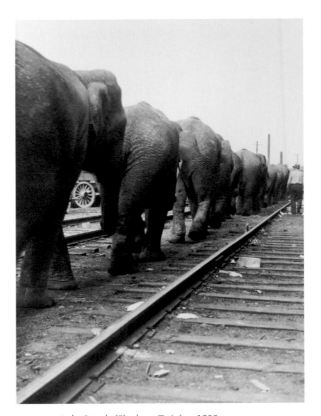

FIGURE 3-6. Luke Swank. [Elephant Train], c. 1933. Gelatin silver print, 5¹³⁄₁₆" x 4¼". Carnegie Museum of Art, Pittsburgh; Gift of Edith Swank Long by transfer from the Pennsylvania Department, Carnegie Library of Pittsburgh, 83.40.18.

became the first teacher of photography at the School of the Art Institute of Chicago.²³ Heilbron and Swank also sometimes focused on the same subject matter. Heilbron made a photograph of the clown Emmett Kelly reading the *Wall Street Journal* (figure 3-4); Swank presented his "Clown Reading a Newspaper" (plate 34) in a more complete environment. Heilbron's portrait of Kelly, while nicely composed, looks staged for the camera. It lacks the spontaneous quality Swank captured in his "Clown Reading a Newspaper," shot in the "backyard" at the Hagenbeck-Wallace Circus.²⁴ This photograph, perhaps better than any other, demonstrates that in his circus work Swank is a master at describing the normalcy of an abnormal lifestyle.

Walker Evans photographed circus life after Swank had moved on to other subjects. In 1941 he produced a series on the Sarasota, Florida, winter quarters of the Ringing Brothers and Barnum and Bailey Circus. Evans's "Circus Trainer Leading Elephant, Winter Quarters, Sarasota" (figure 3-5) is reminiscent of many of Swank's elephant photographs, including his "Elephant Train" (figure 3-6). While Evans presents a single elephant, Swank presents a line of female Asiatic elephants on their walk from the railroad siding to the show grounds. Both Swank and Evans also photographed the circus poster. Evans's photographs are tight; portions of the poster filling the entire picture frame. His "Torn Ringling Brothers Poster" focuses on the transitory nature of the circus (figure 3-7). Swank took a different approach by presenting the circus as an event to come.

Weeks before the circus arrived, advance men put up large posters advertising the big event. Swank used this subject in his

FIGURE 3-7. Walker Evans. Torn Ringling Brothers Poster, 1941.
Gelatin silver print, 6½" x 8⅛". The J. Paul Getty Museum, Los Angeles, 84.XM.956.914.
© The J. Paul Getty Museum.

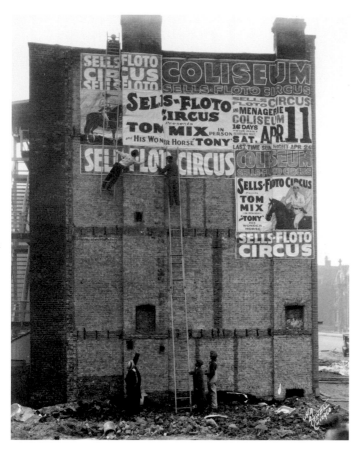

FIGURE 3-8. Harry Atwell. Sells-Floto Circus Posters, 1931.
Gelatin silver print, 9½" x 7⅝". Courtesy of Circus World Museum, Baraboo, Wisconsin,
with permission from Ringling Bros. and Barnum & Bailey, The Greatest Show on Earth.
SF-N81-31-3-N.

"Hagenbeck-Wallace Circus Poster" made in 1933 (plate 30).[25] Swank presents a formal composition, exploring light and shadow, shape, and texture. The tightness of the composition has eliminated most clues regarding the size of the building. The man is on a ladder that at first glance appears to be floating, neither anchored to the ground nor attached from above. The man has one leg on a rung while his other is placed over and behind another rung—an unusual position for someone standing on a ladder anchored to the ground. At the top of the image, just barely discernable, is the suspension mechanism from which the ladder hangs. Swank's photograph presents a visual puzzle to a modern audience unfamiliar with the way posters were attached to buildings nearly seventy-five years ago. This process, however, is seen in the long shot by Harry Atwell[26] of workmen putting up the poster announcing the 1931 season opening at the Chicago Coliseum of the Sells-Floto Circus with Tom Mix (figure 3-8).[27] The difference in the body language between a man on a ladder anchored to the ground and one suspended from a roof is evident. This image provides a descriptive explanation of a process, while Swank's photograph presents a more complex interplay between description and expression.

Swank almost always explored what happened outside the Big Top. The closest he gets to revealing what goes on inside is his photograph of a circus vendor, all in white, shot from behind as the man watches a performance that Swank's camera angle prevents his viewers from observing.[28] Even with the camera inside the tent, the actual performance remains unseen—a mystery.

Swank liked clowns; he photographed them more often than any other performers. His full-length portrait "Paul Jerome, Clown" (plate 43), shows Jerome, who performed for many years with the Ringling Brothers and Barnum and Bailey Circus, in his trademark flashing red nose and wide white collar.[29] He is standing, cane in hand, with the side of a canvas tent as backdrop. Looking directly at Swank, Jerome is presented formally and elegantly, belying the fact that he is a clown. It is not his clown persona that comes through, but his confidence and dignity as a human being that is communicated. With this portrait, Swank reminds us of the power that a straightforward, compositionally simple image can have when the photographer responds brilliantly to the body language presented by his subject.

Two of the best-known clowns Swank photographed were Otto Griebling and Emmett Kelly, neither of whom started out as clowns. Griebling was born in Germany. Before becoming a full-time clown, he was a bareback rider with the Albert Hodgini Riding Act and later with the Sells-Floto Circus as part of the Novellis Riding Troupe.[30]

41

The photograph "Otto Griebling on Horseback" (plate 41) was made when he was with the Sells-Floto Circus, according to a notation in the Carnegie Library records. Since Sells-Floto visited Johnstown in both 1929 and 1930, it would seem that this photograph was made in one of those two years, just as Griebling was beginning his career as a clown.[31]

Kelly began as a trapeze artist, performing in an act with his first wife Eva for a few years. In 1932, the Hagenbeck-Wallace Circus cancelled his trapeze act and Kelly turned full-time to clowning.[32] Between 1932 and 1934, both Kelly and Griebling worked for the Hagenbeck-Wallace Circus.[33] By 1933, Kelly had invented his famous Weary Willie character. He can be seen in Swank's photographs wearing Willie's trademark hat, which Kelly found in a used costume shop in New York City and wore over the next forty-plus years.[34] On June 1, 1933, the circus visited Johnstown, marking that date as the most likely day Swank made his photographs, "Emmett Kelly and Otto Griebling" and "Boss and Porter" (plates 46 and 42).[35]

Swank also produced a small group of portraits of clowns in whiteface, which may be seen as a series of masks (plates 48, 49, and 50). The faces, tightly framed, are isolated from their environment. Without names, the identity of the person behind the mask is gone. The power of these portraits lies in the expressiveness created through the clowns' makeup and the subtlety of plastic expressions of the faces and penetrating eyes caught with sensitivity by Swank. His circus portraits possess a grace and a lyricism that moves them beyond the documentary genre and into a contemplative psychological space that charms, frightens, and humors the viewer. The portraits keep pulling the viewer in closer and closer until the soul of the clown, but not the person behind the mask, is revealed.

The intimate quality present in many of Swank's circus photographs could not have been accomplished without the cooperation of his subjects. Swank's photographs "Arthur Borella Trio" (plate 51),[36] a tight formal composition of clowns in front of a circus wagon; "Juggler," with head up, knees bent, ball in mid-air (plate 39); and "Snake Charmer," bare-chested, with one snake draped around his neck and a second held above his turbaned head (plate 40), are all examples of photographer and subject directly interacting to collectively create compelling images.

Curiously, only one circus photograph in the Carnegie Museum and Library collections, "Otto Griebling on Horseback," had any name attached to it. Given both the intimate and cooperative nature of these portraits, it is hard to believe that Swank wasn't aware of the identity of his subjects, yet the lack of any identification fits with Swank's stated preference that the image be unencumbered by

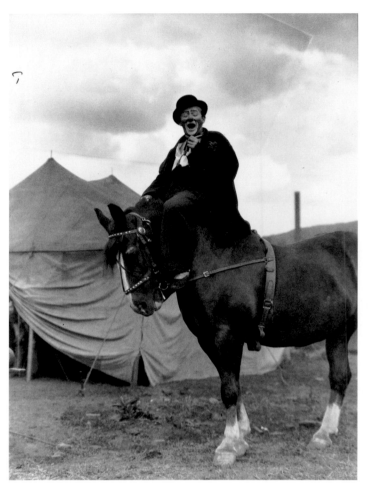

FIGURE 3-9. Luke Swank. [Otto Griebling on Horseback], c. 1929–1930. Full-frame modern gelatin silver print from negative. Carnegie Library of Pittsburgh; Gift of Edith Swank Long, C-247.

words. Swank's decision to keep his circus work without titles, dates, and locations leaves to the viewer the creation of a context. His decision may be seen as a nod to the belief that everything the viewer needs to know is contained within the image. While this may be true for a certain type of aesthetic interaction, it creates problems for understanding the historical context in which his work exists. The more time that passes, the more his photographs float unanchored in time.

When Swank rejected the pictorialist soft-focus approach, he rejected the modification of photographs through handwork in favor of celebrating the clarity of the image achieved through the use of modern equipment, film, and printing paper.[37] Many of his modernist contemporaries went further and believed that an image failed if the recorded composition needed any cropping, a position also ascribed to Swank.[38] A careful examination of Swank's work, how-

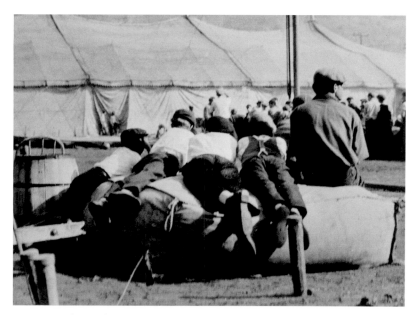

FIGURE 3-10. Luke Swank. [Four Boys and a Man], c. 1930–1936.
Gelatin silver print, 4½" x 6⅛". Carnegie Library of Pittsburgh; Gift of Edith Swank Long,
SWC306B.

ever, demonstrates that he was not a dogmatic purist. While he attempted to tightly compose his images in the camera—and for the most part succeeded in creating compositions that he did not crop at all—many exceptions cut across most of the subjects he photographed. An examination of the negatives for many of his circus series reveals that he regularly cropped these images.[39] Comparing Swank's negatives to the prints of the tight portraits of clowns reveals evidence of cropping as well as burning in the backgrounds.[40]

Perhaps the most dramatic example of cropping in all of Swank's work can be seen in comparing the printed version of Griebling, the equestrian clown (plate 41), with a modern print made from the full negative Swank used to make his print (figure 3-9). Swank has come in tightly in the finished image, selecting just the center portion of the negative, stripping away most of the horse and sky, a portion of the tent, and all of the ground. The body language of both horse and rider is identical, making it clear that the much tighter image comes from the same negative. The tight vintage print presents a composition that Swank, in this case, saw only partially when he viewed Griebling through the ground glass of his camera.

The portrait "Bumpsy Anthony, Clown" (plate 44) is more mysterious than others, partly because Anthony appears to be dissolving into the background and partly because of the strange angle in which he bends his neck. Bumpsy Anthony was the stage

name of George Anthony Hulme, who earned his nickname when he was a three-dollar-a-week acrobat with the ability to absorb hard bumps.[41] The manner in which Anthony presents himself to Swank's camera, however uncomfortable it looks, was not something Swank and Anthony invented just for this picture; it was Anthony's trademark body language. He is also shown as one of the clowns in Swank's "Group of Clowns with Umbrella" (plate 45) and the craning of the neck, while not as pronounced as in the portrait, is evident here. Photographs of this well-known clown by other photographers of the time, such as Harry Atwell, also show Anthony's strange and quizzical manner of presenting himself to his public.[42] Anthony was with Sells-Floto in both 1930 and 1932 when Sells-Floto visited Johnstown, so the photograph was most likely made in one of those years.

Swank presents a circus that was seldom seen by the average person. He made formal studies of the Big Top, transforming it into tactile, sculptural form. "Circus Tent I" (plate 52) presents the undulating exterior of the Big Top. This view relies on the whiteness of the sky and deep shadows to provide contrast to the midtones of the canvas. This abstract image is comprised of massed forms, unlike the ethereal, almost spiderlike "Circus Tent II" (plate 53).

Swank documented the erection of a circus's transitory structures and found a formal beauty in the relationship of worker to task. "Canvasmen, Hagenbeck-Wallace Circus" (plate 31), "Roustabout with Circus Poles" (plate 32), and "Three Workers with Ropes and Tents" (plate 33) take the chaos of this immense task and the confusion of a jumble of poles, ropes, canvas, and people and order them into simple, elegant, formal presentations with a lyrical beauty that Swank froze for all time.

In focusing on exterior spaces, he captured moments that most people would not notice. The "Balloon Vendor" (plate 37) hawking his Mickey Mouse balloons with a sideshow sign in the background advertising Major Mite, the world's smallest man at twenty-six inches and twenty pounds, is one example. "Four Boys and a Man" (figure 3-10) shows four boys flopped on their bellies on top of a straw-filled canvas-covered cushion with a man seated on it, all of them intently gazing at something outside the frame. This image, like so many of Swank's circus photographs, reveals the rhythms of the life lived by the circus performers and laborers. It is in these details, formally composed and expertly seen, that Swank presents the tender, confident, humble, joyous aspects of the circus. Luke Swank's circus photographs are not about freaks and misfits but about people and their disappearing lifestyle, lovingly observed.

43

4 — People

People inhabit a large percentage of Luke Swank's photographs. In most, they are an integral part of the composition but not the primary subject. They are figures within the picture frame, elements critical to the story, but not the story itself. The photographs presented here are an exception, because the people are the story. In all but one of these pictures, the subjects were once easily identifiable. With the exception of the photographs of Grace and Edith, their identities are now lost. Though small in number, Swank's portraits present a diverse view of America. They include the Amish, migrant workers, grieving mothers, and African Americans presented alone as well as integrated with whites.

A portrait is a transaction between subject and photographer—a collaboration that gives the photographer permission to look beyond the surface, to reveal the inner self of the sitter through the mediating eyes of the photographer. Portraits are often both formal and formulaic. Swank's are neither. He hated to make formal portraits but clearly took pleasure in less formal approaches to photographing people. Edith maintained that Swank's distaste for making portraits was so strong that when cornered, he charged much higher fees in hope of escaping the task[1]—an attitude that explains why there are few portraits in his entire body of work.

The personalities of the best portrait photographers are as evident in their images as their subjects' personalities. Richard Avedon, one of the twentieth century's most influential portrait photographers, imposed himself over his sitters. His style is instantly recognizable. As readers flipped through a *New Yorker* magazine, Avedon's frequent contributions leaped off the page. Strong, sparse, and unadorned, Avedon's portraits are at least as much about his view of what a portrait should be as they are about the subjects he so skillfully revealed.

Swank's photographs of people have an entirely different character. They are quiet while Avedon's are loud. Although they are posed and required tacit, if not active, cooperation between photographer and subject, they are loose, natural, and real. While some are dramatic, others are as humble as the modest, unassuming people before his lens. Swank's portraits are transactions between equals. In this they represent a humanistic vision.

Swank made his studies of the Amish and Mennonites of Lancaster County, Pennsylvania, in 1940. The series was comprised largely of images of their land, architecture, one-room schools, buggies, and children.[2] The only photograph that includes an adult is "E. S. Renninger Hardware" (plate 80). In this image, made in New Holland, a woman is seen from behind, and Swank's distance from her suggests that she may not have known she was being photographed.

The act of photographing the Amish and Mennonites presented logistical and ethical problems. Edith, in a letter written to her brother in September 1940, recognized that it would be difficult for Swank to photograph a group of people whose religious views disapproved of photography and whose values remained wedded to a preindustrial lifestyle. "Today we are starting off on a quick trip to Lancaster and Philadelphia. We want to be in Lancaster tonight so we can attend the Amish farmer's market there tomorrow. The Amish and Mennonites are very hard to photograph because they have religious objections to a camera. We are both very interested in the Pennsylvania Dutch and would like to do a book on them sometime.

I had a very rare talk with about 20 little Amish girls one noontime when we stopped by their one-room schoolhouse. It is the basis for a grand article I would like to try my hand on when I'm through with my book."[3]

The schoolgirls Edith refers to became part of Swank's School House series made in the schoolyard of a one-room Amish school with a young Mennonite teacher.[4] "Amish School Girls" (plate 62) shows many of the girls sitting on the schoolyard fence. Some of the girls are oblivious to Swank's camera, some look away, and two provide direct eye contact. It is this casual mix of the natural interaction of the girls combined with the acknowledgment by a few of Swank's presence that makes this an engaging image.

Millen Brand wrote about the Amish schools of Lancaster County almost thirty years after Swank made his photographs. The Amish are not a group to embrace change readily, and what Brand wrote in the 1960s could just as well have been written in the 1930s or 1940s. "The country near New Holland is filled with Amish one-room schools. . . . Each Amish school has a bell and is surrounded by a rail-fence yard, complete with boys' and girls' outhouses. Inside the school are usually eight rows of benches, enough to give each primary grade a row of its own. Teachers are often non-Amish and may be much loved. They may be considered lucky to be loved by the faces one sees in Amish schools. The children go out at lunch time, in good weather, eat their lunches in no time, and play games, or full of body vitality, run just for running's sake."[5]

"Amish Boys with Watermelon" (plate 61) shows a young boy enjoying his watermelon who seems oblivious to Swank's presence but most likely was not. He is seated in front of six boys who are standing and barefoot. They are looking directly at Swank; some seem to enjoy themselves while others, particularly the one without a hat, looks miserable and angry. The way Swank arranged the boys in the frame, combined with the mix of emotions presented subtly through the children's body language, bring this picture to life.

"Amish Boys Nibbling Grapes" (plate 60) shows the "characteristic Dutch bob hair, broad brimmed hats [and] galluses on trousers," Edith wrote on the card that belongs with this image.[6] This formal composition retains a bit of informality because of the body language of the two boys. The smaller one, in the straw hat and wire rim spectacles, is fully engaged in enjoying his grapes, while the older one in the black broad-brimmed hat looks down, disapproval on his face. Perhaps he, like many of the other children, was not happy to be photographed by this outsider who, no matter how well motivated, was violating one of the tenets of this young man's faith.

Outsiders who decide that their value system makes it permissible to violate the belief system of another culture engage in a classic form of cultural exploitation. Swank did not invent this problem; it has been an issue ever since photographers began to make social and cultural records in the mid-1800s. Of course, because Swank violated the belief system of his subjects, we have a set of images today that document the Amish culture more than sixty years ago. Perhaps as time passes, and it becomes increasingly difficult for the Amish to sustain their traditional ways, Swank's cultural transgression will be forgiven because, ultimately, he visually preserved a way of life for generations of the future to see and understand.

This social criticism of Swank could be applied to countless other photographers. It is a conundrum: Swank without question made these images because he believed in their importance. And the issue of social exploitation does not lessen the sensitivity or the insight that he brought to bear in making these visually arresting photographs. These images, however, more than any others in his body of work, raise the question of whether there are limits beyond which a photographer should not go, whether there are images that should not be made. The fact is, however, that Swank did make them, and while some photographers engage in portraiture as an act of power and control over their subject, Swank's were never part of a Faustian bargain. He treated his subjects with respect, and the respect was repaid tenfold by the intangible human spirit that emanates from his photographs. This spirit of humanity sometimes is revealed in the simple joy of children receiving attention as in Swank's "Migrant Children" (plate 55), while sometimes it is more subdued, even painful, as in "War Mother I" (plate 63) and "War Mother II" (plate 64).[7] Swank made palpable the anguish these women feel over the loss of their sons.

Photographic history is replete with image makers who focused on the underclasses and what the upper classes perceived to be out of the ordinary. For the most part, photographers of the 1930s did not look at their own social class, choosing instead to concentrate on migrant workers, the working class, and the poor. The dominant social groups in society have always been able to impose their vision on the other segments of the social order. Gisèle Freund wrote in *Photography & Society* that "[m]ore than any other medium, photography is able to express the values of the dominant social class and to interpret events from their class's point of view, for photography, although strictly linked with nature, has only an illusory objectivity. The lens, the so-called impartial eye, actually permits every possible

distortion of reality; the character of the image is determined by the photographer's point of view and the demands of his patrons."[8]

Swank's photographs of African Americans and migrant workers are studies in dignity and tenderness. Their power derives from Swank's ability to present them as living, breathing people, not as stereotypes. Swank's "Woman in Shadows" (plate 58) and "Three Boys in a Wagon" (plate 54) are comments on both class and race relations. "Three Boys in a Wagon" depicts a moment when race was not an issue, at least for these children. Their clothes suggest they are all working-class, and they have bridged the racial divide through their play. This image is a study of racial tolerance at a time in American history when beatings and lynching of African Americans were not rare. In its subtle description of racial relationships, it is a portrait of hope featuring children not yet knowing of racism, an extraordinary image for the time.

"Woman in Shadows" (plate 58) is soft and tender, dark, and mysterious. The woman sits on a pillow, legs tucked under her; one hand rests on her knee, the other in her lap. Light gently caresses her, and shadow provides a comforting blanket. She is looking down and has no eye contact with Swank. Unlike his other people photographs, this one is unsettling. Why is she posed in such a subservient and vulnerable position? Who is she? Did Swank come across her as he was exploring Pittsburgh, or did he know her? Was she his longtime housekeeper? There may be clues in Edith's letters, but no definitive answers. Edith refers to Swank as having a Negro housekeeper named Celia. In 1947, Edith commented to her sister that Celia was still with her, although she was currently ailing.[9] And in a 1962 letter that was more biography than letter, Edith wrote: "A tyrannical and loving Negro maid whom I had inherited from my husband's family, continued to take care of me."[10] If this is a portrait of Celia, that explains its tenderness. This woman was incredibly loyal. She stayed with Swank through his move to Pittsburgh, Grace's death, and his bankruptcy, and continued to take care of his widow until Edith moved to New Orleans after her remarriage in 1952.

In "Women at Portrait Studio" (plate 57) Swank presents a casual glimpse into lives that intersected momentarily with his. This image shows the human tenderness that one woman feels for her companion and the weariness of the other woman, while the carnival photographer almost vanishes into the shadows. Swank has captured a little, fleeting moment, preserving it for future contemplation; as he worked more and more in the urban milieu, those little moments became important to him.

Swank's photographs "Migrant Children" (plate 55), "Portrait of a Young Girl" (plate 56), and "Man with Cigar" (plate 59) are full of

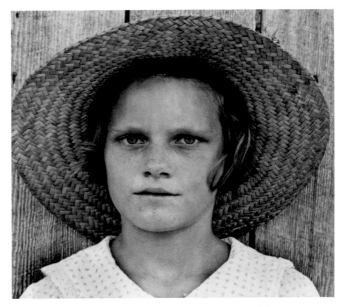

FIGURE 4-1. Walker Evans. Lucille Burroughs. Hale County, Alabama, Summer 1936. Modern gelatin silver print. Library of Congress, LC-USF342-8140A.

optimism and hope rather than pessimism and despair. In this, his imagery differs from that of many of his contemporaries who photographed similar subject matter, such as Walker Evans and Dorothea Lange; their images render the misery of the Depression far better than do Swank's.

Evans and Lange both served the social reform interests of the federal government. If they had depicted people as confident, self-sufficient, and without need, then the social reform agenda of the Roosevelt administration would have been undermined. Swank made his "Migrant Children" and possibly "Portrait of a Young Girl" while on assignment for the H. J. Heinz Company. Its interest was to have Swank portray agriculture and farm labor in a positive light.

The fact that the reform-minded agenda of the government guided the assignments of Evans and Lange while Swank served the corporate needs of Heinz does not lessen the power of the images they created or the validity of the views they presented. It does point out, as Freund argued, that all photography is subjective, especially so the social documentary style of imagery.[11] "Migrant Children" is uplifting; the children's smiles are infectious. How totally different this picture is than those Lewis Hine made between 1908 and 1918 for the National Child Labor Committee. Hine had a brief from this Progressive Era reform group to document the horrors of child labor. Because none of Swank's words survive linked to "Migrant Children," it is not possible to determine from the photograph whether these were just the children of migrant workers or were

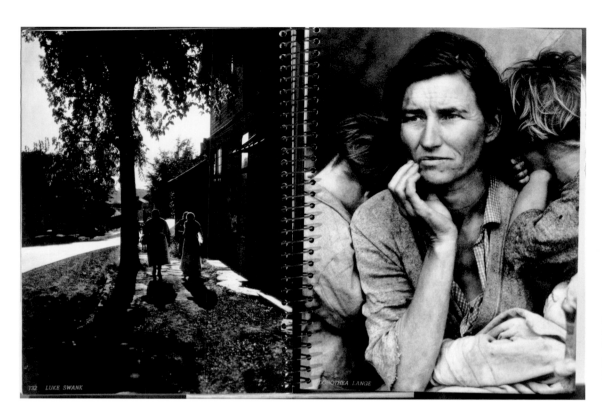

FIGURE 4-2. Luke Swank and Dorothea Lange. Three Women (Swank) and Migrant Mother (Lange). Two-page spread from *U.S. Camera 1936*, ed. T. J. Maloney (New York: William Morrow & Company), 132–33.

child laborers. Most likely they labored alongside their parents, as migrant children often did then and still do in many parts of the United States.

"Portrait of a Young Girl" is similar in subject matter to Evans's portrait of Lucille Burroughs (figure 4-1).[12] Both present young women wearing straw hats. In Evans's photograph, Lucille is presented head-on, in front of a weathered wood background. She looks directly at the camera. The image is almost without shadow, her face tentative, her attitude questioning. In contrast, Swank presents his young woman with her head at an angle. He was positioned a little below her, his camera pointed slightly up, her face framed by a tightly cropped straw hat. The mix of sun and shadow simultaneously reveal and hide her face. Her eyes, cast slightly down, barely engage Swank. Where Evans confronts, Swank presents. Light sculpts the face of Swank's young woman into that of a strong, almost goddesslike figure, although her eyes reveal her human frailties.

Swank's "Man with Cigar," like his "Women at Portrait Studio," represents a captured moment. It is an informal composition, found, more than created, by a keen observer of the environment he worked in. There is a direct engagement between Swank and his subject. Swank presents a man who may work hard and may be poor but is not beaten or defeated or without hope. The joy of being alive leaps from his face and is seen in the twinkle in his eyes.

Dorothea Lange's "Migrant Mother" was published opposite Swank's "Three Women" in a two-page spread in the 1936 *U.S. Camera Annual* (figure 4-2). "Migrant Mother" has become one of the iconic images of the Great Depression. Like a great number of Depression-era photographs it presents an image of stoicism, an image of survival with all the joy of living drained away. While Swank made many photographs throughout the Depression of people on the economic margins of society, it is hard to find much in Swank's work that depicts the crushing of the human spirit. His 1935 "Three Women" (plate 65), made in West Middletown, Pennsylvania, probably comes closest to the ethos of the Depression as we have come to understand it through the iconic images of the era by photographers such as Evans and Lange. But even here, while the photograph is dark, a luminescent light outlines the women seen together in front of a store and under the canopy of a silhouetted tree. Swank gently invites the viewer into the world of his "Three Women" while Lange confronts the viewer with the tightly compacted frame of "Migrant Mother."

Swank's photographs of people reveal him to be a photographer of hope in a time that was, for many Americans, one of despair. His

photographs offered a counterpoint to those of his more somber colleagues. His pictures of people demonstrated that, in the end, his vision spoke to the resiliency of the human spirit.

Photographers have used their spouses and lovers as subjects since the medium was invented. One essayist commented that Stieglitz made love to Georgia O'Keeffe through his camera.[13] Edward Weston photographed his wives and lovers; his relationship to his human subjects has been described as "aesthetic eroticism."[14] Like Stieglitz and Weston before him, Swank used his wives as models. Unlike Stieglitz and Weston, these images comprise just a small part of his oeuvre.

Most of Swank's photographs, including those of Grace and Edith, were made outdoors with available light. Only a small number used studio settings and theatrical lighting. Grace was Swank's principal model until her death. He made a variety of formal portraits of her as he was learning his craft in the 1920s. These portraits explored lighting, costume, and mood. One example is "Grace I" (plate 66) a pictorialist period piece that is dramatic, theatrical, and paradoxical. Grace is presented formally, yet her pose is informal. The sidelight is dramatic with deep shadows and strong highlights, yet the image is soft and the photographer's view is tender. She leans forward, elbow on knee, head separated from the background by a light that is almost like a halo, yet behind her the shadow formed from her torso, arm, and head has a shape suggestive of a giant grasshopper. Loving on one level, this portrait may also be seen as menacing.

All the surviving nudes of Grace are glass plate stereographs made in the garden of their home in Johnstown (figure 4-3). In "Grace in the Garden," Grace drapes herself with foliage. She is looking down and away from her photographer-husband. The lush garden setting brings to mind a modest Eve in her garden, demurely turning from the gaze of Adam. Was Swank consciously constructing an allegorical tale or simply photographing a figure in a landscape?

By the time Swank began to photograph Edith, he had long abandoned the melodrama of pictorialism, and his approach to his photography was straightforward. He photographed Edith at Fallingwater, where the Swanks were frequent guests. Evidently they made themselves at home at Bear Run, pitching in with the chores to keep the place enjoyable and perhaps to make the pool pleasant for their photography sessions. While not mentioning that she was a nude model for Swank, Edith did comment in a letter to her mother on the pool: "Luke and I decided to clean out the pool I swim in up

FIGURE 4-3. Luke Swank. [Grace in the Garden], c. 1925–1934. Positive glass plate stereograph, 2⅜" x 5⅛". Carnegie Library of Pittsburgh; Gift of Edith Swank Long.

at Bear Run. It had become clogged and dirty so we drained the pool, and I swished it out while Luke kept the drain open down below in the rocks."[15] To her sister she was more forthright about the type of pictures they were making and the problem of being a photographer's wife. "I'm like the shoemaker's children. My life is surrounded by pictures but I haven't had a picture taken for almost two years, which is what these are. Unless you'd fancy a couple of pretty nudes? I keep them locked up."[16]

For some of the nudes, that was a good decision because the compositions are uncharacteristically stiff, Edith ill at ease. These nudes within a landscape are formal and distant, lacking the decisiveness apparent in Swank's less personal work. Yet a few nude studies are strong and confident explorations of light and figure within a carefully composed space.

"Edith by the Hangover" (plate 67) was made outside the original cabin at Bear Run, built around 1921 long before Edgar Kaufmann commissioned Frank Lloyd Wright to build Fallingwater.[17] The foreground and cabin are in the shade. The canopy of leaves on the trees effectively filtered out much of the light. Edith is standing on the far side of the pool, in front of a fence bathed in a warm light, small, vulnerable, and fragile almost like a porcelain doll.

Swank's "Edith in Bathing Cap" (plate 68) was made in the pool next to the cabin. The image shows Edith's torso covered with swirls of soap, the swirling lather on her body mirroring the swirls of her bathing cap and the pattern of light refracted in the water. While "Edith in Bathing Cap" reflects Swank's formal concern with abstract explorations of light, texture, and form, it is much more. Swank has elevated Edith's mundane act of bathing into a vision of mysterious sensual and tactile beauty reminiscent of Weston's "aesthetic eroticism."

5 — Transformations

Luke Swank was both a modernist and a humanist. He recorded life and culture while he also explored formal properties of photography—form, focus, texture, and light. With most of his oeuvre, his interest in formalism and humanistic content were balanced. In a small number of images, he stripped away content to concentrate on transforming what was in front of his lens into an abstract composition. Abstraction and transformation were major concerns in some of his sculptural photographs of parts of steel mills, his images of circus tents, in many of his urban photographs including "Rooftops" (plate 140), and in the images in this chapter. At times he also arranged small objects into still life compositions that existed solely for the purpose of making aesthetically pleasing photographs. He also transformed objects found within man-made landscapes into interesting formal compositions. Many of these images were made as he worked a scene: he started with a recognizable view of a place or an object and continually moved closer, exploring angles of view until the object, made interesting by the way light played off its surfaces, dissolved into a study of form and texture.

Swank's formal compositions appear to have been made mostly in the first half of the 1930s. In a letter in the spring of 1933 to Joella Levy, Swank mentioned that he had been photographing, among other things, snow fences, concrete construction forms, an old barn, and kitchen utensils.[1] A January 1934 article mentions photographs of pots and pans, by inference his compositions "Old Basket in the Cellar" (plate 69) and "Tire and Oil Can" (plate 71).[2]

By 1934 he was showing his still life arrangements privately in New York, prompting Frank Crowninshield, the editor of *Vanity Fair*, to compare this specific set of images to the work of Alfred Stieglitz.[3]

Also in early 1934 in a *Pittsburgh Sun-Telegraph* article, Swank mentions his belief that almost any subject may be of interest to the photographer; it is important to concentrate on simple subjects that are seen close-up, and then the nature of the material photographed should be obvious.[4] The camera should be used to reveal texture, not obscure it. By moving in close, Swank removed objects from their readily identifiable context and transformed them into a set of abstract formal relationships.

Swank also explored emerging ideas about photographic vision. From the moment photography was invented it was inextricably linked to technological development, with many seemingly unrelated inventions playing a role in enabling photographers to look at the world in new ways and to explore macro and micro visions previously beyond human contemplation. Beginning in the mid-nineteenth century, the manned hot air balloon made it possible to view the world from above the earth, and the advent of tall buildings as well as the invention of the airplane further freed mankind to look at the world from lofty perspectives. Scientists used photography to explore the stars as well as to examine objects from extremely close distances and, with the invention of the X-ray, even to peer inside. Mankind's relationship to the world was fundamentally altered by the possibilities these new perspectives on the world represented, and this was reflected in the kinds of images photographers began to make.

The post–World War I years were a period of experimentation in art and photography. Pictorialism began to give way to modernism; cubism, constructivism, Dadaism, and futurism influenced photographers just as these movements influenced painters. It was a time of

FIGURE 5-1. Luke Swank. [Boys Swimming], c. 1930.
Gelatin silver print, 7¾" x 6⅛". Carnegie Library of Pittsburgh; Gift of Edith Swank Long.

FIGURE 5-2. László Moholy-Nagy. La Sarraz, 1928.
Gelatin silver print, 19⅜" x 15⁹⁄₁₆". Courtesy of George Eastman House, 81:2163:0068.
© 2004 Artists Rights Society (ARS), New York/VG Bild-Kunst, Bonn.

experimentation with materials and one in which innovative image makers broke the boundaries of what had been considered legitimate photographic subjects. They challenged conventional ways of thinking about photographic perspective as they sought new ways to view their subjects.

In photography, the philosophical ideas of the Bauhaus painter, designer, photographer, typographer, sculptor, filmmaker, and educator László Moholy-Nagy began to take hold.[5] He urged image makers, in part, to exploit the perspectives modern technology made possible. These included the use of bird's-eye view (getting above a scene and pointing the camera down), worm's-eye view (going inside an object and pointing the camera up), and close-up views. Swank was familiar with the ideas of Moholy-Nagy and had exhibited with him as well as André Kertész, also known for his experiments in composition and perspective, in the Brooklyn Museum's 1932 International Photographers exhibition.

Swank explored the perspectives a photographer could use by bird's-eye view or worm's-eye view. Swank's examination of Moholy-Nagy's ideas can be seen through a comparison of their photographs. In "Boys Swimming" (figure 5-1), Swank climbed high above his scene and used a perspective that mimicked the view a bird might have of the land below. This image shares a similar approach with Moholy-Nagy's "La Sarraz," from 1928 (figure 5-2). In each photograph the pictorial elements—including the people—have been reduced to shapes, the scenes transformed into studies of light, texture, and form. In "Boys Swimming" all sense of intimacy and human warmth, so prevalent in most of Swank's later work, is absent.

Swank's "Wooden Tower" (plate 78) presents a perspective created when Swank positioned himself inside the tower, pointed the camera toward the sky, and transformed this structure into an abstract pattern like Moholy-Nagy did in his 1926 architectural view "Dessau" (figure 5-3). "Wooden Tower" and "Boys Swimming" are two of only a few Swank images that fit comfortably with the colder, more mechanistic, and less lyrical approach espoused by Moholy-Nagy.

As Swank moved his camera closer and closer to his subject, stripping away its "objectness," shapes, textures, and forms emerged. Swank was able to explore texture and shape that was not apparent when an object was viewed from a more familiar distance or

FIGURE 5-3. László Moholy-Nagy. Dessau, 1926.
Gelatin silver print, 19½" x 15½". Courtesy of George Eastman House, 81:2163:0007.
© 2004 Artists Rights Society (ARS), New York/VG Bild-Kunst, Bonn.

FIGURE 5-4. Luke Swank. [Intersection of Horizontal and Vertical Wood], c. 1933–1935.
Gelatin silver print, 6½" x 4⅞". Carnegie Library of Pittsburgh; Gift of Edith Swank Long.

perspective. Swank's "Concrete and Wood" (plate 75) and "Intersection of Horizontal and Vertical Wood" (figure 5-4) are two examples. In "Concrete and Wood," Swank obliterated the scale of the objects in front of his lens. He took rough-hewn boards and smooth concrete forms, observed how light modulated their surfaces, and transformed these simple objects into a lyrical geometric sculpture.

In "Intersection of Horizontal and Vertical Wood," Swank presents his most purely geometric composition. Swank created this composition by moving his camera close to a log cabin to reveal the graphic relationships of the vertical deep shadow and the smoothness of the light wood on the left with the intersecting rough-hewn logs. These logs reveal all their tactile properties—knots, chinks, and unevenness—while each alternates with deep shadows that create horizontal strength. For artistic presentation Swank rotated this image 180 degrees in order to further abstract it from pure architectural description. Another version of this image exists in the Western Pennsylvania Architectural Survey collection in the Carnegie Library. This version has been mounted in the natural orientation and in this version the way in which the light falls on the side of the cabin is more easily understandable, although the resulting image is less

poetic and less visually arresting. This may be the only example in Swank's body of work where he chose to change the orientation of an image for viewing purposes.

Swank made a series of images that examined one of winter's necessities, wooden snow fences. In "Rolled Wooden Fence IV" (plate 76) and "Rolled Wooden Fence" (plate 77), Swank looked at patterns created by the different number of rolls included in each composition. In this series, he kept his camera parallel to the fences so that none of these images show optical distortion created by the extreme perspective of bird's- and worm's-eye views. Whether he filled his picture frame with many rolls of fences, moved in close so only parts of a few can be seen, or shifted his view from head-on to the side, he transformed cheap strips of wood held together by twisted metal wire into undulating and elegant forms both beautiful and poetic.

"Onions and Bowl" (plate 70) is a formal still life that presents traditional subject matter in an elegant manner. In his still life explorations, Swank moved from his use of time-honored subject matter such as pottery, onions, wooden bowls, wire whisks, and other kitchen utensils to the use of common modern objects,

including duct tape, fuses, clothespins, and newspapers. During this period of experimentation, he also created abstract studies by employing theatrical lighting to illuminate the small still life sets he constructed. His use of utilitarian man-made objects as the basic compositional building blocks for these images demonstrates his modernist belief that any subject was legitimate to explore. And if all subjects were legitimate to photograph, then it was possible to create visually compelling images by arranging the most mundane objects into formal compositions, as he did with "Tape, Brush, and Newspaper" (plate 73) and "Clothespin, Fuses, and Newspaper" (plate 74).

His "Metal Ring and Shadows" (plate 72) is a formal composition photographed from above. He used cross-lighting to create dramatic, long, and harsh shadows. "Metal Ring and Shadows" is strong and cubist-inspired and is Swank's most successful investigation of structured composition and artificial theatrical lighting.

Swank took the process of creating compositions from man-made objects out of the studio and into his garage when he made "Tire and Oil Can" (plate 71). This is his only still life that exists in several compositional variations made from a variety of angles and distances.[6] Swank constructed an image that relies upon circles, curves, and straight lines for its balance and geometric appeal, while it reveals the properties of the wood, metal, concrete, and rubber that belong to the objects in the composition. It is the compositional strength of Swank's formal arrangement of these utilitarian and mundane objects that transforms them into an intriguing image that keeps asking the viewer to look again. As curator Linda Batis wrote: "These photographs ask the viewer to appreciate the way things look—their material make-up, shape, and texture—as only the camera can capture them."[7]

Light was as much a subject in these pictures as were the objects in front of Swank's lens. The quality of light Swank explored in "Metal Ring and Shadows" relates to the way he used light in his early portraits of Grace, "Old Basket in the Cellar" (plate 69), and "Legs, Gourds, and Shadows" (plate 79). In each of these images Swank used strong light from the side and above to rake across the objects and create dramatic patterns.

Swank exhibited "Old Basket in the Cellar" in the 1931 Pittsburgh Salon. Unlike the other images in this chapter, he printed this one in a pictorialist, painterly style on textured paper. Because of the painterly approach used in the printing process, this image represents a bridge between pictorialism and Swank's clean, crisp, and modern "Metal Ring and Shadows."

The light Swank used in "Legs, Gourds, and Shadows" also casts long, hard shadows. In this image, however, the light was observed, as in his photograph "Edith in Bathing Cap," rather than imposed upon his subject as in "Metal Ring and Shadows." "Legs, Gourds, and Shadows" is a found abstraction. Swank responded to the rectilinear patterns of light created by the strong sun that was blocked by the structural elements of a window or fence. The roundness of the gourds provides a counterpoint to shapes created by the light patterns. The shape, thickness, and tonality of the illuminated portion of the woman's leg resemble the tubular part of the gourd.

Swank's composition at first seems arbitrary, the frame fractured into several pieces. While the gourds are centered and seen whole, the woman, cut in two, is shown from behind, light revealing the texture of her dress as she walks out of the picture frame. Swank's composition represents a daring and radical way to use the frame. In most compositions of the time, the woman would have been seen as the subject and presented as a more complete form. "Legs, Gourds, and Shadows" creates a poetic and surreal moment and shares the radical use of the picture frame with his urban photograph "Looking at a Man through a Car Window" (plate 109). In this photograph he also truncates the human form as well as uses the intense highlights and deep shadows created by the sun both to reveal and hide detail, to heighten the viewer's senses, and transform a mundane moment of no consequence into an enduring image.

Through tightly framed close ups, Swank isolated objects from their environment, creating images at once transformative and abstract. Some exist on a poetic level and suggest the ephemeral relationship of man to his environment. These photographs need to be understood by the associations they bring to mind rather than merely through the description of what they show.

Douglas Naylor wrote in the January 21, 1934, edition of the *Pittsburgh Press* that "Mr. Swank says the world is full of striking pictures waiting to be photographed; he doubts if the artificially arranged design can ever surpass natural arrangements made by man and nature."[8] Given this attitude, it is no wonder that there are so few artificially constructed still life compositions in Swank's body of work. Nor is it surprising that these compositions represent experimentation rather than sustained investigation. In the end, Swank's core concerns led him to record a world that was not constructed by the artist but observed by the photographer, a world that revealed what people did, how people lived, and how they engaged their environments.

5 — Rural Architecture and Landscape

For more than a decade, Luke Swank took his camera on the road. Working mostly in rural Pennsylvania, Swank also photographed in West Virginia, Virginia, Ohio, Tennessee, and New England. Many of his rural photographs were made between 1933 and 1935 as part of his work for the Western Pennsylvania Architectural Survey. Some were created while traveling on assignments for the H. J. Heinz Company and other clients between 1936 and 1943. Between 1940 and 1943, he and his wife Edith worked on several rural series they intended to develop into books. These were jointly researched; she was the writer and he the photographer.[1]

Most of Swank's rural photographs are printed sharp as a tack on gelatin silver paper, suggesting either that this theme began after he rejected pictorialism in the late 1920s or, as with his circus photographs, that he never thought of this subject in pictorialist terms. Some rural images from the 1930s, however, were made as glass plate stereographs, while a few from the 1940s were shot as 4 x 5 and 5 x 7 inch Kodachrome color transparencies.

Stereography, from the time of its invention in the mid-1800s, was a popular form of entertainment and information before the advent of film and television. Stereo cards were made of sites such as the pyramids of Egypt and the American West that intrepid photographers recorded around the world. Stereo cards were also used to present visual stories of morally uplifting or morally bereft character. By the end of World War I, many amateurs, especially in Europe, were making glass plate stereographs. In fact, one 1931 article indicates that in Europe one in ten cameras sold was a stereo camera, while in the United States few people bought them, even though glass plate stereographs, when looked at through a stereo-viewer,

provide a sense of depth and detail unparalleled in any other type of photography.[2]

Although fewer than a hundred of Swank's glass plate stereographs survive, it is clear from the breadth of subject matter recorded that he often turned to this photographic technique.[3] Swank's earliest stereographs were made in Johnstown and included images of his first wife Grace and of steel mills. In 1933–1935, while working for the Western Pennsylvania Architectural Survey, he made a series of stereographs of the Meason Mansion, a historic Pennsylvania home (figure 6-1). This series includes compositions nearly identical to prints he made for the Survey suggesting that the glass plate stereographs were made to complement his Survey photographs. Swank continued to work in this medium until at least 1936 or early 1937. The Carnegie Library of Pittsburgh has several stereograph images of Swank's son Harry posed with an emaciated, haggard, sad-looking Grace Swank, images that must have been made during her illness and shortly before her 1937 death.

Swank first mentions working on the twin themes of rural America and vanishing pieces of the cultural landscape in a 1933 letter to Allen Porter at the Julien Levy Gallery.[4] He writes that he is now making photographs for the Western Pennsylvania Architectural Survey, a project that sought to document all significant architecture built prior to 1860 in the twenty-seven counties of Western Pennsylvania. While primarily rural in subject, it did include buildings within Pittsburgh as well as small towns such as West Middletown. It culminated in the book *The Early Architecture of Western Pennsylvania*. Published in 1936, this book was written by the architect Charles Morse Stotz and funded by the Buhl Foundation

FIGURE 6-1. Luke Swank. [Meason Mansion, Fayette, County, Pa.], c. 1933–1935. Positive glass plate stereograph, 2⅜" x 5⅛". Carnegie Library of Pittsburgh; Gift of Edith Swank Long.

with a grant to the Pittsburgh chapter of the American Institute of Architects.[5]

The survey was a uniquely Depression-era project. Approximately thirty underemployed or unemployed architects made the detailed architectural drawings for the book. While they believed in the value of historic documentation, they also needed support and were willing to work for little compensation. Stotz wrote: "It was a most fortunate coincidence for the Survey that the existing economic depression has made it possible to secure the services of men for this work who are recognized as leaders in the architectural profession. The drawings could not have been made at any other period for many times the amount of money expended."[6]

Swank most likely learned about the project from the publicity sent to over two hundred newspapers and nine radio stations. Swank approached Stotz, who commented in the 1934 annual report of the Committee for the Preservation of Historic Monuments that "the Committee was fortunate in locating a man, or rather in having a man locate the Committee by the name of Luke Swank, whose attitude exactly coincided with their own," and who was willing to work at cost for "the pleasure of participating in this most interesting project."[7] Swank, like the architects, believed in the importance of documenting early architecture before it disappeared.

The Early Architecture of Western Pennsylvania, today considered a classic of architectural history, has been reprinted several times.[8] In the original publication Stotz cites Swank's significant contributions to the success of the project; Swank was responsible for shooting approximately half of the 416 photographs, making the prints for all the photographs and drawings that appeared in the book, and making prints for public exhibitions.[9] In his introduction to the 1966 edition, Stotz also credits Swank with providing photographic

training and advice that enabled Stotz to do a credible job as a photographer for the smaller, secondary images.[10]

The book's longevity makes it the one source that has kept Swank's photographs in public view. Most of the more than two hundred photographs by Swank that appear in the book were created as architectural documents. Although well composed, they lack the personal aesthetic touch that is evident in photographs Swank made of the same subject that did not appear in the book. This can be seen by comparing Swank's "Meason Mansion Office and Outbuilding" (plate 93), not used in the book, to a two-page spread from the book (figure 6-2).[11] Swank printed "Meason Mansion Office and Outbuilding" to accent the shadows falling on the outbuilding and to emphasize shape, texture, and geometry over clarity of architectural detail. It revealed worn, broken steps and weathered doors by the entry to the office. In the book, in contrast, the composition of the same subject made from a slightly different angle is considerably tighter, showing just the edge of the office as well as the complete outbuilding. It is an image printed to be purely descriptive, to maximize the architectural detail. It is not nearly as visually enticing as "Meason Mansion Office and Outbuilding," which was printed to be less descriptive and more evocative, to create a heightened sense of drama. The difference in interpretation may be compared to the difference between nonfiction writing and poetry.

Ironically, while each architect was allowed to sign his individual drawings, none of the photographs is individually credited. From Stotz's comments, however, it is reasonable to conclude that the full-page photographs are by Swank and many of the half and quarter page ones as well.[12] There is no doubt both of these Meason Mansion photographs were made by Swank rather than Stotz. First, "Meason Mansion Office and Outbuilding" is signed on the front with Swank's stylized trademark signature. Second, the shadowing of the building surfaces is similar, suggesting that both images were made within a short time of each other on the same day. Third, there are other photographs, as well as the series of glass plate stereographs, of Meason Mansion in the collections of his work.

Swank's poetic vision is clearly presented in his "Meason Mansion Staircase" (plate 92), one of two formal interior compositions of this home where his aesthetic is important, not the descriptive quality of the architecture.[13] This image is reminiscent of Eugène Atget's interior architectural studies of Old Paris and may represent Swank's synthesis of Atget's sensibilities. "Meason Mansion Staircase" has the same timeworn, shabby elegance so prevalent in Atget's work, no doubt partly because of the age and historic nature of the place. Quietly dramatic, this is an elegant image that explores

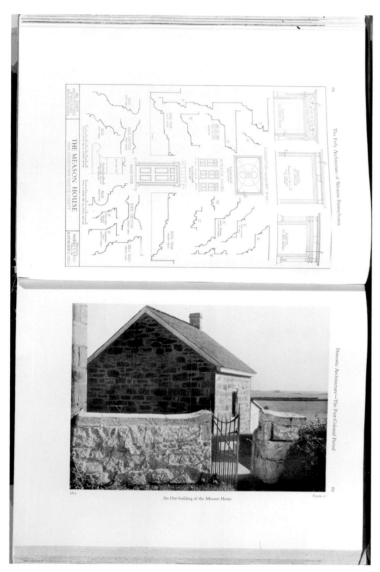

FIGURE 6-2. Luke Swank. From *The Early Architecture of Western Pennsylvania* by Charles Morse Stotz. © 1936, published by the University of Pittsburgh Press.

age and decay, the deep recesses of shadowed space, and the ethereal nature of light—themes often seen in Swank's urban images.

Meason Mansion is one of the most historic structures photographed for the Survey. Construction was begun in 1797 and completed in 1802 on this home for Isaac Meason, a colonel in the Revolutionary War and an ironmaster who built one of the earliest rolling mills and became one of America's first successful industrialists.[14] On this site in 1774, George Washington met with Native Americans from the Six Nations. At one time Henry Clay Frick owned the home that was noted in part for its eleven fireplaces, all with hand-carved mantels, including two "Goddess of Liberty"

mantels by Robert Wellford.[15] Today, this National Historic Landmark, described as the "only Colonial-style seven-part Palladian structure in the U.S.," sits trapped between an auto repair shop in front and land that has been strip-mined behind.[16]

The Western Pennsylvania Architectural Survey was a systematic study of Western Pennsylvania architecture. It involved an enormous amount of planning, including the development of field techniques specific to the project. Charles Stotz, chairman, Rody Patterson, secretary, and sometimes a third person comprised the field team. The purpose of the fieldwork was to do preliminary documentation, including making a photographic record, and to develop the list of properties to be included in the book. Swank's charge was to photograph the buildings selected for special attention.[17] He had to keep in mind that the documentation of architectural detail was more important to the purpose of the survey than pictorial effect.[18]

When Swank photographed, he usually traveled without other members of the project. He accompanied Stotz on only one of his many trips, most likely to gain an understanding of the requirements for survey photography and to provide Stotz with photographic pointers.[19] By the midpoint of the project in January 1934, Stotz and Swank had already made 1,700 photographs and by 1935 almost 2,500.[20] The survey visited more than 1,100 sites, made records of approximately 700 and selected 60 for special attention by Swank.[21]

Stotz described the rigorous and exhausting nature of traveling to all twenty-seven counties of Western Pennsylvania—an area nearly three-quarters the size of New England—along with its occasional unexpected dividends:

A few of the trips extended over a period of three days. They were extremely tiring, as they required constant travel most of the time over very bad roads in Mountain districts and remote country places, occasionally through the bed of a stream. . . . As the conservation of time on these trips was of utmost importance it was a real disaster to chase down an example in some forsaken locality only to find a horrible example of the Queen Anne style or that it was demolished altogether, but the law of compensation still works and on such wild goose chases some very charming old buildings were accidentally discovered which seemed to have escaped the attention of any one.[22]

Swank, uncharacteristically for him, linked at least some of the survey photographs to words. Since he didn't provide context through the use of captions for any of his other bodies of work, this most likely was a project requirement rather than something he decided to do on his own. Swank's photograph "Old Inn on Dry

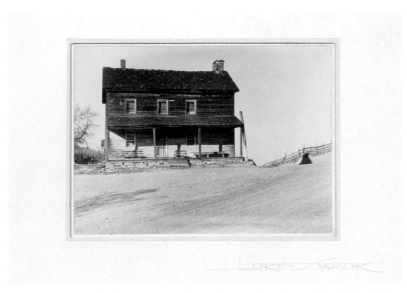

FIGURE 6-3. Luke Swank. [Old Inn on Dry Ridge Road, Pennsylvania Route 31], c. 1933–1935. Gelatin silver print, 2⅞" x 3⅞". Carnegie Library of Pittsburgh; Gift of Edith Swank Long, SW393.

Ridge Road" (figure 6-3) has a lengthy caption written in Swank's handwriting on the back of the image, linking it to related facts about the property. It places the image into a historical context and explains the intent in making the photograph:

Old Inn on Dry Ridge Road (Pa. Route #31). Past this point traveled most of the early settlers in the early part of the 19th century. This old tavern stands on top of a ridge. From this point there is no water for eleven miles, a terrific ordeal for travelers. As the western sections were settled, traffic moved in the opposite direction to the B&O Railroad at Cumberland, Md. Much good rye whiskey moved past here, as it was the least bulky of the farm products. Washington's troops passed here in 1795 to quell the Whiskey Rebellion. I have tried to show the sweep of the modern macadam road past this old building, with the—should I say?—austerity of the old clapboard log tavern.[23]

Given the length and historical nature of the caption, one can assume that originally this was not an orphan and that his images for the survey were extensively captioned. Yet out of more than 3,000 surviving photographs by Swank only a handful carry any caption; this one, for "Old Inn on Dry Ridge Road," is by far the most extensive.

The project required the cooperation of the people living in the homes, and most were happy to provide information and allow their properties to be photographed. Some felt compelled to show to the field team their parchment deeds that in several cases carried the

signature of Benjamin Franklin. Others, while agreeing to allow their property to be recorded, were less convinced of the beauty or importance of their property than was the team. One farmer, who lived in an old stone house in Washington County, told them that while he agreed the unique carving on the interior woodwork was fine, he nevertheless "would much rather see and own a good coal mine or a good field of hay or even a good pile of manure."[24]

Some of the comments illustrate, as much or perhaps even more than the photographs, how the passage of time, as well as the social class and wealth of the occupants, affected these properties, and they make clear that in many cases what was being recorded was rapidly vanishing from the American scene. Stotz commented on this in his petition to the Buhl Foundation to secure a second round of funding—this one to publish the book once all the other work had been completed:

In Versailles, the Committee recorded an old house [that] had been sadly altered but bore signs of having been at one time a very beautiful mansion. It was occupied by two Polish families and ten coal miners. The parlor mantel had had a hole punched through its frieze to admit a pipe from the range and stood as the last remnant of what had been once an interior of rare distinction. In another case an owner had chopped up one of two similar old mantels for kindling in his stove the previous winter, explaining that he did not need two alike. But it was almost axiomatic, that the least altered architecture contained the lowest class of tenant. Those buildings [that] had remained in the hands of families of wealth, were continually remodeled to keep up with current styles and fads, resulting in complete obliteration of original character.[25]

Character and historical significance were certainly prime considerations that went into the decisions regarding what Swank photographed for the survey. What he learned from this project no doubt influenced his understanding of what constituted historical significance for his larger work on a vanishing America, but his modernist ideas about form and composition drove his image-making decisions. It is this overriding concern for the power of the image that separates him from the historical preservationists and places him in more august company.

Swank's photographs of rural America bring to mind the work of four other photographers: Charles Sheeler, Aaron Siskind, Alfred Stieglitz, and Walker Evans. Sheeler and Siskind both created significant bodies of work that examined the architecture of Bucks County in eastern Pennsylvania. Swank's photographs of weathered barns are reminiscent of Stieglitz's photographs of barns in Lake George, New

York. And Evans's photographs made for the Roosevelt administration's Resettlement Administration (RA) share similarities with Swank's rural photographs, even though they were created for entirely different purposes.

Sheeler made photographs in 1915–1917 of his home in Doylestown and of the barns of Bucks County. Sheeler's photographs stand alone as seminal examples of modernist photography, often revealing cubist influences, and served as studies for his paintings. Sheeler's photograph "Side of White Barn, Bucks County" (figure 6-4) is a classic example; he turned a three-dimensional barn into a two-dimensional flat "surfacescape," a rigidly formalist vision that was, for the time, a radical modernist composition.[26]

Like Sheeler before him, Swank stripped away any sense of location in his photographs "Barn with Windows" (plate 86), "Doorway, J. Heinrich Zeller House" (plate 87), and "Double Door Flanked by Ferns" (plate 88). His direct, head-on, tight formal approach echoes Sheeler's "realism of detail and texture."[27] While Swank includes in the foreground a glimpse of earth or plant that provides a small measure of depth to his images, he is moving toward an elimination of identifiable subject and traditional three-dimensional perspective in favor of a more austere and abstract two-dimensional frame.

Aaron Siskind, whose work also has a strong relationship to both Sheeler's and Swank's, began his study of Bucks County architecture in 1935.[28] Siskind's study of Bucks County, like Swank's early rural work, was part of a historical architectural survey project. Siskind was introduced to Charlotte Stryker, an architectural historian who was working on a manuscript titled "Colonial Architecture in Bucks County." His photographs, which he had begun to make prior to meeting Stryker, were meant to complement her architectural history. Their collaboration was never published, and Siskind's photographs of Bucks County architecture languished for decades until his book *Bucks County: Photographs of Early Architecture* appeared in 1974.

Siskind, like Swank, photographed a wide-ranging set of historically significant architectural structures including stone houses, covered bridges, and barns with advertising signs on the side. Although there is no evidence that Swank and Siskind knew each other, their similar aesthetic sensibilities are apparent in their work. By the mid-1930s, they both were exploring tighter and tighter compositions that strip away the identity of the subject matter, exploit the two-dimensional property inherent in print, and move further into abstraction. The same flatness of perspective and the move toward the elimination of identifiable subject that Sheeler

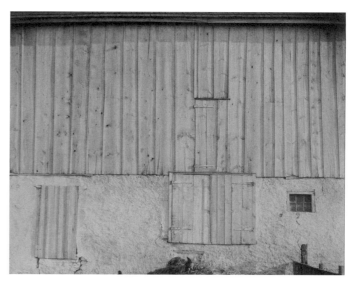

FIGURE 6-4. Charles Sheeler. Side of White Barn, Bucks County, 1915. Gelatin silver print, 8" x 10". © The Lane Collection; Courtesy of Museum of Fine Arts, Boston, L95.3.74.

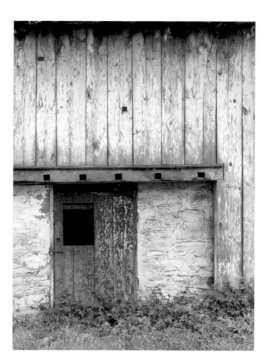

FIGURE 6-5. Aaron Siskind. Stable, c. 1935–1940. Modern gelatin silver print. Collection of the Mercer Museum of the Bucks County Historical Society. © Aaron Siskind Foundation.

and Swank explored is evident in Siskind's "Stable" (figure 6-5). Swank's work anticipates Siskind's breakthrough in the mid-1940s and early 1950s from modernism to abstract expressionism.

As a photographer, Swank had matured greatly by the mid-1930s. He no longer attempted to copy a composition such as Stieglitz's "The Hand of Man" as a learning exercise; he had absorbed what he could. And while he continued to share sensibilities

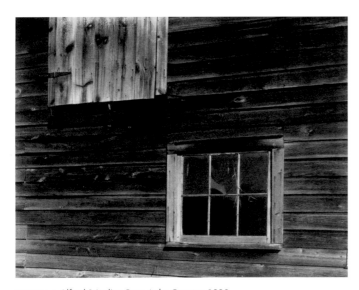

FIGURE 6-6. Alfred Stieglitz. Barn, Lake George, 1920.
Printed 1947 by Lakeside Press, Chicago, photomechanical (halftone) reproduction,
6" x 7⅝". Courtesy of George Eastman House 67:0120:0011.
© 2004 The Georgia O'Keeffe Foundation/Artists Rights Society (ARS), New York.

58

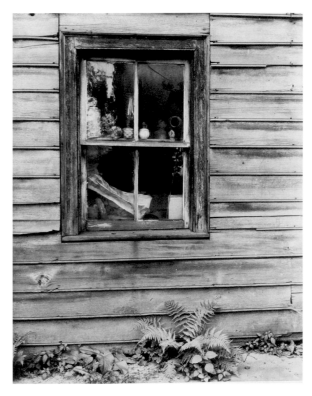

FIGURE 6-7.
Luke Swank.
[Window, Clapboard
House, and Fern],
c. 1934–1935.
Gelatin silver print,
7¾" x 6". Carnegie
Library of
Pittsburgh; Gift of
Edith Swank Long.

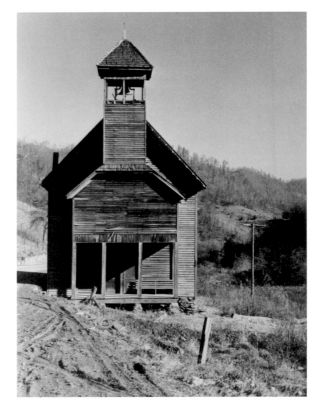

FIGURE 6-8.
Luke Swank.
[Tennessee Church],
c. 1934–1943.
Gelatin silver print,
8" x 6⅛". Carnegie
Museum of Art,
Pittsburgh; Gift of
Elizabeth Hampsey,
93.191.3.

with Stieglitz and others, he had developed his own distinctive, quiet, formal approach to his image making. While Swank's "Barn with Windows" (plate 86) brings to mind Stieglitz's austerely elegant 1920 photograph "Barn, Lake George" (figure 6-6), Swank's image has a messier frame and a harder edge to it due to the difference in the quality of light.

Both photographs present views of barn sides, wood weathered and dried and without paint. Stieglitz's study was made in a softer, more even light, while Swank's shows the dappling and shadows of a more intense sun. Although the light is different, both are extremely tactile, their beauty inextricably linked to the textures revealed. It is both the formal arrangement of subject and these tactile properties in Swank's compositions that prompted Frank Crowninshield, editor of *Vanity Fair*, to first compare Swank to Stieglitz in his introduction to Swank's 1934 Delphic Studios exhibition.[29]

Swank's work also shares aesthetic sensibilities with some of Walker Evans's photographs of rural America made for the Historical Section of the Resettlement Administration (RA). The RA was established by the Roosevelt administration in 1935. In 1937 it became a part of the Department of Agriculture and was renamed the Farm Security Administration (FSA). The Historical Section, under the direction of Roy Stryker, was to provide photographic documentation of rural America.[30] For the most part, the FSA photographers photographed people and places in America that were in distress. Their photographs were made to help the administration

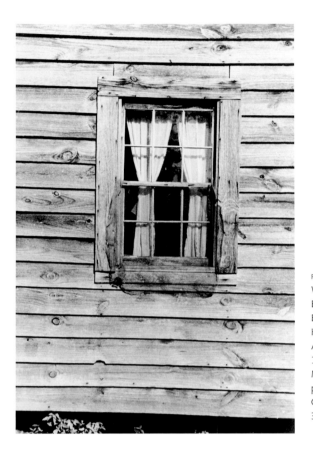

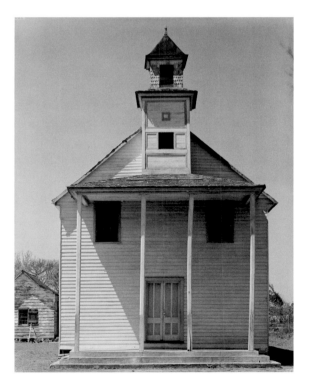

convince the public and Congress of the need to approve the wide-ranging social policy goals of Roosevelt's New Deal. In short, the mission of the photographers who worked for the FSA was first and foremost political; aesthetics were of secondary importance. While aesthetics were not part of the FSA mission, they were important to Evans and many other FSA photographers such as Dorothea Lange, Arthur Rothstein, and Jack Delano who often created well-seen formal compositions that transcended politics and utilitarian description. That Stryker circulated the photographs widely to newspapers and magazines raised the public's awareness of the social and economic conditions of Americans during the Depression. That the government, through the Library of Congress, has kept these photographs in public circulation for more than sixty years is a key reason why the historic understanding of the Depression today is linked to these images.

While there is no documentation that would confirm that Swank and Evans knew each other personally, they must have been acquainted with each other's work because they exhibited together on several occasions in the early 1930s. Their photographs exhibit a strongly shared aesthetic that celebrates pure photographic description and formal composition. Swank's "Window, Clapboard House, and Fern" (figure 6-7) and "Tennessee Church" (figure 6-8) are similar in subject and compositional perspective to Evans's photographs "Bedroom Window of Bud Fields's Home, Hale County, Alabama, Summer 1936" (figure 6-9) and "Wooden Church near Beaufort, South Carolina" (figure 6-10).

While all four of these images are photographed head-on, they differ in subtle ways. Swank's "Tennessee Church" and "Window, Clapboard House, and Fern" are weighted more toward the left side of the frame than Evans's "Bedroom Window of Bud Fields' Home, Hale County, Alabama, Summer 1936" and "Wooden Church near Beaufort, South Carolina." Swank's photograph of the church is seen from further back, providing more depth and context than Evans's church scene. And Swank's "Window, Clapboard House, and Fern" invites the viewer inside to leisurely examine the objects viewed through the window, while Evans presents the side of Bud Fields's home with curtained windows that distance the viewer from the interior. Although both Swank and Evans have created similar formal compositions, the small differences in compositional relationships and details highlight the humanistic warmth of Swank's vision, while Evans maintains a cooler, objective distance.

As the original political agenda that gave Evans the opportunity to make these images fades into the mists of the historical past, and despite the real differences between Evans's and Swank's visions,

their shared aesthetic concerns position their work more closely together. A few days before his death in 1975, Evans commented to a class at Harvard University, "I am fascinated by man's work and the civilization he built. In fact, I think that's the interesting thing in the world, what man does."[31] This fascination was shared by Swank, who, regardless of the specific subject that fell under his lens, was a keen observer of the infinitely variable human civilization.

Most of the rural photographs selected for this book were made after Swank finished working with the Western Pennsylvania Architectural Survey. In 1936, 1938, and 1940 he traveled for the H. J. Heinz Company and made photographs in a documentary style of agricultural scenes and field-workers. These pictures were meant to describe in a positive light the agricultural methods of the company. Some of these images, like the FSA photographs also made to fulfill a sponsor's agenda, were so beautifully crafted that their superb pictorial quality has given them a life of their own.

Swank's "Men Loading Tomatoes on Flatbed Truck" (plate 85), from 1940, is one example of a well-crafted composition that demands to be considered on it own visual merits. This image presents a half-loaded truck with its bushels of tomatoes stacked like a pyramid, its building blocks strong and plentiful. Its laborers work together. They all are in a perfect arrangement for the eye to move from the worker holding the basket past the worker in the middle, swoop up to the pyramid builder, and then circle through the sky back to the man with strong arms outstretched holding the basket of tomatoes. The image has a cinematic quality that Swank exploits in many of his images with people. In these photographs Swank presents people frozen in place, whether directed—as this one at least to a degree must have been—or in a true captured moment, as in his photograph of the Amish woman and children walking toward the hardware store in "E. S. Renninger Hardware" (plate 80). They have the appearance of a still image pulled from continuous motion, just as a single frame from a film might look if pulled from its sequence to be quietly contemplated as a solitary object.

It is not clear just how often Swank was on the road between 1936 and 1940, although an examination of his commercial index card file suggests that he traveled frequently. After he married Edith in 1940, her letters indicate they traveled a great deal. A portion of this travel was for their book, *The Story of Food Preservation*. They also were on the road for other clients, as well as for their own projects. Intending to sell articles and produce a book on the Pennsylvania Dutch, they did extensive historical research into these people, who were also Swank's ancestors. Unfortunately, Swank's death ended the project before it was completed, and it was never published.

Edith described one trip in a December 1940 letter to her sister Nancy.

I got a little tired of so many of the New England villages. They had a postcard kind of prettiness that wearied me after seeing a great many. But we went on up the coast into Maine. And there is country I could lose my heart to if it were not already given to Pennsylvania. Less prim and thin blooded than Massachusetts, Maine is rugged and wild and old, and yet there is a primordial vigor about it as though it would be young and strong when Massachusetts was a doddering ruin.

We went up the Kennebec for miles and miles—tho not enough to satisfy us. We had left Salem early in the morning and needed to be back there by night so we did not have time enough. Besides we dawdled along the coast going up, never suspecting we would love the Kennebec country so much. I shall always think of that country bathed in a softly saffron sunset. It was very beautiful.

We found a wild arm of land going way out into the ocean around Boothbay that I should like to see in the summertime. There in the harbor were decaying hulls of ancient ships—the sort of big, square rigged Maine ships that sailed the seas of the world early in the last century. They were wrecks, but they were still strong and beautiful—and sad and wild on that rough coast.

Maine was definitely to my taste, and so was the Connecticut valley. We came upon that quite by accident too and had to drive quickly through to get home. There was an expansive quality to this valley. The people lived here on modest farms, but they lived pleasantly and they took time off from their plowing to carve dentils around their cornices and broken pediments of rare charm above their doorways. The land rolled gently and it was a pleasant place to be in. I liked York state too, but by that time was glad to be back into our own country.

I know a farm in eastern Pennsylvania that I yearn to buy. Its just been sold, but to a very old man, and maybe someday we will be able to get it or one like it. It's in the Oley Valley perched up on the rim of the valley looking down into the country. The buildings are made of fieldstone and they are in remarkable condition and there are such delightful old buildings. A Swiss bank barn, a springhouse, an icehouse, old log cabins, and small barns of the first settlement there, and a beautiful main house that is very handsome, built in 1815. There is even an old outdoor oven and long, low lying blacksmith shop. We wouldn't have much use for the 175 acres that goes with the farm—so it is just as well we couldn't get it—but someday I would like to have a house in that country.[32]

Their travel to New England took them to Deerfield, Massachusetts, where Swank made "Double Door Flanked by Ferns" (plate

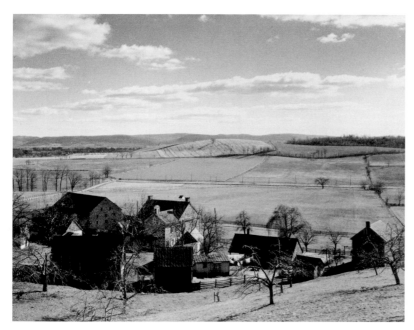

FIGURE 6-11. Luke Swank. [Reiff Farm, Oley Valley], c. 1940.
Gelatin silver print, 6¼" x 7¹⁵⁄₁₆". Carnegie Library of Pittsburgh; Gift of Edith Swank Long, SW443.

88). The door sits centered between a carved relief that suggests the support columns for a Greek temple. The clapboard home, however, has not been painted in decades, its wood is heavily weathered and the ferns are beginning to grow in front of the door. It is now a worn, decaying structure, a shadow of its once proud, elegant self.

The farm so cherished by Edith is the Reiff Farm, today a bed and breakfast inn and since 1982 on the National Register of Historic Properties.[33] It sits in the valley in Oley Township, Berks County, a few miles northeast of Reading in the heart of Pennsylvania Dutch country. Swank photographed it extensively while Edith carefully made note of it in the D-Series set of index cards that catalogued 334 of Swank's Pennsylvania Dutch photographs.[34] "Reiff Farm, Oley Valley" (figure 6-11) photographed from a hill above the farm, shows it nestled into the rich farmland of this region. In cinematic terms, or in the language of photojournalism, this image was a scene-setter, the shot that provides the broad overview. Swank made many additional images of Reiff Farm focusing on smaller and smaller fields of view. He grouped several of these images into a short series titled "Terror in the Farm Yard." While the cards indicate which images belong to this series, they yield few clues as to Swank's intent. Although the series title suggests a fictional, emotive experience, the notations are frustratingly descriptive. For example, the card headed "D-240 Terror" reads: "Pictorial scene on the Reiff Farm. There is something amazingly sparse and bare about this.

Looking into the sparse gray room showing a rake leaning against the wall. Don't recall print."[35] The cards were most likely written by Edith sometime after the pictures were made. The last comment further suggests that the notes for the series were made, at least partly, from looking at negatives rather than prints.

Just to the west and south of the Reiff Farm, between Reading and Lancaster, is the Ephrata Cloister. Swank photographed the Cloister for what may have been a commission by Fiske Kimball, who was the director of the Philadelphia Museum of Art between 1938 and 1948.[36] Swank was supposed to have an exhibition at the museum early in 1941, according to a November 1940 letter written by Edith.[37] Kimball, as the author of the introduction to *The Early Architecture of Western Pennsylvania*, was well acquainted with Swank's architectural studies. The museum, however, has no record of a one-man show for Swank. Although the archivist at the Philadelphia Museum of Art was unable to verify that the show took place because the records for this time period are incomplete, the author's inquiry led the museum to find a previously forgotten fourteen-picture portfolio of Swank's photographs of the Ephrata Cloister.[38] The fact that the museum found this portfolio makes the commission likely, even if the show may not have taken place.

Conrad Beissel, a German immigrant and a Sabbatarian (Seventh Day Baptist), founded the community that built the cloister. The group had its roots in the sixteenth- and seventeeth-century English Puritan movement.[39] Beissel, like others including the Amish and Mennonites who fled European religious persecution, appreciated the religious tolerance in William Penn's colony.

The Ephrata Cloister consisted of two celibate orders. Beissel was opposed to the traditional family structure and published a book that denounced "marriage of the flesh" while "espousing a life of spiritual virginity."[40] The men belonged to the Brothers of Bethania and the women to the Roses of Sharon. Those members of the community who preferred to remain married could do so. They were called householders and had to live on farms that surrounded the cloister, while the brothers and sisters lived in large communal houses on the cloister's grounds. The Ephrata Cloister was well known for the Sisters' choral music, its prolific printing press, and the manuscripts they illuminated in the German Fraktur style of calligraphy.

The oldest buildings of the cloister date to 1732. It closed in 1934 after more than two hundred years of continuous use. Purchased by the Commonwealth of Pennsylvania in 1941, it became a museum. Swank made his photographs in 1940 while the property was still in limbo.

Swank's Ephrata Cloister series focused on the physical remains of a way of life that had passed. The series consists of at least twenty-five interior and exterior images. In "Common Room, Sisters' House (Saron)" (plate 91) it appears as if people are present but not in the room at the moment.[41] The light coming through the two windows eerily illuminates this simply designed and furnished room. "Meetinghouse (Saal) Kitchen" (plate 90) shows a deserted room. It is a formal composition of many rectangles and intersecting planes. The door, the color of the painted wood, and the beamed ceiling make this image reminiscent of Sheeler's photograph "Doylestown House, Stairway, Open Door" (figure 6-12) made in his Bucks County home in 1916–1917.

Swank's "Sisters' House (Saron) I" (plate 89) shows the north side of the building as the sun casts long shadows. The grass is overgrown and the place looks abandoned. This is the building where the Sisters sang their choral music. The two windows on the bottom right mark the location of Swank's interior view "Common Room, Sisters' House (Saron)."

In the early 1940s Swank was also experimenting with color in both his steel and his rural photographs. For example, he made both black-and-white and color versions of the Sisters' House (Saron) compositions. "Sisters' House (Saron) II," the color version, was an exact compositional duplicate of the black-and-white image "Sisters' House (Saron) I."[42] The Kodachrome used to make "Sisters' House (Saron) II" registered the clouds much more fully than the film used for the black-and-white version. Except for the manner in which the sky is rendered, the details of both images are identical. The two photographs must have been made within moments of each other because the pattern and length of shadows are the same. "Sisters' House (Saron) II" looks like a tentative foray into color photography. It records the scene but doesn't interpret it. It is more literal and lacks the impact of the black-and-white version. "Sisters' House (Saron) I" has that crisp, clean black-and-white aesthetic that makes so many of Swank's images a delight to look at. Although many of his color images, except for his studio food shots, are less aesthetically resolved than his black-and-white ones, there are exceptions.[43]

Swank's granddaughter Grace Swank Davis believes the color transparencies of this period were made because Eastman Kodak sent Swank color film to test.[44] For many years, Kodak sent selected photographers film and allowed them to photograph whatever they wanted. Fortune magazine in 1954 published a portfolio of color images created under this program that included photographs by Ansel Adams, Paul Strand, Sheeler, and Weston. Walker Evans wrote in the introduction to this portfolio that "color photography, that

FIGURE 6-12. Charles Sheeler. Doylestown House, Stairway, Open Door, c. 1916–1917. Gelatin silver print, 9⁷⁄₁₆" x 6¹¹⁄₁₆". © The Lane Collection, Courtesy of Museum of Fine Arts, Boston, L95.3.71.

complex and ingenious invention, is still in its infancy. But it has already reflected, in its uses, the true fresh beauties (as well as the fulsome inanities) of the age."[45] Swank's color work was done more than a decade before Evans made his comments. It is, consequently, possible not only that Swank was doing color experiments under this program but that he was a color pioneer.

Although few of Swank's rural photographs have people in them, they show, nonetheless the impact of people on the land and the interaction of social and economic forces on both land and mankind. "Barren Trees with Split Rail Fence" (plate 97) is one of a small number of photographs that doesn't have a building as a central compositional element. This image, with the stark, barren, vertical trees set behind the horizontal fence, is quiet. Like several of his other rural images, he made this photograph in the fall or winter when the foliage was gone and the underlying structure of life so much easier to see.

Quiet, ever peaceful, yet strong are words that describe this landscape and can also be applied to his stark "Old Mennonite Church, Lancaster Co." (plate 82). In this photograph, most likely made in the fall of 1940, the simplicity of the architecture and the

barrenness of the trees may be seen as a metaphor for a way of life where ornamentation and material gratification are not driving forces. The image presents a simple, sparse, white church with a complex but highly ordered set of trees surrounding it. The sky, as in most of Swank's work, is cloudless, and while the sun is casting shadows of trees on one side of the building, the light is not harsh; rather it is soft, dappled, and humble. It is a light well suited to the culture Swank shows directly in "Three Amish Youths with Buggies" (plate 81). By placing the youths in his frame so that they are small and surrounded by a large number of buggies, Swank makes it clear this is a sizable community of people who have chosen to keep their cultural identity, in a country that increasingly valued assimilation.

While Swank came from wealth, photographing the trappings of the rich never interested him. Instead, both in his rural and urban work, he focused his camera on working people and the poor. He does this without being sentimental or judgmental. His photographs "Florence Post Office" (plate 83), "Wooden Houses on a Hillside" (plate 94), "Victorian Farmhouse, Rt. 30" (plate 95), and "Car, House, and Tree" (plate 96) all present structures once new—their useful lives and the lives of those who built and used them full of hope and promise—but now worn, decrepit, and decaying. These are bleak pictures, but they are not lacking in humanity or hope, because Swank found beauty in all these places. They are strong compositions where each element is in its proper pictorial place. The viewer is presented a contemplative still life of real life and asked to reflect not just on the scene presented but also on the beauty that can be found in decay and decline.

Written on the back of Swank's "Victorian Farmhouse, Rt. 30" is the word "Legacy," a notation found on many rural and urban photographs. Included in this group are several photographs, such as "Victory Produce Co." (plate 112), made in the Strip and Hill Districts of Pittsburgh. At first the images labeled "Legacy" seemed to be unrelated and the notation enigmatic, but it became clear that the images so labeled fit under a broad thematic umbrella. Swank wanted to record portions of the urban and rural landscape under severe economic, social, and cultural pressure and preserve their legacy for future generations.[46]

Vanishing America is an overarching theme that ties Swank's rural and urban studies together. Two additional themes also link them—laundry and signage. In both rural and urban scenes Swank presents a variety of images where laundry line-drying outdoors is an important part of the content and integral to the composition. Other images incorporated vernacular advertising signage.

Swank may have been attracted to laundry drying on outdoor lines in backyards, front yards, and even at the end of narrow paths, because he found the shapes and textures of laundry compositionally fascinating, as it billowed when the wind caught it or became translucent when the sun passed through. Although not a prominent element, laundry is an important detail in "Reiff Farm, Oley Valley" (figure 6-11). Laundry is, however, more central in other rural studies and in his urban photographs "Two Women, Laundry, and Graffiti" (plate 107) and "Child with Laundry" (plate 108). Did Swank recognize that technology was changing how household chores were being done and that washing machines and dryers eventually would replace clotheslines, just as refrigerators replaced iceboxes?

Swank was not the only photographer of the period who incorporated advertising signs into compositions, although he was a master at integrating them into his pictures. Some of Walker Evans's best-known photographs also rely upon signs. In Swank's rural work, signage is evident in "Kidwell's Market" (plate 98) and in "Chew Tub Tobacco" (plate 84). The signage represents both commercial content that provided the viewer with information—for example, buy ice-cold Coca Cola for 5 cents a bottle—and structural compositional elements. The signs add rectangular shapes to the compositions and are structurally similar to the way artists used lines and rectangles as the foundation for their abstract paintings.

By the 1930s, the automobile and greatly improved roads had transformed America. Even though the country was in the midst of the Depression, outdoor advertising represented one of the few growth industries of the period.[47] Billboards and barn sides near roads were effective places for advertisers to communicate with their audiences and for photographers to incorporate consumer messages into their work. Swank's photographs of barns with signage fit within his theme of capturing vanishing parts of America, but paradoxically also anticipated what was to come in the push of American society toward greater material consumption.

Swank photographed rural America, portraying the lyrical beauty found in the contrast of barren trees behind a split-rail fence, the simplicity of a Mennonite church, the decay of an empty building, and the austerity of an abandoned religious cloister. His rural photographs show a quiet, dignified reverence for the past as well as for the places he visited. Whether Swank focused on an architectural detail, an interior, or a landscape with or without buildings or people, these photographs, all formal compositions, are expressions of Swank's modernism.

7 — This Is My City

The image of 1930s America is inextricably linked to a documentary vision as exemplified by the photographs of the Farm Security Administration, the social documentary projects of New York's Photo League, and the photo-essays in picture magazines such as *Life*. William Stott, in his classic book *Documentary Expression and Thirties America*, observed that "The hitherto unimagined existence of workers, minorities, the rural, and the poor was . . . what excited the imagination of most artists and reporters in the thirties. They tried to express the texture and particularity of the common man's life."[1]

Bruce Lockwood, an art critic, observed in the mid-1930s that Luke Swank "exalted the snapshot, which most photographers shun, into an art. Luke Swank is doing for photography what [Gustave] Flaubert did for the novel."[2] Like the great French realist of the nineteenth century, Swank believed in a union of content and form. Anything constituted a valid subject—both the beautiful and the ugly. Although realism was a part of literary tradition by the late nineteenth century, it didn't become a major concern of photographer-artists until the early twentieth century. With his direct, methodical style, Swank was among its pioneers. In his photographs, especially his urban photographs of Pittsburgh, his hand is felt but not seen. He combined the ideas of the realist with his sensibility as a modernist to create his perspective on the American scene. While he concentrated on portraying the common man and explored many of the same themes and subjects as other photographers of the period, his vision was unique. His photographs were not made in the service of social reform, as were those made for the Farm Security Administration, nor in the service of journalism like photo-essays in *Life*. Instead, Swank documented the period as a visual poet.

Stefan Lorant, in his 1964 book *Pittsburgh: The Story of an American City*, provided both an assessment of Swank and a description of the characteristics of his urban imagery: "Luke Swank was one of the greatest photographers who came out of Pittsburgh. He did not romanticize, his sensitive eye focused his camera on reality. He had no desire to beautify, no desire to sentimentalize. His photographs of Pittsburgh . . . show the city as he saw it, grim, hard, cold, dirty, but also vibrant and dynamic."[3]

But Lorant, who was writing solely about the history of Pittsburgh, missed the key to understanding Swank. While Swank believed, according to a 1935 article about him, that Pittsburgh was the most pictorially interesting city in the United States and that the slums and the formerly aristocratic homes on the North Side were fascinating,[4] his work was not merely regional. Swank's work was also about the American experience. He examined what was beginning to slip away, as America became more industrial and less agrarian. While Swank used Pittsburgh as his stage, his imagery transcended place. Where his photographs were made was of little importance; what they revealed about life in the industrial heartland of 1930s America was significant.

Swank's urban photographs can be divided into three groups: broad vistas and long shots of Pittsburgh, the urban environment as formal still life composition, and cinematic frames where people are frozen in space and time. While these categories provide a framework for discussing his photographs, there are no impermeable boundaries between them. And although the photographs can be separated into categories, Swank's consistent approach to light, shape, texture, and form, as well as his humanist vision, tie them together into a coherent body of work.

Swank's early urban work dates to the 1920s, although he didn't

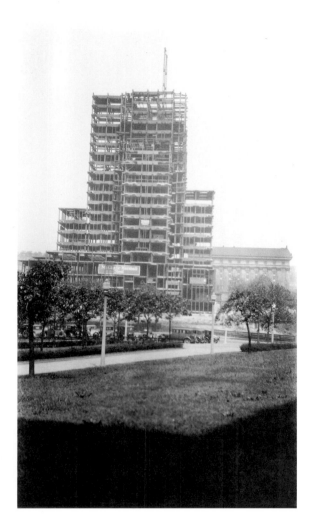

FIGURE 7-1.
Luke Swank.
[Cathedral of Learning under Construction], 1929. Modern gelatin silver print. Carnegie Library of Pittsburgh; Gift of Edith Swank Long, SW1946a.

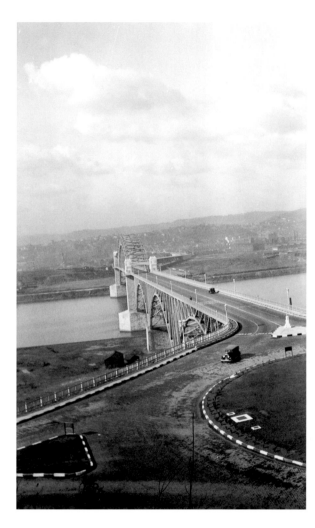

FIGURE 7-2.
Luke Swank.
[McKees Rocks Bridge], c. 1932. Modern gelatin silver print. Carnegie Library of Pittsburgh; Gift of Edith Swank Long, SW2059b.

begin to develop his unique urban vision until the early to mid-1930s.[5] The vision in Swank's early urban photographs is consistent with the optimistic, upbeat view of the machine age prevalent before the economy crashed and the Depression turned hope into despair for so many Americans. Swank's 1929 photograph of the partially built University of Pittsburgh's Cathedral of Learning (figure 7-1) pays homage to the machine age use of steel girders to create a building of monumental size.

Many of his early urban photographs depict easily identifiable public places rather than the anonymous facades of the working-class neighborhoods he favored in his later work. These early photographs celebrated the industrial achievements that new bridges, roads, and buildings represented. From high on Pittsburgh's hills he made long shots that revealed a progressive, changing urban landscape below. Photographs such as "McKees Rocks Bridge" (figure 7-2), a lyrical rendering of the structure begun in 1930 and

completed in 1932, demonstrate his use of man-made landscapes to explore line, shape, and form.

There was, however, a shift in Swank's approach both to steel and the city as the 1920s gave way to the 1930s and the Depression deepened. Gone was the worship of the machine age monument. His subjects changed and his compositions became increasingly sparse. Location was often obliterated. By the mid-1930s, Swank had developed his own approach to image making. He developed a style predicated upon careful composition and contemplation rather than on shooting quickly and making a lot of scattered exposures. It was a style suited to his use of bulky sheet film cameras and perfect for his formal approach to the picture frame.

Beaumont Newhall quoted Swank on his method of working. Swank used an analogy to marksmanship to explain to his students his approach to photography:[6] "He never blindly shoots, and discourages this practice among his students. 'When I was in the

hardware business,' he tells them, 'I bought a Winchester repeating rifle. I used up a lot of ammunition and had a grand time. I got a thrill out of hearing the steady bang bang as the beautiful gun pumped out round after round of shells. But soon I noticed I wasn't hitting the bull's-eye very often. So I got myself a single shooter. When I had to stop and load for each shot, I took a lot more care, and my targets improved right away.'"[7]

Swank's shooting analogy is particularly apt for his urban images. To shoot prey, the hunter's aim needs to be perfect and the moment of release must be precisely anticipated. To photograph effectively, the photographer also must aim and then anticipate the moment to press the shutter. A fraction of a second too soon or too late and the marksman misses his prey or the photographer misses his picture.

The photographs of residential and commercial Pittsburgh represent an interesting paradox. Swank's use of lines, angles, and geometric form; deep shadows as well as intense highlights; and pinpoint sharpness firmly placed him with the modernists. Yet, his choice of subject often hearkened back to nineteenth-century Pittsburgh. These images are reminiscent of the Paris of Eugène Atget, a world that was preserved for posterity even as it was pushed forward into the twentieth century; a world where realism as envisioned by Atget slid seamlessly into surrealism. Atget's aesthetic is discernible in Swank's work, just as it may be seen in the work of Walker Evans, Berenice Abbott, and other photographers of the period. After Atget's death in 1927, Abbott and Julien Levy rescued his work from oblivion. Levy introduced Atget to an American audience in December 1931 and January 1932, which was when Swank first met Levy at his gallery and began their dealer-artist relationship.[8]

It is possible that Swank studied Atget as part of his own educational process, just as he had once carefully looked at Stieglitz's work as a way of learning about composition and light. Regardless of whether Swank was imitative or merely influenced, he took what he found inspiring in Atget, filtered it through the prism of 1930s America, and made it his own. Swank's Pittsburgh, with its reputation as a steel town, bore little resemblance to Paris. Influenced by the grittiness of the city he photographed, Swank produced images with a hardness that is absent from Atget's photographs.

Swank, like Atget, focused broadly on the city as a subject. Both men looked at the older parts of their respective cities, photographed street scenes, and moved in close to focus on shop windows. They produced images that evoke the presence of people, even when none are seen. The architecture of old Paris is so different

FIGURE 7-3. Eugène Atget. Brocanteur, 4 rue des Anglais, Paris, 1910–1911. Gelatin silver print, 9½" x 7". Carnegie Museum of Art, Pittsburgh; Gift of L. Bradley Camp, 84.87.5.

from working-class Pittsburgh that it is surprising to see that a similar aesthetic is so readily apparent. Because Atget favored a wider lens than Swank, Atget's images tend to have more spatial depth while space in Swank's images often is more compressed.[9]

Atget's "Brocanteur, 4 rue des Anglais, Paris" (figure 7-3) and Swank's "John Bonato Co. Clothiers" (plate 120) both use the patterns and textures created by the way light plays off the surfaces of the hanging clothes to transform them from mundane objects barely worth a glance into interesting formal elements worth visually exploring. Atget positioned his camera to fill his frame with a view of the shop as seen from an oblique angle, while Swank positioned his camera head-on to his subject. Much of Swank's photography can be defined by this frontal approach. In "John Bonato Co. Clothiers," the picture space ends up flattened because Swank completely filled his frame with a visual if not a literal wall. Swank also photographed a man leaning against the light pole from behind and used strong shadows as integral parts of his composition. The shadow of the man dissolves into the shadow of the pole, helping to connect separate visual planes.

Although both Atget and Swank frequently photographed shop windows, they often approached the problem differently. Just as with the fuller street scenes, the angle of view is often more oblique

66

FIGURE 7-4.
Eugène Atget.
Balcon, 17 rue du
Petit-Pont, 1913.
Gelatin silver
printing-out paper
print from dry plate
negative, 8⁹⁄₁₆" x 7".
The Museum of
Modern Art, New
York, 1.1969.1947.
Digital image © The
Museum of Modern
Art, New York/
Licensed by SCALA/
Art Resource, New
York.

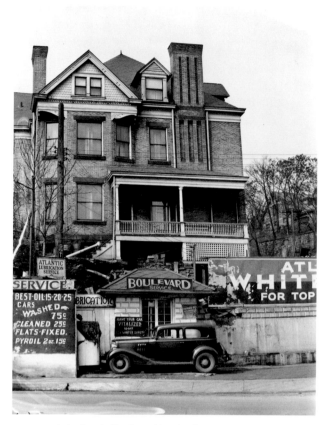

FIGURE 7-5. Luke Swank. [Boulevard Service I], c. 1940.
Modern gelatin silver print. Carnegie Library of Pittsburgh; Gift of Edith Swank Long, SW1497.

and the scene is typically wider in Atget's shop windows. Atget's "Balcon, 17 rue du Petit-Pont" (figure 7-4) presents a multilayered image that combines the shoes hanging in front of the shop window with the geometric structure of the repeating rectangles of the building and the ornamental grillwork of the balcony. Swank was more direct, isolating the shoes and creating more of an abstract still life than an urban street scene in "Shoes in Store Window" (plate 121). In this second image based on the Bonato storefront, Swank used shoes to create pattern, and light reflecting off the shoes to provide depth and dimension. In this still life, like in many of his other store window close-ups, he looked into a space that dissolved into a void. "Men's Coats" (plate 122), the third photograph using the Bonato storefront, combines the strong verticals and gentle curves of the coat sleeves with a tattered awning. The camera has been tilted slightly. This provides visual energy and helps the image escape documentary confines and be transformed into a study in abstraction and form.

The three photographs of the Bonato store as well as a series of images Swank made of the Boulevard Service Station provide clues to how he approached making his photographs. From these two sets of three photographs each, it can be deduced that Swank approached a scene by first focusing on the general and then moving in closer and shifting his angle of view to locate the particular. In cinematic terms,

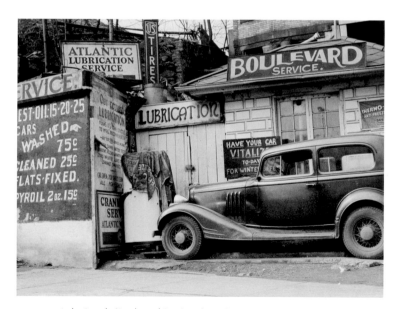

FIGURE 7-6. Luke Swank. [Boulevard Service II], c. 1940.
Gelatin silver print, 6¹⁄₁₆" x 7¹⁵⁄₁₆". Carnegie Library of Pittsburgh; Gift of Edith Swank Long, SW92.

he began with the long shot and then moved in and around his subject looking for the best story-telling details and the most arresting visual frame. This can be seen by comparing Swank's distant view of his "Boulevard Service I" (figure 7-5) to the tighter, head-on view of "Boulevard Service II" (figure 7-6) and finally to his oblique-angle close-up of "Boulevard Service III" (plate 126). In "Boulevard Service II," Swank moved in close and eliminated from the field of view the house that is above and behind the station and trees, as well as a large portion of a sign on the right. All of these details in "Boulevard Service I" make it difficult to focus on the service station, signage, and car. In "Boulevard Service III," the most visually arresting frame, his shift in angle created a more dynamic composition that forces the viewer to interact with the car and signs.

Just as Swank integrated signage into his rural studies, he used signs, posters, and billboards in many of his urban photographs, as can be seen, for example, in "Benkovitz's Fish Market" (plate 115), "Grocery Store," (plate 117), "Corner Store" (plate 127), "Drink Bubble Up" (plate 129), and "Pressing" (plate 130). The signs in these images of the 1930s have an almost quaint quality, viewed from a distance of almost three-quarters of a century. Their quaintness was often enhanced by the hand-drawn or -painted character of the signs, as well as by the use of period drawings and photographs.

Pittsburgh in the 1930s was a steel town with extremely wealthy industrialists along with the working poor. While Swank never lost sight of the way industry shaped the city and its surrounding communities, he chose to focus almost exclusively not on wealth but on working-class Pittsburgh, as exemplified by "Apartment House with Wash Tubs" (plate 139). Many long shots present grand views of this industrial city shaped by its rivers, hills, and bridges. "Those Steps" (plate 136) shows one of Pittsburgh's hills where working-class families resided, with the city laid out below. "Kroger Grocery/Baking Co." (plate 131) explored the way light played off the clouds to create luminous reflections in the water. Complete with a belching smokestack, the bakery is defined by its silhouetted shape as Swank described Pittsburgh's relationship to its rivers. This view is the one urban photograph in the book that hearkens back to pictorialism and is reminiscent of the manner in which Stieglitz handled light. It is romantic and nostalgic while the vast bulk of Swank's other urban images are modern and hard. Although undated, it makes sense that this image, an anomaly within the group, was an early one.

"Street Scene with Steam Train" (plate 119) and "December Day"[10] (plate 118) reveal a gritty realism that "Kroger Grocery/Baking Co." lacks. The presence of the mills is overt in "December

Day," the atmosphere thick with the soot and grime that were part of life where steel was made. In "December Day," which was published in the 1941 *U. S. Camera Annual*, Swank used the dark buildings on the sides of his picture frame to direct the viewer down the center of the street to the critical focal point of his image, the small child at the crossroads of the streets who is almost obliterated by the thick haze of air pollution created by the nearby mills.

"December Day" was singled out in 1941 by one critic who viewed what Swank was portraying in his pictures of Pittsburgh as analogous to what the British photographer Bill Brandt was doing with his photographs of the slums of London. Percy Seitlin wrote in *AD*, a magazine devoted to the arts, that "Luke Swank's Pittsburgh slum, with its sole figure of a child on a grimy street is as good as Bill Brandt's great pictures of London slums."[11] Brandt was well known for his interpretation of working-class British life. While Swank shared an affinity for this subject matter with Brandt, Swank presented the world as a more full-toned, nuanced place than Brandt, who was also well known for images with stark tonal contrasts and less formally constructed frames.

"Street Scene with Steam Train" contrasts the old cobblestone street and the worn houses of workers to modern, commercial Pittsburgh. The scene is cut in two as a steam engine moves along the riverfront. Seen in the distance is a dreamlike view of modern office buildings in Pittsburgh's Golden Triangle, softened by the ever-present industrial haze. The compositional device used here—leading lines creating a visual funnel to direct the viewer through the frame—is familiar in Swank's work, but this is one of the few images he made that overtly contrasts the old and new.[12]

"River Barges and Steel Mill" (plate 134) and "Automobiles, Cobblestone Street, and Steel Mill" (plate 135) both present views that depend on repetition of shape and form for their graphic power. Because of the angle that Swank employed with these images, there is a great sense of depth as strong lines again help move the viewer's eyes through the visual space. While Swank employed compositional devices to extend the sense of space in these images, he used a different compositional method in "Skunk Hollow Looking toward Bloomfield" (plate 133), where the visual space became flatter and more contained even though logic tells the viewer that a large distance is covered in this photograph. "Skunk Hollow Looking toward Bloomfield" derives its visual strength from the strong horizontal of the train and tracks that contrast with the verticals of the chimney in the foreground and the church spire in the background. These compositional elements frame and contain the working-class buildings. The dark train set off from the light-colored

concrete wall, the detail in the debris-strewn hill, and the clearly defined rectangles of the windows enhanced by highlights, engage the viewer.

Either Swank made few urban studies without people, or few have survived. "Corner Store" (plate 127) exudes the presence of people, but reveals none. It is as if Swank asks his viewers to contemplate what might have appeared from around the corner, if he had not frozen the moment. While it is a still life of a street corner, its intersecting planes and angles, shadows and highlights, words and symbols imbue "Corner Store" with a tremendous contained and restrained energy. This image, with its signs advertising products such as Coca Cola that are still part of our consumer landscape, and Avalon cigarettes that are long gone, is quintessentially a Swank—defined by the way he framed his scene, used shadow, and let the shop window slowly dissolve into a black void.

"Pittsburgh #12" (plate 114) and "Watch Tower, Liberty Avenue Near 28th Street" (plate 128) are from Swank's study of the Strip District. The Strip District in Pittsburgh still has open-air produce shops, butchers, fish markets, bakeries, and Italian delicatessens seventy years after Swank made his photographs. While significantly changed, the Strip retains some of the feel that Swank found and remains recognizable as the place he photographed. "Pittsburgh #12," one of Swank's five photographs of Pittsburgh that were accepted into the First Salon of Pure Photography, epitomizes the modernist aesthetic. Its publication in 1934 confirmed that Swank was seriously exploring Pittsburgh locations before he moved from Johnstown in 1935. "Pittsburgh #12" is one of only a few photographs that he titled; apparently he had developed a simple numerical title system for his Pittsburgh photographs. Unfortunately, the documentation necessary for reconstruction of his system has been lost.

"Pittsburgh #12" is more frontal than "Corner Store." It also holds its focus from front to back, whereas the light-colored clapboard house in "Corner Store" was thrown just a little out of focus, which helped to push the viewer's gaze back to the signs on the storefront and in the store windows. In "Pittsburgh #12," Swank imposed visual order where a passerby at the actual scene would have seen cluttered space. The frame invites the viewer to carefully look and examine not just the baskets, but also the coiled hanging ropes, the box of matches, and the boxes of cigarettes stacked one upon the other—Chesterfields, Wings, Sweet Grands, and Paul Jones, all now gone like the Avalon woman and her cigarettes in "Corner Store."

Swank's formalism is also manifest in his "Car and Building"

(plate 123). This is a study in rectangles, lines, and textures interrupted by the circles of the car wheel and headlamps and the fluid curve of the car's fender. The composition is quiet and elegant and contrasts with the shabbiness of the building and street.

With the exception of workers in the interior of steel mills and a few interiors of the Ephrata Cloister and other historical structures, Swank didn't photograph interiors. While he photographed shop windows, he always looked in rather than went in. So when an engaging interior view appears, it is a surprise. Swank's "Emmanuel Episcopal Church Organ" (plate 111), like his other still life images, is formal. It relies on the angles created as he looked down at the organ on the landing and at the patterns made by the floorboards, steps, wall, and railing to provide eye movement and energy. This study in contrasts balances the darkness of the organ with the void created by the staircase.

Dramatic light was important to Swank's aesthetic. It was first seen in his early portraits of his wife Grace. Many of his urban photographs reveal a flair for using dramatic light as a compositional element. Although he abandoned the artificial light of the studio, he finely honed his skill in using dramatic natural light found on the street. In "Street Corner with Shadows" (plate 99) Swank placed his camera low to the ground. He treated the scene as if the city was a tall canyon and the people and cars on the street were spread along the canyon's base. "Street Corner with Shadows" is a modern, edgy composition with strong leading lines that direct the eye from the front of the canyon through to the back.[13] It is one of the earliest examples of Swank's use of the ephemeral shadow as an important pictorial and compositional element—one of his signature traits. The power of the composition depends on its strong verticality and the perfectly composed shadow in the foreground.

While light that casts strong shadows is often most dramatic, Swank demonstrated with his "Rooftops" (plate 140) that drama also could be created with the near absence of light. "Rooftops" depends for its strength on the lines, shapes, and textures contained within the subtle tonal values of the rooftops in shadow, set off against the outline of their structures that are brought into relief by the overcast sky.

Street life played an important role in Swank's urban photographs, with the street itself becoming Swank's stage. People in Swank's urban images rarely feel posed. They often appear as small figures, sometimes walking, sometimes standing, sometimes leaning against poles or walls. People are seldom dominant but they are almost always critical elements within the frame. Many of Swank's urban scenes are tightly drawn pregnant moments where the tension

is great because something is about to happen, not a big something but a small, human moment. Swank's images entice the viewer into the scene. The viewer wonders what will happen in this urban theater Swank created but never sees the action completed or learns what happened next.

In several images, Swank composed his frame to create a funneling effect where the eye is directed into a visual canyon that created a dynamic space for the players to appear. In "Man Crossing City Street" (plate 100), a man in a suit seen from behind wears a fedora and carries an umbrella, walks in a triangle of light that points directly to the corner of a building where another man is blanketed in shadow. This second man casually leans against the side of the building. In the left of the frame is the back half of a taxi. Swank presented a moment that featured anonymous subjects and was without social consequence. Yet, it is a perfectly seen moment; each element is in its proper place. It is not just that Swank saw an interesting image with beautiful light, but that he waited until people—his unwitting actors and accomplices—found their perfect marks and only then did he release his shutter.[14] What elevates this photograph above the mundane is the perfect arrangement of details; little nuances of body language reveal a head turned to just the correct angle, the legs perfectly spaced so light separates them and the left leg bent with the left foot stopped in motion. This sort of subtle vision also imbues Swank's street scenes with their cinematic quality. They seem not only to be the one frame that was pulled out of a continuous sequence of frames but also to be the perfect moment to have been frozen in time.

"Fifth and Liberty" (plate 101) presents a more complicated composition. Trolley tracks cut the frame diagonally in two as well as lend a graceful curve to the composition. There are many vehicles and lots of people, some of whom are clustered in small groups while others walk alone. On a formal level, the photograph is about the textures and patterns created by these elements. But it also transcends formal modernism and moves toward surrealism. Why, one wonders, is the street circled by vehicles that appear to be stopped, yet the center of the composition—the main stage—is filled with people, some of whom are standing and talking in small clusters while others hurry across the street? It is an enigmatic moment presented for his viewer's contemplation.

Both "Man Crossing City Street" and "Fifth and Liberty" also provide a glimpse of downtown city life not often seen in Swank's work. More typical are his photographs of neighborhoods such as the Strip, Hill District, and the North Side.

Swank did a study of Logan Street in the late 1930s where he explored ethnic cultures including Jewish and African American life.[15] By the late 1930s, sections of Logan Street remained Jewish while other parts had become primarily African American.[16] "Logan Meat Market" (plate 113), one of the images from the Logan Street series, shows three African American men standing on the corner, each apparently oblivious to Swank. All appear to be looking off to the right. Were they looking at something or was this a more directed photograph than it would seem to be at first glance?

Swank's photographs of street corner society reveal many subjects shot from behind. Even subjects who are generally looking in his direction seem unaware of him. Were his subjects aware of his presence or did they unknowingly become accomplices in Swank's little dramatic vignettes? No doubt, some were aware, even though he positioned his camera far enough away that in many situations, he may not have been noticed.

The distance from camera to subject that Swank used over and over separates his photographs from most work by other photographers of the period. Walker Evans, Berenice Abbott, Dorothea Lange, and Margaret Bourke-White tended to get much closer to their subjects and often concentrate on the person. They were making statements about specific people. Swank was creating scenes where people's lives, for a brief moment, were played out on the stage he set.

"We Serve Fort Pitt Beer" (plate 116) shows a leisurely moment on a warm afternoon. As with so many of Swank's photographs, there are layers of shadow and highlight and all the central players are bathed in light. This photograph also relies, like "Shoe Doctor" (plate 125), on frames within frames. In "Shoe Doctor," Swank found the moment when the light penetrates into the interior space far enough to illuminate the cobbler tending to his repair work, but the light falls off rapidly, leaving the cobbler isolated within one of the many rectangular frames. "We Serve Fort Pitt Beer" invites study of the repeating rectangles created by windows, doors, and architectural decoration that is enhanced by mostly rectangular signage and the white door on the black truck. The body position of the man holding the newspaper under his arm mimics the shape of the Philip Morris man in the window sign and the seated man looking toward the woman standing within her own rectangular space are the small, but critical, details that make this picture, like "Shoe Doctor," an enduring one.

Repeating rectangles are also important compositional elements in "Catacombs" (plate 106), "Beplen Street" (plate 103), "Waiting" (plate 104), and "Woman Walking" (plate 105). "Catacombs" is the one image in this group where the subject and Swank have direct

eye contact. The girl, whose body just breaks the frame of the tall doorway, stares directly at Swank. Does this eye contact provide tacit approval to be part of Swank's unfolding drama of life or is it recrimination for intruding into her space?

"Waiting" shows a man framed in the doorway at the top of the steps looking off to the left. At the bottom of the steps is a woman, arms folded, head tilted down and to the right. She looks hard, perhaps upset and totally separated—physically as well as psychologically—from the man. What is he looking at? What is she waiting for? Why, while so close, are they so far apart, so alienated?

"Woman Walking" asks fewer questions than "Waiting" but is no less rich. Perhaps because the woman, dressed in clothes better than one might expect for the location she is in, walks down the hill completely unaware of Swank's camera, this picture looks more spontaneous. This image is another one that relies heavily on repeating rectangles and gains much of its interest from the interruptions to the regularity of those shapes. The rectangles are transformed into more complex spaces and ideas by the tattered but curtained second-floor windows that suggest that the building is occupied, and the first floor with its graffiti-covered, broken windows suggesting abandonment.

From a graphic perspective, "Beplen Street" is the most complicated of the group. The boy, who is looking down and toward Swank, is aware of his presence but does not directly engage Swank, unlike the girl in Catacombs. This picture is unsettling; something isn't right when the viewer first engages it. It takes time to explore the variety of contrasting rectilinear spaces and then it slowly becomes clear what Swank has done. The house sits at the corner of a street that is angled. The home that is next to it is also set at an angle. The perspective Swank got from his camera position makes the corner home seem to only have a front surface while the one next to it is pressed against the one-dimensional home. This photograph, more than any other by Swank, has cubist overtones.

It is the details that make Swank's photographs burst with life. "Man Looking Out Window" (plate 110) would be nothing without the small figure of the man standing statuelike, framed by the window and nestled into the curve of the ironwork of the fence. "Oakland Soho" (plate 137) would fall flat without the little girl walking up the steep road, and "Street Shadows" (plate 124) would lose all of its mystery without the silhouette that is suggestive of a couple embracing being repeated on the side of the houses. The way Swank framed the sunlit man standing in the doorway with one hand cradling the other in "Looking at a Man through a Car Window" (plate 109) reveals that this image is about nuanced moments.

These details and moments, so clearly seen by Swank, set his work apart.

Swank's photographs are not loud and brash. They are quiet, yet they gently and firmly ask to be studied. Swank's images don't reveal themselves all at once. They invite the viewer to look deeply into each nook and cranny, to peer into every window, to examine every surface, to revel in the textures of surfaces made tactile by being bathed in light and rendered mysterious as objects slide in and out of shadow.

With shadow playing such a dominant role in so many of Swank's images, it is not surprising that some people thought that his vision, by the late 1930s, was dark and gloomy.[17] While it is true that there is darkness in many of Swank's images, it is due to the deep shadows, not to a brooding sense of despair. It is just as true that in Swank's images there is light that not only illuminates a physical space but also reveals his inherent optimism. The light in "Child with Laundry" (plate 108) passes through the translucent laundry drying on the line and bathes the head of the child. And like "Corner of South Canal and Madison" (plate 138), "Child with Laundry" uses a tunnel-like frame that moves the viewer through darkness to reveal a luminescent reality at the other end.

Shadow in the foreground gives way to the sun that cuts across the surface of the storefront in "Grocery Store" (plate 117) and then dissolves into the dark recesses of the store's interior. The two women, wearing identical uniforms, appear to be engaged in conversation. "Victory Produce Co." (plate 112) is a mixture of patterns created by the stacked baskets illuminated by the sun, the various shapes created by the shadows, all of which frame the woman in the print dress. She leans against the barrel and the angle of her arm, the curve of her back and the way she holds her head suggest this is a moment of relaxation, a moment to savor. "Benkovitz's Fish Market" (plate 115), part of Swank's Logan Street series, is less formal than "Grocery Store" or "Victory Produce Co." While "Benkovitz's Fish Market" relies on the same mix of light and shadow and the same compositional precision of these images, it depends for its visual strength on the precise spot within the picture frame that Swank froze the young women, as they walked in front of the store.

"Train Shed" (plate 141) is a study in contrasts. The photograph relies on patches of dappled light that come through the windows to illuminate his subjects. Whatever electric light may have been on in the waiting area of the train shed has been completely overpowered by the natural light that floods through the windows transforming the building into a set of intriguing abstract patterns, some of which

are melded to the backs of his subjects. Depicted here are men and women, smartly clothed in suits and dresses and all wearing the hats that were part of everyday attire in the 1930s. Two women stand next to men, facing toward the camera, faces bathed in light. Some of the men are reading newspapers, some standing and waiting, while others hurry through the area. Almost all are seen from behind, fitting the general sense of anonymity that defined much of Swank's work. This photograph shows people whose lives seem comfortable, at least on the surface. They are waiting to go home after a day working or shopping, while Swank also records the visual cacophony playing at their feet, which is perhaps the reason he was moved to make this image.

"Monongahela River, Pittsburgh" (plate 132) shows the exterior of the train shed in the left corner of the photograph. While "Train Shed" shows that for some, life retained its normalcy during tough times, "Monongahela River, Pittsburgh" shows an entirely different reality. Life is hard for the men under the bridge, some of whom warm themselves over a fire. They are shown small, distant, and fragile, huddled under the bridge, next to the train shed that in many respects could be a million miles away. "Monongahela River, Pittsburgh" is the perfect expression of the Depression. It relies on stark contrast to create the strong shapes that provided Swank his stage. The top third of the image is the underside of a bridge in deep shadow with little detail. It is almost reduced to a flat black area that visually as well as physically acts as a weight helping to make the overcast sky appear much lighter in contrast.

Swank's poetic images of urban life were created when he seized unscripted moments from the flow of time, when someone doing something quite mundane became the critical element in his composition. The tension in Swank's urban compositions is palpable; the moment of exposure is exquisitely precise, occurring just as the people within the frame have moved into the spot where their presence and their body language results in a perfectly seen composition. They encapsulate what the French photojournalist/surrealist Henri Cartier-Bresson would describe as the "decisive moment," when all the elements within the frame coalesce into a powerful composition and, in the blink of an eye, turn back into an ordinary scene.[18]

Swank's photographs are intimate without being intrusive. Swank viewed the picture frame as his stage, the people in the frame as actors, and the moment of exposure as the dramatic climax. "Old Woman Crossing the Street" (plate 102) shows a frail, stooped woman in the middle of curving trolley tracks. "Two Woman, Laundry, and Graffiti" (plate 107) depicts a woman walking into her dirt courtyard past graffiti-covered outbuildings, while another woman stands shadowed in a darkened doorway, her face and arms illuminated. Both represent once-fleeting, ordinary moments that Swank elevated through his extraordinary vision. These photographs demand attention, pull the eye into the scene, and reward the viewer with an evocative visual narrative.

Social documentary photography in the 1930s became a mirror for a society struggling with poverty, labor unrest, and issues of class and race. Although the social documentary was a powerful tool, as William Stott commented, it was not "the thing that held American society together in the thirties. . . . It was imagination with a strong fellow feeling: it was human sympathy."[19] And Swank, in his direct manner, presented the lives of his subjects with sympathy and dignity but without sentiment or judgment. Swank's study of Pittsburgh was urban poetry, an elegy to urban life. He approached his picture frame with the tools of a modernist, filled it with the vision of a realist, and created with his photographs a unique, poetic exploration of American culture.

PLATES

Steel 1–28

Circus 29–53

People 54–68

Transformations 69–79

Rural Architecture and Landscape 80–98

This Is My City 99–141

Almost all of the reproductions of Swank's photographs were
made from vintage prints, electronically retouched to eliminate dust
marks, scratches from reproduction, and other obvious signs of
degradation, in an attempt to present the photographs as they would
have appeared in Swank's lifetime.

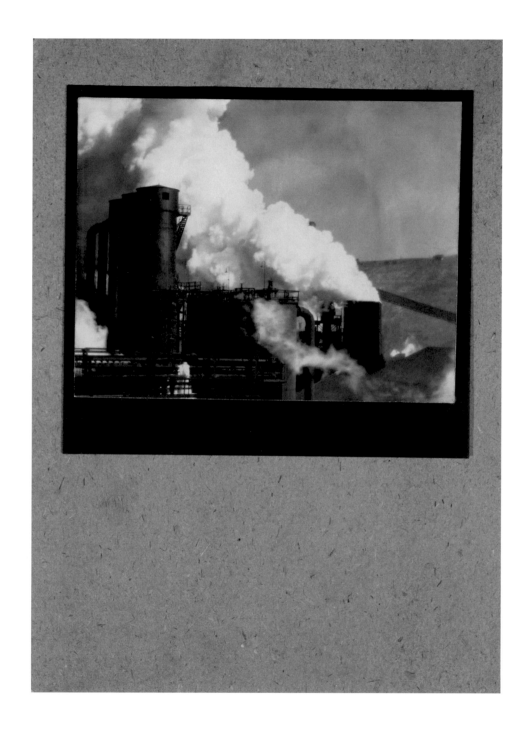

1. [Blast Furnace Stoves and Washer], c. 1927–1930

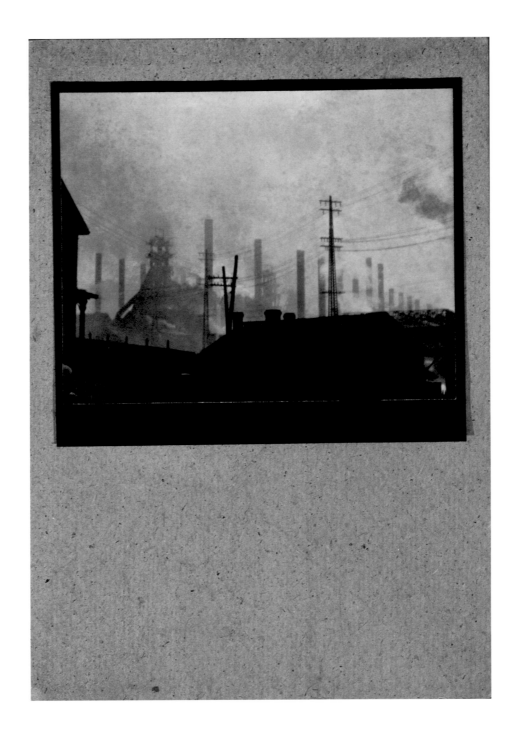

2. [Blast Furnace], c. 1927–1930

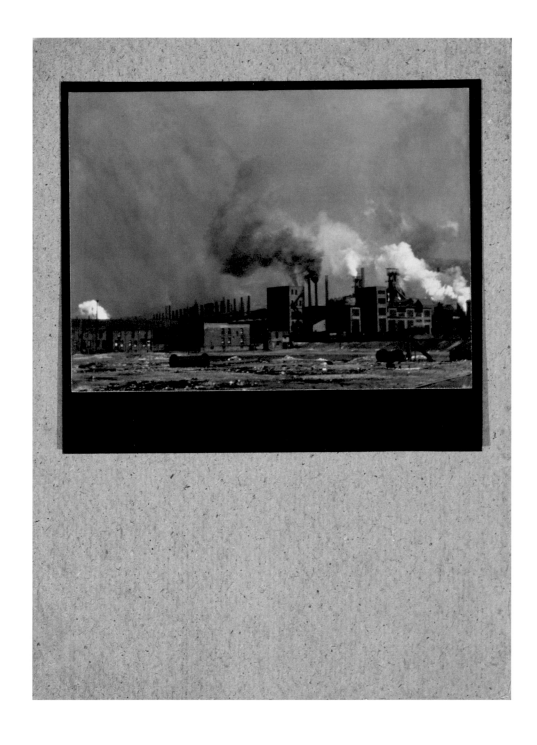

3. [Steel Plant], c. 1927–1930

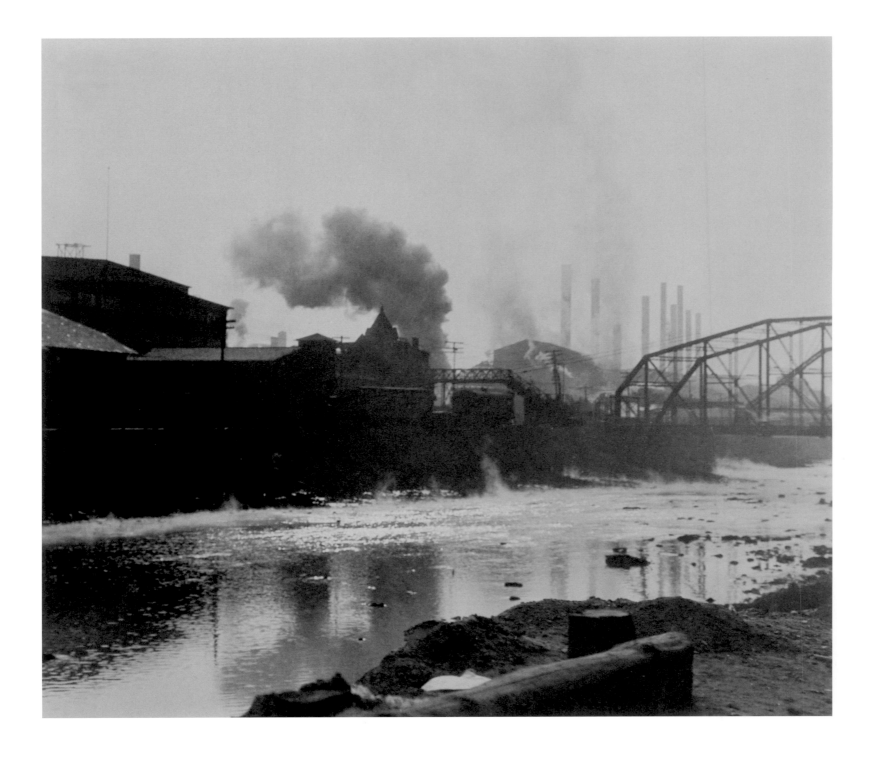

4. [Lower Cambria Works], c. 1930

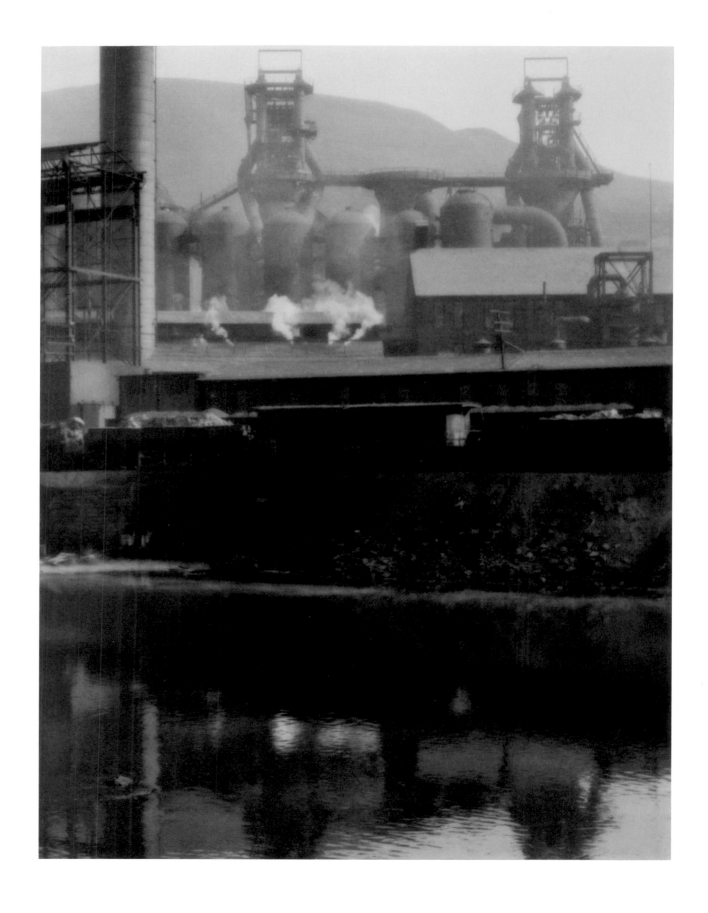

5. [Blast Furnaces,
Lower Cambria
Works], c. 1930

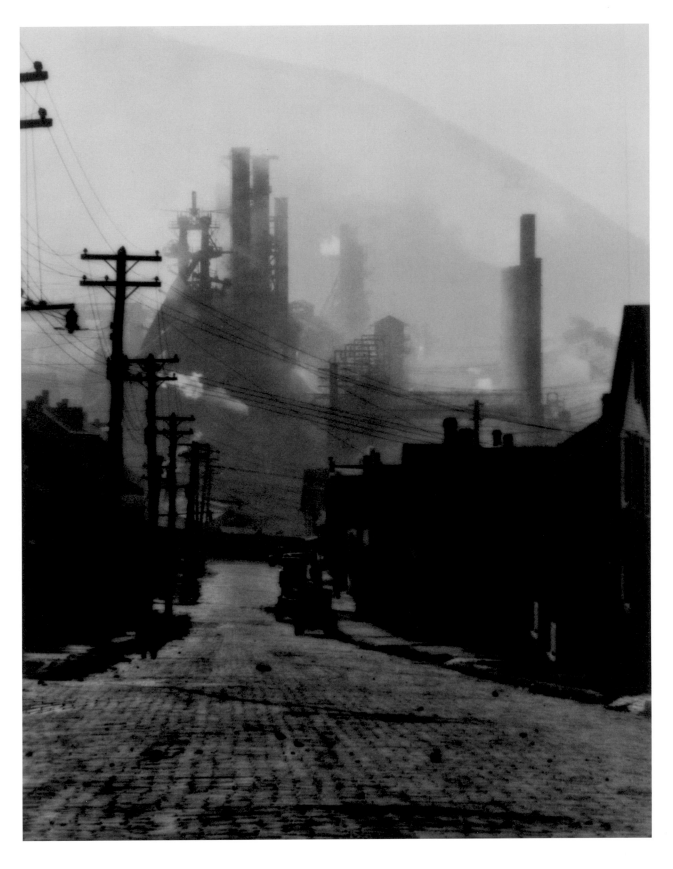

6. [Spruce Street,
Franklin Borough I],
c. 1930

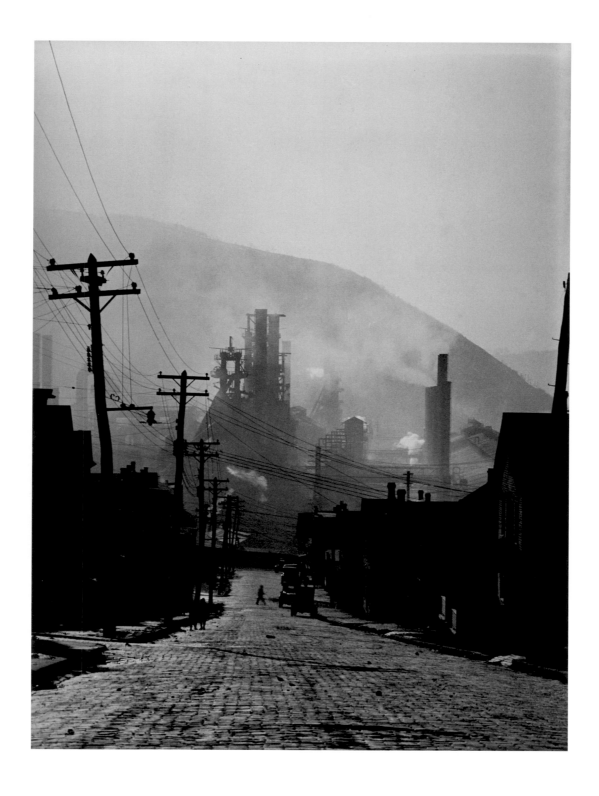

7. [Spruce Street, Franklin Borough II], negative c. 1930, print c. 1938

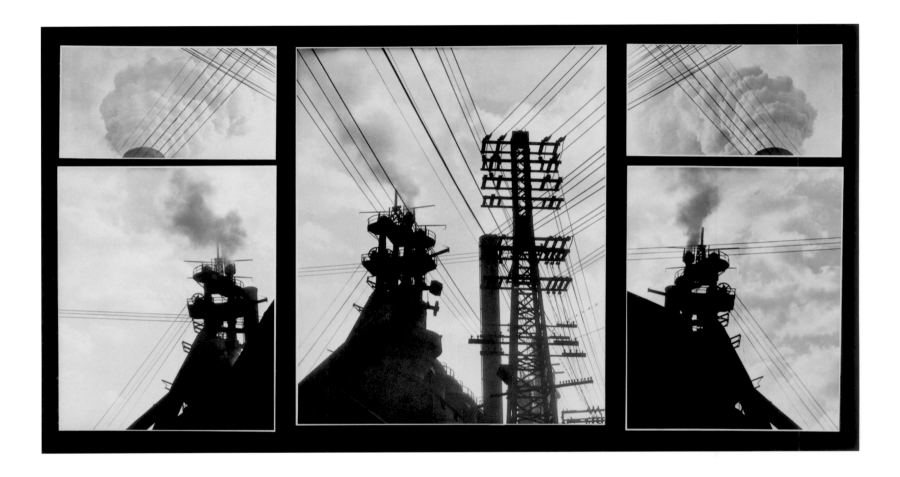

8. Steel Plant (design for mural), 1932

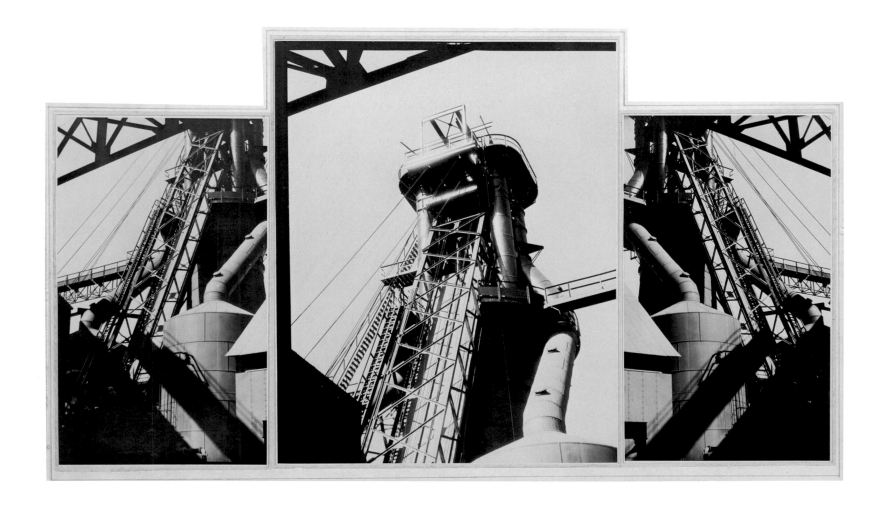

9. [Skip Bridge and Dust Catcher I] (design for mural), 1932

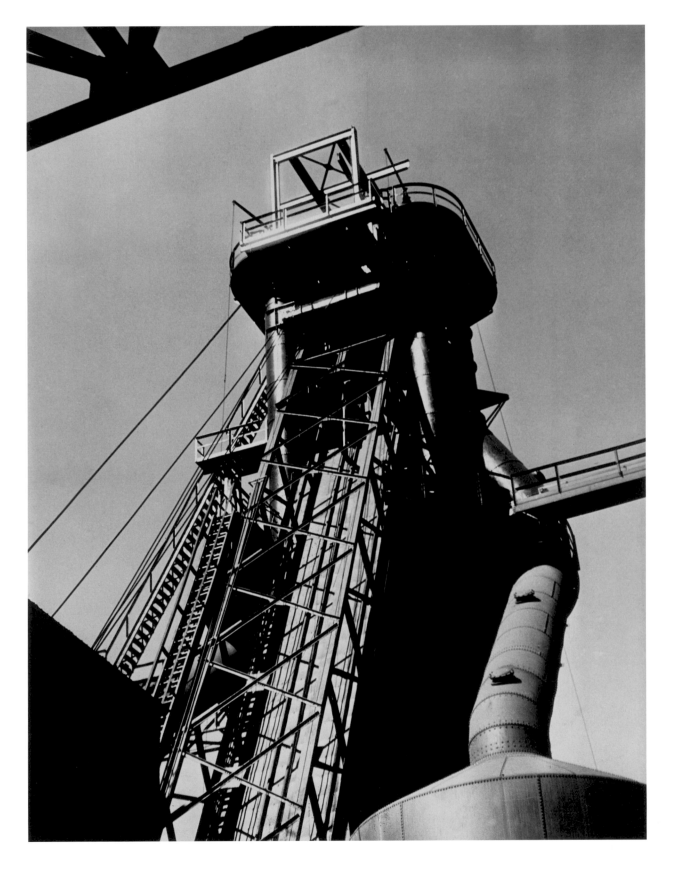

10. [Skip Bridge],
c. 1930–1932

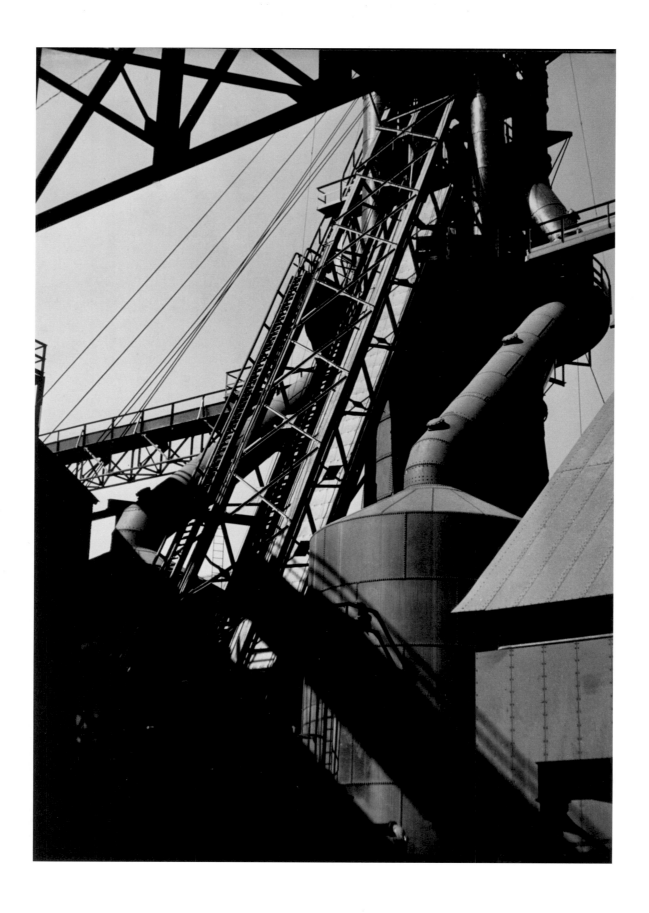

11. [Skip Bridge and
Dust Catcher II],
c. 1930–1932

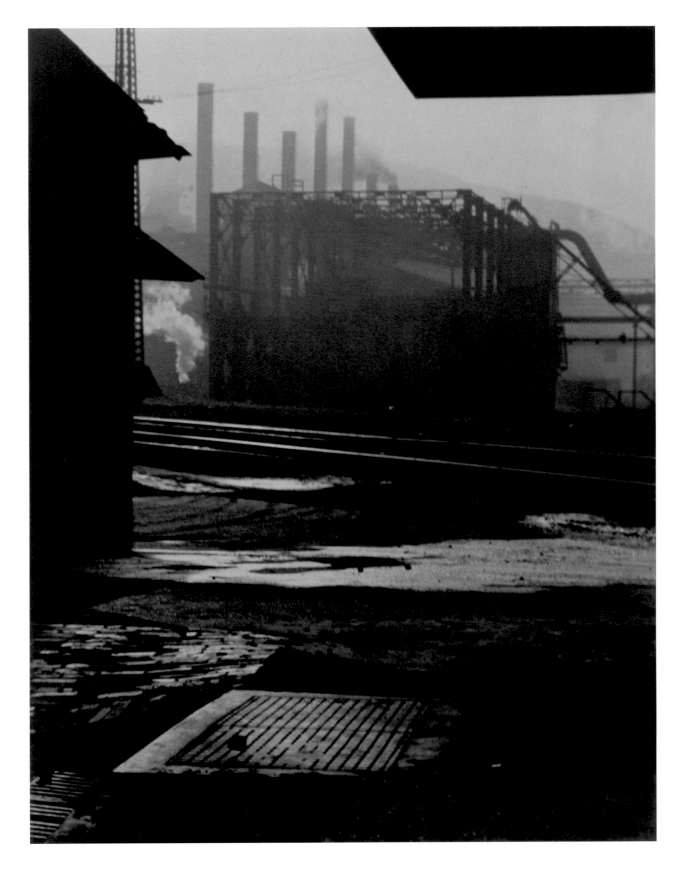

12. [Franklin Borough],
c. 1930

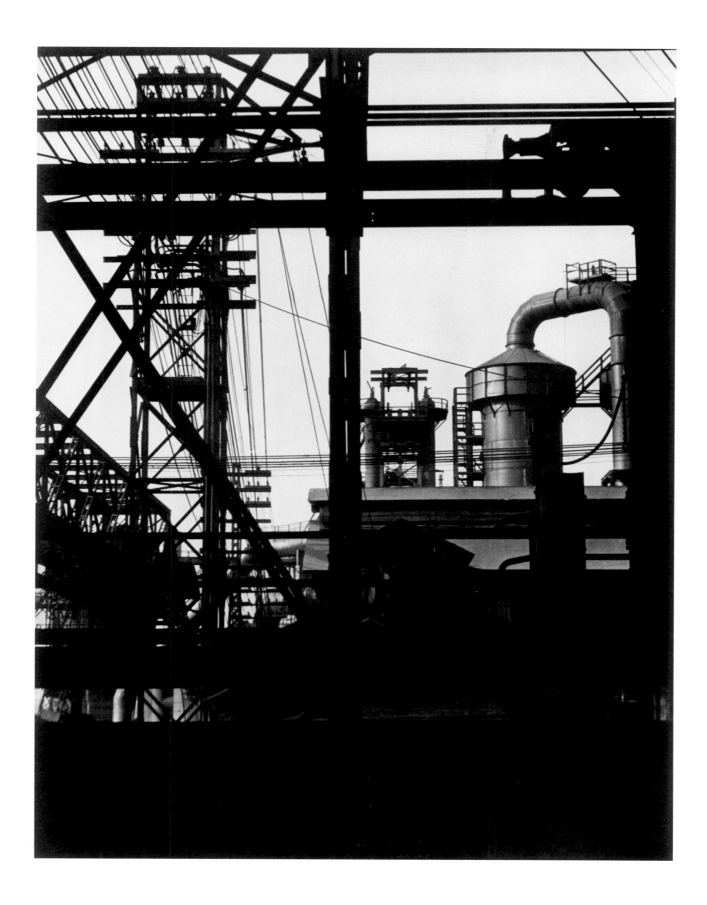

13. [Blast Furnace
Area, Franklin Works],
c. 1930

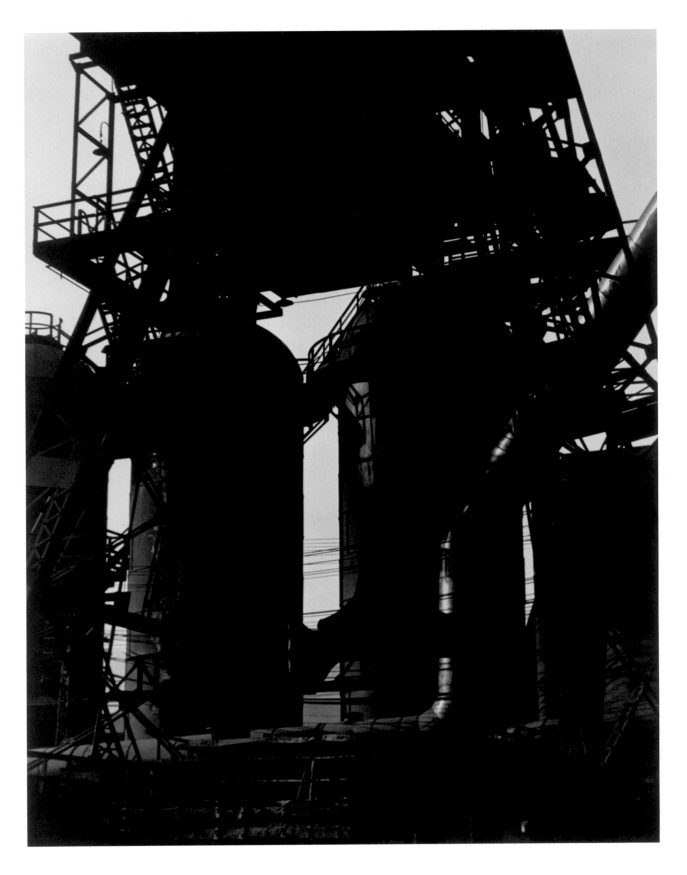

14. [Hot Blast Stoves
and Ore Bridge,
Franklin Works],
c. 1930

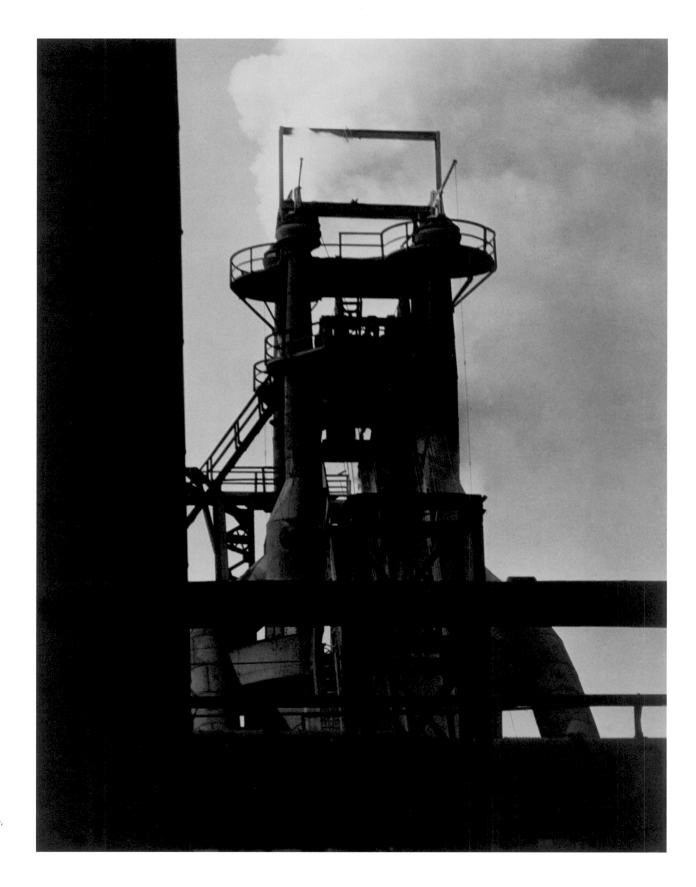

15. [Blast Furnace Top,
Franklin Works],
c. 1930

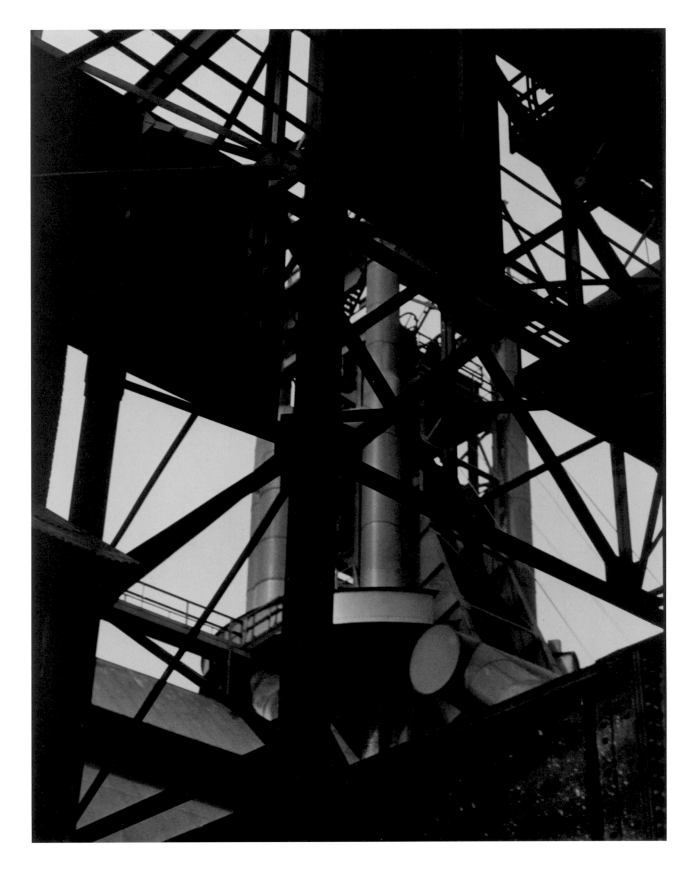

16. [Top of Blast
Furnace], c. 1930

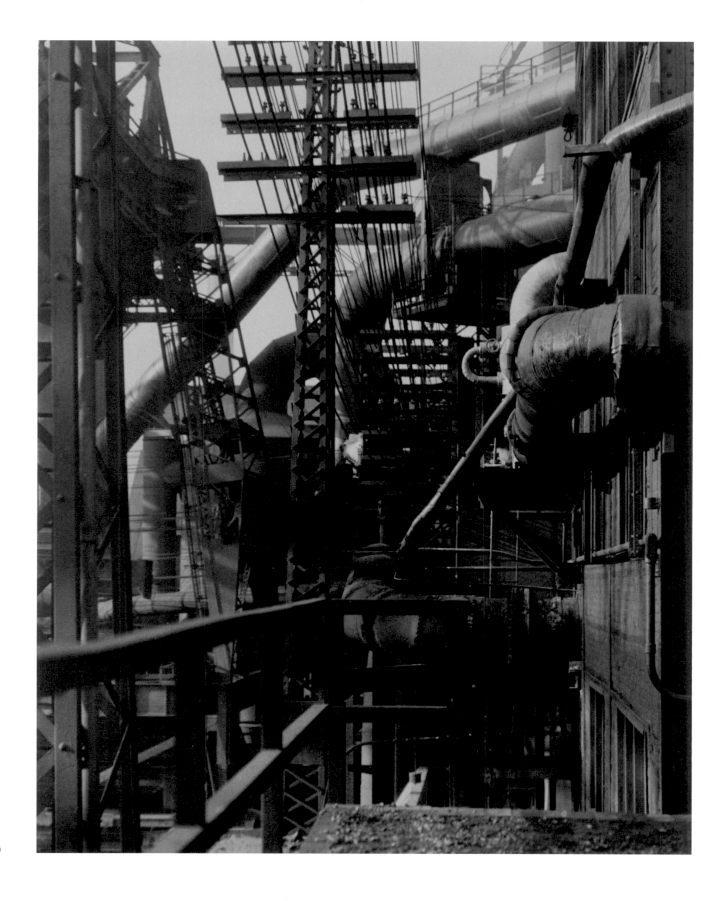

17. [Stacks], c. 1930

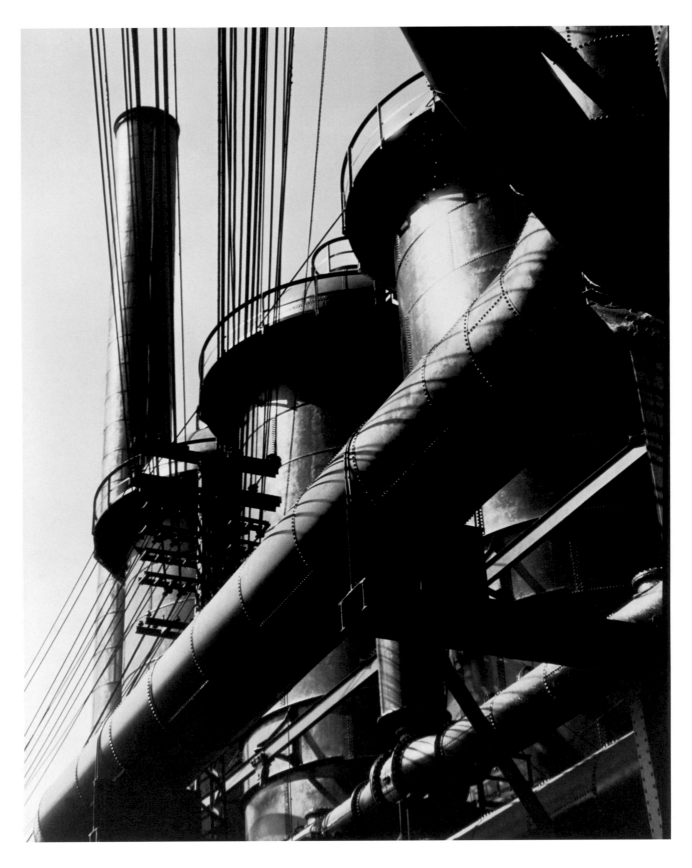

18. [Hot Blast Stoves
and Waste Heat
Stack], c. 1930–1932

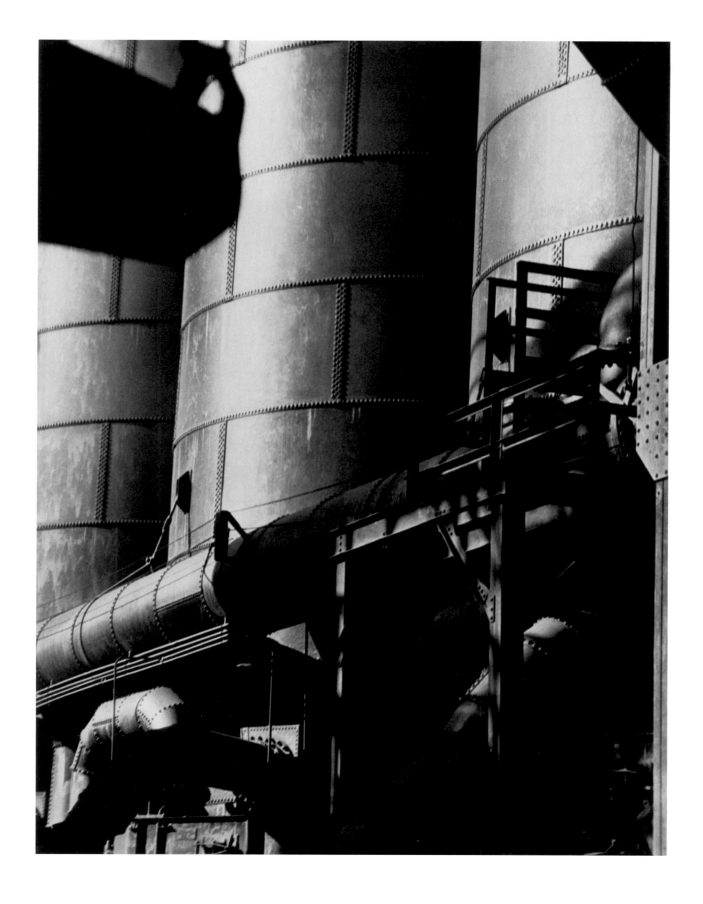

19. [Hot Blast Main
and Stoves, Franklin
Works], c. 1930

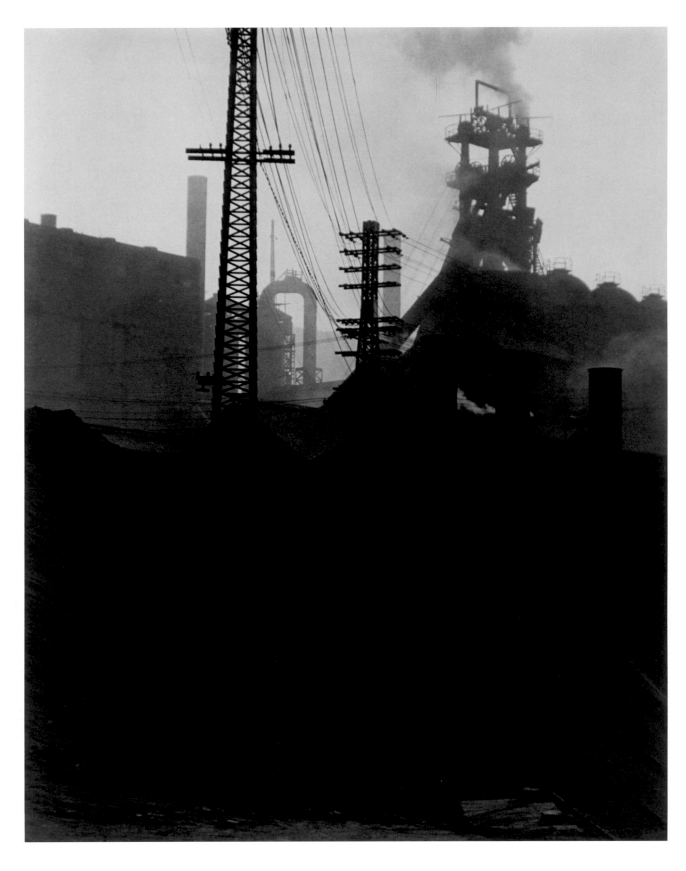

20. [Blast Furnace,
Franklin Works],
c. 1930

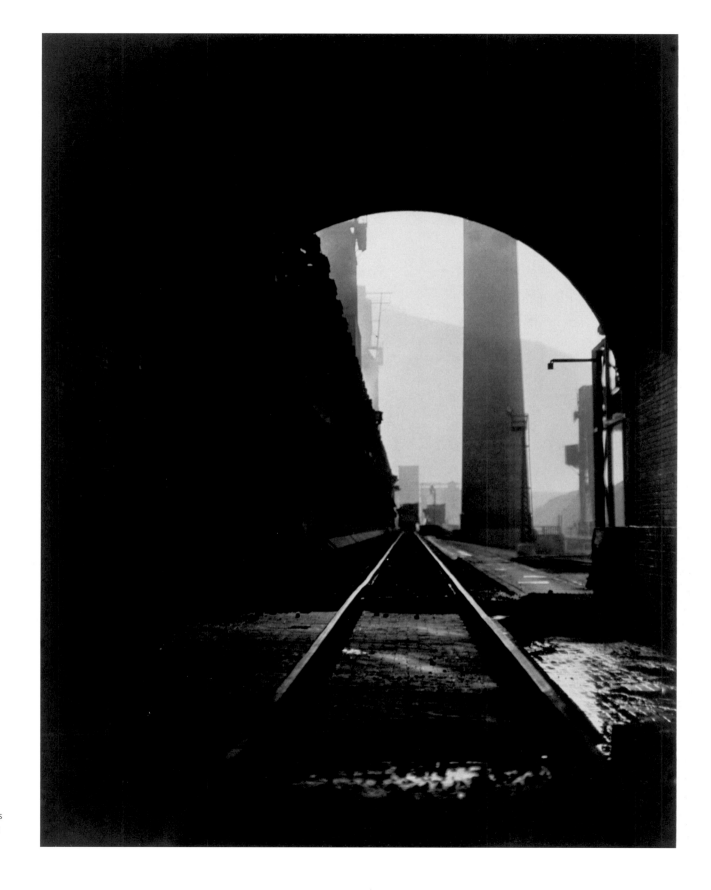

21. [Railroad Tracks
next to Coke Oven
Battery], c. 1930

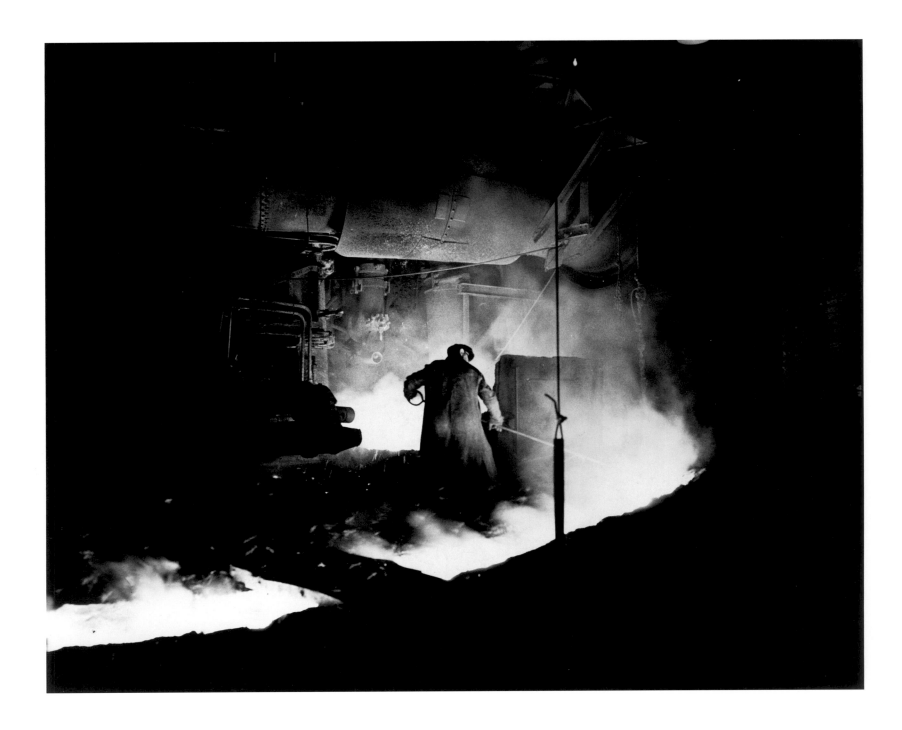

22. [Interior of Cast House, Molten Pig Iron and Runners], c. 1930

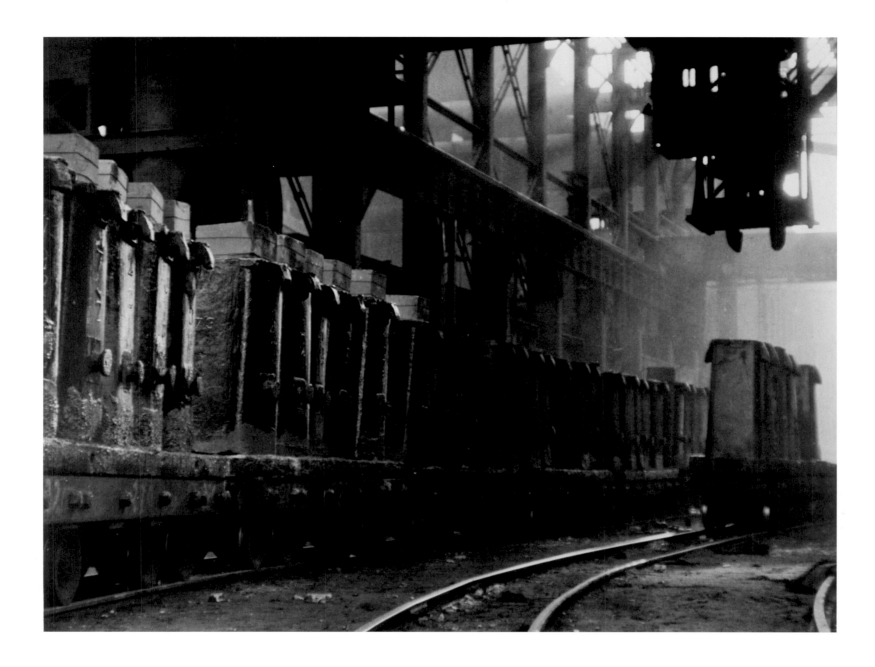

23. [Overhead Crane for Stripping Ingots], c. 1930

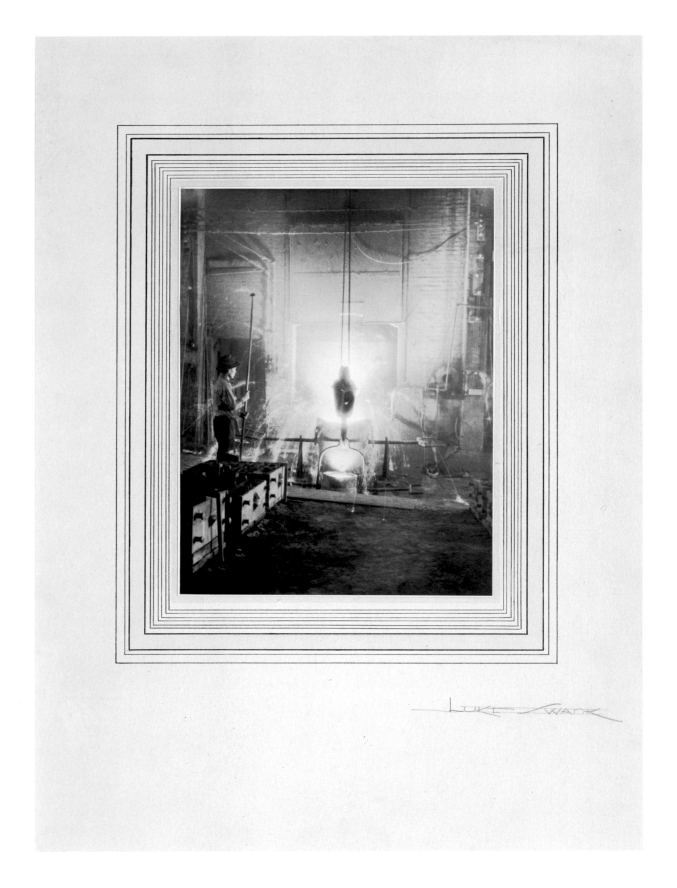

24. [Steel Worker
with Foundry Crane],
c. 1930

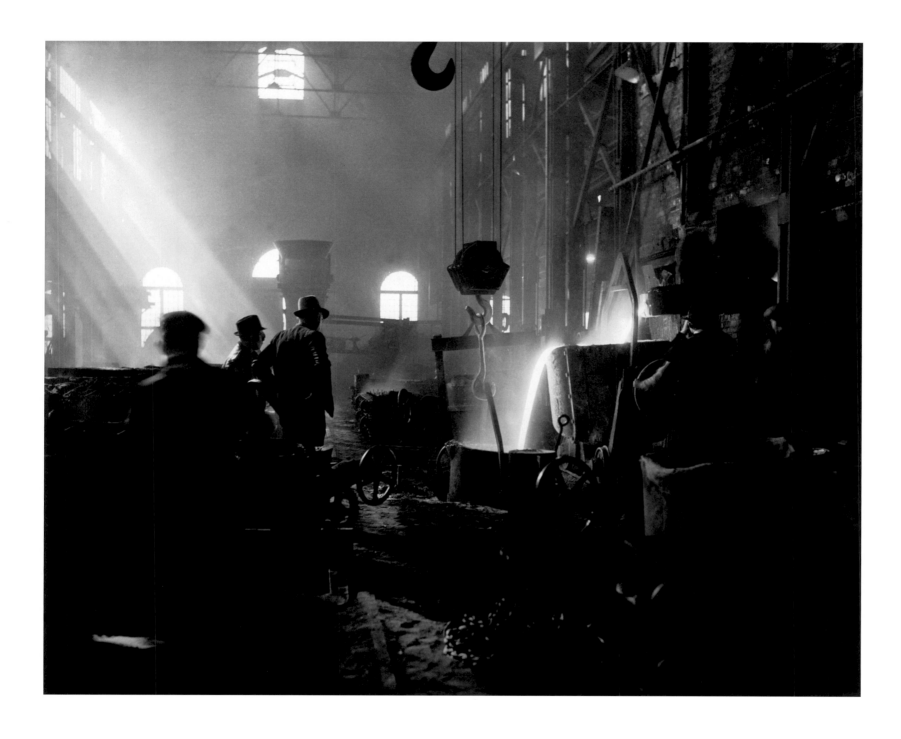

25. [Steelworkers with Cupola Furnace in Iron Foundry], c. 1934

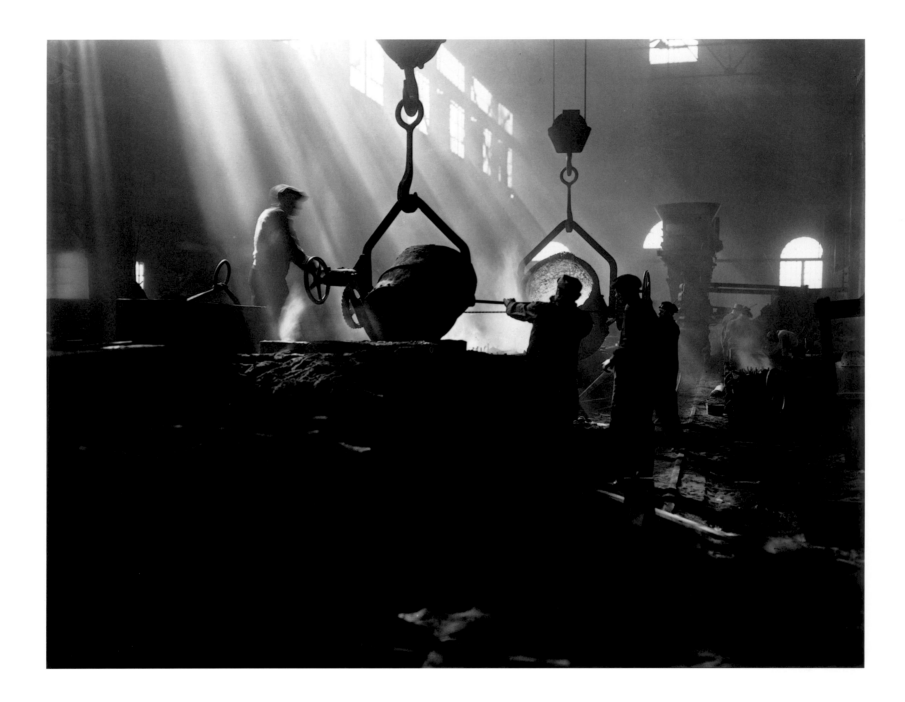

26 . [Filling Molds with Molten Iron I], c. 1934

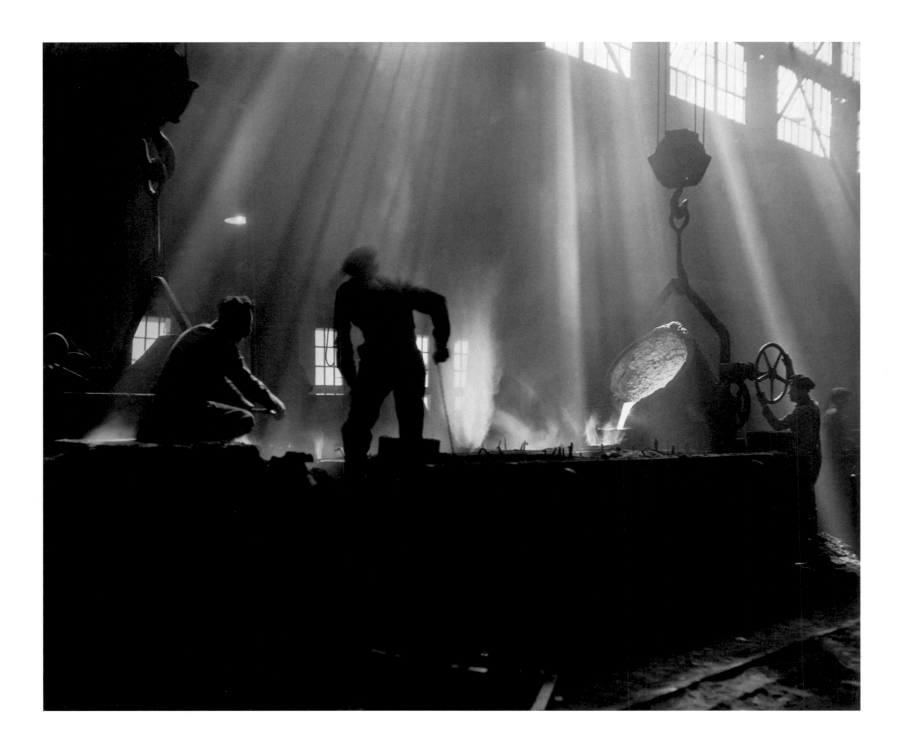

27. [Filling Molds with Molten Iron II], c. 1934

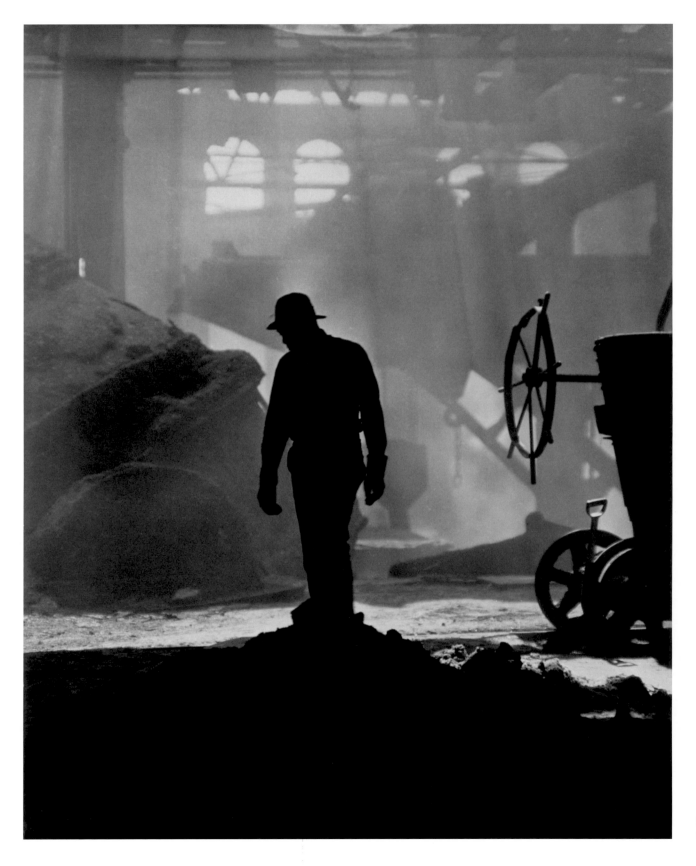

28. [Steel Worker in
Foundry], c. 1934

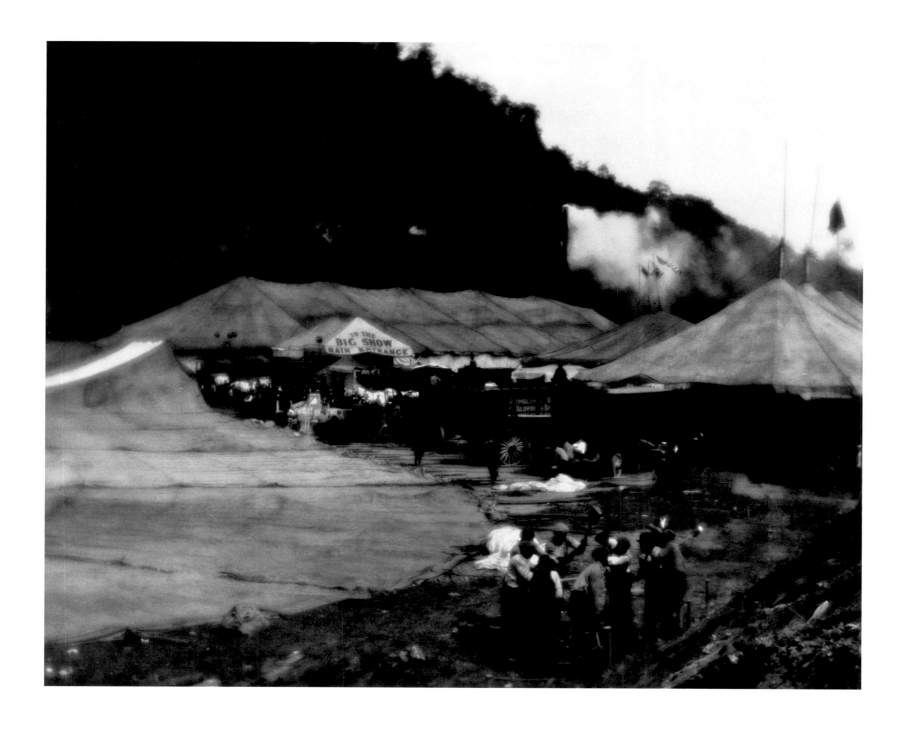

29. [To the Big Show], c. 1919–1924

30. [Hagenbeck-Wallace Circus Poster], 1933

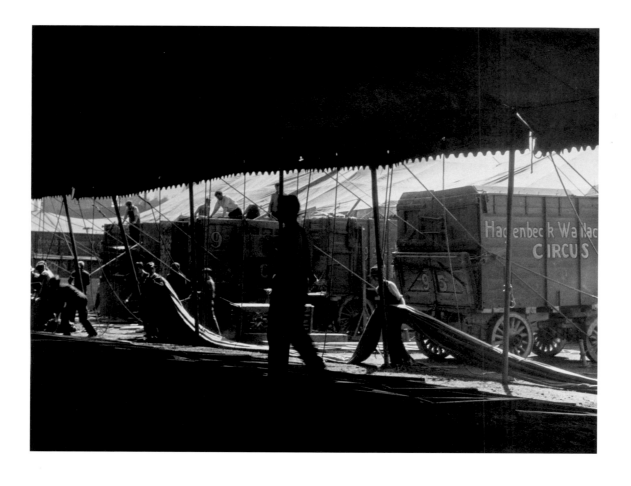

31. [Canvasmen, Hagenbeck-Wallace Circus], c. 1933

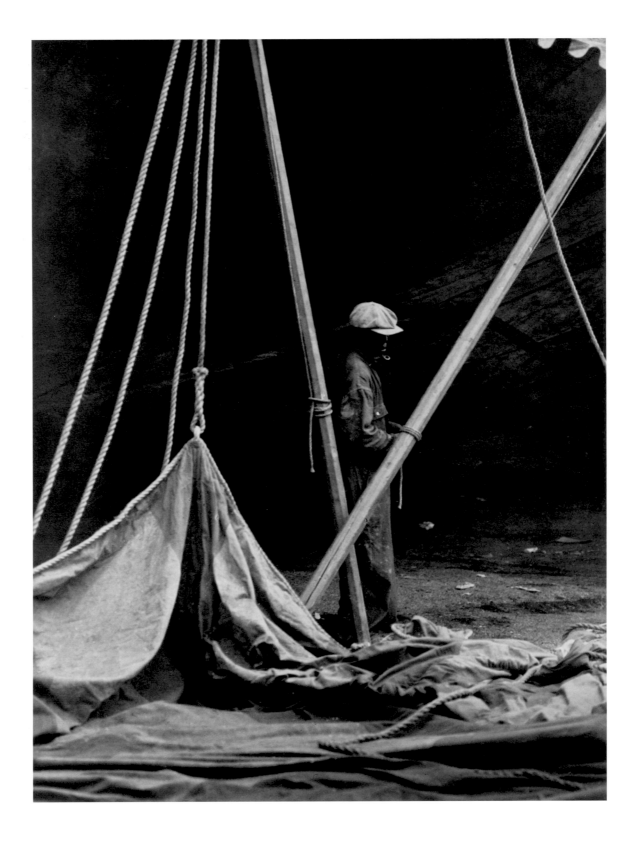

32. [Roustabout with Circus Poles], c. 1934

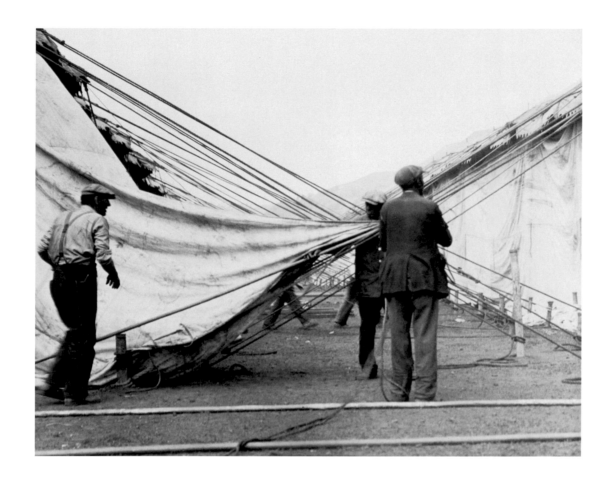

33. [Three Workers with Ropes and Tents], c. 1932–1933

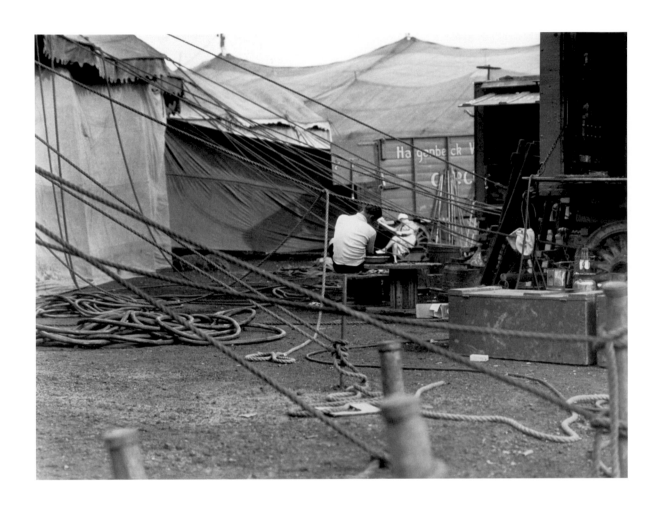

34. [Clown Reading a Newspaper], c. 1932–1933

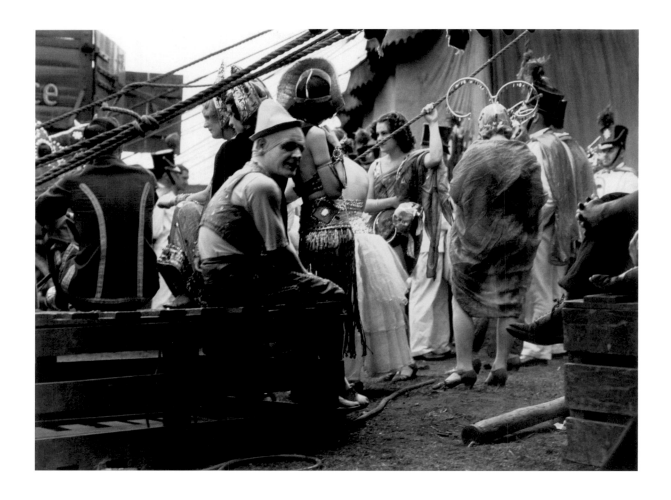

35. [Performers], c. 1934

36. [Man Lying on Hay], c. 1932–1934

37. [Balloon Vendor], c. 1932–1934

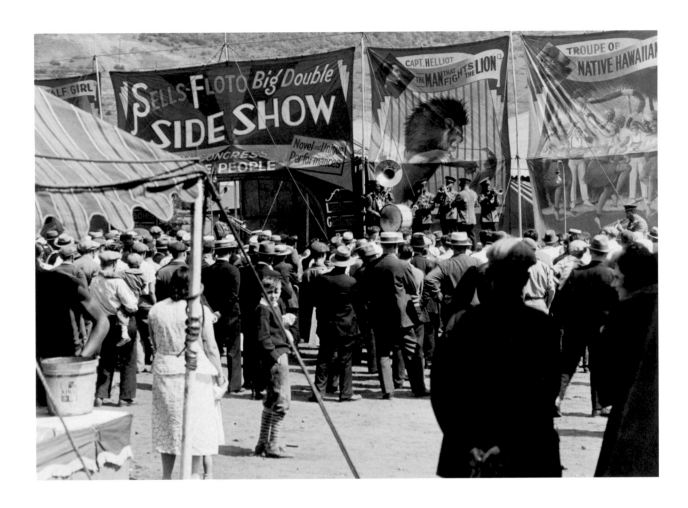

38. [People Watching], c. 1930–1932

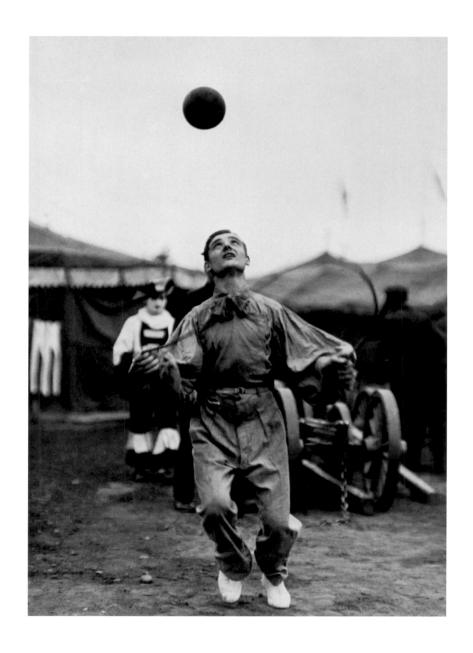

39. [Juggler], c. 1932–1934

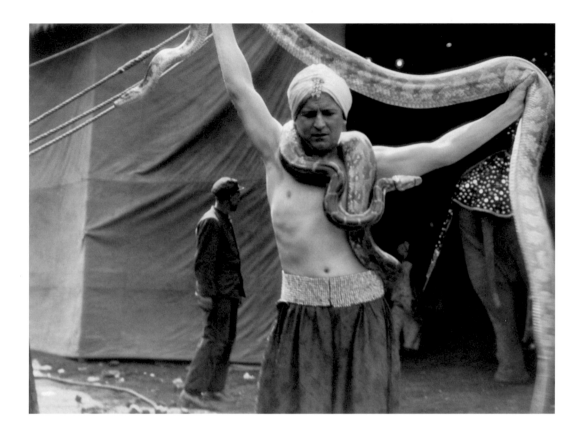

40. [Snake Charmer], c. 1934

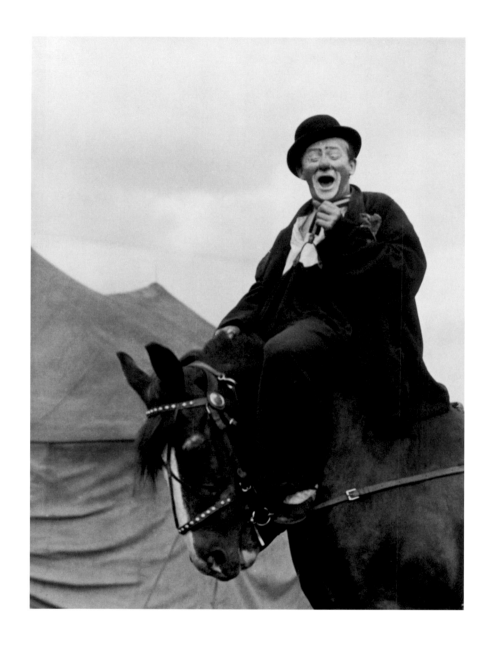

41. [Otto Griebling on Horseback], c. 1929–1930

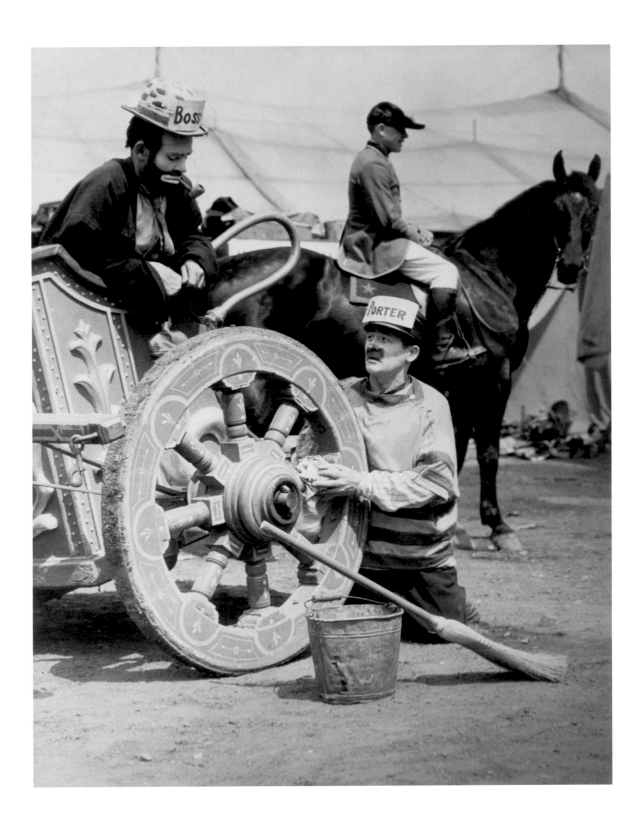

42. [Boss and Porter], c. 1933

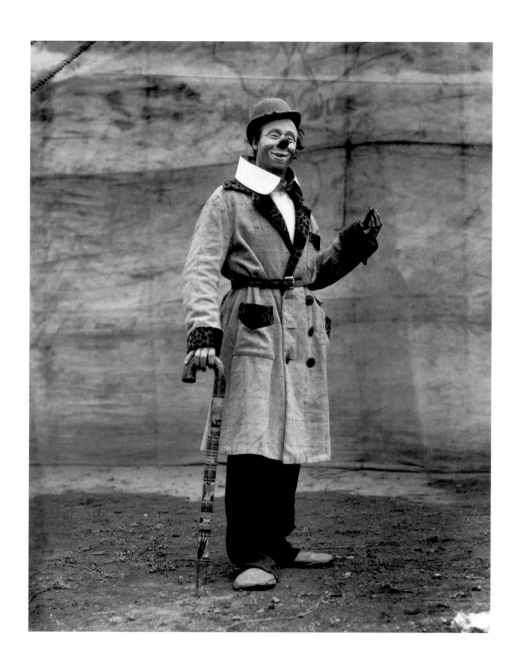

43. [Paul Jerome, Clown], c. 1930–1934

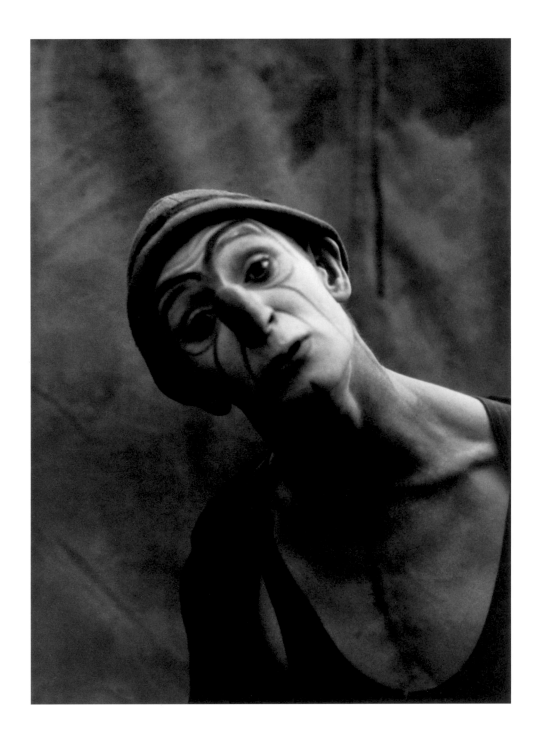

44. [Bumpsy Anthony, Clown], c. 1930–1932

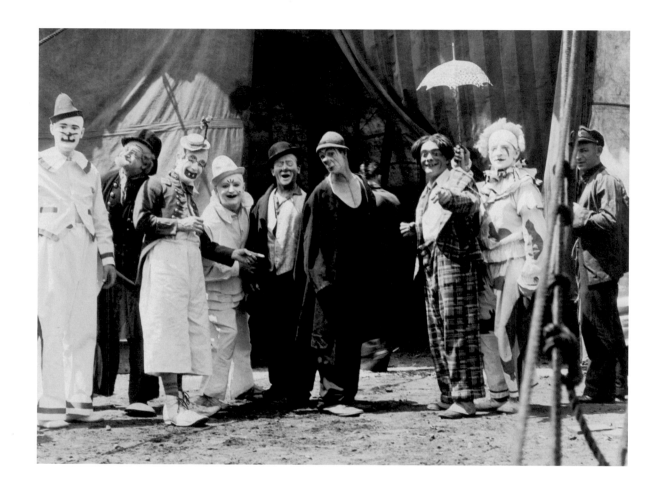

45. [Group of Clowns with Umbrella], c. 1930–1932

120

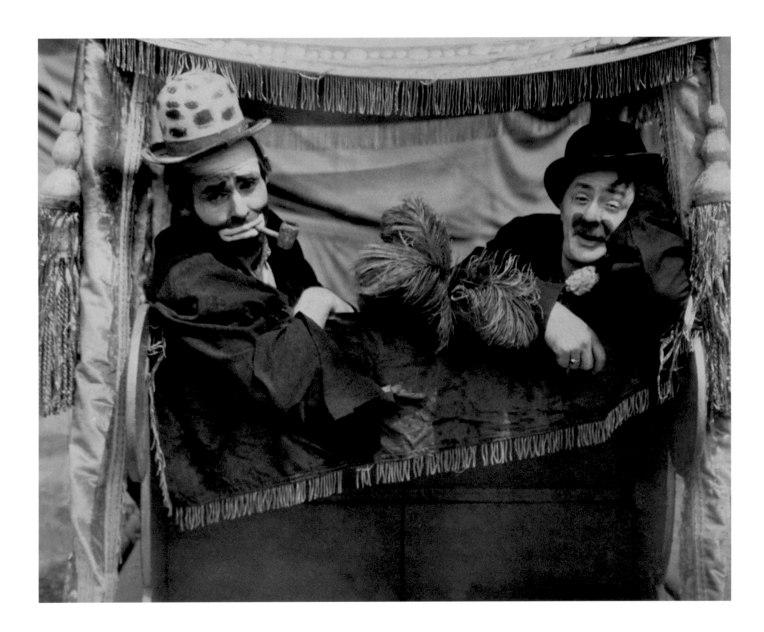

46. [Emmett Kelly and Otto Griebling], c. 1933

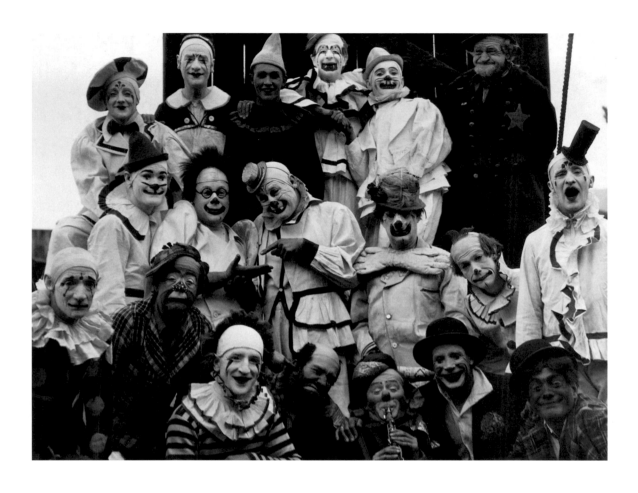

47. [Nineteen Clowns], c. 1930

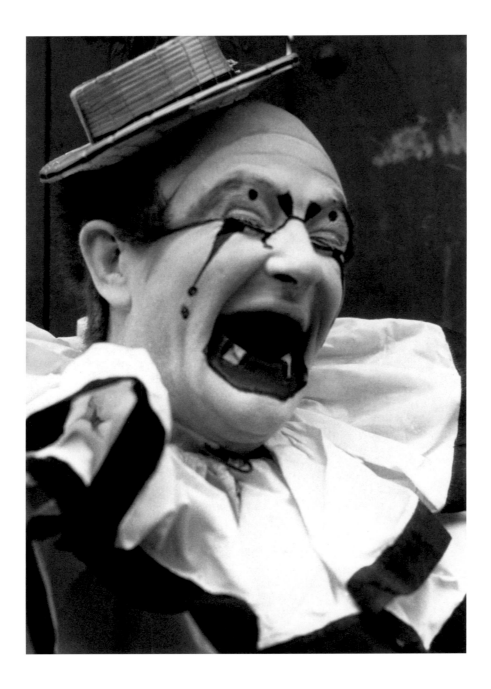

48. [Clown Face I], c. 1930

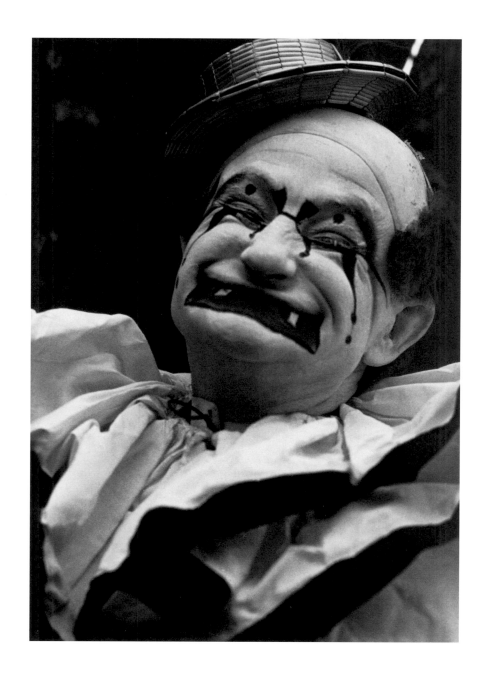

49. [Clown Face II], c. 1930

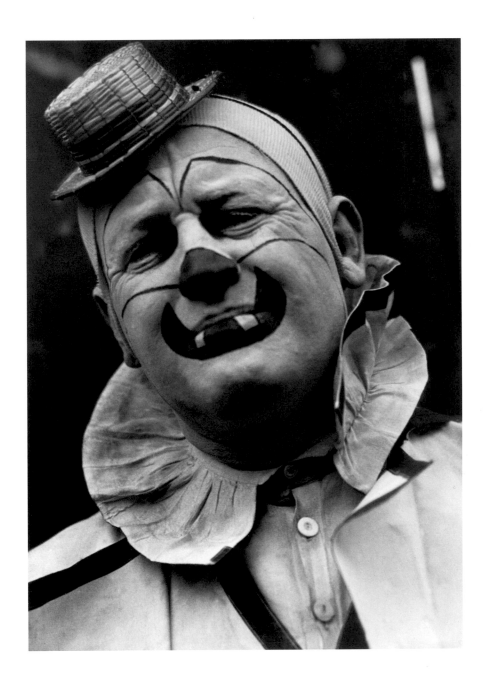

50. [Clown Face III], c. 1930

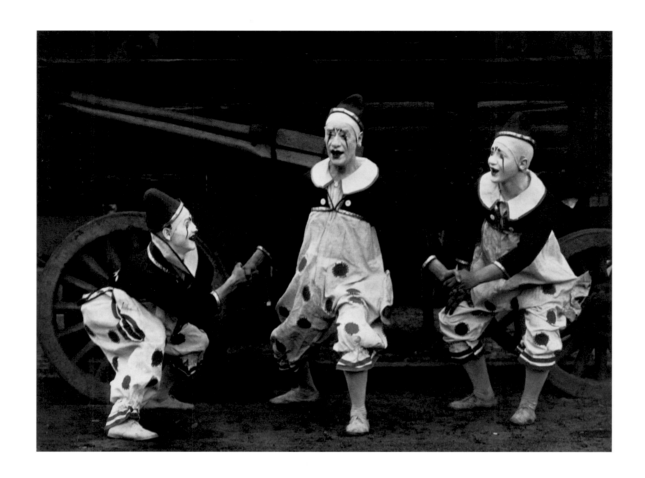

51. [Arthur Borella Trio], c. 1930

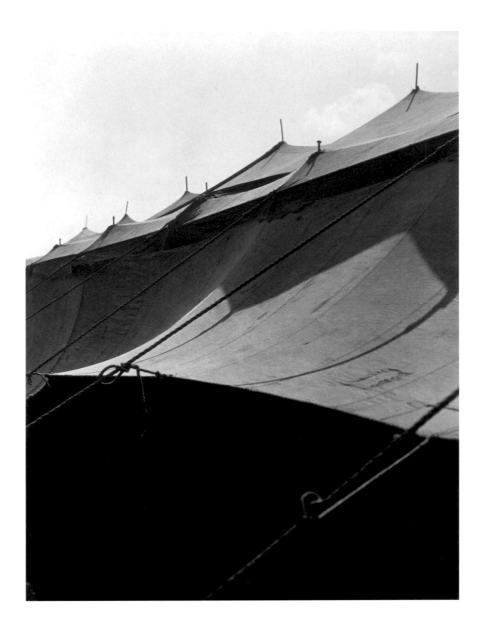

52. [Circus Tent I], c. 1928–1934

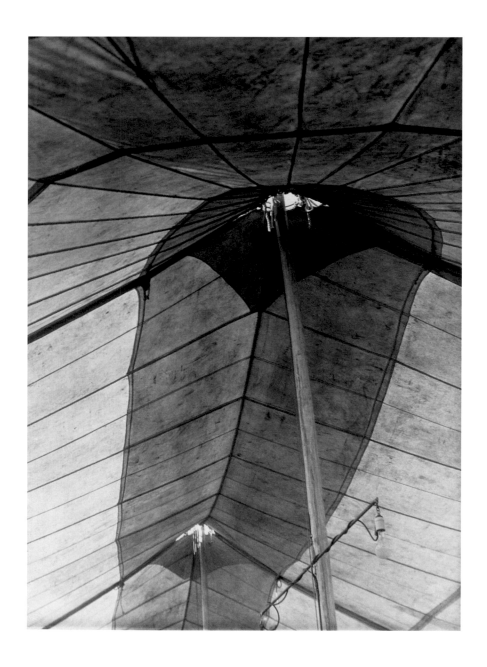

53. [Circus Tent II], c. 1928–1934

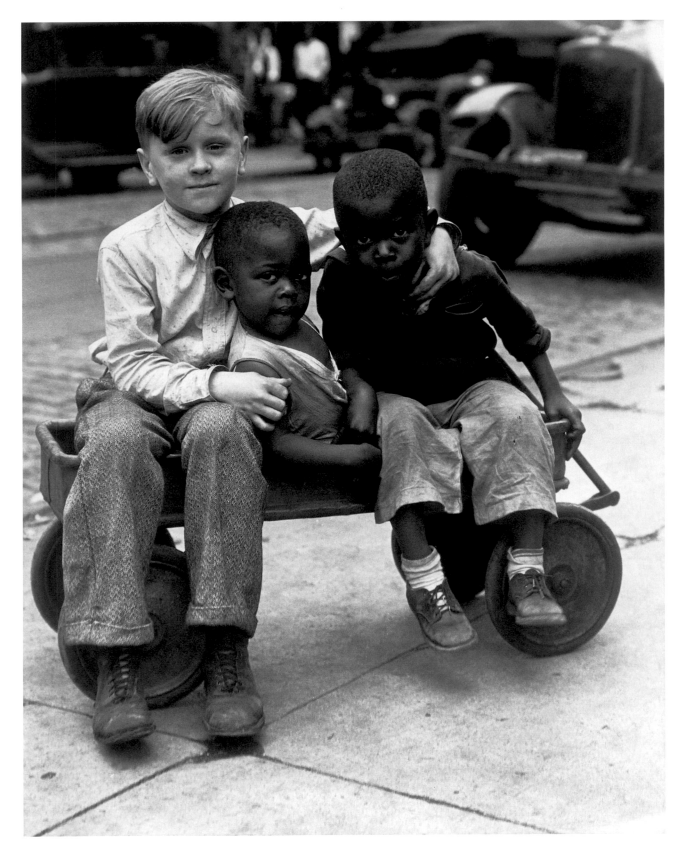

54. [Three Boys in a Wagon], c. 1934

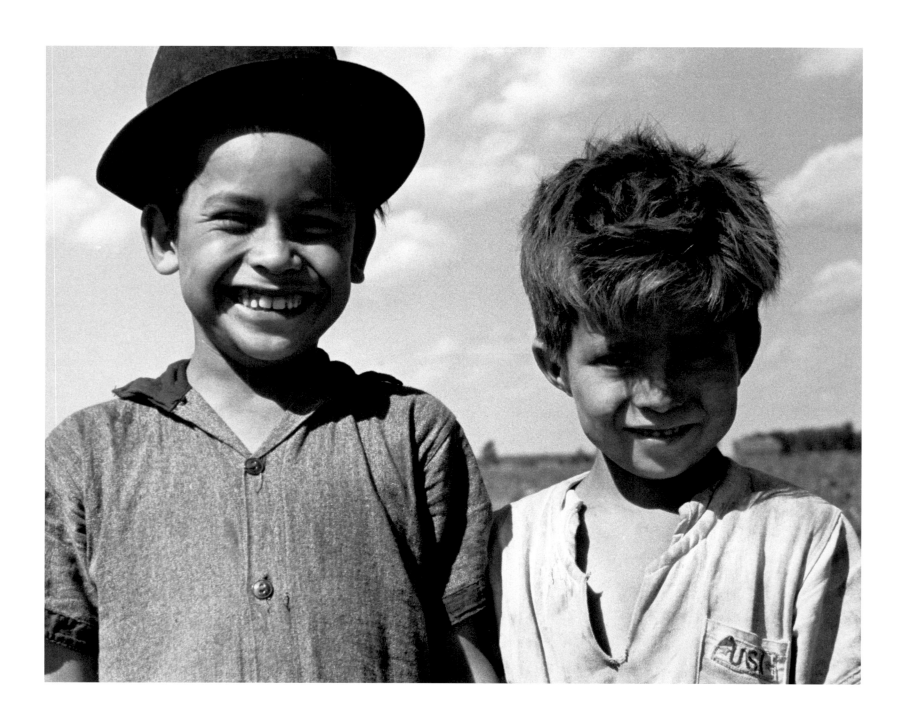

55. [Migrant Children], c. 1936–1940

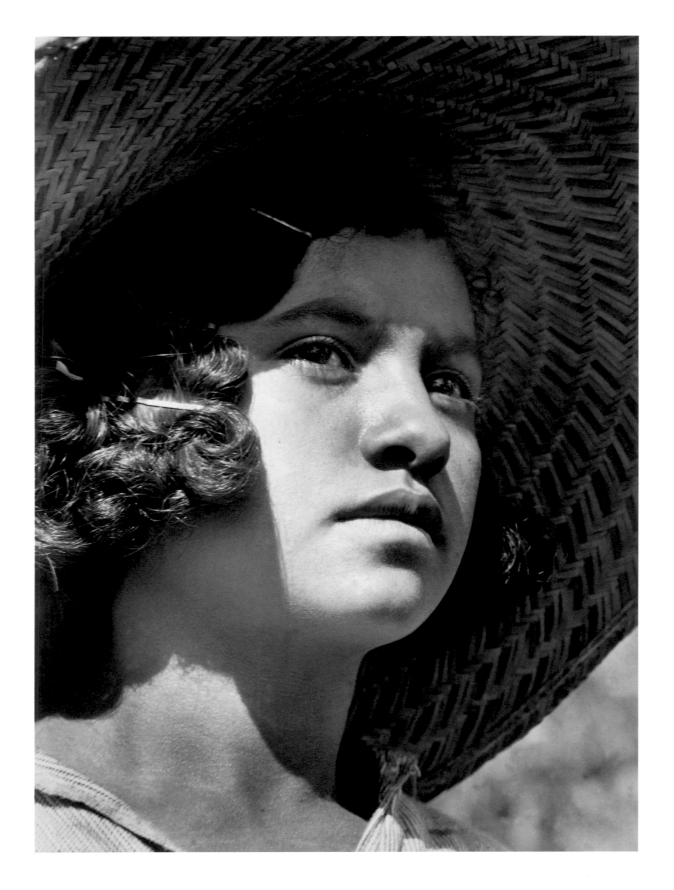

56. [Portrait of
a Young Girl],
c. 1936–1940

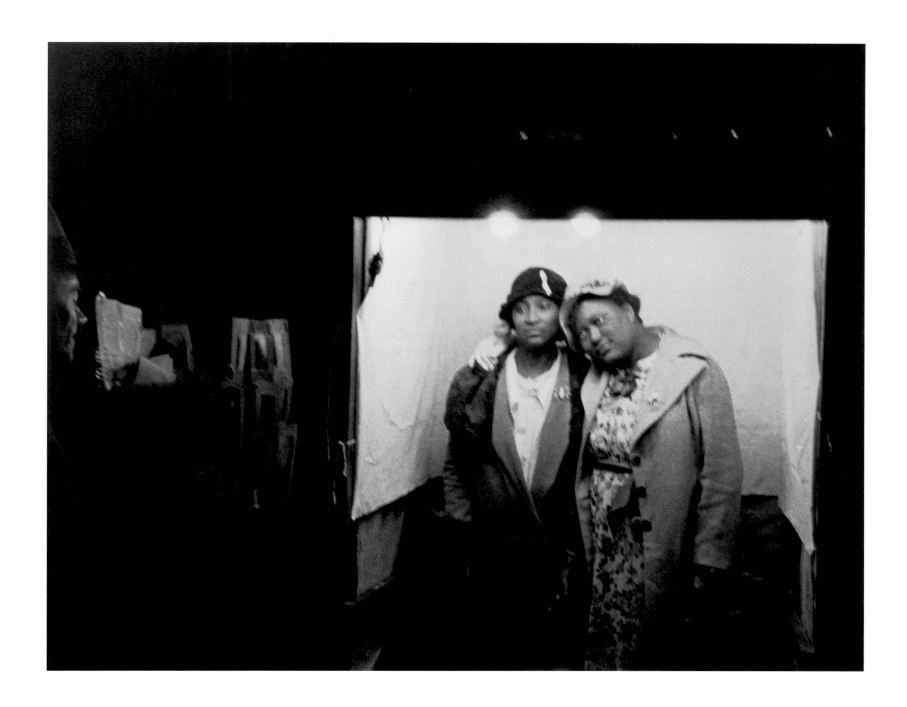

57. [Women at Portrait Studio], c. 1939

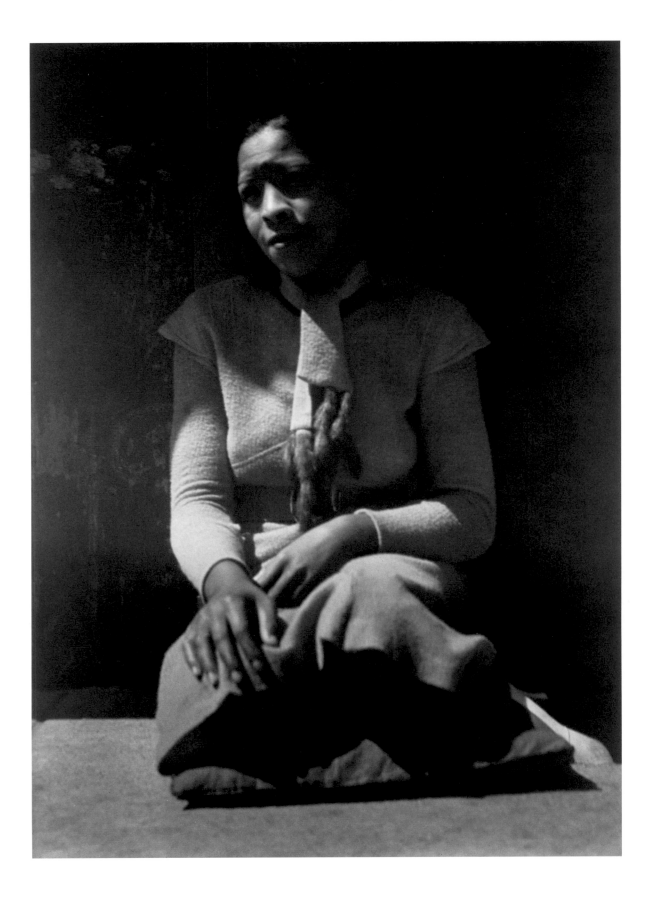

58. [Woman in
Shadows], c. 1937

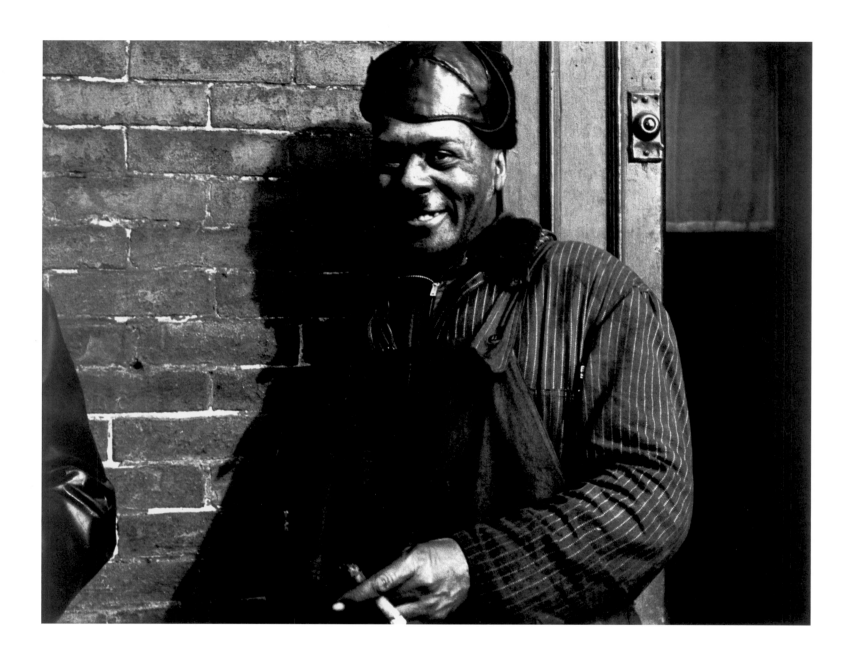

59. [Man with Cigar], c. 1939

134

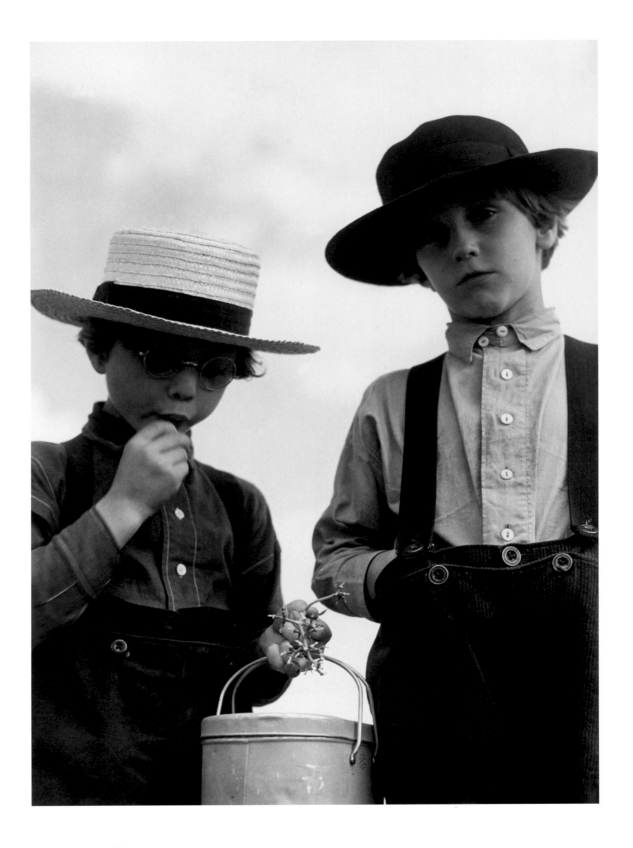

60. [Amish Boys Nibbling Grapes], c. 1940

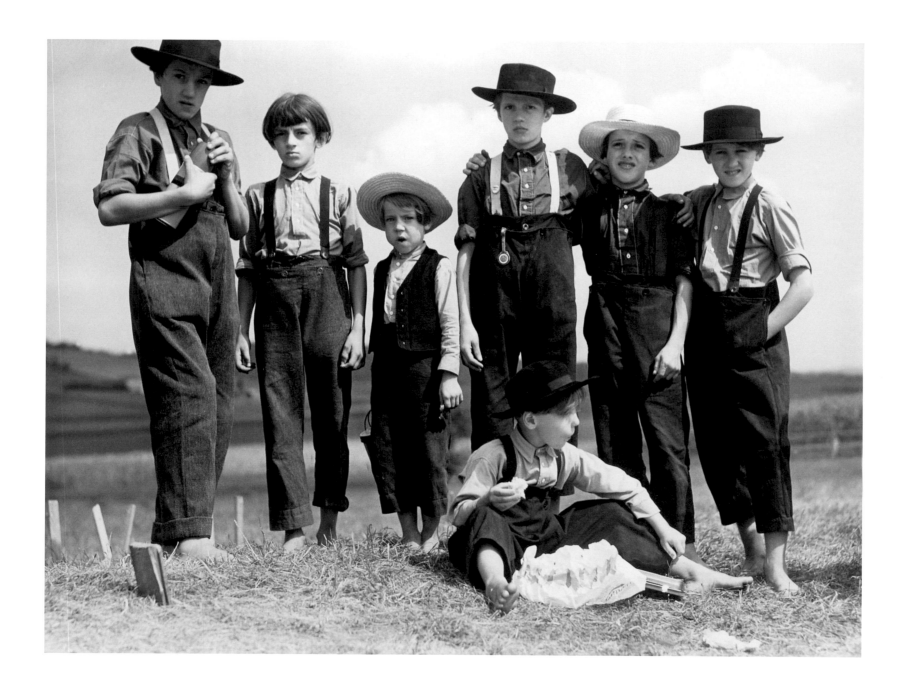

61. [Amish Boys with Watermelon], c. 1940

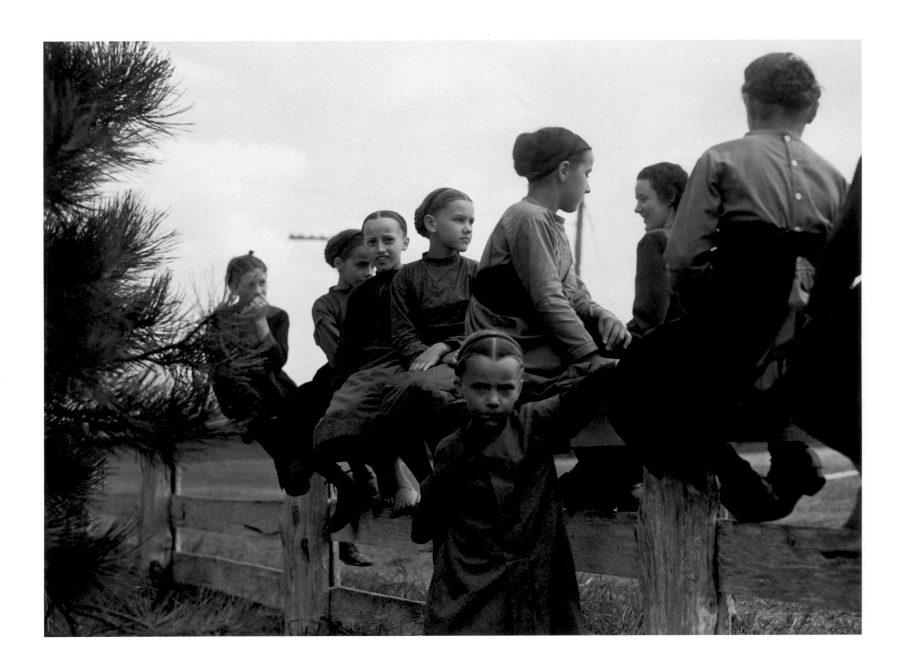

62. [Amish School Girls], c. 1940

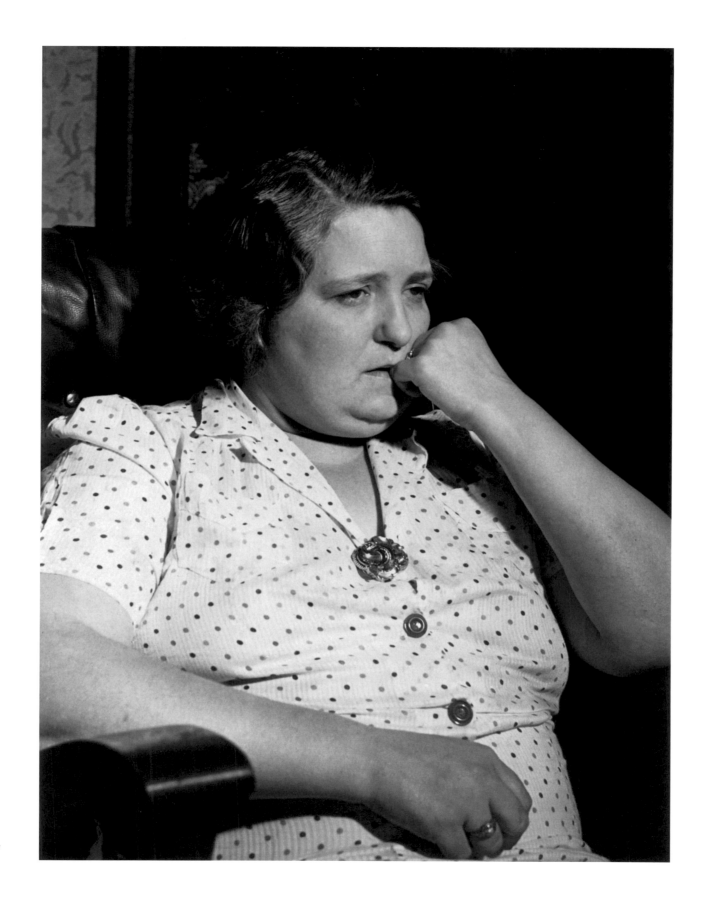

63. [War Mother I],
c. 1941

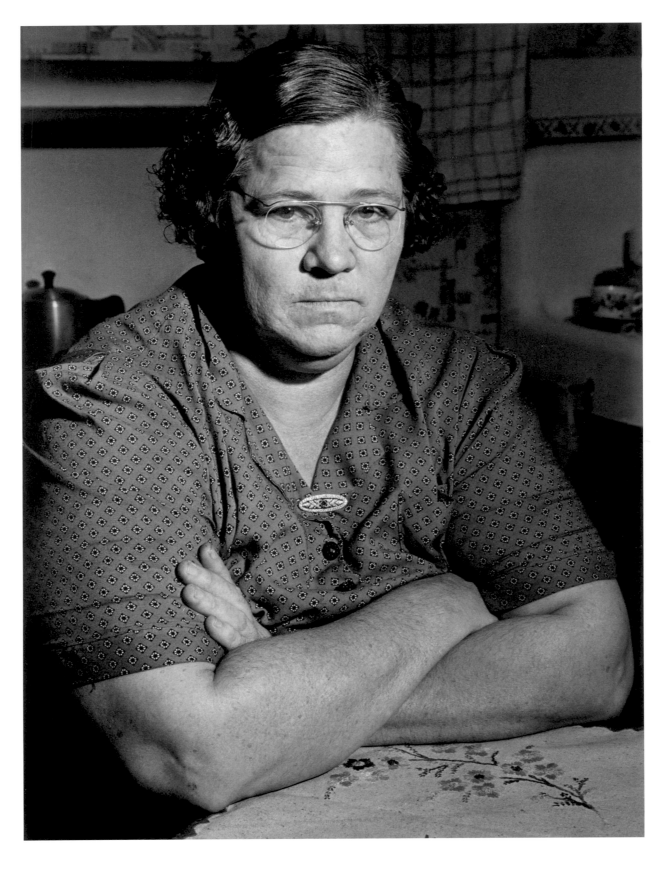

64. [War Mother II],
c. 1941

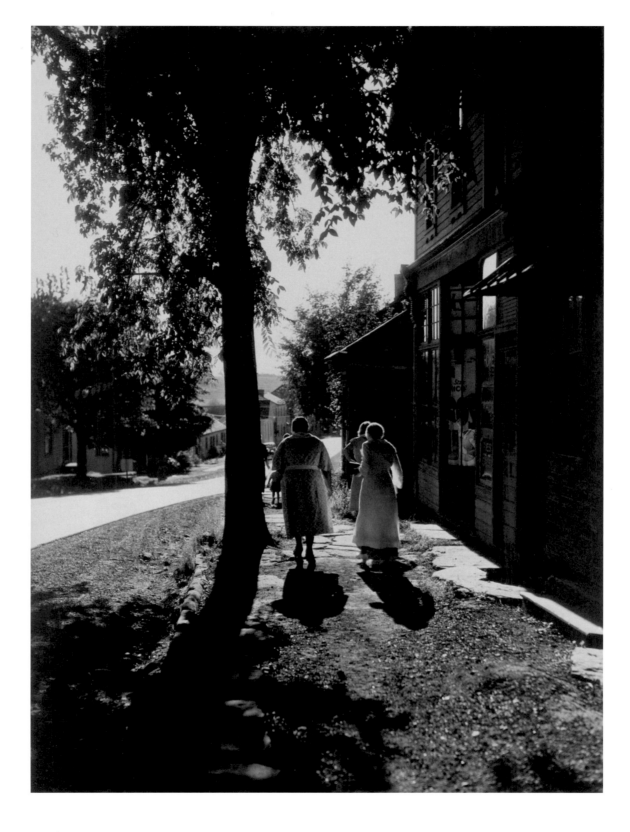

65. [Three Women], c. 1935

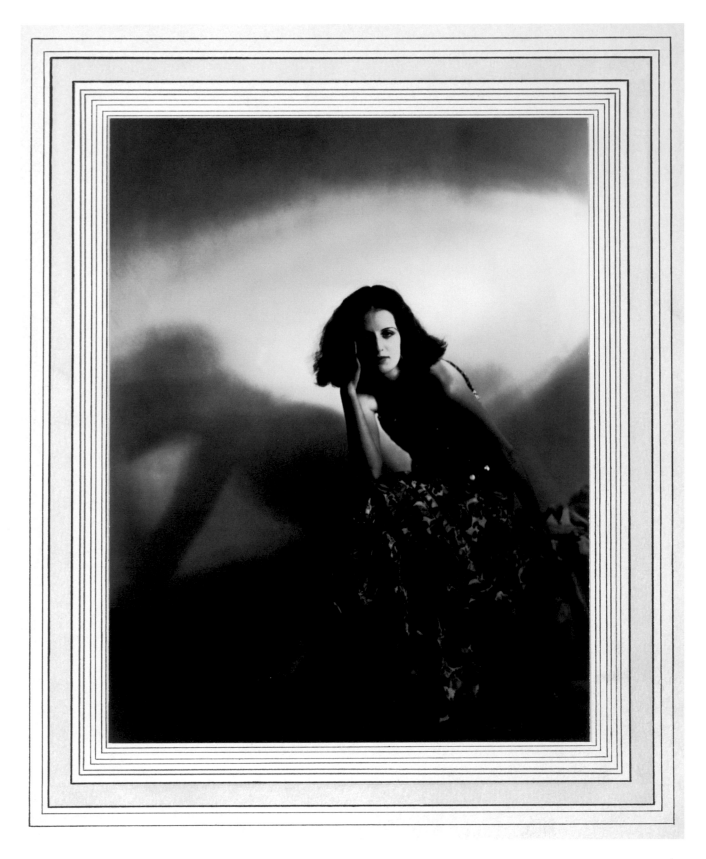

66 . [Grace I],
c. 1925–1930

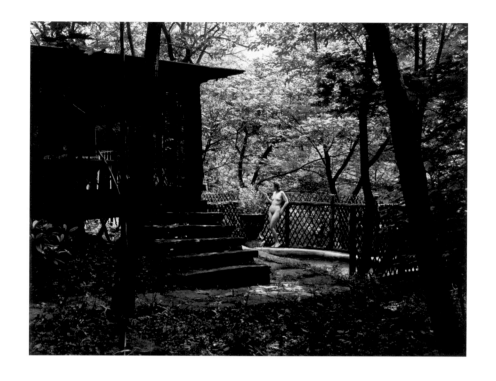

67. [Edith by the Hangover], c. 1940–1943

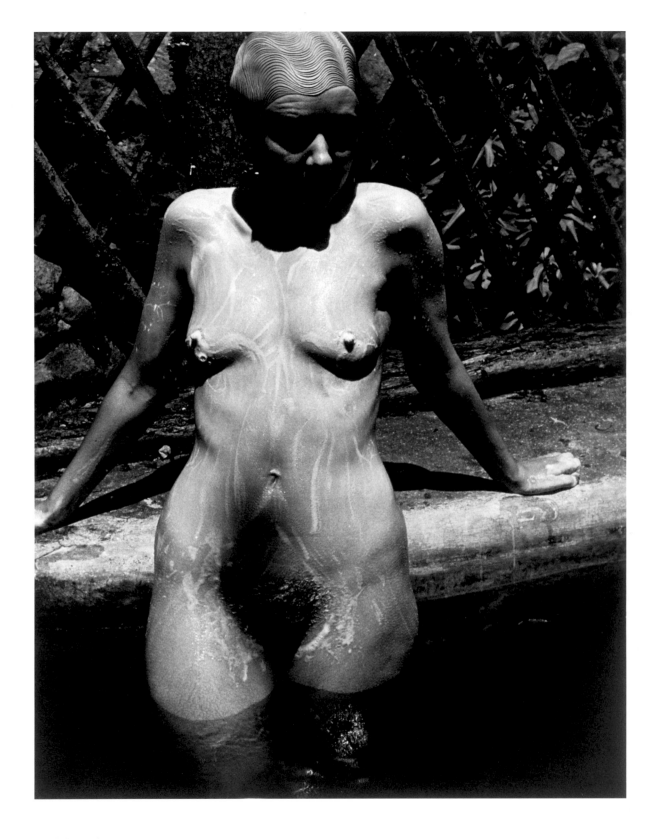

68. [Edith in Bathing Cap], c. 1940–1943

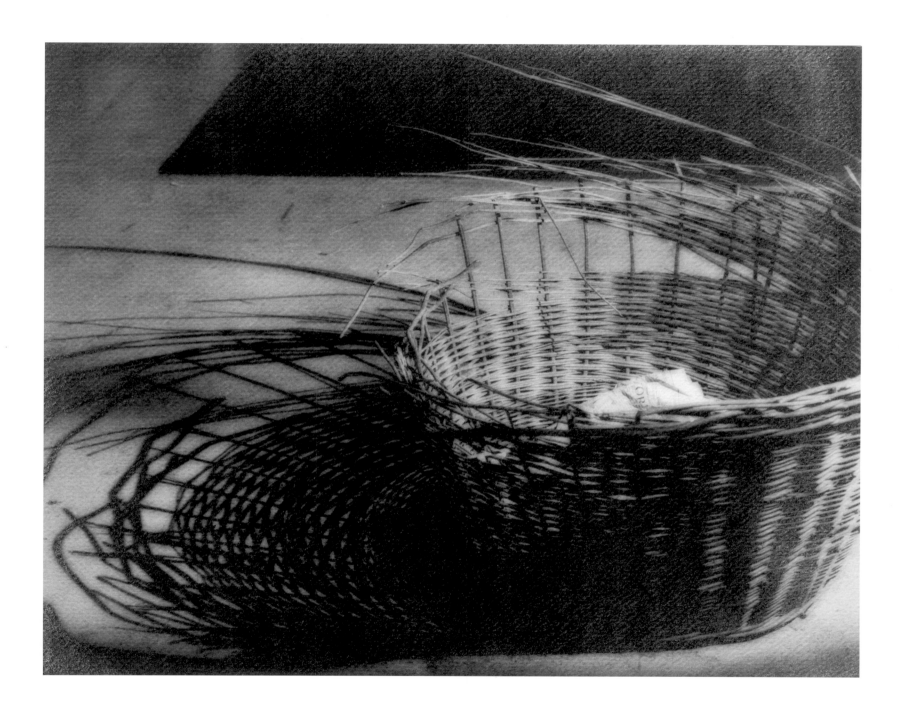

69. [Old Basket in the Cellar], c. 1931

70. [Onions and Bowl], c. 1932

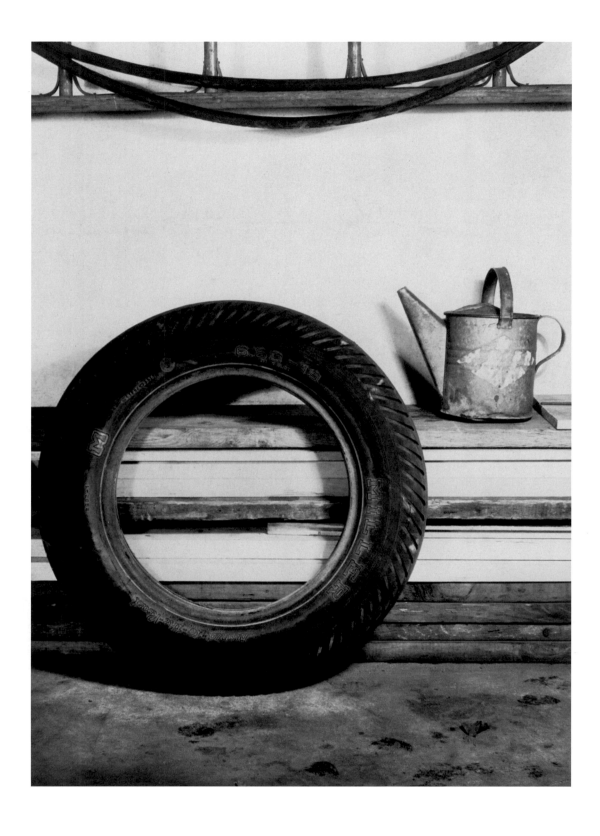

71. [Tire and Oil Can], c. 1932

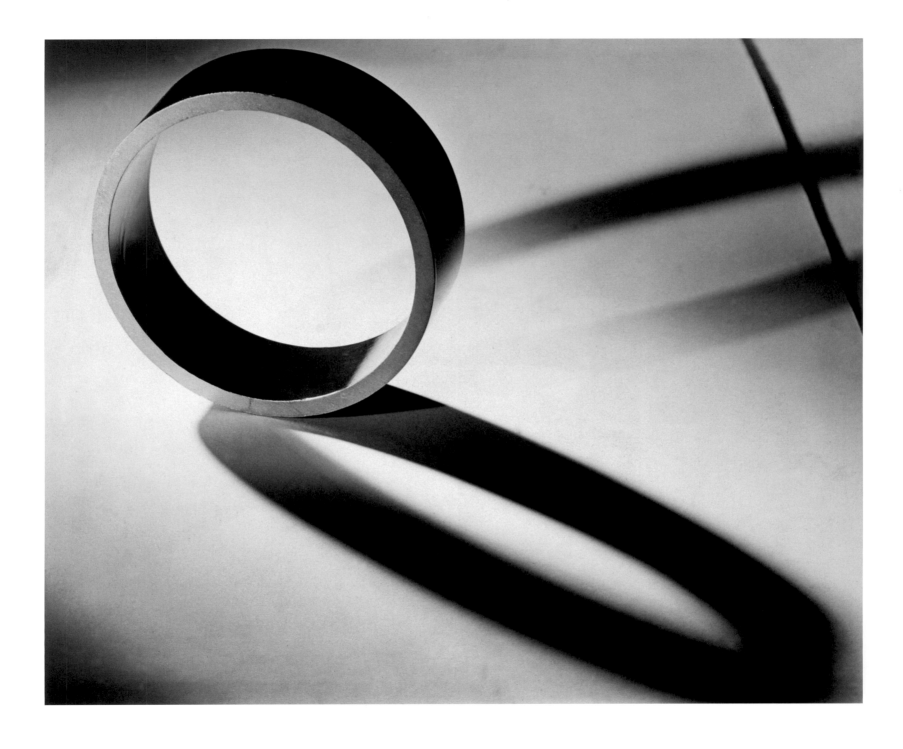

72. [Metal Ring and Shadows], c. 1932

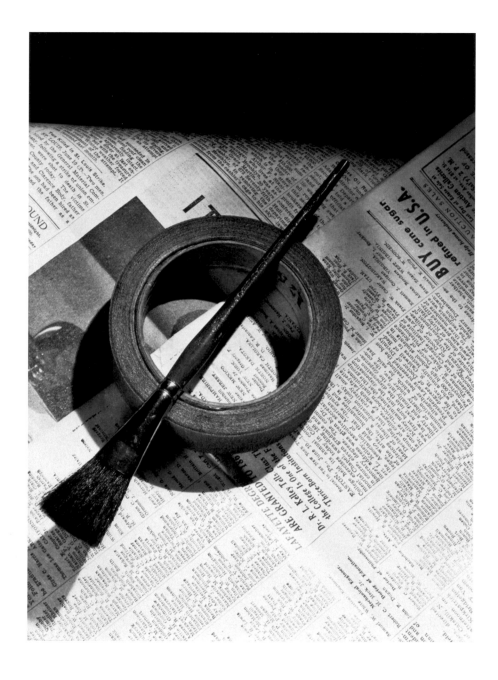

73. [Tape, Brush, and Newspaper], c. 1932

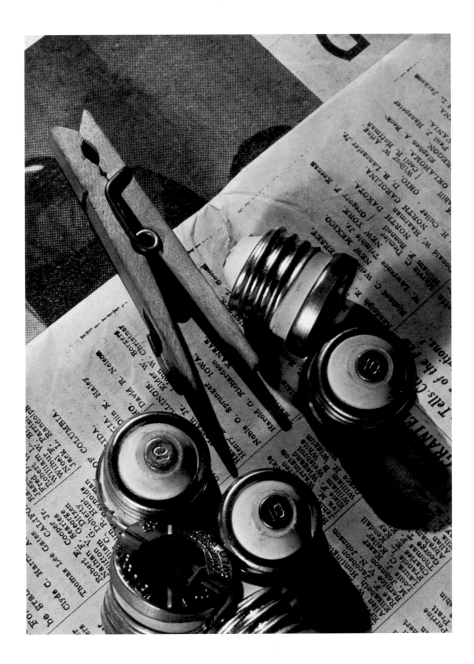

74. [Clothespin, Fuses, and Newspaper], c. 1932

75. [Concrete and Wood], c. 1932

76. [Rolled Wooden Fence IV], c. 1932

77. [Rolled Wooden Fence], c. 1932

78. [Wooden Tower], c. 1932–1935

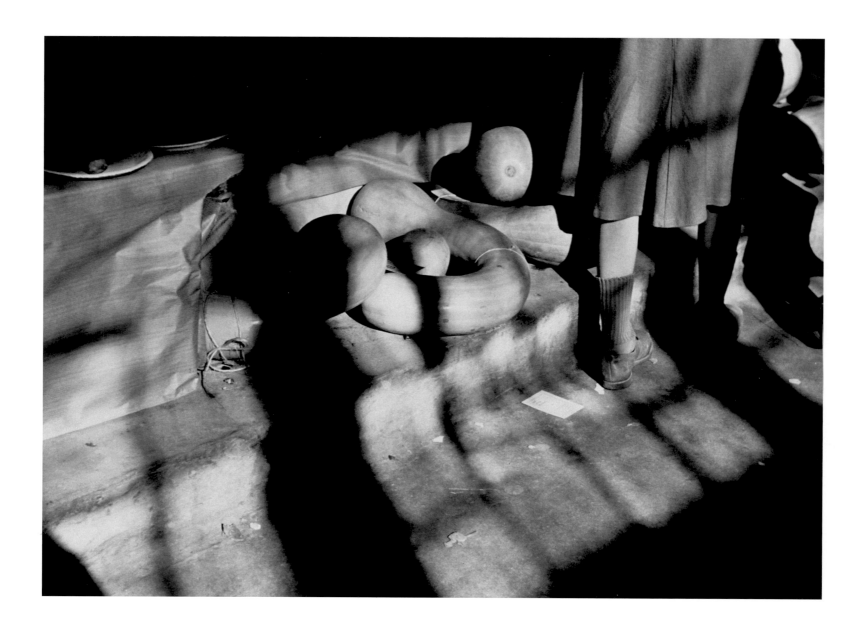

79 . [Legs, Gourds, and Shadows], c. 1939

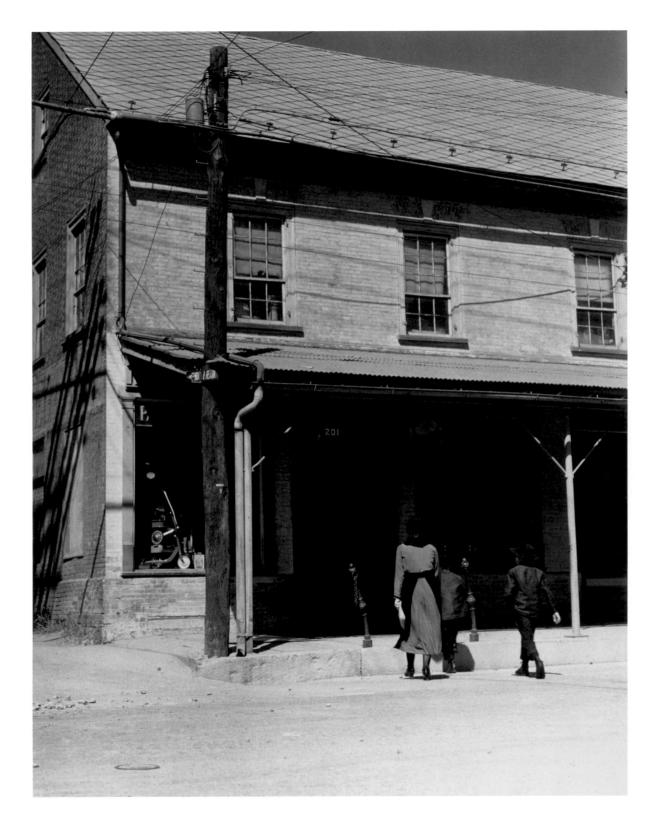

80. [E. S. Renninger Hardware], c. 1940

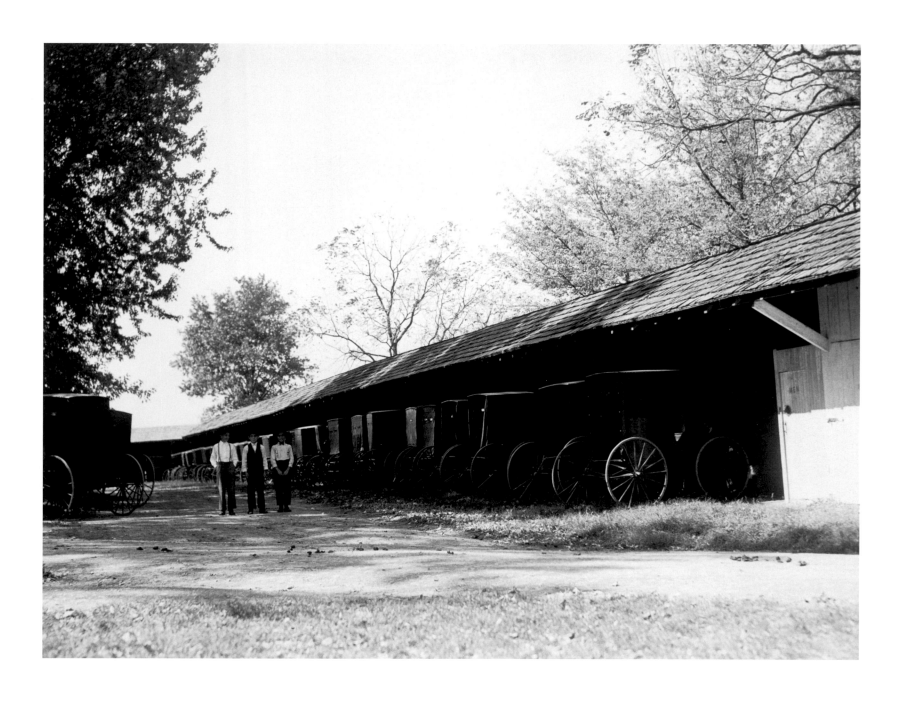

81. [Three Amish Youths with Buggies], c. 1940

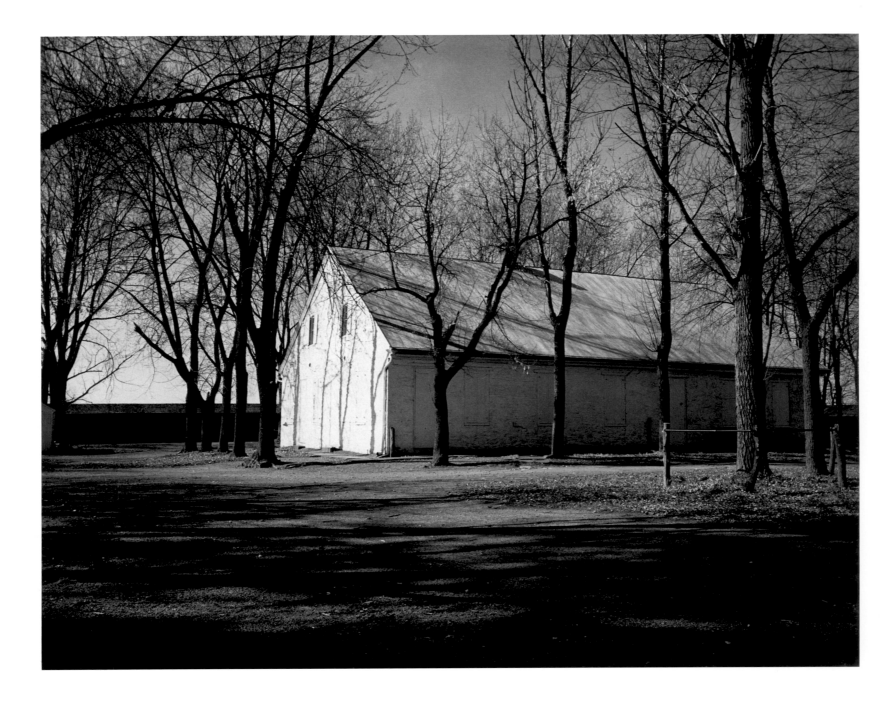

82. [Old Mennonite Church, Lancaster County], c. 1940

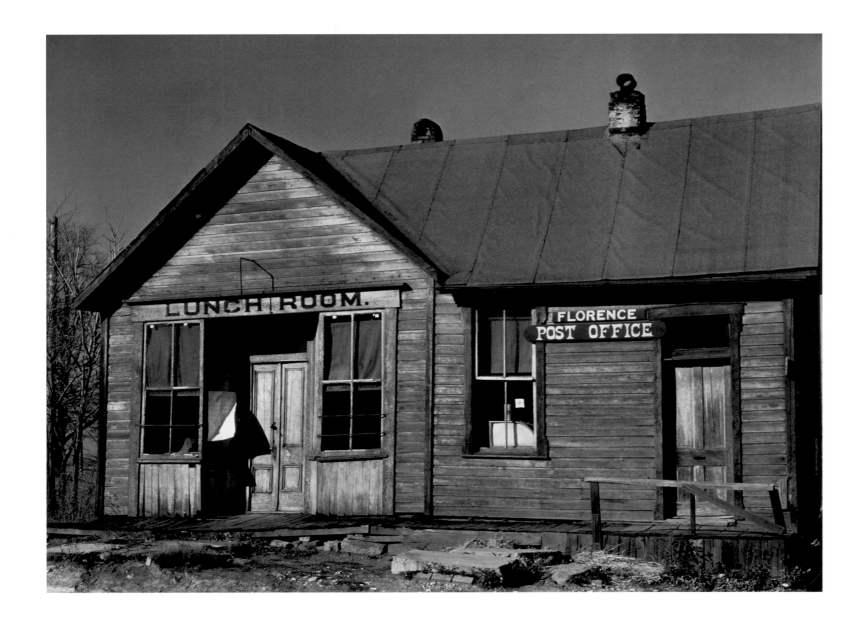

83. [Florence Post Office, Washington County, Pa.], c. 1933–1935

84. [Chew Tub Tobacco], c. 1940–1943

85. [Men Loading Tomatoes on Flatbed Truck], c. 1940

160

86. [Barn with Windows], c. 1940

87. [Doorway,
J. Heinrich Zeller
House, Lebanon
County, Pa.],
c. 1940–1943

162

88. [Double Door
Flanked by Ferns,
Deerfield, Mass.],
c. 1940–1943

89. [Sisters' House (Saron) I, Ephrata Cloister, Ephrata, Pa.], c. 1940

90. [Meetinghouse (Saal) Kitchen, Ephrata Cloister, Ephrata, Pa.], c. 1940

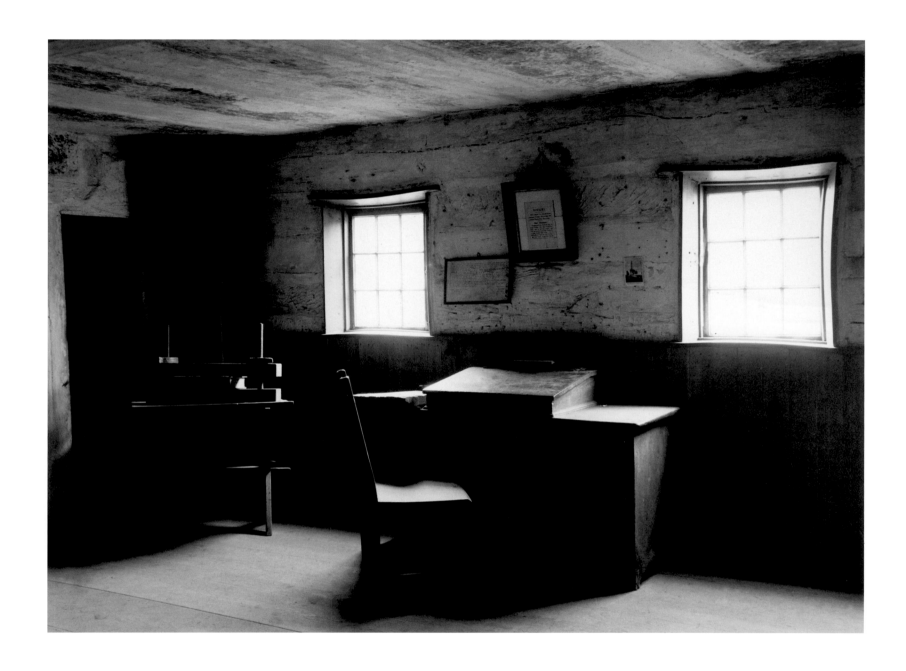

91. [Common Room, Sisters' House (Saron), Ephrata Cloister, Ephrata, Pa.], c. 1940

92 . [Meason Mansion Staircase, Fayette County, Pa.], c. 1933–1935

93 . [Meason Mansion Office and Outbuilding, Fayette County, Pa.], c. 1933–1935

94. [Wooden Houses on a Hillside], c. 1935–1940

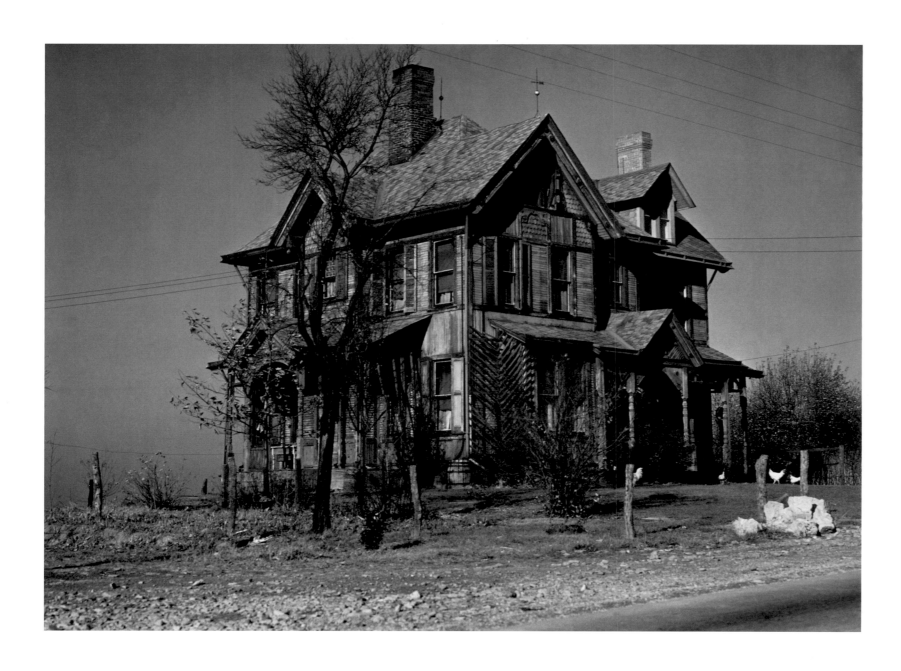

95. [Victorian Farmhouse, Rt. 30], c. 1940–1943

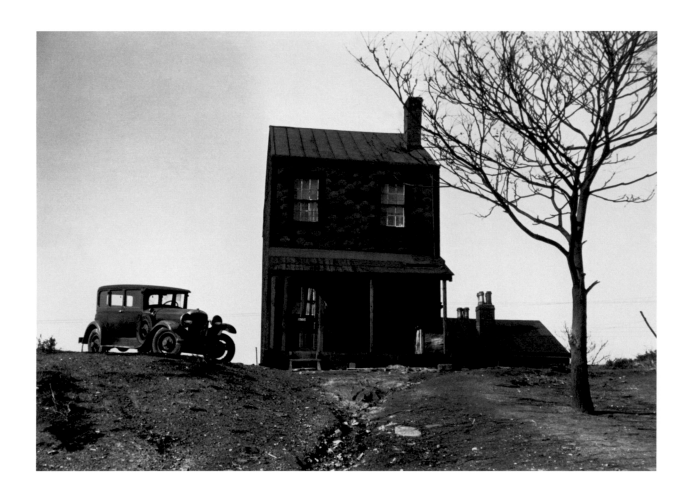

96. [Car, House, and Tree], c. 1940

97. [Barren Trees with Split Rail Fence], c. 1940–1943

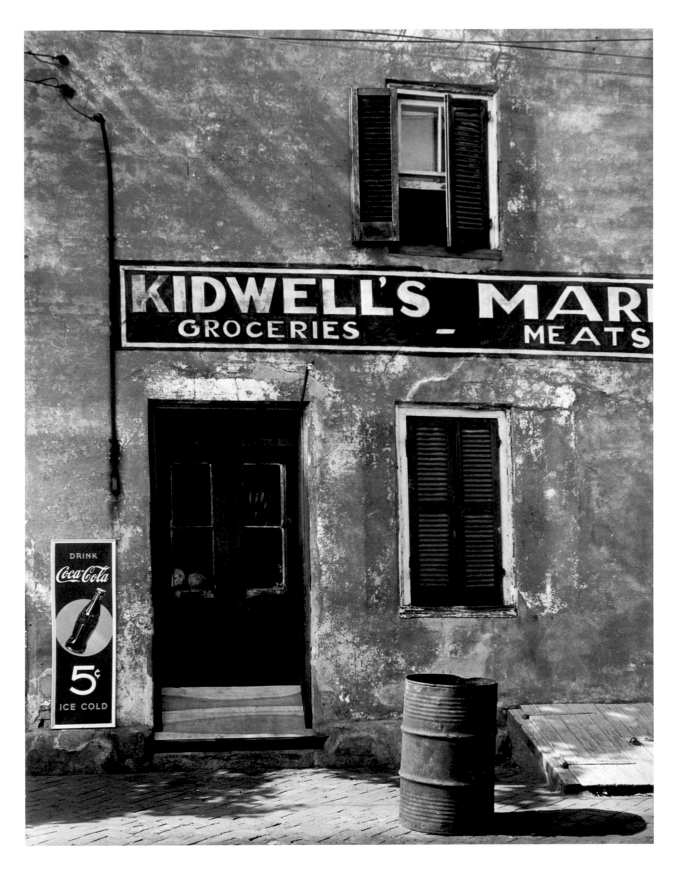

98. [Kidwell's Market,
Leesburg, Virginia],
c. 1940–1943

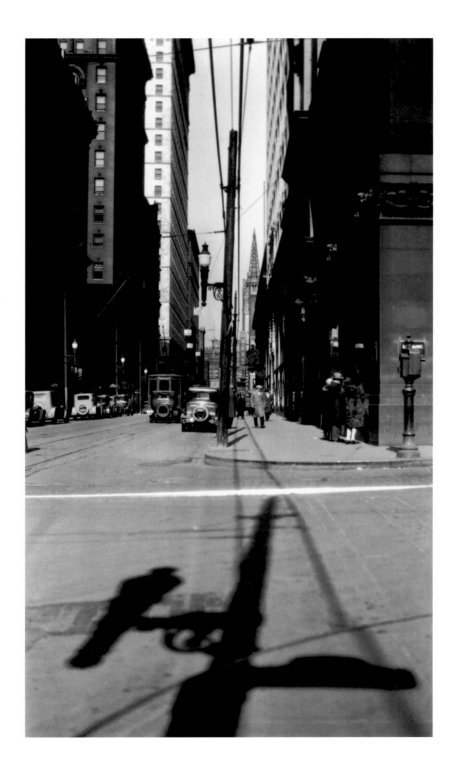

99 . [Street Corner with Shadows], c. 1920s

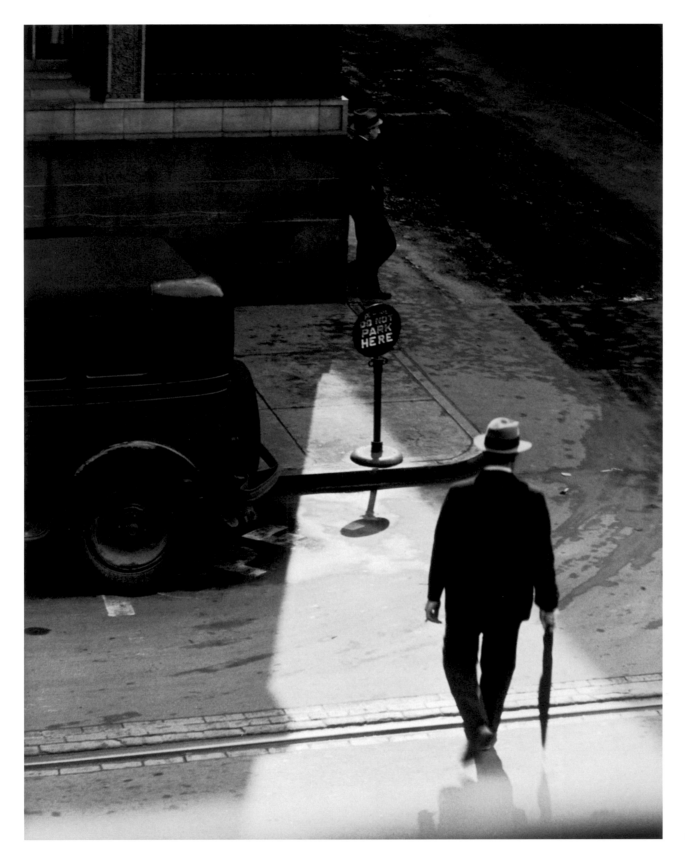

100. [Man Crossing
City Street], c. 1935

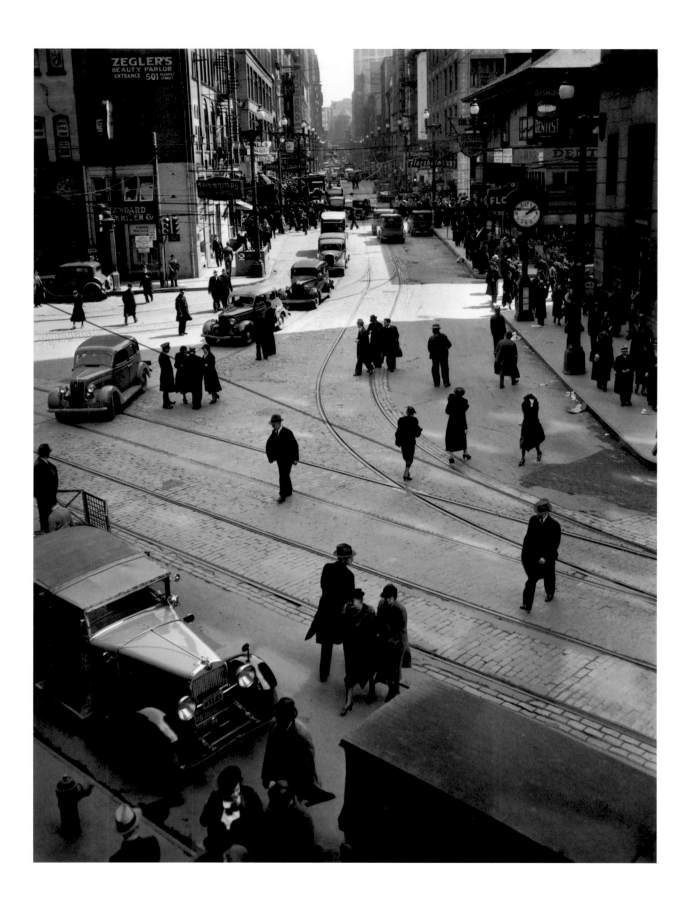

101 . [Fifth and Liberty], c. 1935

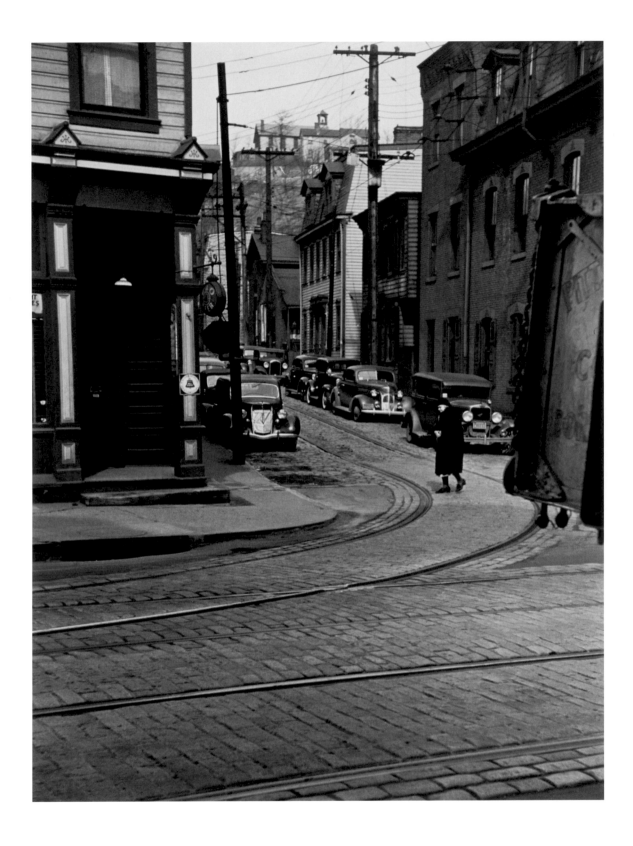

102. [Old Woman Crossing the Street, North Side, Pittsburgh], c. 1935

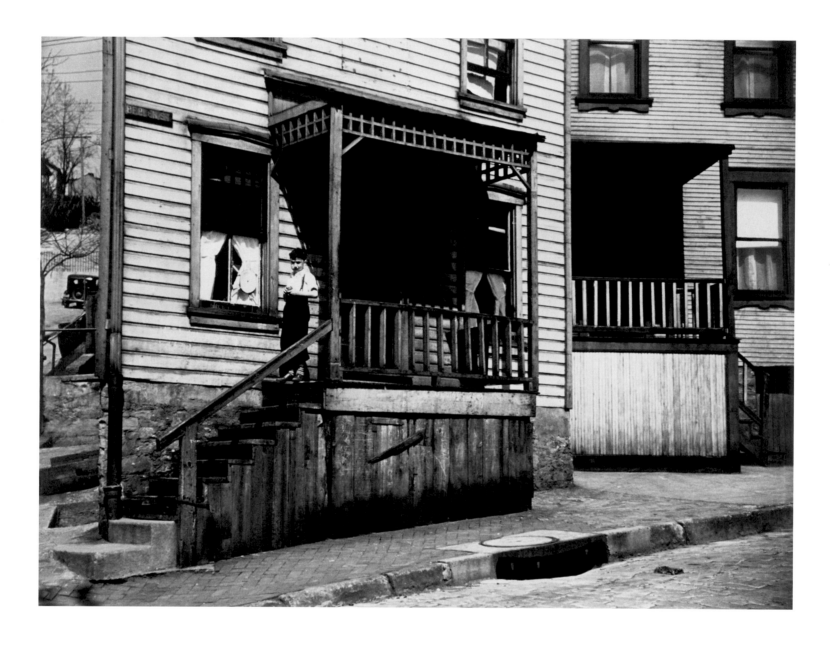

103. [Beplen Street], c. 1935

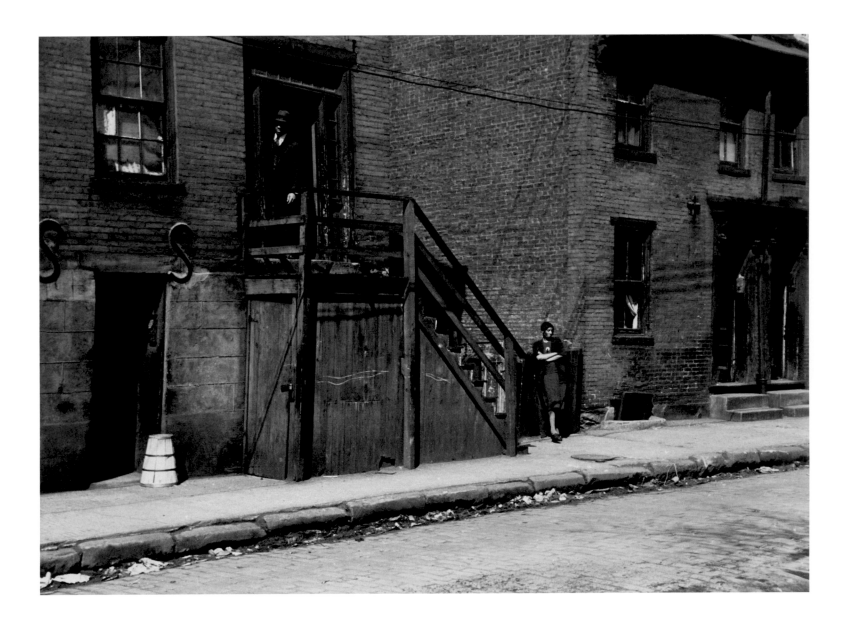

104 . [Waiting], c. 1938

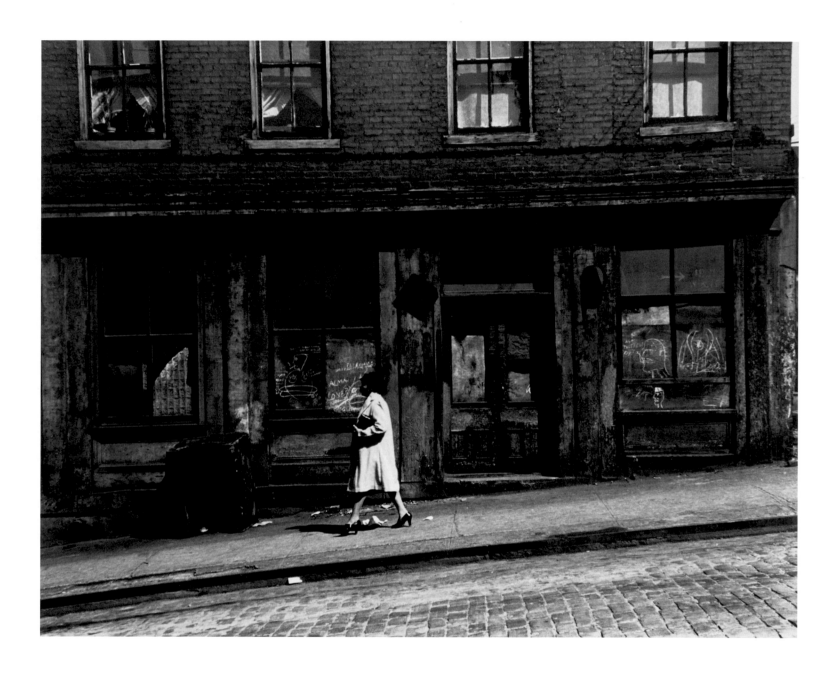

105. [Woman Walking], c. 1938

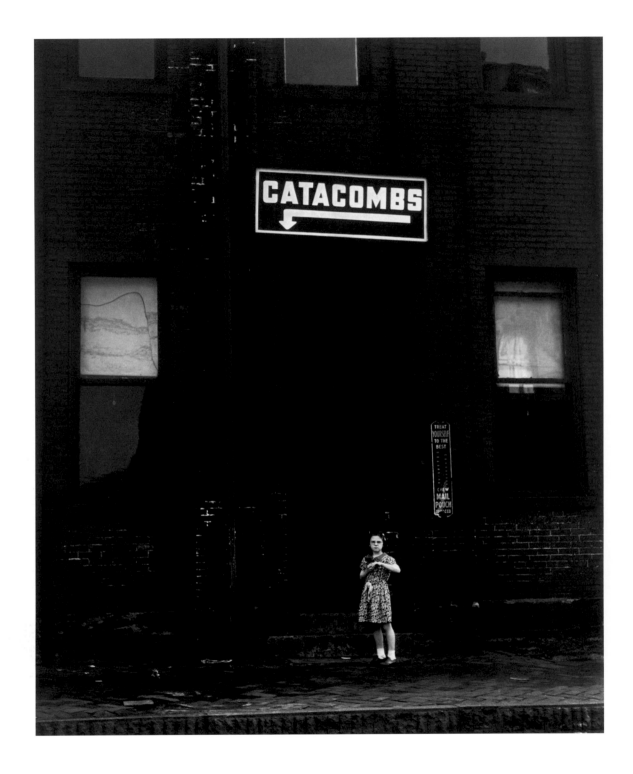

106. [Catacombs], c. 1930–1934

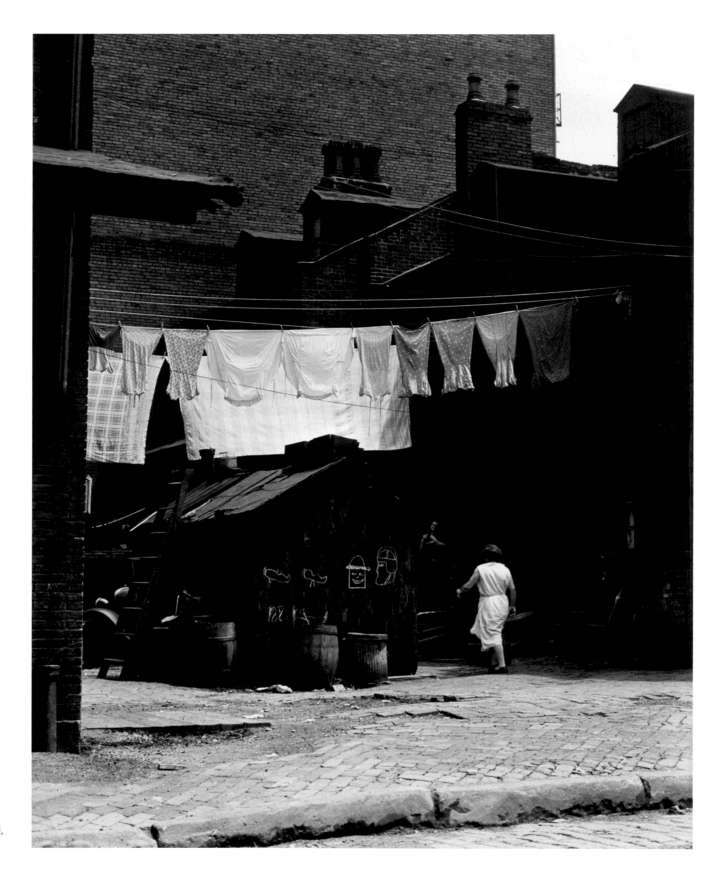

107. [Two Women,
Laundry, and Graffiti],
c. 1938

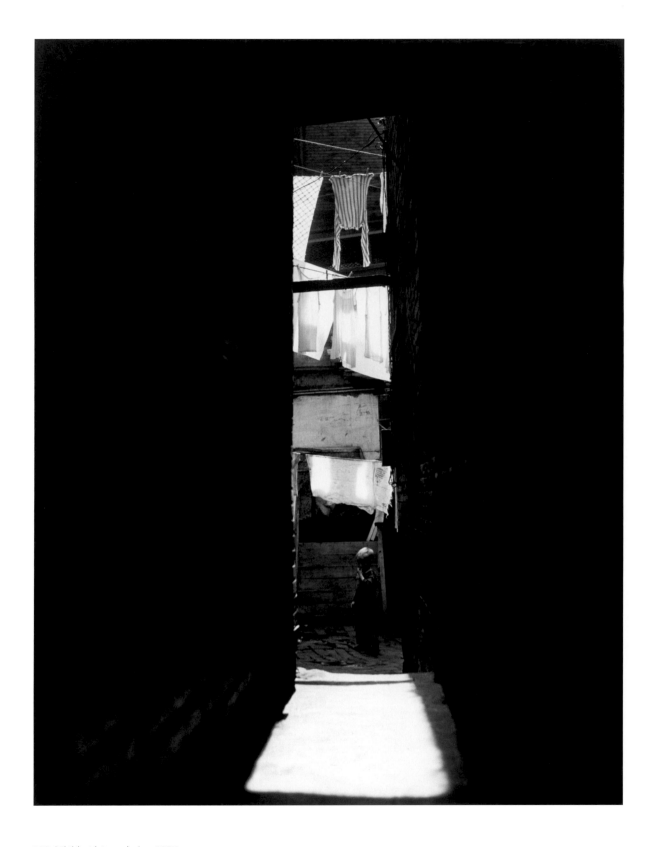

108. [Child with Laundry], c. 1937

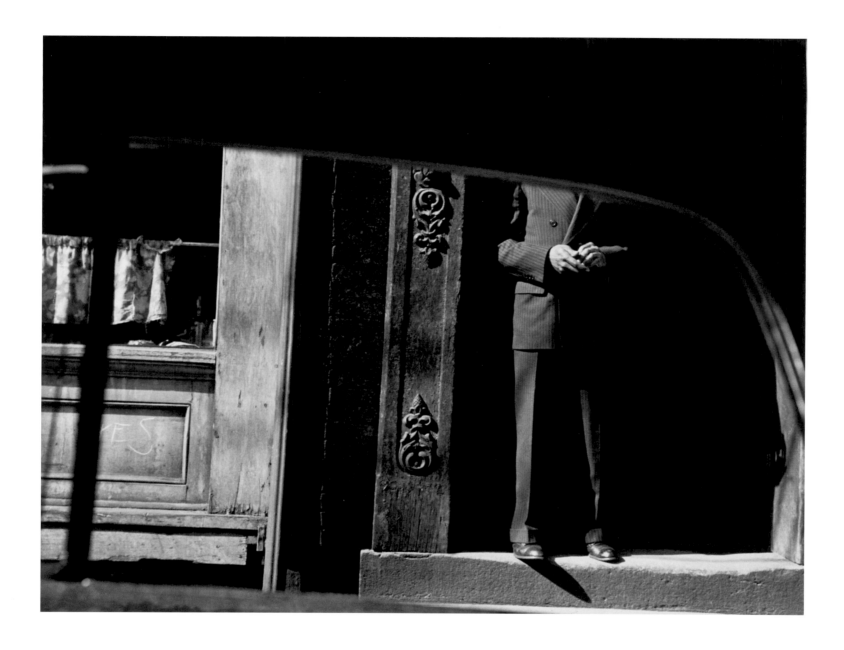

109. [Looking at a Man through a Car Window], c. 1934

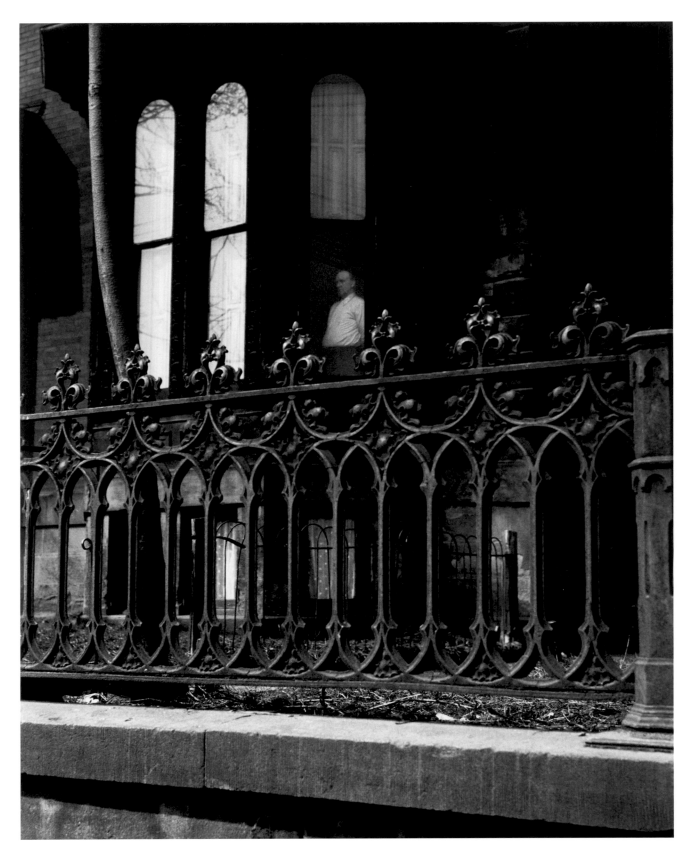

184

110. [Man Looking
Out Window],
c. 1930s

111. [Emmanuel
Episcopal Church
Organ], c. 1937

112. [Victory Produce
Co., Strip District,
Pittsburgh], c. 1935

113. [Logan Meat Market], c. 1939

114. Pittsburgh #12,
c. 1930–1933

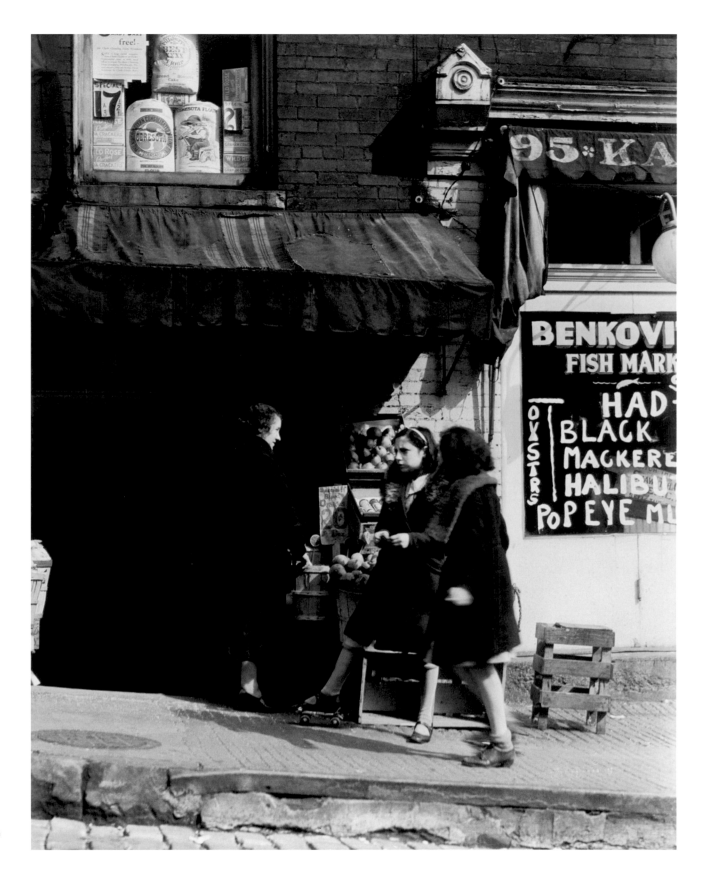

115. [Benkovitz's Fish
Market], c. 1939

190

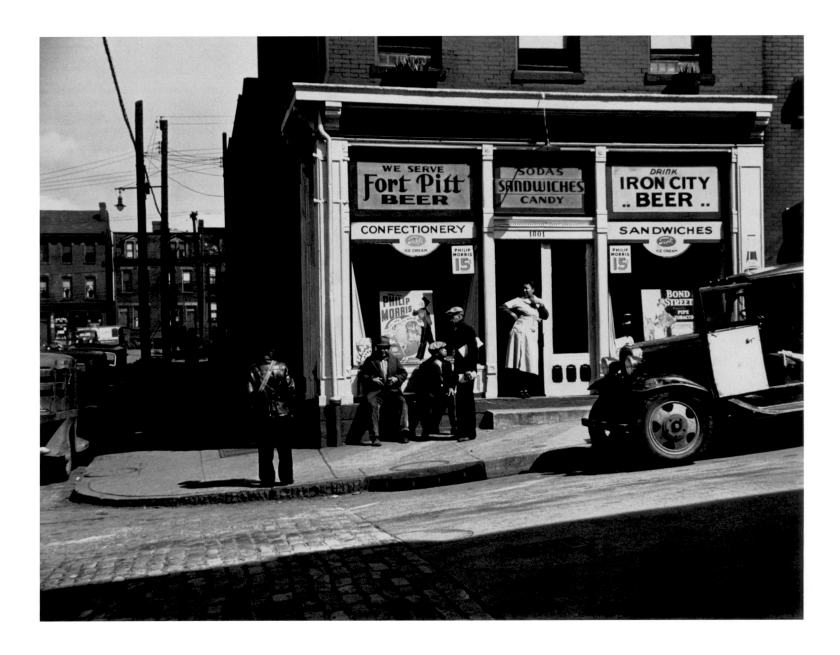

116. [We Serve Fort Pitt Beer], c. 1935

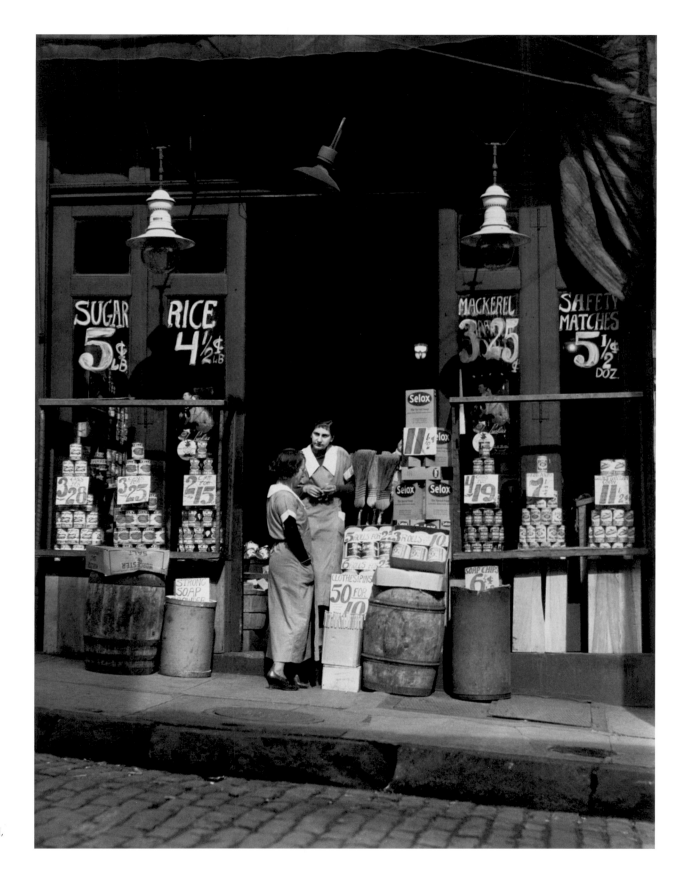

117. [Grocery Store],
c. 1935

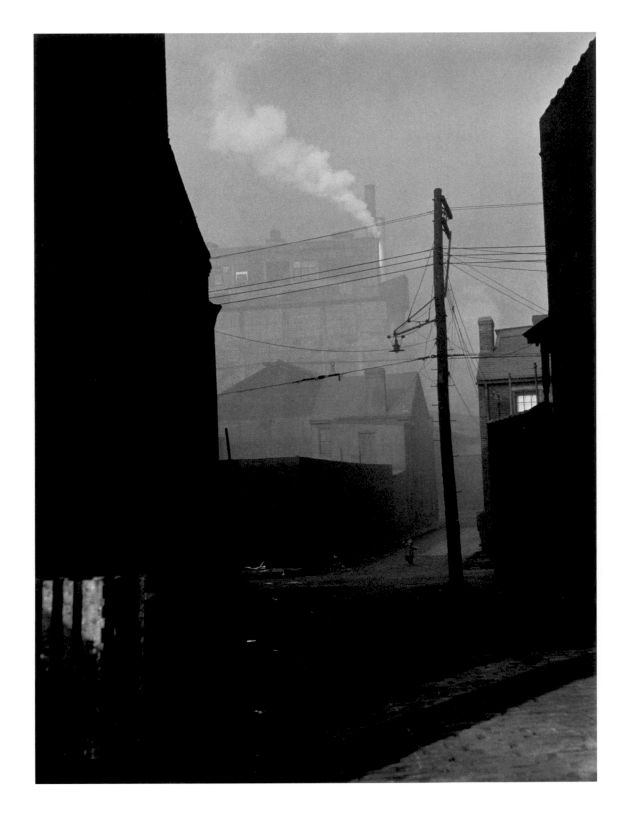

118. December Day, c. 1939

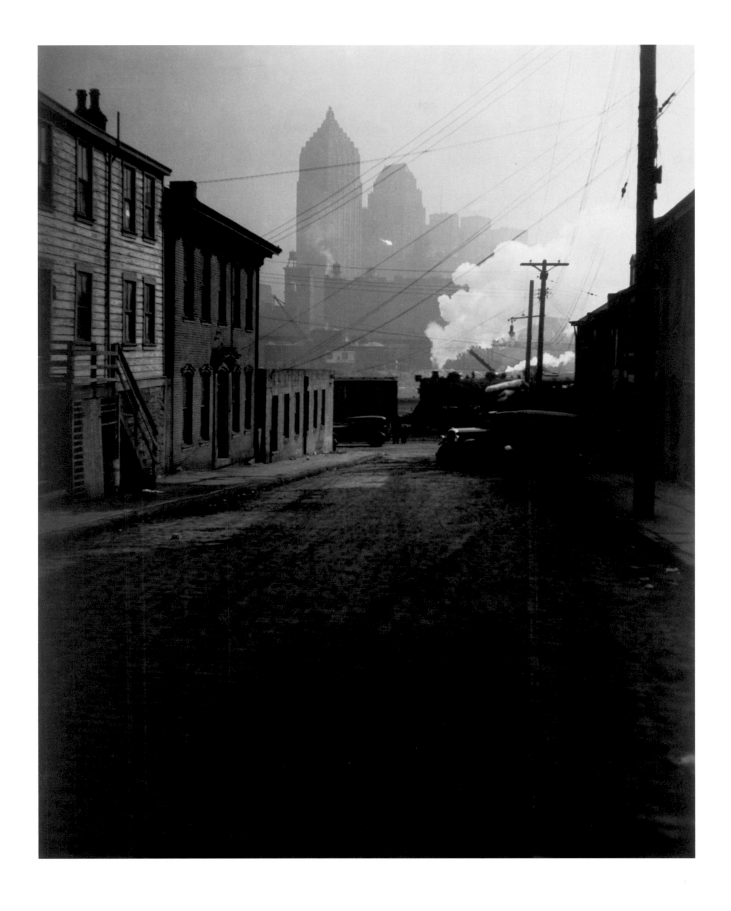

119. [Street Scene
with Steam Train],
c. 1935

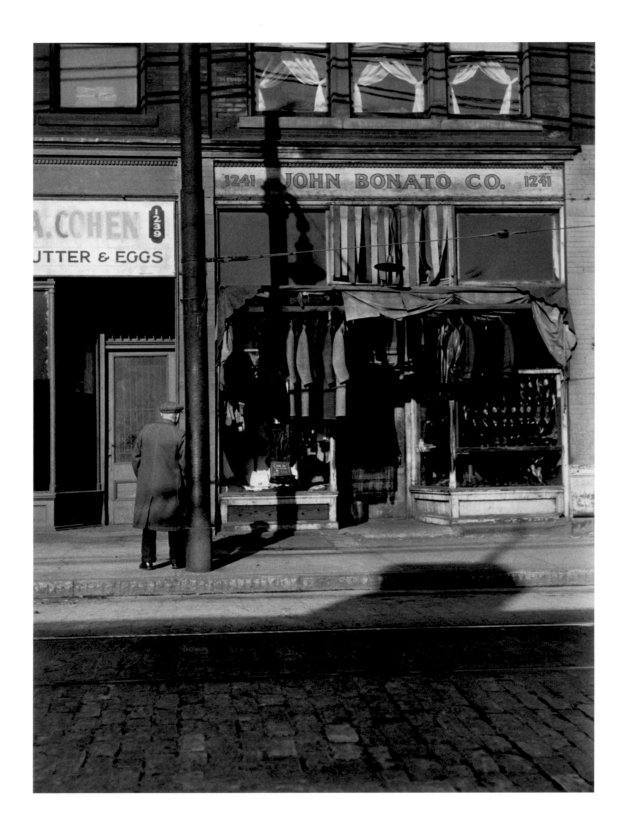

120. [John Bonato Co. Clothiers], c. 1930

121. [Shoes in Store Window], c. 1930

196

122. [Men's Coats], c. 1930

123. [Car and Building], c. 1934

124. [Street Shadows], c. 1935

125. [Shoe Doctor, East Ohio Street, Pittsburgh], c. 1935

126. [Boulevard Service III], c. 1940

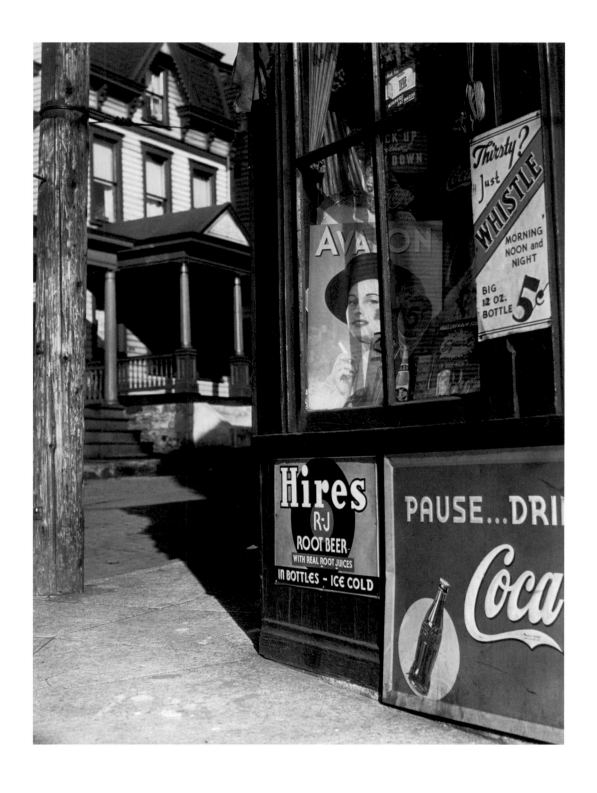

127. [Corner Store], c. 1934

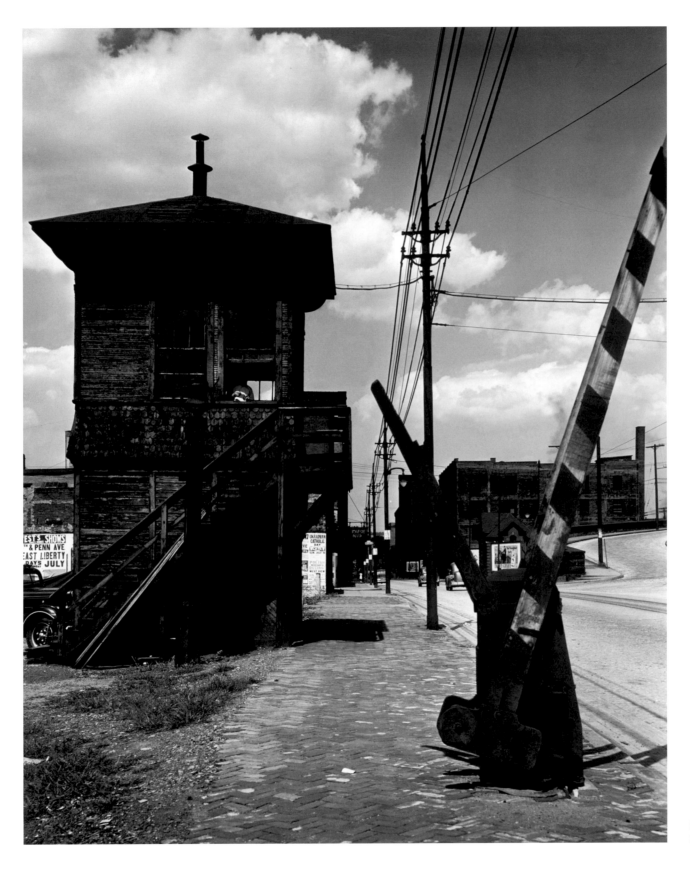

128. [Watch Tower,
Liberty Ave. near 28th
Street], c. 1935

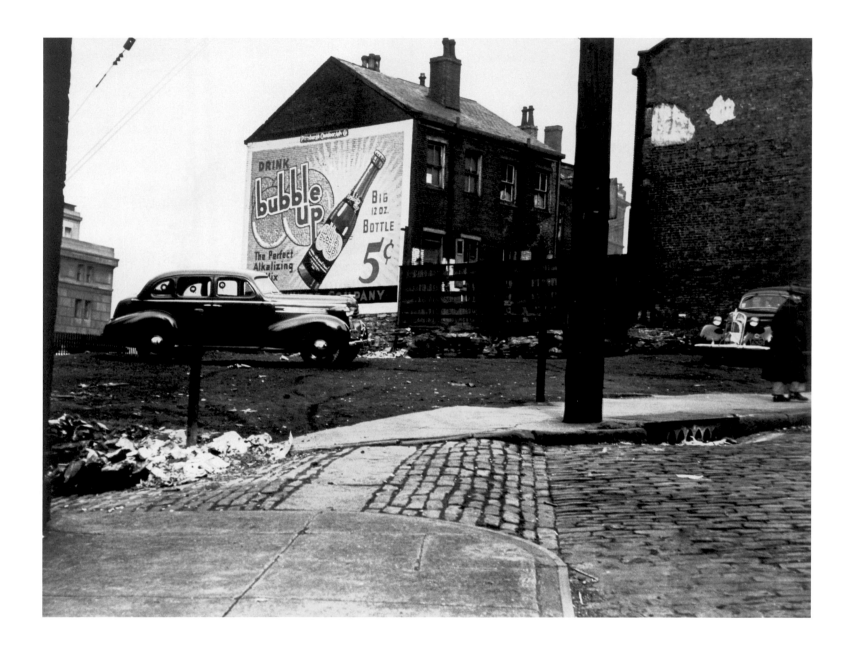

129. [Drink Bubble Up], c. 1939

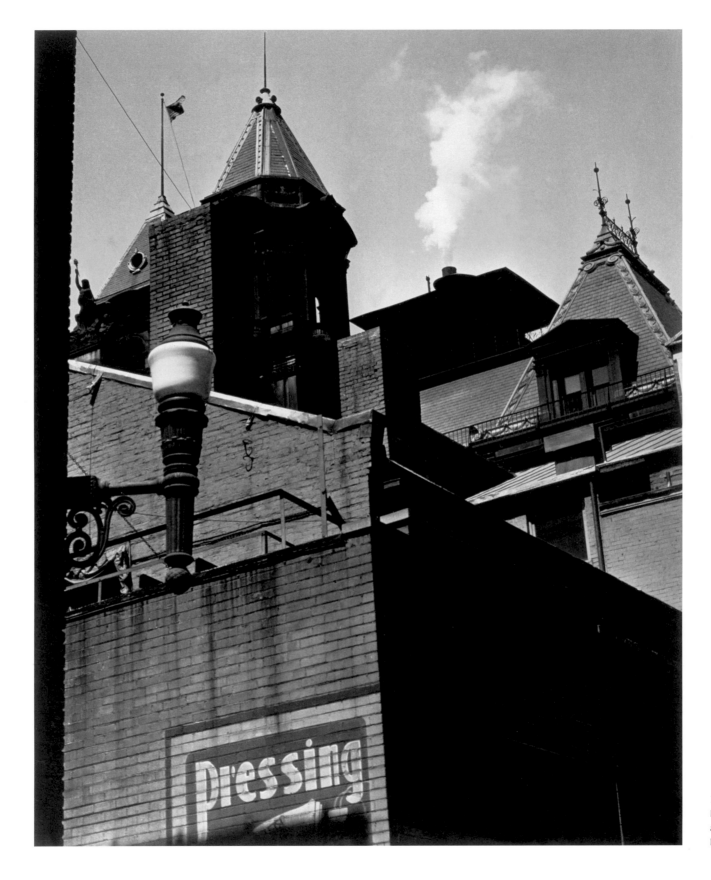

130 . [Pressing,
Near Fourth Avenue
and Smithfield,
Pittsburgh], c. 1930

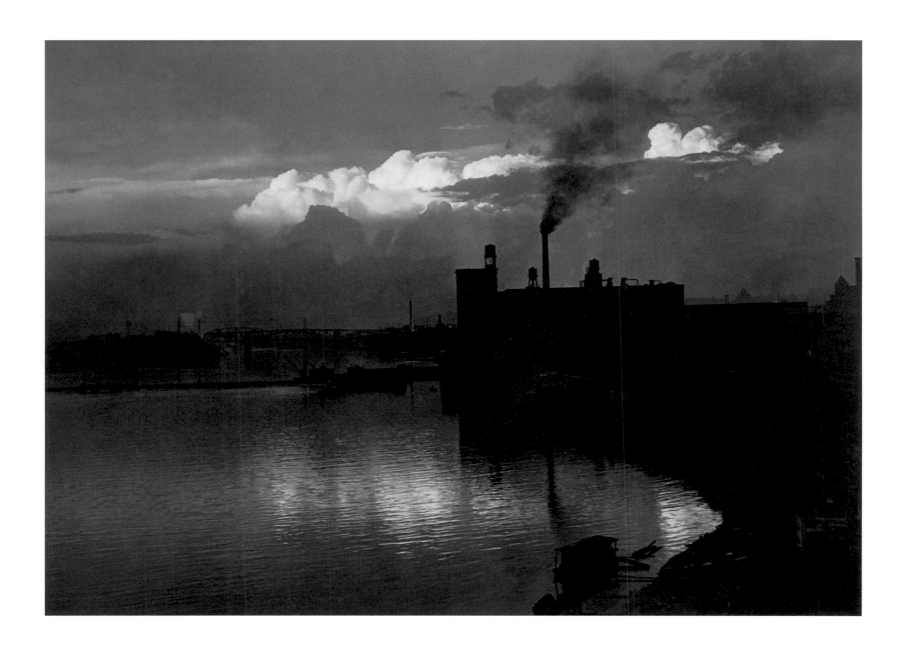

131. [Kroger Grocery/Baking Co.], c. 1923–1930

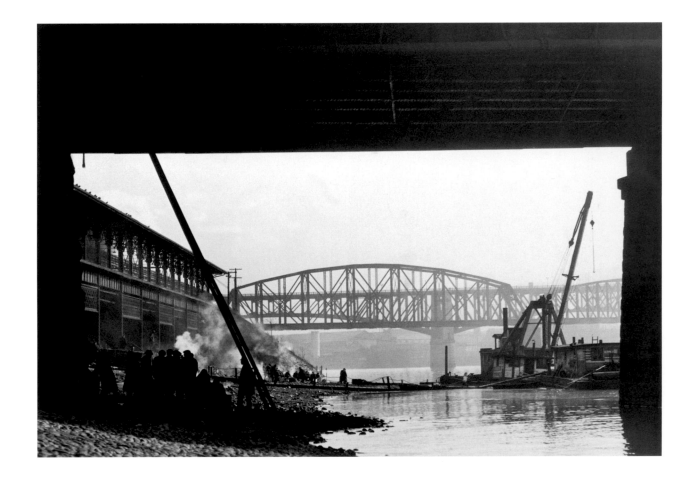

132. [Monongahela River, Pittsburgh], c. 1935

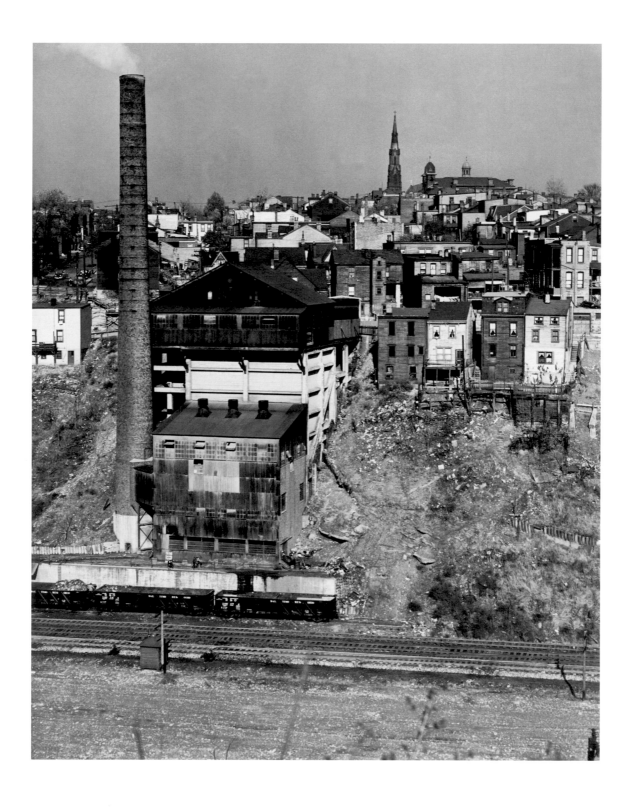

133. [Skunk Hollow Looking toward Bloomfield], c. 1937–1943

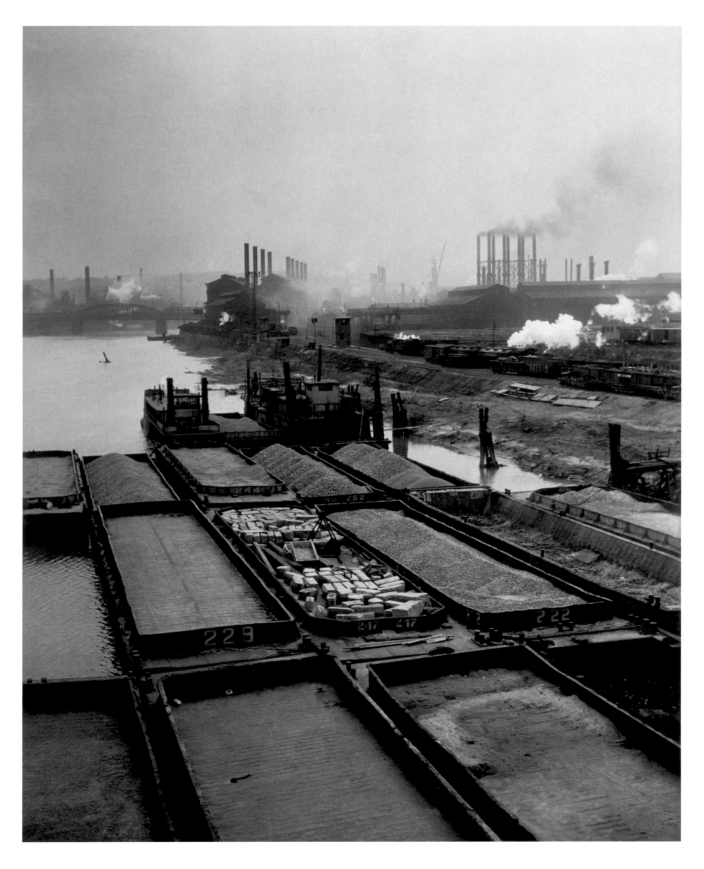

134. [River Barges and
Steel Mill], c. 1935

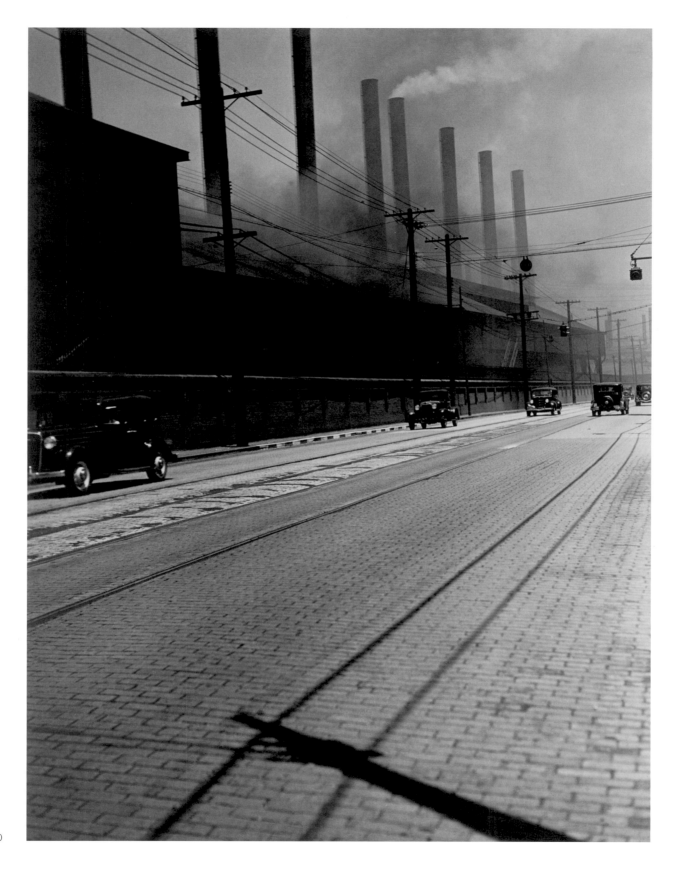

135. [Automobiles,
Cobblestone Street,
and Steel Mill], c. 1930

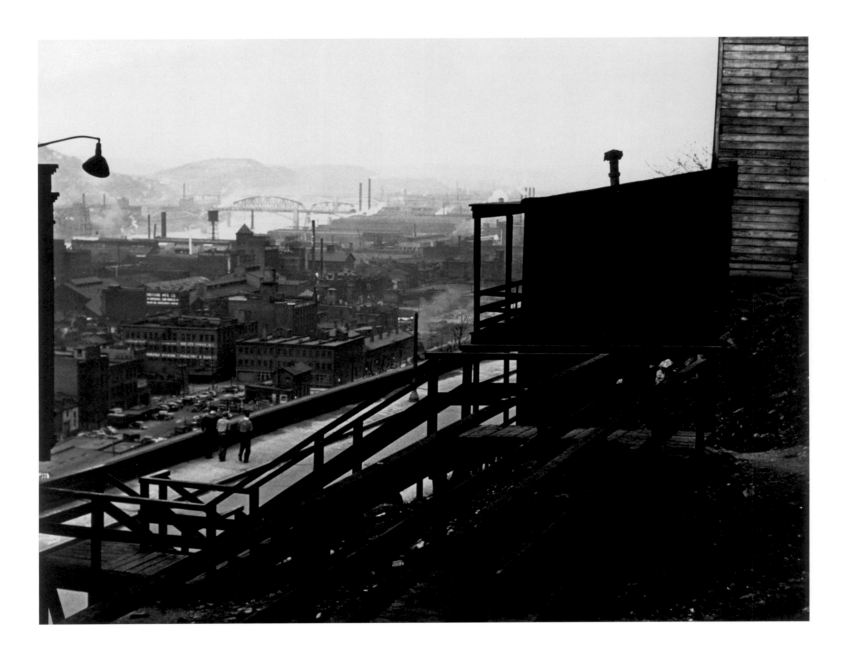

136. [Those Steps], c. 1933

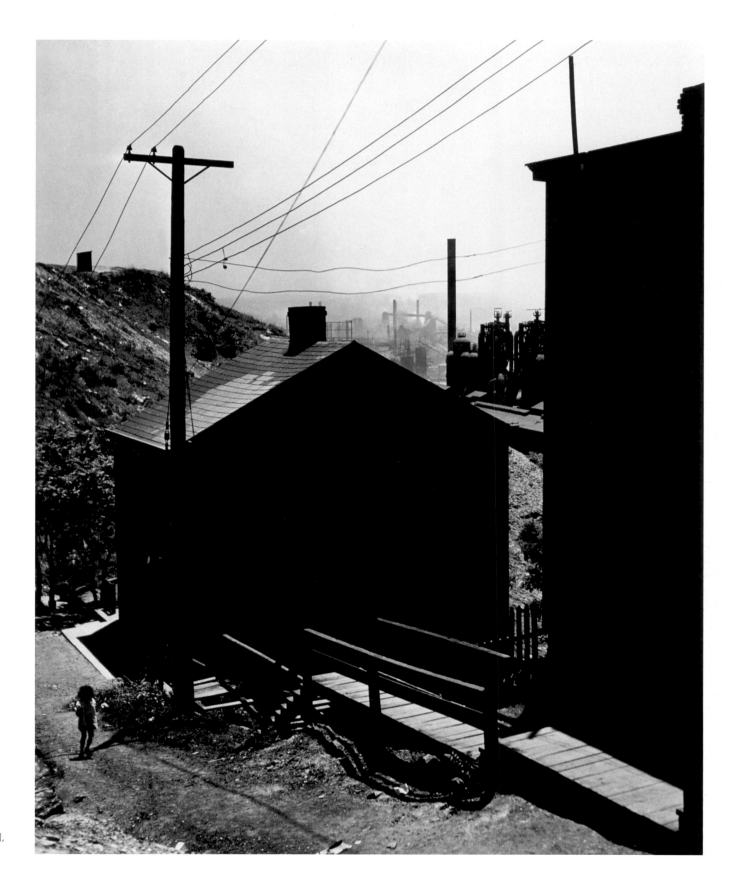

137. [Oakland Soho],
c. 1930

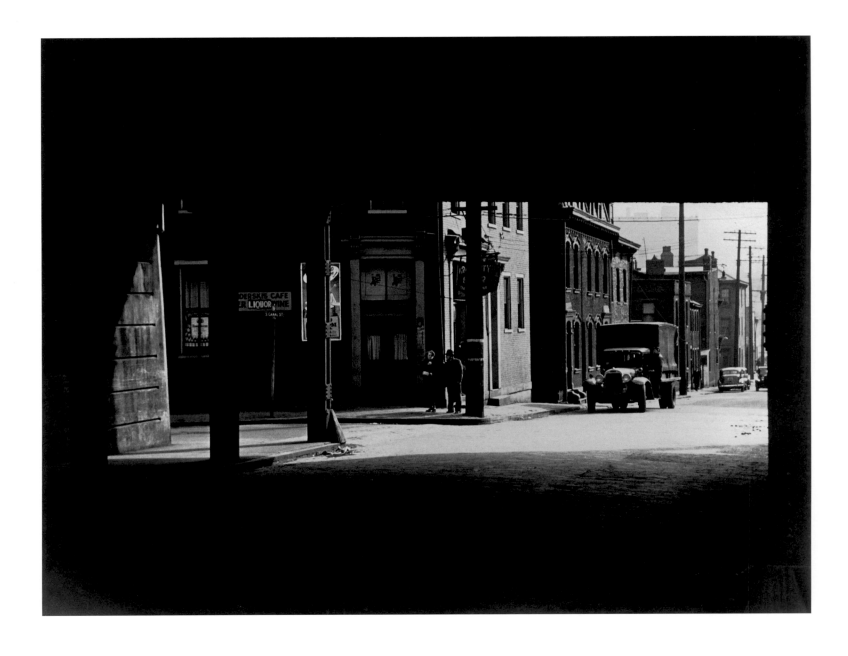

138. [Corner of South Canal and Madison], c. 1937

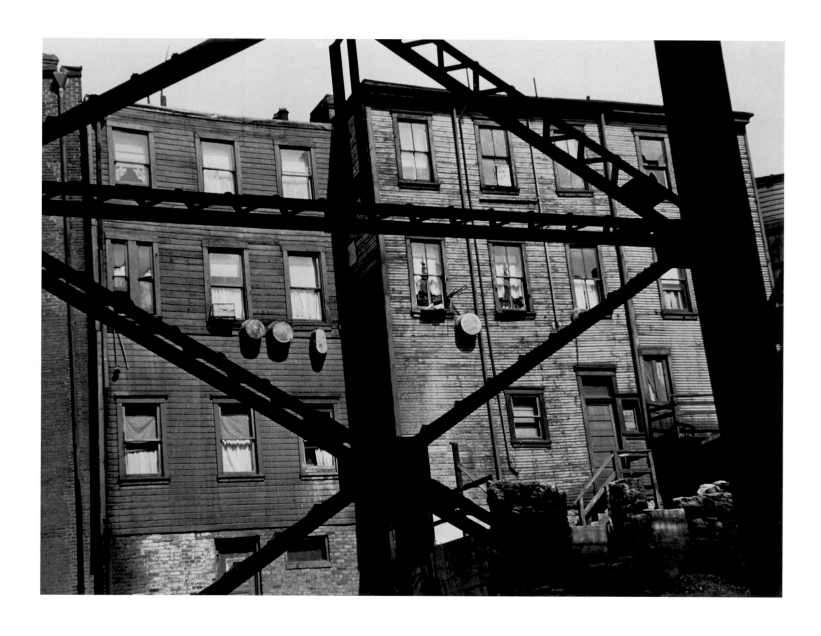

139. [Apartment House with Wash Tubs], c. 1935

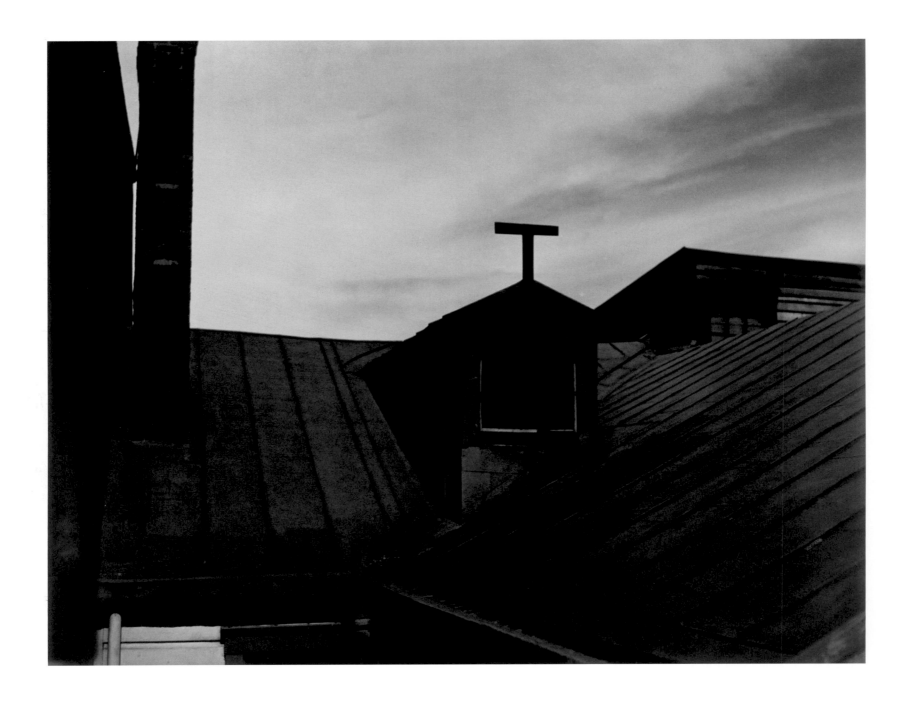

214

140. [Rooftops], c. 1935–1943

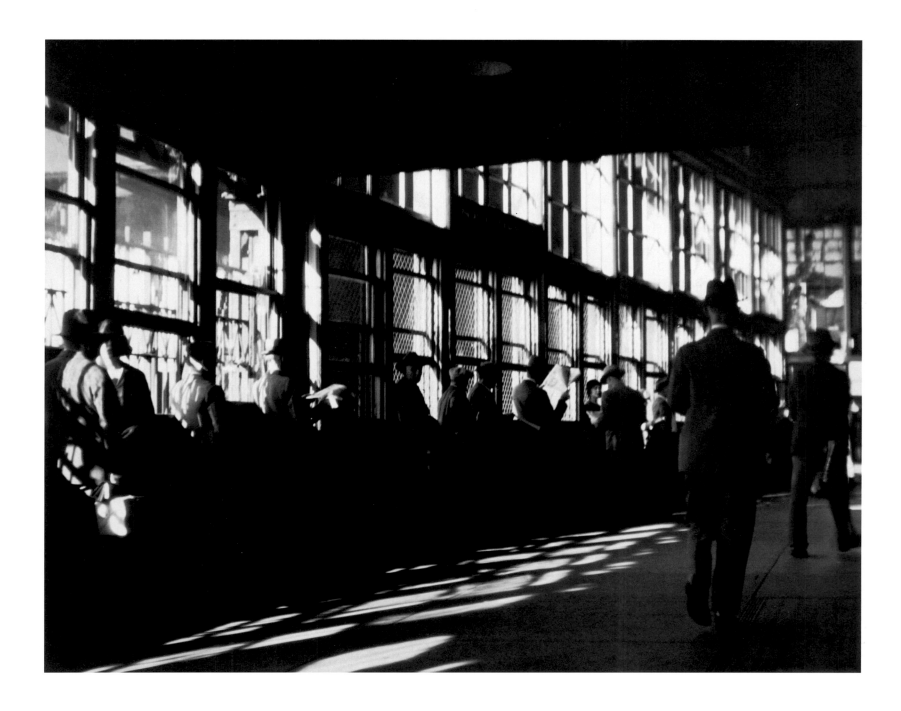

141. Train Shed, c. 1935

LIST OF PLATES

The plates are organized thematically rather than chronologically. Unless otherwise noted, all prints are vintage gelatin silver prints.

Luke Swank titled very few of his photographs. I have added descriptive titles for all of Swank's untitled photographs; these are enclosed in square brackets. The titles without brackets are believed to be Swank's original titles.

Only a portion of the Luke Swank collection in the Carnegie Library of Pittsburgh has been catalogued. Some prints have identifying numbers while others do not. For many images the number indicated on the print corresponds to that number in the negative collection. Dimensions are given in inches with height preceding width. Most photographs were mounted by Swank. For mounted images the image size precedes the mount size. Where information is missing, it is not known. Many prints have Swank's stylized trademark signature in pencil below the right side of the image. If the print is signed that is noted.

Luke Swank's photographs are reproduced through the courtesy of Claudia M. Elliott. Richard Stoner made most of the reproduction transparencies and prints.

STEEL

1

[Blast Furnace Stoves and Washer], c. 1927–1930

3³⁄₁₆" x 4"; mount 7" x 5"

Carnegie Museum of Art; Gift of Edith Swank Long by transfer from the Pennsylvania Department, Carnegie Library of Pittsburgh, 83.76.74.1

2

[Blast Furnace], c. 1927–1930

3⅛" x 4⅛"; mount 7" x 5⅛"

Carnegie Museum of Art; Gift of Edith Swank Long by transfer from the Pennsylvania Department, Carnegie Library of Pittsburgh, 83.76.74.2

3

[Steel Plant], c. 1927–1930

3¼" x 4⅛"; mount 7" x 4⅞"

Carnegie Museum of Art; Gift of Edith Swank Long by transfer from the Pennsylvania Department, Carnegie Library of Pittsburgh, 83.76.74.3

4

[Lower Cambria Works], c. 1930.

7¼" x 8¼"; mount 13¾" x 14⅝"

Southern Alleghenies Museum of Art; Gift of Mr. and Mrs. Joseph H. Wilson, 90.023

5

[Blast Furnaces, Lower Cambria Works], c. 1930

9³⁄₁₆" x 7¼"; mount 15¼" x 13"

Southern Alleghenies Museum of Art; Gift of Mr. and Mrs. Joseph H. Wilson, 90.038

6

[Spruce Street, Franklin Borough I], c. 1930

9³⁄₁₆" x 7¼"; mount 18" x 14"

Southern Alleghenies Museum of Art; Gift of Mr. and Mrs. Joseph H. Wilson, 90.037

7

[Spruce Street, Franklin Borough II], negative c. 1930, print c. 1938

7⁷⁄₁₆" x 5⅝"; mount 18' x 14"; signed

Carnegie Library of Pittsburgh; Gift of Edith Swank Long

8

Steel Plant (design for mural), 1932

Five brown-toned gelatin silver prints, mount 10½" x 20½"

The Art Institute of Chicago; Julien Levy Collection, Gift of Jean Levy and the Estate of Julien Levy, 1988.157.84; Reproduction, The Art Institute of Chicago

9

[Skip Bridge and Dust Catcher I] (design for mural), 1932

9⅝" x 17⅜"

Carnegie Library of Pittsburgh; Gift of Edith Swank Long, SW152, SW152a

10

[Skip Bridge], c. 1930–1932

13⁹⁄₁₆" x 10½"; mount 20" x 16"

Carnegie Library of Pittsburgh; Gift of Edith Swank Long, SW152

11

[Skip Bridge and Dust Catcher II], c. 1930–1932

13⅛" x 9⅜"; mount 18" x 14"; signed

Carnegie Museum of Art; Gift of Edith Swank Long by transfer from the Pennsylvania Department, Carnegie Library of Pittsburgh, 83.40.56

12

[Franklin Borough], c. 1930

9³⁄₁₆" x 7¼"; mount 18" x 14"

Southern Alleghenies Museum of Art; Gift of Mr. and Mrs. Joseph H. Wilson, 90.030

13

[Blast Furnace Area, Franklin Works], c. 1930

9³⁄₁₆" x 7¼"; mount 15¼" x 13"

Southern Alleghenies Museum of Art; Gift of Mr. and Mrs. Joseph H. Wilson, 90.027

14

[Hot Blast Stoves and Ore Bridge, Franklin Works], c. 1930

9³⁄₁₆" x 7¼"; mount 15¼" x 13"

Southern Alleghenies Museum of Art; Gift of Mr. and Mrs. Joseph H. Wilson, 90.036

15

[Blast Furnace Top, Franklin Works],
c. 1930

9³⁄₁₆" x 7¼"; mount 18" x 14"

Southern Alleghenies Museum of Art; Gift
of Mr. and Mrs. Joseph H. Wilson, 90.026

16

[Top of Blast Furnace], c. 1930

9³⁄₁₆" x 7¼"; mount 18" x 14"

Southern Alleghenies Museum of Art; Gift
of Mr. and Mrs. Joseph H. Wilson, 90.024

17

[Stacks], c. 1930

9³⁄₁₆" x 7¼"; mount 15¼" x 13"

Southern Alleghenies Museum of Art; Gift
of Mr. and Mrs. Joseph H. Wilson, 90.035

18

[Hot Blast Stoves and Waste Heat Stack],
c. 1930–1932

9½" x 7½"; mount 18" x 14"; signed

Carnegie Museum of Art; Gift of Edith
Swank Long by transfer from the
Pennsylvania Department, Carnegie
Library of Pittsburgh, 83.76.63

19

[Hot Blast Main and Stoves, Franklin
Works], c. 1930

9³⁄₁₆" x 7¼"; mount 15¼" x 13"

Southern Alleghenies Museum of Art; Gift
of Mr. and Mrs. Joseph H. Wilson, 90.031

20

[Blast Furnace, Franklin Works], c. 1930

9³⁄₁₆" x 7¼"; mount 15¼" x 13"

Southern Alleghenies Museum of Art; Gift
of Mr. and Mrs. Joseph H. Wilson, 90.029

21

[Railroad Tracks next to Coke Oven
Battery], c. 1930

9³⁄₁₆" x 7¼"; mount 15¼" x 13"

Southern Alleghenies Museum of Art; Gift
of Mr. and Mrs. Joseph H. Wilson, 90.032

22

[Interior of Cast House, Molten Pig Iron
and Runners], c. 1930

10½" x 13⅜"; mount 20" x 16"

Carnegie Museum of Art; Gift of Edith
Swank Long by transfer from the
Pennsylvania Department, Carnegie
Library of Pittsburgh, 83.76.71

23

[Overhead Crane for Stripping Ingots],
c. 1930

6⅞" x 8¼"; mount 13⅛" x 15⅛"

Southern Alleghenies Museum of Art; Gift
of Mr. and Mrs. Joseph H. Wilson, 90.025

24

[Steel Worker with Foundry Crane],
c. 1930

9³⁄₁₆" x 7¼"; mount 24¾" x 19½"; signed

Southern Alleghenies Museum of Art; Gift
of Mr. and Mrs. Joseph H. Wilson, 90.033

25

[Steelworkers with Cupola Furnace in Iron
Foundry], c. 1934

7⁹⁄₁₆" x 9⅜"; mount 18" x 14"

Carnegie Museum of Art; Gift of Edith
Swank Long by transfer from the
Pennsylvania Department, Carnegie
Library of Pittsburgh, 83.40.48

26

[Filling Molds with Molten Iron I], c. 1934

Modern gelatin silver print, 6⅝" x 8¾"

Carnegie Library of Pittsburgh; Gift of
Edith Swank Long, SW0130

27

[Filling Molds with Molten Iron II], c. 1934

10½" x 13¼"; unmounted

Carnegie Museum of Art; Gift of Edith
Swank Long by transfer from the
Pennsylvania Department, Carnegie
Library of Pittsburgh, 83.40.46

28

[Steel Worker in Foundry], c. 1934

13³⁄₁₆" x 9⁷⁄₁₆"; unmounted

Carnegie Museum of Art; Gift of Edith
Swank Long by transfer from the
Pennsylvania Department, Carnegie
Library of Pittsburgh, 83.40.44

CIRCUS

29

[To the Big Show], c. 1919–1924

10⁹⁄₁₆" x 13⅜"; mount 16" x 20"

Carnegie Library of Pittsburgh; Gift of
Edith Swank Long, SWC144; Reproduced
by permission from Ringling Bros. and
Barnum & Bailey, The Greatest Show on
Earth

30

[Hagenbeck-Wallace Circus Poster], 1933

6⁵⁄₁₆" x 4½"; mount 18" x 14"; signed

Carnegie Library of Pittsburgh; Gift of
Edith Swank Long, SWC115; Reproduced
by permission from Ringling Bros. and
Barnum & Bailey, The Greatest Show on
Earth

31

[Canvasmen, Hagenbeck-Wallace Circus],
c. 1933

4½" x 5⅞"; mount 18" x 14"; signed

Carnegie Library of Pittsburgh; Gift of
Edith Swank Long, SWC289; Reproduced
by permission from Ringling Bros. and
Barnum & Bailey, The Greatest Show on
Earth

32

[Roustabout with Circus Poles], c. 1934

8" x 6"; mount 18" x 14"; signed

Carnegie Museum of Art; Gift of Edith
Swank Long by transfer from the
Pennsylvania Department, Carnegie
Library of Pittsburgh, 83.40.34

33

[Three Workers with Ropes and Tents],
c. 1932–1933

4⁹⁄₁₆" x 5¹¹⁄₁₆"; mount 18" x 14"; signed

Carnegie Library of Pittsburgh; Gift of
Edith Swank Long, SWC33

34

[Clown Reading a Newspaper],
c. 1932–1933

4⅝" x 6⅛"; mount 18" x 14"; signed

Carnegie Library of Pittsburgh; Gift of
Edith Swank Long, SWC271; Reproduced
by permission from Ringling Bros. and
Barnum & Bailey, The Greatest Show on
Earth

35

[Performers], c. 1934

4⅝" x 6¼"; mount 18" x 14"; signed

Carnegie Museum of Art; Gift of Edith
Swank Long by transfer from the
Pennsylvania Department, Carnegie
Library of Pittsburgh, 83.40.24

36

[Man Lying on Hay], c. 1932–1934

5½" x 4¼"; mount 18" x 14"; signed

Carnegie Library of Pittsburgh; Gift of
Edith Swank Long, SWC29

37

[Balloon Vendor], c. 1932–1934

8¹⁄₁₆" x 6⁷⁄₁₆"; mount 18" x 14"; signed

Carnegie Library of Pittsburgh; Gift of
Edith Swank Long, SWC266

38

[People Watching], c. 1930–1932

4⅝" x 6½"; mount 18" x 14"; signed

Carnegie Library of Pittsburgh; Gift of
Edith Swank Long, SWC301; Reproduced
by permission from Ringling Bros. and
Barnum & Bailey, The Greatest Show on
Earth

39

[Juggler], c. 1932–1934

6¼" x 4½"; mount 18" x 14"; signed

Carnegie Library of Pittsburgh; Gift of
Edith Swank Long, SWC45

40

[Snake Charmer], c. 1934

4¹¹⁄₁₆" x 5⁷⁄₁₆"; mount 18" x 14"; signed

Carnegie Museum of Art; Gift of Edith Swank Long by transfer from the Pennsylvania Department, Carnegie Library of Pittsburgh, 83.40.37

41

[Otto Griebling on Horseback], c. 1929–1930

6" x 4½"; mount 18" x 14"; signed

Carnegie Museum of Art; Gift of Edith Swank Long by transfer from the Pennsylvania Department, Carnegie Library of Pittsburgh, 83.40.10

42

[Boss and Porter], c. 1933

7¾" x 6"; mount 18" x 14"; signed

Carnegie Library of Pittsburgh; Gift of Edith Swank Long, C-259

43

[Paul Jerome, Clown], c. 1930–1934

Modern gelatin silver print, 6¼" x 4⅞"

Carnegie Library of Pittsburgh; Gift of Edith Swank Long, C-11

44

[Bumpsy Anthony, Clown], c. 1930–1932

6¹⁵⁄₁₆" x 4½"; mount 18" x 14"; signed

Carnegie Museum of Art; Gift of Edith Swank Long by transfer from the Pennsylvania Department, Carnegie Library of Pittsburgh, 83.40.7

45

[Group of Clowns with Umbrella], c. 1930–1932

4⅝" x 6⅛"; mount 18" x 14"; signed

Carnegie Library of Pittsburgh; Gift of Edith Swank Long, SWC320

46

[Emmett Kelly and Otto Griebling], c. 1933

5⅞" x 7¼"; mount 18" x 15¾"; signed

Carnegie Museum of Art; Gift of Edith Swank Long by transfer from the Pennsylvania Department, Carnegie Library of Pittsburgh, 83.40.29

47

[Nineteen Clowns], c. 1930

4½" x 6"; mount 18" x 14"; signed

Carnegie Library of Pittsburgh; Gift of Edith Swank Long, SWC57

48

[Clown Face I], c. 1930

6½" x 4⅝"; mount 18" x 14"; signed

Carnegie Library of Pittsburgh; Gift of Edith Swank Long, SWC13

49

[Clown Face II], c. 1930

6⁵⁄₁₆" x 4½"; mount 18" x 14"; signed

Carnegie Library of Pittsburgh; Gift of Edith Swank Long

50

[Clown Face III], c. 1930

6⅜" x 4⁹⁄₁₆"; mount 18" x 14"; signed

Carnegie Museum of Art; Gift of Edith Swank Long by transfer from the Pennsylvania Department, Carnegie Library of Pittsburgh, 83.40.9

51

[Arthur Borella Trio], c. 1930

4½" x 6"; mount 18" x 14"; signed

Carnegie Museum of Art; Gift of Edith Swank Long by transfer from the Pennsylvania Department, Carnegie Library of Pittsburgh, 83.40.12

52

[Circus Tent I], c. 1928–1934

6" x 4⁹⁄₁₆"; mount 18" x 14"; signed

Carnegie Museum of Art; Gift of Edith Swank Long by transfer from the Pennsylvania Department, Carnegie Library of Pittsburgh, 83.76.16

53

[Circus Tent II], c. 1928–1934

6³⁄₁₆" x 4⁵⁄₁₆"; mount 18" x 14"; signed

Carnegie Museum of Art; Gift of Edith Swank Long by transfer from the Pennsylvania Department, Carnegie Library of Pittsburgh, 83.76.18

PEOPLE

54

[Three Boys in a Wagon], c. 1934

13¼" x 10⁵⁄₁₆"; mount 20" x 16"; signed

Carnegie Museum of Art; Gift of Edith Swank Long by transfer from the Pennsylvania Department, Carnegie Library of Pittsburgh, 83.40.85

55

[Migrant Children], c. 1936–1940

7½" x 9⅜"; unmounted

Courtesy of the Heinz Family, 3389

56

[Portrait of a Young Girl], c. 1936–1940

13⅛" x 9¾"; unmounted

Carnegie Museum of Art; Gift of Edith Swank Long by transfer from the Pennsylvania Department, Carnegie Library of Pittsburgh, 83.40.118

57

[Women at Portrait Studio], c. 1939

7¼" x 9½"; mount 13⅛" x 10⅜"

Carnegie Museum of Art; Gift of Edith Swank Long by transfer from the Pennsylvania Department, Carnegie Library of Pittsburgh, 83.76.168

58

[Woman in Shadows], c. 1937

9" x 6½"; mount 18" x 14"

Property of the Western Pennsylvania Conservancy, 90.418

59

[Man with Cigar], c. 1939

6" x 8"; mount 14" x 18"; signed

Property of the Western Pennsylvania Conservancy, 90.384

60

[Amish Boys Nibbling Grapes], c. 1940

8" x 5⅞"; mount 18" x 14"

Carnegie Museum of Art; Gift of Edith Swank Long by transfer from the Pennsylvania Department, Carnegie Library of Pittsburgh, 83.40.121

61

[Amish Boys with Watermelon], c. 1940

7⅛" x 9⅜"; mount 18" x 14"

Carnegie Museum of Art; Gift of Edith Swank Long by transfer from the Pennsylvania Department, Carnegie Library of Pittsburgh, 83.40.117

62

[Amish School Girls], c. 1940

6¹⁵⁄₁₆" x 9⅜"; mount 18" x 14"

Carnegie Museum of Art; Gift of Edith Swank Long by transfer from the Pennsylvania Department, Carnegie Library of Pittsburgh, 83.40.115

63

[War Mother I], c. 1941

13⁵⁄₁₆" x 10⁵⁄₁₆"; unmounted

Carnegie Museum of Art; Gift of Edith Swank Long by transfer from the Pennsylvania Department, Carnegie Library of Pittsburgh, 83.40.119

64

[War Mother II], c. 1941

13⅜" x 10⁵⁄₁₆"; unmounted

Carnegie Museum of Art; Gift of Edith Swank Long by transfer from the Pennsylvania Department, Carnegie Library of Pittsburgh, 83.40.120

65

[Three Women], c. 1935

8¹⁄₁₆" x 6"; mount 18" x 14"

Carnegie Museum of Art; Gift of Edith Swank Long by transfer from the Pennsylvania Department, Carnegie Library of Pittsburgh, 83.40.104

66

[Grace I], c. 1925–1930

9½" x 7⁷⁄₁₆"; mount 17¾" x 13¾"

Carnegie Museum of Art; Gift of Edith Swank Long by transfer from the Pennsylvania Department, Carnegie Library of Pittsburgh, 83.76.133

67

[Edith by the Hangover], c. 1940–1943

3½" x 4½"; mount 9" x 7"

Collection of Claudia M. Elliott

68

[Edith in Bathing Cap], c. 1940–1943

8" x 6⅛"; unmounted

Collection of Claudia M. Elliott

TRANSFORMATIONS

69

[Old Basket in the Cellar], c. 1931

Bromide print, 10⁵⁄₁₆" x 13⅜"; mount 15¹⁄₁₆" x 16¼"; signed

Carnegie Library of Pittsburgh; Gift of Edith Swank Long

70

[Onions and Bowl], c. 1932

4³⁄₁₆" x 6⅜"; mount 18" x 14"; signed

Carnegie Museum of Art; Gift of Edith Swank Long by transfer from the Pennsylvania Department, Carnegie Library of Pittsburgh, 83.40.126

71

[Tire and Oil Can], c. 1932

7¹³⁄₁₆" x 5⅝"; mount 18" x 14"; signed

Carnegie Library of Pittsburgh; Gift of Edith Swank Long

72

[Metal Ring and Shadows], c. 1932

10½" x 12¾"; mount 20" x 16"

Carnegie Museum of Art; Gift of Edith Swank Long by transfer from the Pennsylvania Department, Carnegie Library of Pittsburgh, 83.40.1

73

[Tape, Brush, and Newspaper], c. 1932

6⅜" x 4⅝"; mount 18" x 14"; signed

Carnegie Museum of Art; Gift of Edith Swank Long by transfer from the Pennsylvania Department, Carnegie Library of Pittsburgh, 83.76.24

74

[Clothespin, Fuses, and Newspaper], c. 1932

6¼" x 4⁷⁄₁₆"; mount 18" x 14"; signed

Carnegie Museum of Art; Gift of Edith Swank Long by transfer from the Pennsylvania Department, Carnegie Library of Pittsburgh, 83.76.22

75

[Concrete and Wood], c. 1932

6⅜" x 4½"; mount 18" x 14"; signed

Carnegie Library of Pittsburgh; Gift of Edith Swank Long

76

[Rolled Wooden Fence IV], c. 1932

6½" x 4⅝"; mount 18" x 14"; signed

Carnegie Library of Pittsburgh; Gift of Edith Swank Long

77

[Rolled Wooden Fence], c. 1932

6½" x 4⅝"; mount 18" x 14"; signed

Carnegie Museum of Art; Gift of Edith Swank Long by transfer from the Pennsylvania Department, Carnegie Library of Pittsburgh, 83.40.2

78

[Wooden Tower], c. 1932–1935

6" x 4¹¹⁄₁₆"; mount 18" x 14"; signed

Carnegie Museum of Art; Gift of Edith Swank Long by transfer from the Pennsylvania Department, Carnegie Library of Pittsburgh, 83.76.36

79

[Legs, Gourds, and Shadows], c. 1939

6" x 8⅛"; mount 18" x 14"

Carnegie Museum of Art; Gift of Edith Swank Long by transfer from the Pennsylvania Department, Carnegie Library of Pittsburgh, 83.40.40

RURAL ARCHITECTURE AND LANDSCAPE

80

[E. S. Renninger Hardware], c. 1940

8" x 6"; mount 18" x 14"

Property of the Western Pennsylvania Conservancy, 93.142

81

[Three Amish Youths with Buggies], c. 1940

7¹⁄₁₆" x 9⅜"; mount 18" x 14"

Carnegie Museum of Art; Gift of Edith Swank Long by transfer from the Pennsylvania Department, Carnegie Library of Pittsburgh, 83.76.148

82

[Old Mennonite Church, Lancaster County], c. 1940

7⁵⁄₁₆" x 9⅜"; mount 18" x 14"

Carnegie Library of Pittsburgh; Gift of Edith Swank Long

83

[Florence Post Office, Washington County, Pa.], c. 1933–1935

5⅞" x 8¹⁄₁₆"; mount 18" x 14"; signed

Carnegie Museum of Art; Gift of Elizabeth Hampsey, 93.191.16

84

[Chew Tub Tobacco], c. 1940–1943

5¹⁵⁄₁₆" x 8¹⁄₁₆"; mount 18" x 14"

Carnegie Library of Pittsburgh; Gift of Edith Swank Long

85

[Men Loading Tomatoes on Flatbed Truck], c. 1940

7⅝" x 9⅜"; unmounted

Courtesy of the Heinz Family, 3395

86

[Barn with Windows], c. 1940

5⁷⁄₁₆" x 7⅞"; mount 18" x 14"

Carnegie Library of Pittsburgh; Gift of Edith Swank Long

87

[Doorway, J. Heinrich Zeller House, Lebanon County, Pa.], c. 1940–1943

13¼" x 10¼"; mount 20" x 16"

Carnegie Library of Pittsburgh; Gift of Edith Swank Long

88

[Double Door Flanked by Ferns, Deerfield, Mass.], c. 1940–1943

13⅜" x 10½"; unmounted

Carnegie Library of Pittsburgh; Gift of Edith Swank Long

89

[Sisters' House (Saron) I, Ephrata Cloister, Ephrata, Pa.], c. 1940

10" x 13¼"; flush mounted

Property of the Western Pennsylvania Conservancy, 90.1028

90

[Meetinghouse (Saal) Kitchen, Ephrata Cloister, Ephrata, Pa.], c. 1940

10½" x 13⅜"; mount 20" x 16"

Carnegie Museum of Art; Gift of Edith Swank Long by transfer from the Pennsylvania Department, Carnegie Library of Pittsburgh, 83.40.114

91

[Common Room, Sisters' House (Saron), Ephrata Cloister, Ephrata, Pa.], c. 1940

9⅜" x 13"; mount 20" x 14"; signed

Philadelphia Museum of Art; Gift of the artist, 1944-99-1

92

[Meason Mansion Staircase, Fayette County, Pa.], c. 1933–1935

6⅜" x 4⁹⁄₁₆"; mount 11" x 8½"

Western Pennsylvania Architectural Survey Collection, Carnegie Library of Pittsburgh, F2: F1-23

93

[Meason Mansion Office and Outbuilding, Fayette County, Pa.], c. 1933–1935

6¾" x 9½"; mount trimmed to 8½" x 11"; signed

Charles Morse Stotz photographs, Library & Archives Division, Historical Society of Western Pennsylvania, Pittsburgh, Pa., MSP 0021

94

[Wooden Houses on a Hillside], c. 1935–1940

5¹⁵⁄₁₆" x 8⅛"; mount 18" x 14"; signed

Carnegie Museum of Art; Gift of Elizabeth Hampsey, 93.191.24

95

[Victorian Farmhouse, Rt. 30], c. 1940–1943

5¹⁵⁄₁₆" x 8⅝"; mount 18" x 14"; signed

Carnegie Museum of Art; Gift of Elizabeth Hampsey, 93.191.2

96

[Car, House, and Tree], c. 1940

4⅜" x 6⁷⁄₁₆"; mount 18" x 14"; signed

Carnegie Library of Pittsburgh; Gift of Edith Swank Long

97

[Barren Trees with Split Rail Fence], c. 1940–1943

10⅜" x 13¼"; unmounted

Carnegie Library of Pittsburgh; Gift of Edith Swank Long

98

[Kidwell's Market, Leesburg, Virginia], c. 1940–1943

13¹¹⁄₁₆" x 10⅝"; mount 20" x 16"; signed

Carnegie Library of Pittsburgh; Gift of Edith Swank Long

THIS IS MY CITY

99

[Street Corner with Shadows], c. 1920s

Modern gelatin silver print, 7⁵⁄₁₆" x 4⁵⁄₁₆"

Carnegie Library of Pittsburgh; Gift of Edith Swank Long, SW1918

100

[Man Crossing City Street], c. 1935

9" x 7"; mount 18" x 14"; signed

Carnegie Museum of Art; Gift of Edith Swank Long by transfer from the Pennsylvania Department, Carnegie Library of Pittsburgh, 83.40.93

101

[Fifth and Liberty], c. 1935

Modern gelatin silver print, 9⁷⁄₁₆" x 7⁵⁄₁₆"

Carnegie Library of Pittsburgh; Gift of Edith Swank Long, SW1857b

102

[Old Woman Crossing the Street, North Side, Pittsburgh], c. 1935

7¹⁵⁄₁₆" x 6"; mount 18' x 14"; signed

Carnegie Library of Pittsburgh; Gift of Edith Swank Long

103

[Beplen Street], c. 1935

6" x 7⅞"; mount 18" x 14"

Property of the Western Pennsylvania Conservancy, 90.517

104

[Waiting], c. 1938

5¹³⁄₁₆" x 8"; mount 18" x 14"; signed

Collection of Mervin S. Stewart, M.D.

105

[Woman Walking], c. 1938

6¼" x 7⅞"; mount 18" x 14"

Carnegie Library of Pittsburgh; Gift of Edith Swank Long, SW240

106

[Catacombs], c. 1930–1934

7⁵⁄₁₆" x 5¹⁵⁄₁₆"; mount 18" x 14"; signed

Carnegie Museum of Art; Gift of Edith Swank Long by transfer from the Pennsylvania Department, Carnegie Library of Pittsburgh, 83.76.130

107

[Two Women, Laundry, and Graffiti], c. 1938

9½" x 7⁹⁄₁₆"; unmounted

Carnegie Museum of Art; Gift of Edith Swank Long by transfer from the Pennsylvania Department, Carnegie Library of Pittsburgh, 83.40.91

108

[Child with Laundry], c. 1937

8" x 6¼"; mount 18" x 14"; signed

Carnegie Library of Pittsburgh; Gift of Edith Swank Long

109

[Looking at a Man through a Car Window], c. 1934

6" x 8"; mount 18" x 14"; signed

Carnegie Museum of Art; Gift of Edith Swank Long by transfer from the Pennsylvania Department, Carnegie Library of Pittsburgh, 83.40.92

110

[Man Looking Out Window], c. 1930s

9⁷⁄₁₆" x 7⁹⁄₁₆"; mount 18" x 14"

Carnegie Museum of Art; Gift of Edith Swank Long by transfer from the Pennsylvania Department, Carnegie Library of Pittsburgh, 83.40.94

111

[Emmanuel Episcopal Church Organ], c. 1937

9¹¹⁄₁₆" x 6¹¹⁄₁₆"; mount 18" x 14"; signed

Carnegie Library of Pittsburgh; Gift of Edith Swank Long

112

[Victory Produce Co., Strip District, Pittsburgh], c. 1935

9⅜" x 7½"; mount 18" x 14"

Carnegie Library of Pittsburgh; Gift of Edith Swank Long, SW178

113

[Logan Meat Market], c. 1939

8¹⁄₁₆" x 6"; mount 18" x 14"

Carnegie Library of Pittsburgh; Gift of Edith Swank Long, SW46

114

Pittsburgh #12, c. 1930–1933

13¹⁵⁄₁₆" x 10½"; mount 20" x 16"

Carnegie Library of Pittsburgh; Gift of Edith Swank Long

115

[Benkovitz's Fish Market], c. 1939

9⅜" x 7½"; mount 18" x 14"

Carnegie Museum of Art; Gift of Edith Swank Long by transfer from the Pennsylvania Department, Carnegie Library of Pittsburgh, 83.76.95

116

[We Serve Fort Pitt Beer], c. 1935

6⅛" x 7¹⁵⁄₁₆"; mount 18" x 14"

Carnegie Library of Pittsburgh; Gift of Edith Swank Long

117

[Grocery Store], c. 1935

9⅛" x 6¹³⁄₁₆"; mount 18" x 14"

Carnegie Museum of Art; Gift of Edith Swank Long by transfer from the Pennsylvania Department, Carnegie Library of Pittsburgh, 83.76.94

118

December Day, c. 1939

7¹³⁄₁₆" x 5⅞"; mount 18" x 14"; signed

Carnegie Museum of Art; Gift of Elizabeth Hampsey, 93.191.14

119

[Street Scene with Steam Train], c. 1935

13⁵⁄₁₆" x 10⅜"; unmounted

Carnegie Museum of Art; Gift of Edith Swank Long by transfer from the Pennsylvania Department, Carnegie Library of Pittsburgh, 83.40.105

120

[John Bonato Co. Clothiers], c. 1930

7⅞" x 5⅞"; mount 18" x 14"; signed

Carnegie Library of Pittsburgh; Gift of Edith Swank Long, SW86

121

[Shoes in Store Window], c. 1930

7¾" x 5¹⁵⁄₁₆"; mount 18" x 14"; signed

Carnegie Museum of Art; Gift of Elizabeth Hampsey, 93.191.17

122

[Men's Coats], c. 1930

7⅞" x 5⅞"; mount 18" x 14"; signed

Carnegie Museum of Art; Gift of Elizabeth Hampsey, 93.191.1

123

[Car and Building], c. 1934

7⅞" x 6"; mount 18" x 14"

Carnegie Museum of Art; Gift of Edith Swank Long by transfer from the Pennsylvania Department, Carnegie Library of Pittsburgh, 83.40.83

124

[Street Shadows], c. 1935

4¹¹⁄₁₆" x 6¾" mount 18" x 14"; signed

Carnegie Library of Pittsburgh; Gift of Edith Swank Long, SW242

125

[Shoe Doctor, East Ohio Street, Pittsburgh], c. 1935

6" x 8"; mount 18" x 14"

Property of the Western Pennsylvania Conservancy, 93.50

126

[Boulevard Service III], c. 1940

6" x 7¹³⁄₁₆"; mount 18" x 14"

Carnegie Library of Pittsburgh; Gift of Edith Swank Long, SW250

127

[Corner Store], c. 1934

7¹³⁄₁₆" x 5¹⁵⁄₁₆"; mount 18" x 14"; signed

Carnegie Museum of Art; Gift of Edith Swank Long by transfer from the Pennsylvania Department, Carnegie Library of Pittsburgh, 83.40.86

128

[Watch Tower, Liberty Ave. near 28th Street], c. 1935

19" x 15"; flush mounted

Property of the Western Pennsylvania Conservancy, 90.937

129

[Drink Bubble Up], c. 1939

6" x 8"; mount 18" x 14"; signed

Property of the Western Pennsylvania Conservancy, 90.419

130

[Pressing, Near Fourth Avenue and Smithfield, Pittsburgh], c. 1930

9" x 7¼"; signed

The Heinz Endowments

131

[Kroger Grocery/Baking Co.], c. 1928–1930

6⁹⁄₁₆" x 9¾"; mount 18" x 14"; signed

Carnegie Library of Pittsburgh; Gift of Edith Swank Long, SW335

132

[Monongahela River, Pittsburgh], c. 1935

4¹¹⁄₁₆" x 6⁹⁄₁₆"; mount 18" x 14"; signed

Carnegie Library of Pittsburgh; Gift of Edith Swank Long, SW122

133

[Skunk Hollow Looking toward Bloomfield], c. 1937–1943

6" x 7½"; mount 18" x 14"

Property of the Western Pennsylvania Conservancy, 90.706

134

[River Barges and Steel Mill], c. 1935

9⅜" x 7⁹⁄₁₆"; mount 18" x 14"

Carnegie Library of Pittsburgh; Gift of Edith Swank Long, SW112

135

[Automobiles, Cobblestone Street, and Steel Mill], c. 1930

13⅛" x 10⅛"; flush mounted

Carnegie Museum of Art; Gift of Edith Swank Long by transfer from the Pennsylvania Department, Carnegie Library of Pittsburgh, 83.76.57

136

[Those Steps], c. 1933

6" x 8"; mount 18" x 14"

Property of the Western Pennsylvania Conservancy, 90.458

137

[Oakland Soho], c. 1930

9" x 7¼"; signed

The Heinz Endowments

138

[Corner of South Canal and Madison], c. 1937

6³⁄₁₆" x 8⅛"; mount 18" x 14"

Carnegie Library of Pittsburgh; Gift of Edith Swank Long, SW67

139

[Apartment House with Wash Tubs], c. 1935

6¼" x 7¹⁵⁄₁₆"; mount 18" x 14"

Carnegie Library of Pittsburgh; Gift of Edith Swank Long

140

[Rooftops], c. 1935–1943

6¹³⁄₁₆" x 8¹³⁄₁₆"; mount 18" x 14"

Carnegie Museum of Art; Gift of Edith Swank Long by transfer from the Pennsylvania Department, Carnegie Library of Pittsburgh, 83.76.97

141

Train Shed, c. 1935

7¹⁄₁₆" x 9¹⁄₁₆"; mount 18" x 14"; signed

Carnegie Library of Pittsburgh; Gift of Edith Swank Long, SW22

NOTE*s*

INTRODUCTION

1. Prior to Swank's exhibition in January–February 1933, only Berenice Abbott, Man Ray, and Man Ray's protégé Lee Miller had had one-person exhibitions. Walker Evans exhibited with George Platt Lynes, and it was almost nine months after Swank's exhibition that Levy introduced Henri Cartier-Bresson. For the complete list of the exhibitions Levy had from 1931 until he closed his gallery permanently in 1949, see Ingrid Schaffner and Lisa Jacobs, eds., *Julien Levy: Portrait of an Art Gallery* (Cambridge, Mass.: MIT Press, 1998); or Julien Levy, *Memoir of an Art Gallery* (New York: G. P. Putman's Sons, 1977).

2. Swank's photographs are almost always untitled and rarely even have notations as to date and place. He did, however, give titles to several series of his work, referring to some by subject, including the circus, the carnival, river steamboat scenes, and mountain farm. See Luke Swank to Julien Levy, undated letter written in 1933, the personal papers of Julien Levy in the Julien Levy Archive.

FRAGMENTS OF A LIFE

1. David G. McCullough, *The Johnstown Flood* (New York: Simon and Schuster, 1968), 145–47.

2. "This is Johnstown . . . Highlights of the City's Older Industries and Businesses in Johnstown's Sesqui-Centennial Year, TODAY: Swank Hardware Company," *Johnstown Tribune*, October 23, 1950 (Monday evening), private collection of Margaret Glock.

3. "Unique Features Mark Anniversary of Swank Company: Company to Award Gifts to All Born in 1862, Year of Founding: Has Had Good Growth," *Johnstown Tribune*, October 22, 1921.

4. Henry Wilson Storey, *History of Cambria County Pennsylvania*, vol. 3 (New York and Chicago: Lewis Publishing Company, 1907), 149–50, 582–83, 674–75, http://www.rootsweb.com/~pacambri/books/Storey/v3/tp.html.

5. Swank Hardware Company, "7% Cumulative Preferred Stock $600,000 Free of Normal Federal Income and State Taxes," prospectus for a public stock offering in 1920, private collection of Margaret Glock.

6. Harry Swank to "Friends and Customers of the Swank Hardware Company," Johnstown, Pennsylvania, 1920, private collection of Margaret Glock.

7. Letters from Earl F. Glock to his father written on the following dates at University Park, Pennsylvania State College: September 26 and December 5, 1907, and March 4, 1908, private collection of Margaret Glock.

8. "Luke Hartzell Swank and Miss Grace D. Ryan Are United in Wedlock: Popular Young Couple Leave for Honeymoon Tour in the East: Best Wishes From Many Friends," unidentified newspaper clipping from the private collection of Margaret Glock.

9. "Funeral Service for Mrs. Swank at 11 Tomorrow: Wife of Well-Known Photography Expert, Dies in Pittsburgh," *Johnstown Tribune*, March 26, 1937.

10. Luke Swank to Julien Levy, April 10, 1932, Department of Photography Files, The Museum of Modern Art, New York.

11. "Luke Hartzell Swank and Miss Grace D. Ryan Are United in Wedlock."

12. Grace Swank Davis, interview by Howard Bossen, June 1, 2003, Mount Pleasant, Iowa.

13. Photographs that show Swank's gardens are in the collection of Claudia M. Elliott. The spines of some of the books that can be read in the photograph of his library (figure 1-2) reveal that he owned books on the trees and shrubs of the British Isles.

14. "Luke Swank Dies; Nationally Known as Photographer: Made Start Locally; Funeral Services Here on Thursday," *Johnstown Tribune*, March 14, 1944.

15. John Walters, interview by Howard Bossen, November 22, 2002, Mount Lebanon, Pennsylvania.

16. Ibid.

17. Luke Swank to the Julien Levy Gallery, December 30, 1931, the personal papers of Julien Levy in the Julien Levy Archive.

18. Luke Swank to Julien Levy, April 10, 1932.

19. Ibid.

20. On the mantel in the photograph not shown here are more sailing prints and Luke's announcement for his exhibition at the Julien Levy Gallery, which dates this picture to sometime after January 1933.

21. Grace Swank Davis, interview by Howard Bossen, June 1, 2003, Mount Pleasant, Iowa.

22. Ibid.

23. Franklin Toker, *Fallingwater Rising: Frank Lloyd Wright, E. J. Kaufmann, and America's Most Extraordinary House* (New York: Alfred A. Knopf, 2003), 205.

24. Swank's photo-mural is reproduced in the exhibit catalog: *Murals by American Painters and Photographers*, with essays by Julien Levy and Lincoln Kirstein (New York: The Museum of Modern Art, 1932).

25. Christian A. Peterson, *After the Photo-Secession: American Pictorial Photography, 1910–1955* (Minneapolis: Minneapolis Institute of Arts in association with W. W. Norton, 1997), 131.

26. Ibid., 134.

27. *Catalogue of the Eighteenth Pittsburgh Salon of Photographic Art*, Pittsburgh: The Photographic Section of the Academy of Science and Art, Carnegie Institute, 1931. Library and Archives Division of the Historical Society of Western Pennsylvania, Pittsburgh. Drtikol was identified as "Frank Drtikol."

28. *Catalogue of the Eighteenth Pittsburgh Salon of Photographic Art.*

29. "All American: Photographic Salon 1931," catalog of entries in exhibition, held at Los Angeles Museum, Exposition Park, June 13–30, 1931. In the collection of the Natural History Museum of Los Angeles County, Los Angeles.

30. The technique for making bromoil prints was developed by C. Welbourne Piper from an idea by E. J. Wall. "[I]t was a variant of the oil-pigment process (q.v.). Prints, or more usually, enlargements were made on a suitable gelatin-silver bromide paper, and the image was bleached in a solution containing potassium bichromate. The gelatin became selectively hardened so that it would take up more or less pigment when hand applied with special brushes. The bleached image was thus 'redeveloped' in pigment, the distribution of which was to a large extent under the photographer's control. Bromoil prints, which may be in a variety of colours, generally show broader tonal effects and more diffuse detail than conventional prints." Brian Coe and Mark Haworth-Booth, *A Guide to Early Photographic Processes* (London: Victoria & Albert Museum in association with Hurtwood Press, 1983), 17.

31. The structure in *"Painters"* is the same one that can be seen in figure 2–9, *"Man on Top of Hot Blast Main."* The salon was held in the print room of the Museum of Science and Art in Los Angeles.

32. James Nichols Doolittle, "Observations & Impressions," in *Pictorialist 1932* (Los Angeles: Adcraft, published for the Camera Pictorialists of Los Angeles, 1932).

33. Peterson, *After the Photo-Secession*, 28.

34. Ibid., 37, 39.

35. Ingrid Schaffner and Lisa Jacobs, eds., *Julien Levy: Portrait of an Art Gallery*, (Cambridge, Mass.: MIT Press, 1998), 173.

36. Carolyn Burke, "Loy-alism: Julien Levy's Kinship with Mina Loy," in Schaffner and Jacobs, *Julien Levy*, 67. Beginning in 1931 Mina Loy also acted as Levy's agent. In an interview about his father Julien Levy, Jonathan Levy Bayer offered an insight into how his father responded to unknown artists who approached him. Bayer said, "As a surrealist my father was rather curious about people. . . . I think he was intrigued by someone who just wanders in and happens to have these miraculous things but otherwise he was a nobody." Jonathan Levy Bayer, interview by Howard Bossen, July 10, 2003, London.

37. Luke Swank to the Julien Levy Gallery, December 30, 1931. Also see "On and Off the Avenue," *New Yorker*, December 19, 1931.

38. Luke Swank to the Julien Levy Gallery, December 30, 1931. Additionally, the markings stamped on the back of several prints in the Carnegie Library of Pittsburgh would support the idea that pictures—many times the same ones—were entered into a variety of competitions.

39. "Dual Photography Exhibit Opened in Museum Galleries," *Brooklyn Eagle*, March 8, 1932, Brooklyn Museum of Art Archives, Brooklyn.

40. "International Photography in Brooklyn Museum Show: Exhibitions Stress Photography as Art—Gallery," Unidentified newspaper clipping from the Brooklyn Museum Yearbooks (clipping scrapbooks), 1932, Brooklyn Museum of Art Archives, Brooklyn. Article stamped March 13, 1932.

41. Julien Levy, *Memoir of an Art Gallery* (New York: G. P. Putman's Sons, 1977), 114.

42. *Murals by American Painters and Photographers*, with essays by Julien Levy and Lincoln Kirstein (New York: The Museum of Modern Art, 1932).

43. The Museum of Modern Art, "Specifications for Exhibition of Mural Painting," c. February or March 1932. The Museum of Modern Art Archives, New York.

44. Levy, in *Murals by American Painters and Photographers*, 11.

45. Ibid., 11–12.

46. Luke Swank to Julien Levy, April 10, 1932. In the letter to Levy, Swank refers to several designs. "Steel Plant," the maquette that was the basis for his mural in the 1932 MoMA exhibition *Murals by American Painters and Photographers*, is one of five maquettes found during the research for this book. It is in the collection of the Art Institute of Chicago, while two maquettes, including "Skip Bridge and Dust Catcher I," are in the collection of the Carnegie Library of Pittsburgh, and two are in the collection of the Carnegie Museum of Art.

47. Tania Passafiume in September 2002 analyzed Sheeler's mural using *Adobe Photoshop* to deconstruct and then reconstruct the center panel. Her work explains each element added to the base image that Sheeler relied upon to create his composite panel. The research is in the Photography Department of the Art Institute of Chicago.

48. Edward Alden Jewell, "Art in Review: The Museum of Modern Art Gives Private Showing Today of Murals by American Painters," *New York Times*, May 3, 1932.

49. Lincoln Kirstein, "Art Chronicle: Contemporary Mural Painting in the United States," *Hound & Horn* 5.4 (July–September 1932): 656–63.

50. Mary Morsell, "The Museum of Modern Art Opens in Its New Home: American Trends in Mural Painting and Photography Displayed in Museum's Fine New Quarters," *Art News* 30 (May 7, 1932): 5–6.

51. *Murals by American Painters and Photographers.*

52. Ibid., unnumbered pages.

53. Stephen Bennett Phillips, *Margaret Bourke-White: The Photography of Design 1927–1936* (Washington, D.C.: Phillips Collection in association with Rizzoli, 2002).

54. "A New Gallery of Photography," *Brooklyn Eagle*, November 8, 1931.

55. Luke Swank to Joella Levy, April 19, 1932, the personal papers of Julien Levy in the Julien Levy Archive.

56. Luke Swank to Joella Levy, undated letter written in 1932, the personal papers of Julien Levy in the Julien Levy Archive.

57. Luke Swank to Julien Levy, December 9, 1932, the personal papers of Julien Levy in the Julien Levy Archive.

58. Julien Levy to Luke Swank, New York, January 9, 1933, the personal papers of Julien Levy in the Julien Levy Archive. Courtesy of the estate of Jean Farley Levy and the Julien Levy Archive.

59. Levy, *Memoir of an Art Gallery*, 68–69.

60. This means that some circus, rural, and steel images all date to before January 1933. "Around the Galleries," review of Swank exhibition at the Julien Levy Gallery, *Art News*, February 4, 1933, the personal papers of Julien Levy in the Julien Levy Archive.

61. The following sources from the personal papers of Julien Levy in the Julien Levy Archive. Elizabeth H. Payne to Julien Levy, Northampton, Massachusetts, March 6, 1933. It is from this show that the Swanks in the Smith collection come. Elizabeth H. Payne to Julien Levy, Northampton, Massachusetts, February 17, 1933; Smith College Museum of Art, Northampton, Massachusetts, list of "Photographs lent Mr. Jere Abbott," February 11, 1933.

62. The following sources from the personal papers of Julien Levy in the Julien Levy Archive: "Memo: Photographs lent to Mrs. Katz, for exhibition Conservatory of Music, Brinkerhof Court, Englewood"; Photographs on Memoranda: Russell Hitchcock Jr., Wesleyan University, Middletown, Conn.," April 1, 18, 1933, Julien Levy Gallery, 602 Madison Avenue, New York City.

63. Luke Swank to Allen Porter, March 20, 1933, the personal papers of Julien Levy in the Julien Levy Archive.

64. See chapter 6, "Rural Architecture and Landscape," for a fuller discussion of this project.

65. Swank to Porter, March 20, 1933.

66. Luke Swank to Joella Levy, c. 1932, the personal papers of Julien Levy in the Julien Levy Archive.

67. Luke Swank to Julien Levy, undated letter written sometime in 1933, the personal papers of Julien Levy in the Julien Levy Archive.

68. Luke Swank to Julien Levy, undated letter written in 1935, the personal papers of Julien Levy in the Julien Levy Archive.

69. Levy, *Memoir of an Art Gallery*, 68–69.

70. Edith Elliott to Nancy Riggs, November 13, 1939, private collection of Nancy Hessel.

71. Schaffner and Jacobs, *Julien Levy*; Levy, *Memoir of an Art Gallery*, 173, 180, 184.

72. Frank Crowninshield, statement in an announcement titled "Announcing an Exhibition of Photographs by Luke Swank, May 6th to May 20th 1934, Delphic Studios, 9 East 57 Street, New York," Collection of the Carnegie Library, Pittsburgh, Pennsylvania.

73. Marcello Truzzi, "The Decline of the American Circus: The Shrinkage of an Institution," in *Sociology and Everyday Life*, edited by Marcello Truzzi (Englewood Cliffs, N.J.: Prentice-Hall, 1968), 315.

74. John Paul Edwards, "Group f.64," *Camera Craft* 42 (March 1935), quoted in Beaumont Newhall, ed., *Photography: Essays & Images: Illustrated Readings in the History of Photography* (New York: The Museum of Modern Art; distributed by New York Graphic Society, Boston, 1980), 251.

75. Ibid., 251–52.

76. John Paul Edwards, "First Salon of Pure Photography," *Camera Craft* 41 (September 1934): 418.

77. Ibid., 420.

78. Willard Van Dyke to Luke Swank, July 3, 1934, private collection of Claudia M. Elliott. © 2000, Willard Van Dyke Estate.

79. Edwards, "First Salon of Pure Photography," 421.

80. Ibid., 423. It is possible that other Pittsburgh scenes in this book were also in the exhibition, but the record that would allow verification has been lost.

81. Van Dyke to Swank, July 3, 1934.

82. Luke Swank to Willard Van Dyke, July 16, 1934, Center for Creative Photography at the University of Arizona.

83. Edward Weston to Luke Swank, July 21, 1934, private collection of Claudia M. Elliott. Text by Edward Weston © 1981, Center for Creative Photography, Arizona Board of Regents.

84. Harvey Gaul, "Swank Show of Photography at Tech School," review of Swank exhibition at the College of Fine Arts of Carnegie Institute of Technology, *Pittsburgh Post-Gazette*, January 16, 1934.

85. Luke Swank to Julien Levy, late 1932 or early 1933, the personal papers of Julien Levy in the Julien Levy Archive.

86. Gaul, "Swank Show of Photography."

87. Penelope Redd, "3 Art Exhibitions Now in City Unusually Thought-Compelling," review of three Pittsburgh exhibitions, *Pittsburgh Sun Telegraph*, January 14, 1934.

88. "Photography: U.S. Camera Trends to Nudes in Bathtubs; Pittsburgh Newsphotos to Grisly Americana," review of exhibition including Swank work at Kaufmann's Department Store, *Bulletin Index*, November 7, 1935.

89. Review of Swank exhibition at the Gulf Gallery, on the third floor of the Gulf Building, *Pittsburgh Press*, October 24, 1936.

90. Beaumont Newhall, "Luke Swank's Pennsylvania," *U.S. Camera Magazine* 1 (Autumn 1938): 16–19, 65. © 1938, Beaumont Newhall, renewed 2004 by the estate of Beaumont Newhall and Nancy Newhall. Permission courtesy of Scheinbaum and Russek Ltd., Santa Fe, New Mexico.

91. Ibid.

92. David H. McAlpin, statement on MoMA's new photography department, in "The New Department of Photography," *Museum of Modern Art Bulletin* 8:2 (December–January 1940–41): 2, The Museum of Modern Art, New York.

93. Beaumont Newhall to Ansel Adams, New Years Day 1941, Center for Creative Photography at the University of Arizona. Copyright © 2004 by the estate of Beaumont Newhall and Nancy Newhall. Permission courtesy of Scheinbaum and Russek Ltd., Santa Fe, New Mexico.

94. Ibid.

95. "Photographs by Luke Swank and Philip Elliott," *The Buffalo Fine Arts Academy Gallery Notes: Albright Art Gallery* 10.1 (May 1943): 11, Albright Knox Art Gallery Archive, Buffalo, New York.

96. Luke Swank to Julien Levy, undated letter written in 1935, the personal papers of Julien Levy in the Julien Levy Archive.

97. "News Photography Course at Pittsburgh University," *New York Times*, April 28, 1935.

98. Ibid.

99. "Lens Lines," *U.S. Camera Magazine* 1 (Autumn 1938): 32–33, 67. See Robert C. Alberts, "The 1930s: Dissension in the House," in *Pitt: The Story of the University of Pittsburgh, 1787–1987* (Pittsburgh, Pa.: University of Pittsburgh Press, 1986), for a discussion of the Turner case and other issues that led the American Association of University Professors (AAUP) to censure the University of Pittsburgh in 1936. The censure remained in place until 1947. "Censured Administrations 1930–2002" may be found on the AAUP Web site, *www.aaup.org*.

100. October 9 portion of the following letter: Edith Elliott Swank to Grace Pote Elliott, undated October 1941; October 9, 1941, private collection of Nancy Hessel.

101. Toker, *Fallingwater Rising*, 43.

102. Toker, *Fallingwater Rising*, 111.

103. See p. 56 in Toker, *Fallingwater Rising*, for a discussion of Kaufmann and his horses and Liliane and her dogs.

104. Toker, *Fallingwater Rising*, 317.

105. October 9 portion of the following letter: Edith Elliott Swank to Grace Pote Elliott, Pittsburgh, undated October 1941; October 9, 1941, private collection of Nancy Hessel.

106. Toker, *Fallingwater Rising*, 310.

107. Ibid., 7.

108. Certificate of Incorporation for Kaufmann Department Store, Library and Archives Division of the Historical Society of Western Pennsylvania, Pittsburgh, Kaufmann Department Store/MSS #371/Ledger: Kaufmann Studios 1927–1938/Box 3, Vol. 5, pg. 11.

109. "Minutes of a Special Meeting of the Board of Directors of Kaufmann Studios Held at the Principal Office of the Corporation at Smithfield Street and Fifth Avenue, Pittsburgh, Pennsylvania at 9:00 O'Clock a.m. Eastern Standard Time on Thursday, September 23, 1937," Library and Archives Division of the Historical Society of Western Pennsylvania, Pittsburgh, Kaufmann's Department Store/MSS #371/Ledger: Kaufmann Studios 1927–1938/Box 3, Vol. 5, pg. 90.

110. Ibid., 87.

111. Joint Plan of Merger of Kaufmann Department Stores, Inc. (a New York Corporation), Investment Land Company (a Pennsylvania Corporation), Kaufmann Department Stores Securities Corporation (a Delaware Corporation), Luke Swank, Inc. (a Pennsylvania Corporation), and Sampeck Clothes, Inc. (a New York Corporation), Library and Archives Division of the Historical Society of Western Pennsylvania, Pittsburgh.

112. Toker, *Fallingwater Rising*, 203.

113. Clyde "Red" Hare, interview by Howard Bossen, November 12, 2003, Pittsburgh.

114. *A New House by Frank Lloyd Wright on Bear Run Pennsylvania*, The Museum of Modern Art, New York, 1938. This catalog featured the photographs of Swank, Kenneth Hedrich, and John McAndrew, who helped organize the exhibition for MoMA.

115. Edward Alden Jewell, "Pictures Analyze 'Cantilever' House: Photos of Home Built Over a Waterfall Is Displayed at Modern Art Museum; Frank Lloyd Wright Drew Plan: House Extends From Cliffs of Deep Ravine— Builder Tells of Problems He Met," *New York Times*, January 25, 1938, 24L.

116. Frank Lloyd Wright to Luke Swank, January 3, 1941, The Frank Lloyd Wright Foundation, Scottsdale, Arizona.

117. Edith Elliott Swank to Grace Pote Elliott, undated, written in December 1940, private collection of Nancy Hessel.

118. Frank Lloyd Wright to Luke Swank, telegram, March 24, 1941, The Frank Lloyd Wright Foundation, Scottsdale, Arizona.

119. Edith Elliott to Nancy Riggs, November 13, 1939, private collection of Nancy Hessel.

120. Toker, *Fallingwater Rising*, 64.

121. Edith Elliott to Grace Pote Elliott, May 10, 1934, private collection of Nancy Hessel. Edith's given name was Lena Edith Elliott, but she hated Lena and dropped its use partway through her years at the University of Chicago.

122. Edith Elliott to Grace Pote Elliott, undated letter, but reference in letter suggests it was written in 1935, private collection of Nancy Hessel.

123. Edith Elliott Swank, *The Story of Food Preservation*, illustrated by Luke Swank (Pittsburgh, Pa.: H. J. Heinz Company, 1943); Edith Elliott to Grace Pote Elliott, undated letter; Edith Elliott to Nancy Riggs, undated letter, most likely 1935 or 1936, private collection of Nancy Hessel.

124. Newhall, "Luke Swank's Pennsylvania"; T. J. Maloney, ed., *U.S. Camera Annual* (New York: William Morrow & Company) for 1936 through 1942.

125. The Carnegie Library of Pittsburgh collection contains approximately one hundred 4 x 5 inch and 5 x 7 inch color transparencies, most of which are food shots and other commercial assignments. There are a few color steel mill images, a few of rural structures and landscapes, and some of Edith Swank in Swank's studio and at Fallingwater.

126. J. R. Hilderbrand, "Revolution in Eating: Machine Food Age— Born of Roads, Research, and Refrigeration—Makes the United States the Best-fed Nation in History," *National Geographic Magazine* 81 (March 1942): 310.

127. "Hall of Cleanness," *National Geographic Brazil*, May 2002, http://uol.com.br/nationalgeographic/flashback/0205 (accessed August 15, 2002; now discontinued).

128. Edith Elliott to Nancy Riggs, November 13, 1939, private collection of Nancy Hessel.

129. Ibid.

130. Edith Elliott to John and Jo Elliott, January 29, 1940, private collection of Claudia M. Elliott.

131. Edith Elliott to Nancy Riggs, January 15, 1940, private collection of Nancy Hessel.

132. Edith Elliott to Luke Swank, New Harmony, Indiana, January 4, 1940, private collection of Claudia M. Elliott.

133. Edith Elliott Long to Evna (full name unknown), New Orleans, undated letter written sometime after June 20, 1962, private collection of Claudia M. Elliott.

134. Edith Elliott to John and Jo Elliott, January 29, 1940; Toker, *Fallingwater Rising*, 205, 309.

135. Jack Hedenburg, "A History of the First Baptist Church of Pittsburgh," The First Baptist Church of Pittsburgh, http://trfn.clpgh.org/fbcpgh (accessed November 24, 2003).

136. Luke Swank, "A One-Act Play Written Especially for Margaret Bourke-White," undated, circa 1937–1938, Margaret Bourke-White Collection, Syracuse University Library, Department of Special Collections.

137. Edith Elliott to John and Jo Elliott, January 29, 1940, private collection of Claudia M. Elliott.

138. December 10 portion of the following letter: Edith Elliott Swank to Nancy Riggs, Pittsburgh, November 25, 1940; December 10, 1940, private collection of Nancy Hessel.

139. Edith Elliott Swank to Grace Pote Elliott, Pittsburgh, undated letter, private collection of Nancy Hessel.

140. Ibid.

141. Ibid.

142. Ibid.

143. Grace Swank Davis, interview by Howard Bossen, June 1, 2003, Mount Pleasant, Iowa.

144. Edith Elliott Swank to Mr. and Mrs. John S. Elliott, c. 1943, private collection of Nancy Hessel.

145. "Luke Swank in Critical Condition," *Johnstown Tribune*, March 13, 1944; "Luke Swank Dies," *Johnstown Tribune*, March 14, 1944.

146. Edith Elliott Swank to Edgar J. Kaufmann, November 15, 1946, private collection of Claudia M. Elliott.

147. Edith Elliott Swank to Ada Louise Huxtable, December 3, 1946, private collection of Claudia M. Elliott.

148. John Elliott, acting on the wishes of his sister Edith Elliott Swank Long, and with assistance from H. J. Heinz II, rescued Swank's photographic archive after Edith's death in 1974. This conclusion is based upon the document gifting the collection to the Carnegie Institute and a copy of the bill for shipping the collection from New Orleans, where Edith had lived at the time of her death in 1974, to the Carnegie. Copies of these documents are with the Swank collection in the Carnegie Library of Pittsburgh.

STEEL

1. Laurie Graham, *Singing the City: The Bonds of Home in an Industrial Landscape* (Pittsburgh, Pa.: University of Pittsburgh Press, 1998), 34.

2. Expert analysis of his circus photography demonstrates that he began this work no later than 1924. While Swank began to make circus pictures before photographing the steel mill, it is entirely possible that he didn't regard the circus as an in-depth study until after he began his steel mill work.

3. For example, see image SW1915 in the Swank negative collection in the Carnegie Library of Pittsburgh.

4. Luke Swank to Julien Levy, April 10, 1932, Department of Photography files, The Museum of Modern Art, New York.

5. Before her death in 1974, Swank's widow, Edith, bequeathed her library to Indiana State University at Evansville (now the University of Southern Indiana). While some of the books were hers or came from her second husband, Bill Long, it is reasonable to assume that the photography collection—beginning with Stieglitz's *Camera Work* number 5 from 1904, including many publications from the 1920s and 1930s, and ending with the 1942 *U.S. Camera Annual*—were Luke's.

6. There is no known print of this image, negative number SW1888b in the Swank negative collection in the Carnegie Library of Pittsburgh, but a notation in the library's database for negative SW7162 indicates that negative was made in 1929. The framing and content of these two images is almost identical. SW1888b has a steam locomotive in it, while SW7162 shows several men walking on the tracks. Both negatives must have been made the same day, most likely moments apart.

7. All the images in the collection of the Southern Alleghenies Museum of Art were found in Bethlehem Steel's Johnstown Works before they were given to the museum.

8. Karen Lucic, *Charles Sheeler and the Cult of the Machine* (Cambridge, Mass.: Harvard University Press, 1991), 9.

9. Paul Kellogg (editor of publication), "Social Forces," *Charities and The Commons* (March 9, 1909): 1035–36.

10. F. Jack. Hurley, ed., *Industry and the Photographic Image: 153 Great Prints from 1850 to the Present* (Rochester, N.Y.: George Eastman House; New York: Dover Publications, 1980), 45. Hine is also considered to be the first to use the term "social documentary" to describe a genre of photography that would be embraced by the 1930s by many photographers making striking images of the economic and social conditions of the Depression.

11. *Pittsburgh Revealed: Photographs since 1850* (Pittsburgh, Pa.: Carnegie Museum of Art, 1997), 156.

12. Beaumont Newhall, "Luke Swank's Pennsylvania," *U.S. Camera Magazine* 1 (Autumn 1938): 16–19, 65.

13. Thomas Leary, assistant professor of history at Youngstown State University, conversation with Howard Bossen, August 22, 2003, Youngstown, Ohio. Leary provided invaluable assistance in identifying which steelmaking process was portrayed in each image. This information, and his brief tutorial on steelmaking, enabled me to write descriptive titles for these photographs.

14. Hurley, *Industry and the Photographic Image*, 77.

15. Theodore E. Stebbins Jr., Gilles Mora, and Karen E. Haas, *The Photography of Charles Sheeler: American Modernist* (Boston, New York, and London: AOL Time Warner, Bulfinch Press, 2002), 89.

16. Ibid.

17. Stephen Bennett Phillips, *Margaret Bourke-White: The Photography of Design 1927–1936* (Washington, D.C.: Phillips Collection in association with Rizzoli, 2003), 23.

18. This is the only known steel mill image to have survived with the multiple rectangles on the mount board. Swank also used this pictorialist style of presentation for some of his early portraits. See the portrait of Grace Swank (plate 66) for a similar style mount.

19. "Filling Molds with Molten Iron II" is a vintage print while "Filling Molds with Molten Iron I" is a modern print made from negative SW0130 in the Carnegie Library of Pittsburgh.

20. Luke Swank, "A One-Act Play Written Especially for Margaret Bourke-White," undated, circa 1937–1938, Margaret Bourke-White Papers in the Department of Special Collections at the Syracuse University Library.

21. Newhall, "Luke Swank's Pennsylvania," 17–18.

22. "U.S. Steel: IV," *Fortune*, June 1936, 113–20, 172.

23. Transparencies 90.1040, 90.1041, 90.1043, 90.1044, and 90.1048 housed at Fallingwater and belonging to the Western Pennsylvania Conservancy are examples.

24. See chapter 6, "Rural Architecture and Landscape," for further discussion of color.

25. See chapter 5, "Transformations," for a discussion of this small body of work.

CIRCUS

1. John Walters, interview by Howard Bossen, November 22, 2002, Mount Lebanon, Pennsylvania.

2. *U.S. Camera 1937*, edited by T. J. Maloney (New York: William Morrow & Company, 1937), 84–85.

3. "Father's Art Work Leads 16-Year-Old Son to Experiment with 'Big Top' Career: Luke Swank Tells Boy He Can Try Life in Circus 'for a Year,'" *Pittsburgh Press*, March 1, 1935; "Luke Swank," *Bulletin Index*, March 7, 1935.

4. "Barnett Bros.' Business Off: Will Carry On Even If Retrenchment Is Necessary—Blowdown in W. Va.," *Billboard*, May 14, 1938, 39; "Barnett Ahead of Last Year: Final Week in Keystone State Spotty Due to Coal Strike Situation," *Billboard*, May 27, 1939, 35.

5. Edith Elliott Swank to Grace Pote Elliott, May 1947, private collection of Nancy Hessel. Edith wrote: "Remember my stepson Harry? He remarried about six months ago—a war widow with a baby girl. He and his family came to see me last week and he told me he was going to make me a real grandmother this time—Ruthie was going to have a child in late September. Harry is part owner of his circus now and is very happy. It will always seem a curious life to me, and one not especially suited to bringing up a child, least of all a Swank."

6. Marcello Truzzi, "The Decline of the American Circus: The Shrinkage of an Institution," in *Sociology and Everyday Life*, edited by Marcello Truzzi (Englewood Cliffs, N.J.: Prentice-Hall, 1968), 317.

7. Fred D. Pfening III, "The Frontier and the Circus," *Bandwagon* 15 (September–October 1971): 18.

8. Truzzi, "Decline of the American Circus," 318; Pfening, "The Frontier and the Circus," 16–20; Stuart Thayer, "A Note on the Decline of the Circus," *Bandwagon* 16 (July–August 1972): 17.

9. Swank's circus photographs in the Swank collection in the Carnegie Library of Pittsburgh show signs for the Ringling Brothers and Barnum and Bailey Circus, Sells-Floto Circus, Hagenbeck-Wallace Circus, and the Downie Brothers Circus. It is possible that he photographed other circuses but did not include any of their signage in those photographs.

10. Miles Barth and Alan Siegel, *Step Right This Way: The Photographs of Edward J. Kelty*, essay by Edward Hoagland (New York: Barnes and Noble Books, 2002), 15; Joseph T. Bradbury, "The Old Circus Album: A Historic Look at Shows of the Past," *White Tops* 42 (March–April 1969): 9–13; Joseph T. Bradbury, "Sells-Floto Circus: Seasons of 1931 and 1932, Part I," *White Tops* 49 (November–December 1976): 5–20; Bradbury, "Sells-Floto Circus: Seasons of 1931 and 1932, Part II," *White Tops* 50 (January–February 1977): 44–62.

11. "Luke Swank," *Bulletin Index*, March 7, 1935.

12. Barth and Siegel, *Step Right This Way*, 17.

13. George L. Chindahl, *A History of the Circus in America* (Caldwell, Idaho: Caxton Printers, 1959), 159–64.

14. Other early themes were steamboats, which are not included in this book, and rural Pennsylvania architecture.

15. Swank's circus series is represented in the Carnegie Library of Pittsburgh collection by 269 negatives.

16. Copies of the circus photographs were sent to the Wisconsin Historical Society's Circus World Museum in Baraboo, Wisconsin, and the John and Mable Ringling Museum of Art in Sarasota, Florida, in order to identify people and date the images. Dating the marquee that reads "To the Big Show" to 1924 or earlier changed our understanding of when Swank became serious about photography. Fred Dahlinger Jr., former director of historic resources and facilities at the Circus World Museum, suggested sending that image to Robert MacDougall for corroboration. MacDougall, a self-described circus historian and for twenty-five years the general manager of the Ringling Brothers and Barnum and Bailey Circus, has done extensive research into the dates various marquees were used by the Ringling Brothers and Barnum and Bailey Circus. Dahlinger provided commentary on the circus photographs and explained the content of many of the images. Without his comments and assistance this essay would be far less thorough.

17. See the circus route log for the Ringling Brothers and Barnum and Bailey Circus in the Circus World Museum in Baraboo, Wisconsin.

18. Dahlinger provided the tent identifications.

19. Luke Swank to Willard Van Dyke, July 16, 1934, Center for Creative Photography at the University of Arizona.

20. Barth and Siegel, *Step Right This Way*, 13–16, 25.

21. Dahlinger's analysis established that these clowns were part of the 1930 Sells-Floto clown alley that played Johnstown on May 30, 1930.

22. Heilbron also contributed to *Fortune, Life,* and *Time* magazines. See *Kenneth Heilbron, Inside the Dream*, exhibit catalog number 404, November–December 2000, from Stephen Daiter Gallery, Chicago, Illinois.

23. Biographical information on Heilbron is from the artist's file in the Department of Photography in the Art Institute of Chicago, Chicago, Illinois.

24. "Backyard," according to Dahlinger, is circus terminology for the area where performers had dressing rooms and a place to relax. The backyard was also the "working" area of the circus. It's where the dining tent, dressing tops, cookhouse, horse tops, and a myriad of other tents were located and where the behind-the-scenes work and activity of the circus took place. Dahlinger also commented that "[T]he fact that Swank had ready access to the backyard and could have various performers pose suggests that he either knew them as friends or had some type of approved entrée to the area. It was not usually frequented by the paying general public." Dahlinger's comment is consistent with a comment Swank made to Levy in one of his letters about accompanying a circus for several days. Luke Swank to Joella Levy, undated letter c. 1932, the personal papers of Julien Levy in the Julien Levy Archive.

25. This photo was dated by examining the Circus World Museum circus route log sheet for the Hagenbeck-Wallace Circus. The only year the circus played in Johnstown was 1933. This also suggests that many of the surviving photographs of this circus were also made in 1933.

26. Atwell was a Chicago photographer who specialized in photographing the circus. He began his career as a circus photographer after Otto Ringling stopped by his studio in 1906. He photographed all the major circuses over a career that spanned more than forty years. Both the Chicago Historical Society and the Circus World Museum in Baraboo, Wisconsin, have collections of his circus photographs. See Erwin Bach, "Circus Photos Go on Display," *Chicago Tribune*, June 3, 1965; and Eugene Whitmore, "Harry Atwell, Lensman, Was 'With It and For It,'" *White Tops*, May–June 1973, 18–21.

27. Tom Mix, a silent film cowboy movie star, was the headliner of the Sells-Floto Circus from 1929–1931, earning a reported $10,000 per week at the height of the Depression.

28. See negative C309 in the Luke Swank negative collection of the Carnegie Library of Pittsburgh.

29. His full name was Paul Jerome James. "Paul Jerome," *White Tops* (November 1960): 32, John and Mable Ringling Museum of Art, Sarasota, Florida.

30. The following articles from the John and Mable Ringling Museum of Art in Sarasota, Florida: "Name Two to Circus Hall of Fame," *White Tops* 46 (January–February 1973): 4; Eugene Whitmore, "Eugene Whitmore Remembers . . . the Bareback Rider Who Wanted to Be a Clown," *White Tops* 46 (January–February 1973): 48.

31. This conclusion was corroborated by Dahlinger's research.

32. John Culhane, "Unforgettable Emmett Kelly," *Reader's Digest*, December 1979: 135–38; John and Mable Ringling Museum of Art, Sarasota, Florida.

33. "Name Two to Circus Hall of Fame," 4; Fred Dahlinger to Howard Bossen, memorandum in which Dahlinger provides identifications and commentary on Swank's circus photographs, Baraboo, Wisconsin, September 8, 2003.

34. Dahlinger to Bossen, September 8, 2003; Emmett Kelly with F. Beverly Kelley, *Clown* (New York: Prentice-Hall, 1954), 116.

35. Hagenbeck-Wallace Circus tour list, Circus World Museum, Baraboo, Wisconsin.

36. Identification of circus, date, and performers by Fred Dahlinger.

37. Penelope Redd, "3 Art Exhibitions Now in City Unusually Thought-Compelling," review of three Pittsburgh exhibitions, *Pittsburgh Sun-Telegraph*, January 14, 1934.

38. Nora Lee Rohr, "Albright Art Gallery Promises Features Having Wide Interest: Exhibit of Photographs Opens Today; Oriental Art, Blood Donor Posters Also to Be Shown," *Buffalo Evening News*, October 10, 1942; Beaumont Newhall, "Luke Swank's Pennsylvania," *U.S. Camera Magazine* 1 (Autumn 1938): 16–19, 65.

39. See as examples the following copy prints of the uncropped negatives in the Swank negative collection in the Carnegie Library of Pittsburgh. For each example, a cropped version of the image appears in the book. The negative number of the uncropped version precedes the plate number for the cropped version: C-277, plate 30; C-342, plate 44; and C-13, plate 48.

40. "Burning in" is a photographic term that means the background has been darkened by giving it more exposure to light than other portions of the image.

41. Iva May Headley, "George 'Bumpsy' Hulme," *White Tops* 62 (March–April 1989): 40, John and Mable Ringling Museum of Art.

42. Dahlinger showed me at least a half dozen photographs by Harry Atwell of Bumpsy Anthony in the Circus World Museum in Baraboo, Wisconsin. Every one of them shows Anthony with this bent-neck body presentation.

PEOPLE

1. Edith Elliott to Nancy Riggs, November 13, 1939, private collection of Nancy Hessel.

2. At least some of these images were made while traveling for Heinz and a few ended up being used in a collage for a possible Heinz advertisement. The Heinz archivist searched the company records and couldn't find evidence that these were used, but he assumed that although his records couldn't confirm it, they had been made for Heinz.

3. This excerpt is from the September 26 portion of the following letter: Edith Elliott Swank to John Elliott, September 12, 1940; September 26, 1940, private collection of Claudia M. Elliott.

4. The D-series of index cards in the Swank collection in the Carnegie Library of Pittsburgh has a set of cards that describe the photographs Swank made of Amish boys and girls, their school, and their Mennonite teacher.

5. Millen Brand in the essay that accompanied George Tice's photographs of the Pennsylvania Dutch in *Fields of Peace: A Pennsylvanian German Album*, photographs by George Tice, text by Millen Brand (Boston: David R. Godine, 1998), 119.

6. See D-100 index card in the D-series of index cards in the Swank collection in the Carnegie Library of Pittsburgh. Galluses are suspenders that hold up pants.

7. I based the titles "War Mother I and II" on an index card in the Carnegie Library of Pittsburgh Swank file referring to a series of three images of war mothers made for *Life* in December 1941. While there were no notations on these two images, they were found in the Carnegie Museum of Art's Swank collection with another photograph of a woman from this period seated beside a photograph of a young soldier.

8. Gisèle Freund. *Photography & Society* (Boston: David R. Godine, 1980), 4–5.

9. Edith Elliott Swank to Grace Pote Elliott, May 1947, private collection of Nancy Hessel.

10. Edith Elliott Long to Evna (full name unknown), New Orleans, undated letter written sometime after June 1962, private collection of Claudia M. Elliott.

11. Freund, *Photography & Society*, 4–5.

12. This portrait of Lucille Burroughs was made in 1936 when Evans was on loan to *Fortune* magazine from his government job. The portrait was made as part of Evans's collaboration with James Agee that resulted in the 1941 publication of *Let Us Now Praise Famous Men* (Boston: Houghton Mifflin, 1941). For a discussion of Walker Evans's life see *Walker Evans: A Biography*, by Belinda Rathbone (Boston: Houghton Mifflin, 1995).

13. See the essay "J. P. Morgan's Nose" by Eric Homberger, in *The Portrait in Photography*, edited by Graham Clarke (London: Reaktion Books, 1992), 119.

14. Ibid., 123.

15. Edith Elliott Swank to Grace Pote Elliott, undated October 1941; October 9, 1941, private collection of Nancy Hessel.

16. Edith Elliott Swank to Nancy Riggs, November 25, 1940; December 10, 1940, private collection of Nancy Hessel.

17. Franklin Toker observed in his book *Fallingwater Rising* that because the cabin tottered on a ridge overlooking the road it was called "'The Hangover,' with emphasis on the double entendre." Franklin Toker, *Fallingwater Rising: Frank Lloyd Wright, E. J. Kaufmann, and America's Most Extraordinary House* (New York: Alfred A. Knopf, 2003), 94.

TRANSFORMATIONS

1. Luke Swank to Joella Levy, undated letter, most likely written in early to mid-1933, the personal papers of Julien Levy in the Julien Levy Archive.

2. Harvey Gaul, "Swank Show of Photography at Tech School," review of Swank exhibition at the College of Fine Arts of Carnegie Institute of Technology, *Pittsburgh Post-Gazette*, January 16, 1934.

3. Frank Crowninshield, statement in an announcement titled "Announcing an Exhibition of Photographs by Luke Swank, May 6th to May 20th 1934, Delphic Studios, 9 East 57 Street, New York," collection of Carnegie Library, Pittsburgh, Pennsylvania.

4. Penelope Redd, "3 Art Exhibitions Now in City Unusually Thought-Compelling," review of three Pittsburgh exhibitions, *Pittsburgh Sun-Telegraph*, January 14, 1934.

5. László Moholy-Nagy, *Painting, Photography, Film* (Cambridge, Mass.: MIT Press, 1973); *Moholy-Nagy*, edited by Richard Kostelanetz, Documentary Monographs in Modern Art (New York: Praeger, 1970).

6. For this image and related ones see negatives numbered SW7192 through SW7199 in the notebook Swank 5: SW7111–AE9135, Miscellaneous and Aerial in the Swank negative collection in the Carnegie Library of Pittsburgh.

7. Linda Batis (associate curator of fine arts at the Carnegie Museum of Art, Pittsburgh), "Reality and Imagination: Photography by Luke Swank," biography of Swank for exhibition of the same name at the California University of Pennsylvania, California, Pennsylvania, January 15 through March 1, 2002.

8. Douglas Naylor, "Guilty of Artistry . . . Amateur Photographer Doesn't Think His Work Is Good as Others," review of Swank exhibition at the College of Fine Arts of Carnegie Institute of Technology, *Pittsburgh Press*, January 21, 1934.

RURAL ARCHITECTURE AND LANDSCAPE

1. Edith Elliott Swank to John Elliott, September 12, 1940, private collection of Claudia M. Elliott.

2. T. H. Scanlan, "Some Notes on Stereoscopic Photography," in *The American Annual of Photography*, vol. 45, edited by Frank R. Fraprie (Boston: American Photographic Publishing Company, 1931), 197–202.

3. The Carnegie Library of Pittsburgh collection contains approximately eighty-five glass plate stereograph views. Some are positive, some negative, and the subject matter runs from steel mills to rural architecture to nude figure studies of Grace Swank.

4. Luke Swank to Allen Porter, March 20, 1933, the personal papers of Julien Levy in the Julien Levy Archive.

5. Charles Morse Stotz, *The Early Architecture of Western Pennsylvania* (New York: W. Helburn for the Buhl Foundation, Pittsburgh, 1936). "A Petition from the Pittsburgh Chapter of the American Institute of Architects to the Buhl Foundation Concerning the Publication of a Volume Entitled 'The Early Architecture of Western Pennsylvania' from the Material Assembled by the Western Pennsylvania Architectural Survey," April 16, 1934, the Charles Stotz Collection in the Library and Archives Division of the Historical Society of Western Pennsylvania, Pittsburgh, Charles Stotz MSS #21 Box 3 Folder 9.

6. "A Petition," 16.

7. Committee for Preservation of Historic Monuments, Pittsburgh Chapter, A.I.A., "Annual Report for Year Ending January 16th, 1934," first draft, superseded by later report of much briefer character, Library and Archives Division of the Historical Society of Western Pennsylvania, Pittsburgh.

8. The Buhl Foundation first published the book in 1936. It was published subsequently in 1966 and 1995, both times by the University of Pittsburgh Press.

9. Stotz, *The Early Architecture of Western Pennsylvania*, 282. "Announcing: The Early Architecture of Western Pennsylvania: A Record of Building Before 1860 Based Upon the Western Pennsylvania Architectural Survey—A Project of the Pittsburgh Chapter of the American Institute of Architects—With an Introduction by Fiske Kimball," brochure announcing *The Early Architecture of Western Pennsylvania*, by Charles Morse Stotz, published by William Helburn, Inc., New York, for the Buhl Foundation, Pittsburgh, 1936, Library and Archives Division of the Historical Society of Western Pennsylvania, Pittsburgh.

10. Charles Morse Stotz, "Introduction," in *The Architectural Heritage of Early Western Pennsylvania: A Record of Building Before 1860* (Pittsburgh: University of Pittsburgh Press, 1966), l.

11. The version of "Meason Mansion Office & Outbuilding" reproduced in the book is in the Charles Morse Stotz collection in the Library and Archives Division of the Historical Society of Western Pennsylvania, Pittsburgh. Both of these images are also in the Western Pennsylvania Architectural Survey (WPAS) files of the Carnegie Library of Pittsburgh. They are both 5 x 7 inch contact prints mounted and labeled, and they have the WPAS stamp on the bottom and the catalog stamps on the top. These are stamped "Fayette" for the county they were made in and "2" for the property they denote. "Meason Mansion Office & Outbuilding" is cataloged in the collection as Fayette 2: F1–2l while the outbuilding is Fayette 2: F1–2k.

12. See "A Petition," especially the second part containing the Progress Report. Also see Committee for Preservation of Historic Monuments, Pittsburgh Chapter, A.I.A., "Annual Report for Year Ending January 16th, 1934," revised submitted version, Library and Archives Division of the Historical Society of Western Pennsylvania, Pittsburgh, 3.

13. Both of these images are in the Western Pennsylvania Architectural Survey (WPAS) files of the Carnegie Library of Pittsburgh. "Meason Mansion Staircase" and the other image, "Meason Arch," a tightly framed view of the archway and top part of a hall door, are both 5 x 7 inch contact prints mounted and labeled. They have the WPAS stamp on the bottom and the catalog stamps on the top. These are stamped "Fayette" for the county they were made in and "2" for the property they denote. "Meason Mansion Staircase" is cataloged in the collection as Fayette 2: F1–23; "Meason Arch" is Fayette 2: F1–2aa.

14. Pennsylvania Historical and Museum Commission roadside marker in front of the Meason Mansion outside Uniontown, Pa. The following sources are available from the World Wide Web: "A Priceless Piece of Early Americana," eBay listing for the Meason Mansion, http://cgi.ebay.com/ws/eBayISAPI.dll?ViewItem&item=2321194486&category-12605 (accessed May 30, 2003; site now discontinued); *The Isaac Meason Mansion: A National Historic Landmark*, http://isaacmeasonmansion.com (accessed May 30, 2003); Karen Kane, "Historic Fayette County Mansion for Sale on eBay: 1802 Gem of Hand-hewn Stone Must Be Removed from Fayette Site," *Pittsburgh Post-Gazette*, May 5, 2003, http://www.post-gazette.com/localnews/20030505meason0505p3.asp (accessed May 30, 2003); Marylynne Pitz, "Can Fayette County's Historic Meason House Be Saved?" *Pittsburgh Post-Gazette*, June 23, 2002, http://wwww.postgazette.com/homes/20020623meason0623fnp2.asp (accessed May 30, 2003).

15. "A Priceless Piece of Early Americana."

16. Ibid.; Pitz, "Can Fayette County's Historic Meason House Be Saved?"

17. "A Petition."

18. "Announcing: The Early Architecture of Western Pennsylvania."

19. Committee for Preservation of Historic Monuments, Pittsburgh Chapter, A.I.A., "Annual Report for Year Ending January 16th, 1934," first draft, superseded by later report of much briefer character, Library and Archives Division of the Historical Society of Western Pennsylvania, Pittsburgh.

20. Ibid.; Committee for Preservation of Historic Monuments, "Annual Report of the Committee for the Preservation of Historic Monuments for the year 1934 and 1935 to January 15," Library and Archives Division of the Historical Society of Western Pennsylvania, Pittsburgh, 6.

21. Committee for Preservation of Historic Monuments, Pittsburgh Chapter, A.I.A., "Annual Report for Year Ending January 16th, 1934," 3 (revised submitted version), Library and Archives Division of the Historical Society of Western Pennsylvania, Pittsburgh.

22. Committee for Preservation of Historic Monuments, Pittsburgh Chapter, A.I.A., "Annual Report for Year Ending January 16th, 1934," first draft.

23. Swank's handwritten notation on the back of the photograph titled "Old Inn on Dry Ridge Road," labeled as SW393, Carnegie Library of Pittsburgh.

24. Committee for Preservation of Historic Monuments, Pittsburgh Chapter, A.I.A., "Annual Report for Year Ending January 16th, 1934."

25. "A Petition," 22.

26. Gilles Mora, "Charles Sheeler: A Radical Modernism," in Theodore E. Stebbins, Jr., Gilles Mora, and Karen E. Haas, *The Photography of Charles Sheeler: American Modernist* (Boston, New York, and London: AOL Time Warner, Bulfinch Press, 2002), 79–93.

27. Ibid.

28. Carl Chiarenza, *Aaron Siskind: Pleasures and Terrors* (Boston: Little, Brown and Company in association with the Center for Creative Photography, 1982), 16.

29. Frank Crowninshield, statement in an announcement titled "Announcing an Exhibition of Photographs by Luke Swank, May 6th to May 20th 1934, Delphic Studios, 9 East 57 Street, New York," collection of Carnegie Library, Pittsburgh, Pennsylvania.

30. Evans was fired by Stryker before the name change.

31. Walker Evans as quoted on the book jacket of *Walker Evans First and Last* (New York: Harper & Row, 1978).

32. Edith Elliott Swank to Nancy Riggs, November 25, 1940; December 10, 1940, private collection of Nancy Hessel.

33. "Reiff Farm Bed & Breakfast," InnSite: The Internet Directory of Bed and Breakfasts, http://www.innsite.com/inns/A000475.html (accessed March 1, 2004).

34. These cards, part of the Swank collection in the Carnegie Library of Pittsburgh, when looked at in conjunction with his prints, negatives, the Carnegie Library database notations derived from notes on the original negative envelopes, and Edith's letters, provide a wealth of information regarding this segment of Swank's oeuvre.

35. Luke Swank, "D-240 Terror," photographic print in a series titled *Terror in the Farm Yard*, card D-240 in the D-Series index card file in the Carnegie Library of Pittsburgh Swank collection.

36. Susan K. Anderson to Howard Bossen, January 28, 2003.

37. Edith Elliott Swank to Nancy Riggs, November 25, 1940; December 10, 1940, private collection of Nancy Hessel.

38. Eleven of these photographs were numbered sequentially on the back in Swank's handwriting. This is the only series of his images known to exist where the order in which he wanted the viewer to see his visual essay is known. The photographs are numbered so the viewer begins by looking at the interiors of the Cloister and then moves outside to the exterior spaces, suggesting a tour.

39. Doug Ward, "The Ephrata Cloister: A Sabbatarian Commune in Colonial Pennsylvania," BibleStudy.org, http://www.biblestudy.org/godsrest/ephrata.html (accessed December 20, 2003). Also see Kay Jenkins Rew, "The Mystical Legacy of Ephrata Cloister: Lancaster County's 18th Century Spellbinding Culture," http://www.paturnpike.com/tools/newsletters/summer98/page-7.htm (accessed October 3, 2004); and Jan Stryz, "The Alchemy of the Voice at Ephrata Cloister," *Esoterica* 1 (1999): 133–59, (http://www.esoteric.msu.edu/Alchemy.html (accessed March 18, 2003).

40. Stryz, "The Alchemy of the Voice at Ephrata Cloister."

41. The Ephrata Cloister supplied titles for this group of images.

42. "Sisters' House (Saron) II," accession number 90.1049 in the Western Pennsylvania Conservancy collection at Fallingwater.

43. One example is "White House with Picket Fence and Colored Laundry," accession number 90.1053 in the Western Pennsylvania Conservancy collection at Fallingwater. Without color, the brightly colored sheets would lack their energetic staccato rhythm.

44. In the interview the author conducted with Grace Swank Davis in June 2003, she commented that her father told her that Swank often received film from Eastman Kodak to test. Both the company and the International Museum of Photography at George Eastman House in Rochester, New York, were contacted. Neither could find records to verify that Swank was or was not one of the photographers to whom they sent film (Grace Swank Davis, interview by Howard Bossen, June 1, 2003, Mount Pleasant, Iowa).

45. Walker Evans, "Test Exposures: Six Photographs from a Film Manufacturer's Files," *Fortune* 50 (July 1954): 77–80.

46. This interpretation is confirmed by comments Swank made to Julien Levy in a letter: Luke Swank to Julien Levy, undated but probably January 1933, the personal papers of Julien Levy in the Julien Levy Archive.

47. James Fraser, *The American Billboard: 100 Years* (New York: Harry N. Abrams, 1991), 68.

THIS IS MY CITY

1. William Stott, *Documentary Expression and Thirties America* (Chicago and London: University of Chicago Press, 1986), 134.

2. "Luke Swank," *Bulletin Index: Pittsburgh's Weekly Newsmagazine*, March 7, 1935. Lockwood was an art critic whose work appeared in *Creative Art: A Magazine of Fine and Applied Art*.

3. Stefan Lorant, *Pittsburgh: The Story of an American City* (Garden City, New York: Doubleday & Company, 1964), 343. Lorant mentions that Swank's pictures of Pittsburgh were taken in the 1920s. This is a mistake. While there are a small number of photographs of Pittsburgh made by Swank in the late 1920s, none of them are these. The images Lorant shows can be dated to the 1930s.

4. "Luke Swank," *Bulletin Index*, March 7, 1935.

5. The film format is the same one he used in his early steel mill photographs, and notes in the Carnegie Library of Pittsburgh database suggest that he may have begun to photograph Pittsburgh as early as 1920. Automobiles that appear in his photographs can be dated to the mid-1920s. Identifying the year an automobile was made, however, only provides a date before which his images could not have been made. Based upon automobiles, buildings, and other clues visible in his photographs, it seems reasonable to conclude that Swank began his urban studies around the mid-1920s.

6. Swank taught photography at the University of Pittsburgh and Duquesne University between 1935 and 1941.

7. Beaumont Newhall, "Luke Swank's Pennsylvania," *U.S. Camera Magazine* 1 (Autumn 1938): 16–19, 65.

8. Swank wrote his letter of introduction to Levy in December 1931 and became involved with Levy almost immediately thereafter. Atget was featured in an exhibit, along with Nadar, from December 12, 1931, to January 9, 1932, and then was in Levy's group exhibition Surréalisme from January 9 to January 29, 1932.

9. Atget used a large glass plate camera with his negatives being around 8 x 10 inches while Swank used sheet film cameras and most often produced negatives in the 4 x 5 inch format.

10. This is the title used when this image was published in the 1941 *U.S. Camera Annual*.

11. Percy Seitlin, "Books & Pictures," review of *U.S. Camera* (edited by T. J. Maloney), *AD 7* (December–January 1940–41): 35–36, Rochester Institute of Technology.

12. This image is one of at least nineteen of Swank's urban photographs that were used posthumously in a series of institutional advertisements titled *Landmarks* that the H. J. Heinz Co. placed in the programs of the Pittsburgh Symphony and the Pittsburgh Summer Opera in 1951 and 1952. Most likely Edith Swank wrote these ads just before she left the H. J. Heinz Co. in 1952.

13. "Street Corner with Shadows" is one of several images found in the Swank negative collection in the Carnegie Library of Pittsburgh that was made in the same general location on the same day. After examining this set of images, it is reasonable to conclude that Swank was working out the problem of how to make an interesting, powerful image by integrating strong shadow into an otherwise mundane picture frame. The example used here shows that with this frame he solved the problem.

14. The Carnegie Museum of Art owns a version of this image where the frame is exactly the same, only the man in the fedora hat is missing. In comparison, the photograph without the man is an unfinished statement.

15. The Logan Street series is comprised of a group of mounted, signed, and labeled photographs. On the front of these images in Swank's handwriting is the notation, "Logan St. Jan. 1939." Enough images with this notation were found in the Luke Swank collection in the Carnegie Library of Pittsburgh that they clearly constitute a series. It is not possible to determine if only these photographs were part of the series or if others at one time were included.

16. In 1939, the Federal Writers Project, one of many New Deal initiatives to employ artists, terminated "The Negro in Pittsburgh," which was to have been a publication that detailed the history of Pittsburgh's African Americans. Curiously, one of the Federal Writers Project documents recently uncovered by Laurence Glasco, a University of Pittsburgh historian, indicated that it was planned to have Swank and another photographer produce up to thirty photographs for the project. Since Swank's exploration of Logan Street is within the appropriate time frame it seems plausible that this series of photographs might be the ones referred to in the Federal Writers Project papers, although there is no way to prove this. See *The WPA History of the Negro in Pittsburgh*, edited by Laurence A. Glasco (Pittsburgh, Pa.: University of Pittsburgh Press, 2004), 2–3, n. 4.

17. In 1939, the Princeton art historian Erwin Panofsky tried to arrange a show for Swank at Princeton. In one letter to Swank, Panofsky told Swank that he fell in love with his photographs, only to report in his next letter that the person in charge of exhibits "considered your pictures of Pittsburgh too 'gloomy' to meet with the approval of the local public. And as this is perhaps the silliest thing one can say about them I simply fell silent. Thus your photos will not be shown in public. They are and will be shown, however, in private. And it may give you some satisfaction to hear that of my better friends, there is not one who does not admire them as much as I do." Erwin Panofsky to Luke Swank, August 5, 1939, transcript copy in the collection of the Carnegie Museum of Art, Pittsburgh. Erwin Panofsky to Luke Swank, undated letter written after August 5, 1939, transcript copy in the collection of the Carnegie Museum Art, Pittsburgh. While the originals of these letters have not been found, the transcripts are believed to be accurate. Material quoted with the permission of Dr. Gerda S. Panofsky.

18. For a discussion of this concept see Cartier-Bresson's introduction to his book *The Decisive Moment: Photography by Henri Cartier-Bresson* (New York: Simon and Schuster, 1952). Cartier-Bresson began photographing in the early 1930s and managed his brilliant accomplishments with the aid of the then relatively new Leica. This faster and smaller 35 mm camera was an instrument designed for greater spontaneity of use than the larger, clumsier sheet film cameras that Swank relied on.

19. Stott, *Documentary Expression and Thirties America*, 135.

INDEX

Abbott, Berenice, 13, 66, 70; exhibitions of, 9–12, 17

abstracts, Swank's, 14, 57, 67; circus photos as, 37, 43; steel mill photos as, 30, 32–33; still life photos as, 49–51, 52

Adams, Ansel, 1, 27, 62; in exhibitions, 15, 17–18

Adamson, Robert, 17

After the Photo-Secession: American Pictorial Photography (Peterson), 6, 8

Albright Art Gallery (Buffalo), 18

All-American Photographic Salon competition, 7

Altwater, F. Ross, 7, 29, 32

American Institute of Architects, 13, 53–54

American Photography Retrospective Exhibition, 9, 12

Amish. *See* Pennsylvania Dutch region

"Amish Boys Nibbling Grapes," 45, **134**

"Amish Boys with Watermelon," 45, **135**

"Amish School Girls," 45, **136**

Anthony, Bumpsy, 43, 229n42. *See also* "Bumpsy Anthony, Clown"

Archer, Charles K., 29, 31

army, Swank in, 4

art photography, 6, 17; First Salon of Pure Photography and, 1–2; pictorialism in, 6–7; Swank's, 5, 18, 22, 31; Swank's legacy in, 26–27

Atget, Eugène, 13, 232n9; in exhibitions, 17, 232n8; Swank compared to, 12, 54, 66–67; urban photos of, 66–67

Atwell, Harry, 41, 228n26, 229n42

Avedon, Richard, 44

"Balcon, 17 rue du Petit-Pont" (Atget), **67**

"Balloon Vendor," 43, **111**

"Barn, Lake George" (Stieglitz), **58**

"Barn with Windows," 57–58, **160**

Barnum, P. T., 37

"Barren Trees with Split Rail Fence," 62, **171**

Bayer, Herbert, 9

"Bedroom Window of Bud Fields's Home, Hale County, Alabama" (Evans), **59**

Beissel, Conrad, 61

Bell, Franklin, 24

"Benkovitz's Fish Market," 71, **189**

"Beplen Street," 70–71, **177**

Bethlehem Steel Works, 7, 28–30, 75–77, 227n7

"Blast Furnaces, Lower Cambria Works," 7, **79**

"Boulevard Service I–III," 67, 67–68, **200**

Bourke-White, Margaret, 11, 27, 70; in exhibitions, 9, 16; industrial photographs of, 33–36; Swank and, 12, 29, 33; Swank's play for, 24, 34

Bowman, John, 18

"Boys Swimming," **50**

Brady, Mathew, 9, 13, 17

Brand, Millen, 45

Brandt, Bill, 68

Bravo, Manuel Alvarez, 12, 14

"Brocanteur, 4 rue des Anglais, Paris" (Atget), **66**

bromoil prints, 7–8, 224n30

Bruehl, Anton, 13

Bucks County: Photographs of Early Architecture (Siskind), 57

"Bumpsy Anthony, Clown," 43, **118**

Camera Craft, 15

Camera Pictorialists of Los Angeles, 8

Camera Work (Stieglitz), 29

cameras, 6, 232n18; used by Swank, 22, 232n9. *See also* film

"Car and Building," 69, **197**

Carnegie Institute, 6, 27, 227n148

Cartier-Bresson, Henri, 27, 232n18; in exhibitions, 12, 14, 17

"Catacombs," 70–71, **180**

"Cathedral of Learning under Construction," **65**

"Charles Sheeler: A Radical Modernism" (Mora), 33

Charles Sheeler and the Cult of the Machine (Lucic), 30

"Child with Laundry," 71, **182**

chloro-bromoide prints, 8

circus: advertising for, 40–41; in art, 38–39; decline of, 37–38; Harry Swank (son) with, 21, 25, 37

circus photographs, Swank's, 15, **38**, 228nn9,24; comparisons of, 39–40; cropping, 43, 229n39; dating of, 14, 16, 38, 43, 227n2, 228n16; documentation of, 21–22; style of, 37, 41–43; workers in, 39–43

"Circus Tent" (E. Weston), 39

"Circus Tent I," 43, **126**

"Circus Tent II," 39, **127**

"Circus Trainer Leading Elephant, Winter Quarters, Sarasota" (Evans), **40**

Circus World Museum, 228n16

class, social, 45–46, 63, 68

Clausen, Rev. Bernard, 24

"Clown Reading a Newspaper" (Kelty), 40, **108**

"Clowns, Hagenbeck-Wallace Circus, Brooklyn, N.Y." (Kelty), 39

Coburn, Alvin Langdon, 6

color photographs, Swank's, 22, 225n125, 231n43; of rural scenes, 53, 62; of steel mills, 28, 36

commercial photography, Swank's, 18, 26–27; documentation of, 21–22; studio for, 19–20, 25. *See also* H. J. Heinz Company

"Common Room, Sisters' House" (Saron), 62, **165**

"Concrete and Wood," 51, **149**

"Corner Store," 69, **201**

Crowninshield, Frank, 14–15, 49, 58

Cunningham, Imogen, 1–2, 9, 15

Dahlinger, Fred, Jr., 38, 228n16

Dalí, Salvador, 12

Davis, Grace Swank (granddaughter), 62

Davis, Stuart, 10

"December Day," 68, **192**

Delano, Jack, 59

Delphic Studios, exhibit at, 14–15, 58

Depression, the, 12, 65; Swanks' experiences in, 3–4, 13, 18; photo documentation of, 46–47, 58–59, 64

"Dessau" (Moholy-Nagy), 51

Documentary and Anti-Graphic Photographs, 12, 14

Documentary Expression and Thirties America (Stott), 64

documentary photography, 64; steel mill photos as, 30, 35–36; Swank's, 2, 22, 35–37. *See also* social documentary photography

Doolittle, James Nichols, 8

"Doormat, The," 17, 18

"Double Door Flanked by Ferns," 57, 60–61, **162**

"Doylestown House, Stairway, Open Door" (Sheeler), **62**

Drtikol, František, 7

dry plate photography, 6

Duquesne University, 19, 232n6

"E. S. Renninger Hardware," 44, 60, **154**

Early Architecture of Western Pennsylvania (Stotz), 13, 53–54, **54**, 230nn8–9

Eastman Kodak, 6, 62, 231n43

"Eating Lunch," 35

Edgerton, Harold, 17

"Edith by the Hangover," 48, **141**

"Edith in Bathing Cap," 48, **142**

education: Swank learning photography, 28–29, 66, 227n5; Swank's, 4–6; Swank teaching photography, 19, 232n6

Edwards, John Paul, 15

Edwards, Mary Jeanette, 15

"Elephant Train," 40

Elliott, John and Jo (Edith's brother and sister-in-law), 23, 227n148

Elliott, Philip, 18

233

"Emmanuel Episcopal Church Organ," 69, **185**

"[Emmet Kelly]", Untitled, (Heilbron), **40**

Ephrata Cloister, 61–62, 231n38. See also Pennsylvania Dutch region

Ernst, Max, 12

Evans, Walker, 40, 62, 66, 70; in exhibitions, 9, 12–14, 17–18; photos for social reform interests by, 46–47; reputation of, 13, 27; rural photos by, 56–57, 63, 229n12; Swank compared to, 12, 58–59

Fallingwater (Kaufmann house), 20–21, **21**, 229n17; Swank's photos of, 20–21, 48; Swanks visiting, 24, 48

Fallingwater Rising (Toker), 229n17

Farm Security Administration (FSA), 58–59, 64

Fifteenth Annual International Salon of Pictorial Photography, 8

"Fifth and Liberty," 70, **175**

film, 231n43; color, 36, 62, 225n125; panchromatic, 15; roll, 6; used by Swank, 22, 65, 225n125, 232n9

finances, Swanks', 3–4, 13, 24–25

First Salon of Pure Photography, 1–2, 15

"Ford Motor: Blast Furnace" (Bourke-White), 34, **35**

Ford Motor Company, 33–34

"Ford Plant, River Rouge, Blast Furnace and Dust Catcher" (Sheeler), 33, **34**

Fortune magazine, 29, 35–36, 62, 229n12

42nd Annual Exhibition of Pictorial Photography, 9–10

"Four Boys and a Man," **43**

"Franklin Borough," 31–32, **86**

Franklin Mills. See Bethlehem Steel Works

Freund, Gisèle, 45–46

Gaul, Harvey, 16

"George Washington Bridge" (Steichen), 11

Glasco, Laurence, 232n16

glass plate stereographs, 28, **29**, 48, 53, **54**, 230n3

Glock, Charles, 3

Glock, Earl (cousin), 4

"Grace I," 48, **140**

"Grace in the Garden," 48

Graham, Laurie, 28

Griebling, Otto, 37, 41–42, **42**, 115, **120**

"Grocery Store," 71, **191**

Group f.64, 15, 17

Gulf Gallery, Swank's exhibit at, 16

Gursky, Andreas, 11

H. J. Heinz Company: Edith working for, 23, 27; effects of WWII on, 25–26; as Swank's client, 20–22, 53; Swank's photos for, 22–23, 46, 59, 229n2; use of Swank's photos for ads, 27, 232n12

Hagenbeck-Wallace Circus, 38, 42, 228n25

"Hagenbeck-Wallace Circus Poster," 40–41, **104**

"Hand of Man, The" (Stieglitz), 29, **30**

Hare, Clyde, 20

Heilbron, Kenneth, 39–40, 228n22

Heinz, H. J., II, 21

Hill, David Octavius, 17

Hine, Lewis, **30**; social documentary photography of, 6, 30–31, 46, 227n10

homes, Swank's, **5**, 24

Hulme, George Anthony. See Anthony, Bumpsy

Hurley, F. Jack, 31

Huxtable, Ada Louise, 26–27

industrial photographs, 33–36. See also steel mill photographs, Swank's

Industry and the Photographic Image (Hurley), 31

"Industry" (Sheeler), 10, **11**

"Ingot Molds," 7–8

International Photographers exhibition, 9–10

"Intersection of Horizontal and Vertical Wood," **51**

Jerome, Paul, 41, 228n29

"John Bonato Co. Clothiers," 66–67, **194**

Johnstown, Pennsylvania, 53; circus photos in, 38, 42–43, 228n24; flood in, 3; steel mills in, 5, 28; Swank family in, 3–4

Julien Levy Gallery: other exhibitions at, 9, 12; photography at, 11–12, 14; Swank's exhibitions at, 12–14, 223n1, 232n8. See also Levy, Julien

Kahlo, Frida, 19

Käsebier, Gertrude, 9

Kaufmann, Edgar, 6, 19–20, 26

Kaufmann, Edgar, Jr., 20

Kaufmann, Liliane, 6, 19, 23

Kaufmann Department Store, 16, 20

Kellogg, Paul, 30

Kelly, Emmett, 37, **40**, 41–42, **120**

Kelty, Edward J., 39

Kertész, André, 9, 13, 50

Kimball, Fiske, 61

Kirstein, Lincoln, 10

Kodak. See Eastman Kodak

"Kroger Grocery/Baking Co. ," 68, **205**

Lange, Dorothea, 17, 46–47, **47**, 59, 70

laundry, in Swank's photos, 63, 71

Leary, Thomas, 33, 227n13

Legacy series, 63

"Legs, Gourds, and Shadows," 52, **153**

Le Secq, Henri, 17

Levy, Joella, 12–13, 49

Levy, Julien, 1, 19; arranging photography exhibits, 10–11, 13; artists and, 66, 224n36; showing Swank's work, 9, 13; Swank's correspondence with, 12–14, 18; on Swank's work, 12, 14. See also Julien Levy Gallery

Life magazine, 64

Lockwood, Bruce, 64

"Looking at a Man through a Car Window," 52, 71, **183**

Lorant, Stefan, 64, 231n3

Los Angeles Camera Pictorialists, 8

Los Angeles photographic salon, 6–7

"Lower Cambria Works," 7–9, **9**, 31–32, **78**

Loy, Mina, 9, 12–13, 224n36

Lucic, Karen, 30

"Lucille Burroughs, Hale County, Alabama" (Evans), 46, 47, 229n12

Luke Swank, Inc., 20

"Luke Swank's Pennsylvania" (Newhall), 16–17, 32, **33**

Lynes, George Platt, 9–10, 12–13

MacDougall, Robert, 38, 228n16

machine age, 9, 30; photographs celebrating, 33–34, 36, 65; steel mills symbolizing, 28, 36

"Man Crossing City Street," 70, **174**

"Man Looking Out Window," 71, **184**

"Man on Top of a Hot Blast Main," 33, **34**

"Man with Cigar," 46–47, **133**

Marsh, Reginald, 10

Marvel, Josiah, 9

McAlpin, David, 17

"McKees Rocks Bridge," 65

"Meason Mansion Office and Out-building," 54, **167**, 230n11

Meason Mansion photographs, 53–55, **54**, 230nn11,13

"Meason Mansion Staircase," 54–55

"Meetinghouse (Saal) Kitchen," 62, **164**

"Men Loading Tomatoes on Flatbed Truck," 59, **159**

"Men's Coats," 67, **196**

"Metal Ring and Shadows," 52, **146**

"Migrant Children," 45–47, **129**

"Migrant Mother" (Lange), **47**

Miller, Lee, 9, 12

modernism: beginning of, 6, 8; other photographers', 34, 57; relation to pictorialism, 9–10; in rural photos, 56–57; Swank embracing, 1, 9–10, 15–16; Swank's, 16–17, 19, 32–33, 38, 42–43, 66; techniques of, 42–43

Modotti, Tina, 9

Moholy-Nagy, László, 9, 13, 17–18, 50

"Monongahela River, Pittsburgh," 72, **206**

Mora, Gilles, 33

Morsell, Mary, 10–11

mounting: modernist, 15, 33; of pictorialists, 8–9; of steel mill photos, 32–33, 227n18

Murals by American Painters and Photographers exhibition, 1, 6, 10–11, 13, 33, 224n47

Museum of Modern Art (MoMA), 20; asking for Swank's photos, 26–27; Department of Photography of, 1, 17; murals exhibition at, 1, 6, 10–11, 13, 33, 224n47

National Geographic magazine, 22

Naylor, Douglas, 52

"Negro in Pittsburgh, The" (Federal Writers Project), 232n16

Newhall, Beaumont: "Luke Swank's Pennsylvania" by, 16–17, 32–33; MoMA's Department of Photography and, 1, 17; Sixty Photographs exhibition and, 17–18; on Swank's photos, 34–35, 65–66

news photography. See photojournalism

"New York" (Abbott), 11
New York Photo League, 64

objectivity/subjectivity, of photography, 31, 45–46
O'Keeffe, Georgia, 10
"Old Basket in the Cellar," 7, 52, **143**
"Old Inn on Dry Ridge Road," 55–56, **56**
"Old Mennonite Church, Lancaster Co.", 62–63, **156**
Orozco, José Clemente, 10
O'Sullivan, Timothy, 17
"Otto Griebling on Horseback," **42**, 42–43, **115**
Outerbridge, Paul, Jr., 9

"Painters," 8, 224n31
Panofsky, Erwin, 232n17
Passafiume, Tania, 224n47
Patterson, Rody, 55
"Paul Jerome, Clown," 41, **117**
Pennsylvania Agricultural College, 4
Pennsylvania Dutch region, 23, 62–63; ethical problems in photographing in, 44–45; Swanks' book plans about, 25, 60; Swank's photos of, 60, 229n4
personality, Swank's, 21, 23
Peterson, Christian, 6, 8–9
Philadelphia Museum of Art, 61
photographic salons, 6–7, 15, 29
Photographs of New York by New York Photographers exhibition, 12
Photographs of the American Scene exhibition, 1, 12
photography: capturing moments in, 66, 69–72; dating Swank's work, 13, 16, 224n60, 227n2; influences on Swank's, 15, 39, 50; quality of Swank's work, 12, 14; Swank experimenting in, 6–7, 50; Swank not dating or labeling images, 42, 44, 223n2; Swank's evolution in, 4–6, 57–58; Swank's goals for, 14, 16, 49, 64; Swank's novice image in, 13, 16; Swank's reputation in, 9, 11, 15–16, 26–27, 54; Swank's self-education in, 1, 5, 28–29, 49–50, 57–58. *See also* social documentary photography
Photography & Society (Freund), 45–46
photojournalism, 16, 18–19
Photo-Secession, 6
pictorialism, in photography, 6–8, 34; modernism's relation to, 9–10;

steel mills and, 7–9, 28, 31–32; Swank's, 6–9, 28, 32, 42–43, 53, 68; techniques of, 8–9
Pictorialist, 8
Pittsburgh, 14, 31
Pittsburgh: The Story of an American City (Lorant), 64
"Pittsburgh #12," 15, 69, **188**
Pittsburgh photographic salon, 6
Pittsburgh photographs, Swank's, 27; as captured moments, 69–72; composition of, 67–72; dating, 14, 231n3, 232n5; development of, 64–65; light in, 71–72, **182**, 232n14; Logan Street series in, 70, 232nn15–16; people in, 69–72; subjects of, 65, 68–69; Swank's style in, 64–67
Pittsburgh Survey, 30
Porter, Allen, 13, 53
"Portrait of a Young Girl," 46–47, **130**
portraits, 23, 44, 48
prints: modernist, 15, 33; pictorialists', 8; Swank cropping, 42–43, 229n39; Swank's, 12, 32–33, 38
"Prosperity—A Vision" (Archer), 31

race, 46, 70
"Railroad Tracks and Steel Mill, Johnstown, Pa.", 29, **30**
Ray, Man, 9, 12–13, 17
realism, 9, 64, 68
"Reiff Farm, Oley Valley," **61**, 63
Resettlement Administration (RA), 58–59
Richardson, H. H., 26–27
Riggs, Nancy (sister-in-law), 23
Riis, Jacob, 6
Ringling Brothers and Barnum and Bailey Circus, 38
Rivera, Diego, 10, 19
"River Barges and Steel Mill," **31**
"River View with Barges" (Torrance), **31**
"Rolled Wooden Fence," **151**
"Rooftops," 69, **214**
Rotan, Thurman, 10–11
Rothstein, Arthur, 59
rural photographs, 21–22, 53; comparison of styles of, 56–59; Farm Security Administration commissioning, 58–59; Swank's, 55–56, 59, 61–62, 63; Swank's, for Western Pennsylvania Architectural

Survey, 53–56; Swank's style in, 56–57, 59
Ryan, Grace. *See* Swank, Grace Ryan

"Sarraz, La" (Moholy-Nagy), **50**
School House series, 45
Seitlin, Percy, 68
Sells-Floto Circus, 41–42, 228nn21, 27
"Sells-Floto Circus Posters" (Atwell), 41
Shahn, Ben, 10
Sheeler, Charles, 12, 62, **62**, in exhibitions, 9, 17–18; industrial photographs of, 33–34; photomural by, 10–11, 224n47; rural photos by, 56–57
"Shoe Doctor," **199**
"Shoes in Store Window," 67, **195**
"Side of White Barn, Bucks County" (Sheeler), **57**
signage, in Swank's photos, 63, 68–69, 228n9
Siskind, Aaron, 56–57
"Sisters' House (Saron)", 62, **163**
683 Brockhurst Gallery, 15
Sixty Photographs: A Survey of Camera Aesthetics exhibition, 17
"Skip Bridge," 10, **84**
"Skip Bridge and Dust Catcher I," 10, **83**
"Skip Bridge and Dust Catcher II," 10, **85**
"Skunk Hollow Looking toward Bloomfield," 68–69, **207**
"Skyscrapers" (Rotan), 10–11
Smith College Museum of Art, 13
social documentary photography, 6, 46, 72; for Farm Security Administration, 58–59; Hine's, 30–31, 227n10
"Spruce Street, Franklin Borough I," 7, 31–32, **80**
"Spruce Street, Franklin Borough II," 32–33, **81**
"Stable" (Siskind), **57**
"Steel Mill on the Monongahela" (Altwater), 32
steel mill photographs, Swank's: dating of, 28, 33–34; early, 5, 32, **75–77**; pictorialism in, 7–9; style of, 30, 32–36; techniques of, 28, 33, 227n18; workers in, 34–35
steel mills, 53, 68; other photographers of, 7, 24, 31–32; symbolizing machine age, 28, 36
"Steel Plant," 1, 6, 10, **82**

"Steel Worker in Foundry," 7, **102**
"Steel Worker with Foundry Crane," 7–8, **98**
"Steelworkers at the Russian Boarding House" (Hine), **30**
Steichen, Edward, 1, 9–11, 16
stereography. *See* glass plate stereographs
Stieglitz, Alfred, 13; in exhibitions, 9, 17–18; modernism and, 6, 9; Photo-Secession and, 6; rural photos by, 56–57; Swank compared to, 1, 14–15, 29, 49, 57–58, 68; Swank studying, 28–29
still life photos, Swank's, 15, 22; as abstracts, 49–51, 52; dating, 14, 16; formal, 51–52; urban photos as, 67, 69; use of light in, 7, 49, 51–52, **146**
Story of Food Preservation, The (Swank), 21, 24, 60
Stott, William, 64, 72
Stotz, Charles Morse, 13, 53–56
Strand, Paul, 6, 9, 17, 62
"Street Corner with Shadows," 69, **173**, 232n13
"Street Scene with Steam Train," 68, **193**
Strip District study, in Pittsburgh photos, 69
Struth, Thomas, 11
Stryker, Charlotte, 57
Stryker, Roy, 58–59
style, Swank's, 2, 14, 16–17, 49, 71; in circus photographs, 37, 41–43; in Pittsburgh photographs, 64–67; in rural photographs, 56–57, 59; of shooting photos, 65–68; in steel mill photographs, 30, 32–36
surrealism, 2, 12
Surréalisme exhibition, 12, 232n8
Swank, Edith Elliott (wife), 46; book plans with Luke, 53, 60; on ethical problems in photographing Amish and Mennonites, 44–45; Harry and, 25, 228n5; on Luke, 5, 23–24; photos of, 44, 48, **141–42**; travel with Luke, 21–22, 24–25, 60; trying to protect Luke's legacy, 26–27, 227n148; work for H.J. Heinz Company, 21, 23
Swank, George W. (uncle), 3
Swank, Grace Ryan (wife), 4; death of, 21; photos of, 5, 7, 44, 48, 53, **140**
Swank, Harry (father), 3–4, 19, 24–25, 37

Swank, Harry (son), 4, 7; circus and, 21, 37, 228n5; parents and, 6, 24; as photographer, 25, 37, **38**, 53
Swank, Morell (uncle), 3
Swank family: businesses of, 3–4, **4**, 16, 19, 21, 24–25; circus obsession of, 37; in Johnstown flood, 3
Swank Hardware Company, 3–4, **4**
Swank Motor Sales, 3–4, 16

"Tennessee Church," **58**, 59
"Terror in the Farm Yard" series, 61
themes, in Swank's photos, 28; in pictures of people, 45–48; of vanishing America, 14–15, 36, 38, 53, 56, 63–64
Thorek, Max, 16

"Three Amish Youths with Buggies," 63, **155**
"Three Boys in a Wagon," **128**
"Three Women," **47**, **139**
"Tire and Oil Can," **145**
Toker, Franklin, 229n17
"Torn Ringling Brothers Poster" (Evans), 40, **41**
Torrance, Hew Charles, 29, 31
"To the Big Show," 38, **103**
"Train Shed," 71–72, **215**

University of Pittsburgh, 18–19, 232n6
urban photos, Swank's. *See* Pittsburgh photographs, Swank's

U.S. Camera Magazine, 16
U.S. Camera Salon, 16

Van Dyke, Willard, 15
"Victorian Farmhouse, Rt. 30," 63
"Victory Produce Co. ," 63, 71, **186**

"Waiting," 70–71, **178**
Walters, John, 5, 37
"We Serve Fort Pitt Beer," 70, **190**
Western Pennsylvania Architectural Survey: files of, 230nn11, 13; stereographs for, 53, **54**; Swank working on, 53–56
Weston, Brett, 12, 14, 17
Weston, Edward, 15, 27; circus photos of, 38–39; in exhibitions, 1–2, 9, 15, 17–18; influence on Swank, 12, 15, 28–29, 39
White, Clarence, 8–9, 13, 17
"Window, Clapboard House, and Ferns," **58**, 59
Wolf, Irwin D., 20
"Wooden Church near Beaufort, South Carolina" (Evans), **59**
"Woman in Shadows," 46
"Woman Walking," 70–71, **179**
"Women at Portrait Studio," 46–47, **131**
workers: agriculture, 46; in circus photos, 38–43; in steel mill photos, 34–36
World War II, 25–26
Wright, Frank Lloyd, 20–21